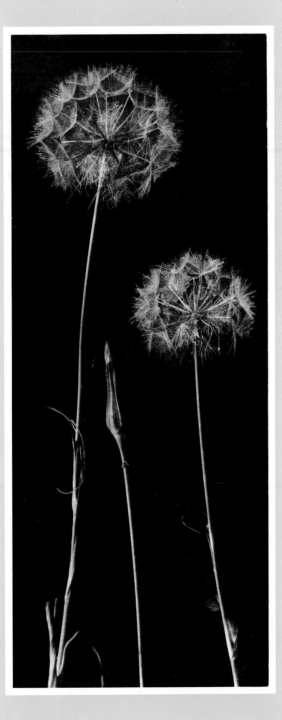

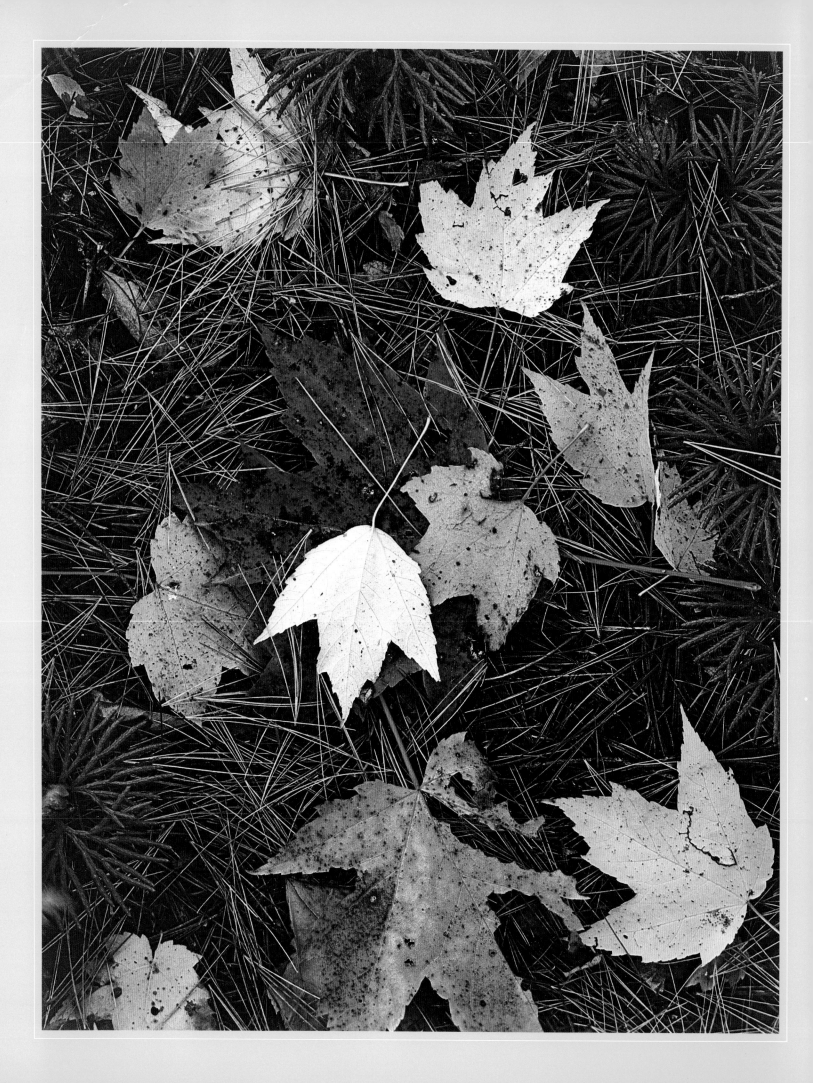

LANDSCAPE

With 180 plates

including 29 in full colour

Preface by

David Plowden

Introduction by

Ian Jeffrey

Thames and Hudson

The editors and publisher express their sincere thanks to the photographers, collectors, and museums who have made this selection of pictures possible. The photographs in the book follow a general chronological order decade by decade, but for technical as well as artistic reasons, certain departures have been made. Biographical notes on the photographers are included at the end of the book, as well as a glossary of photographic-process terminology.

On page 1: Frederick H.Evans/*Dandelions*/Platinum print, n.d.
On page 2: Eliot Porter/*Maple Leaves and Pine Needles, Tamworth, New Hampshire*/Dye transfer print, 1956
On Page 5: Edward S. Curtis/*The Rush Gatherer, Kutenai*/Photogravure, 1910
On page 6: Henri Le Secq/*Untitled*/Salt print, 1852
On page 21: Alfred Stieglitz/*Lake George*/Gelatin silver print, 1922
On page 210: NASA/*The Earth, from the Mediterranean to Antarctica (From the Apollo 17 Spacecraft)*/Special thin-base Ektachrome, 1972

Series conceived and originated by Shueisha, Tokyo
Published by Shueisha under the title 'The Gallery of World Photography'
Project director: Hiroyuki Yamagata. Project consultant: Koen Shigemori

Editor-in-chief: Bryan Holme. Research Consultant: Weston Naef
Director of photographic research: Joan Morgan. Designer: Robert Scudellari

First published in Great Britain in 1984 by Thames and Hudson Ltd, London

Printed and bound in Japan

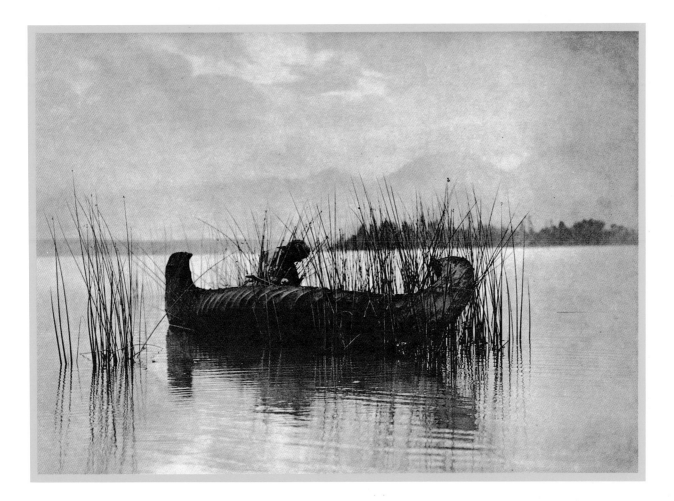

CONTENTS

'Of all the varieties of photography, landscape . . . is the supreme test for the photographer,' wrote Wallace Stegner in his introduction to *Ansel Adams Images 1923-1974*. The photographer has to catch the fortunate combination of earth, sky, and cloud – he can't compose or position them. The camera must, in the small space of the print, convey the very presence of the scene. And, finally, there is the need to catch the moment when the light is, in Nancy Newhall's word, most 'eloquent'.

The power of still photography rests with its stillness. It has an unparalleled ability to force the eye to look at everything that is within the frame, right down to the last blade of grass in the bottom right corner. Whatever is captured by the camera is inescapable to the viewer. The most irrelevant objects in the real scene can become most relevant in the print. Not only does the camera freeze the world, preserving what is caught at one time for someone else in another time to see, but it also takes what it sees out of context. The danger, of course, is that photographs, like quotations lifted from a body of work, will be too fragmentary to convey the sense of the original. Conversely, the strength of the still photograph is its ability to emphasize, to abstract the salient features of the subject, and thereby clarify it.

The process of elimination – selection – in making photographs is paramount. What not to include becomes as important a consideration as what to include. I find this especially difficult when photographing landscape because there are so many unpredictable factors to deal with. Take, for example, the following imaginary but typical situation. I am driving around the country looking for a certain type of location to photograph. Suddenly around a curve the view I have been looking for materializes. I stop the car, find a camera, set up my tripod and start to look.

At first everything seems just right. But there is a line of telephone poles stretching away across a distant hillside that I didn't notice through the windshield. The illusion of wilderness – if that is what I was looking for – is thus shattered. Still, I wasn't looking for wilderness today and the telephone poles could be assimilated. The clouds, the nemesis of many a photographer, are another matter. Today they are huge puffy 'beautiful summer day' clouds, the kind that Paul Strand called 'Johnson & Johnson' clouds. They will be as solid as blocks of concrete in the photograph. I wish they weren't there; they are playing havoc with what would otherwise be a fine composition. 'Otherwise'! But they are part of it, so I deal with it. Like a dog who sits down to scratch his ear as a way of avoiding a fight, I rummage through my pockets for a light meter. By the time I find it, the whole scene has changed. A thunderhead is moving in on the left and a jet plane at thirty-five thousand feet has left its contrail across the bowl of the sky. The shadows of the thunderhead and the beautiful clouds are creating great chasms in an almost flat cornfield. Now suddenly a burst of sunlight reflects off the tin roof of a chicken-house, which until now has been a benign little feature in the landscape. There is no way to change my

vantage point to remove it without standing in the middle of the road or falling down a twenty-foot precipice at its edge. I am thinking that perhaps I should call the whole thing off. Then the sun is suddenly turned off the roof and the contrail has been carried beyond my frame. My spirits are raised again. I am just feeling able to cope when a herd of cows begins to appear over the brow of a hill. Cows always seem to be strewn haphazardly across a field without the slightest regard for their effect on a composition. Even Edward Weston, I am told, had problems with cows whose tails kept switching during his long exposures. Sheep are different. They cooperate. They always arrange themselves harmoniously around a field as if choreographed.

The thundercloud is beginning to take over the sky now, so that the exposure will have to be longer. The wind begins to pick up so I will have to use a faster shutter-speed to still the blowing grass and leaves. This combination means that there won't be enough depth of field to keep the foreground stone wall in focus. It will be ever so slightly out of focus, just enough so that anyone looking at the print will feel like changing glasses to make sure his eyes aren't bad. I decide to eliminate the wall altogether, and am prepared to grab the cable-release when a flock of starlings decides to fly in and out of my picture. Finally they fly on. The uncooperative cows have grazed their way to greener pastures, for a moment the clouds and shadows become part of the architecture of the scene. The sun comes out, the wind stops blowing, I have my wall in focus. Everything is set – when a car pulls up right in front of my tripod. A cheery voice asks, 'What you takin' a picture of, Mister?'

'Nothing now,' I reply. I pack up my gear and leave. I reject the idea of returning. It is impossible to find a photograph again – a particular photograph exists only at that moment; to return to the location does not mean it will still be there. Often I have returned to a location hoping to find what I found before, but I have never succeeded. The stage-set, the mountains, the trees, may all be in place, but they are in a different light now. The subject exists, if it does so at all, only as my print.

There are, in fact, several photographs that I have taken whose location is a mystery to me. I have never been able to find a trace that the places existed at all. Unfortunately, today there may be a more important sense in which a place has ceased to exist. We no longer live in a land where we can keep moving west to inhabit untouched territory. Man has begun to leave scars on the landscape which so inspired the nineteenth-century pioneer photographers. Photographic documentation is too often the only evidence that a country-place ever existed.

The role of the landscape photographer as conservationist has a long history. Indeed, most of us who have turned the camera toward the land for our subject matter have been conservationists at heart. Photographers like Timothy H. O'Sullivan, Carleton E. Watkins and Francis Frith were among the most illustrious. Their photographs left a most valuable record of time and place, and celebrated the land as well. Their work helped to awaken a populace largely unaware of the value of the land as a human resource. Jackson's photographs made in 1871 in the Yellowstone region, for example, were instrumental in the creation of the park by Congress the following year. Others, less celebrated, created priceless documents, like L. A. Huffman, who recorded the buffalo herds before they were exterminated (p. 10).

Robert Adams and Lewis Baltz (p. 13) are two among a number whose photographs deal directly with the modern assault on the landscape. The work of Walker Evans (p. 16), Dorothea Lange, Arthur Rothenstein, Russell Lee, and the other photographers who worked for the American Farm Security Administration in the 1930s, constitutes one of the most telling documents we have of the effect that man has had on the land. Certainly, twentieth-century photographers like Ansel Adams and Eliot Porter and Philip Hyde are as dedicated conservationists as any the world has seen. The work of these people as defenders of a natural world under increasing threat is in every way as important as are their considerable contributions to the art of photography.

Introduction
by Ian Jeffrey

Although pioneer photographers were interested in rustic life they were equally fascinated by representation itself, by the way in which actuality transferred itself to paper and became image. Country corners, or 'rural bits' as they were called in Britain, recur in nineteenth-century photographs. The tile-hung thatched cottage (p. 19) with its lean-to extension and trained roses is a typical subject from the 1850s. Under deep eaves and in a summer garden the place looks tranquil and welcoming, even if disorderly. An enquirer, looking into details, might ask questions about brickwork, tiling and regional styles of thatching, but that would be to approach Victorian photography with a modern outlook, one schooled in documentary habits.

Photography was described by Fox Talbot as 'The Pencil of Nature'. The sun drew on the photographer's specially prepared surfaces, and the pioneers did their utmost, by using silhouettes and sharply defined shadows, to emphasize this element of drawing. They relished whatever could be gauged or measured: the bulk of a cottage among trees, a stack in the fields, half-timbered farm buildings. They showed these simple forms and spaces charted by stays, poles and ladders. De Molard's Norman cottage (p. 24) has an intricate spray of poles cutting across the space made by two angled roofs. In Fox Talbot's frail woodland scene of 29 August 1840 (p. 23) two ladders reach mysteriously out of a still pool. Fox Talbot, who was the inventor of the negative-positive process in photography, used such devices in his images of a calibrated countryside. In addition, many early photographs show collections of implements, brooms, spades, sieves and so on, which suggests an absorption in process, in the very act of fabricating.

Fox Talbot and his contemporaries were practical picture-makers, well aware that depth could be indicated by such yardsticks as ladders, beanpoles and brooms. They were merely using what readily came to hand in the surrounding countryside. Nor were they in a pictorial sense inventors, but relied on idioms in common use by painters and illustrators. Fox Talbot's assemblages of outbuildings, ladders and garden tools were improvisations in the style of the painter and etcher John Sell Cotman, who charted his often very abstract landscapes with fences, gates and furrows. Such schematic motifs had been used by Cotman from the beginning of the century, and in the 1840s they were an established part of the Cotman style, as practised and taught by his sons and daughter. Charles Marville's woodland dreamer (p. 27) would also have been at home in the painting of the 1830s and 1840s; such introverted figures appear in Théodore Rousseau's woodland scenes, and in Gustave Courbet's countryside. Robert MacPherson's beautifully lucid view of the Aqua Claudia in the countryside near Rome (pp. 40–1) might have been based on the clearly arranged Italian landscapes of Jean-Baptist-Camille Corot, painted in the 1820s and 1830s; both delighted in simple shapes plainly set out.

There were many points of contact between landscape photography and the traditional media. Some photographers had been painters and illustrators before they turned to the new medium. Charles

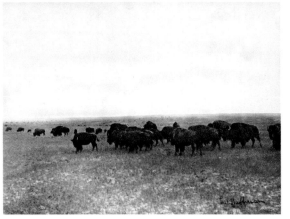

L.A. HUFFMAN / *Buffalo Grazing, 1890s*

Marville was one such: in 1836, for example, he illustrated two successful guides to French rivers, *La Sâone et ses bords* and *La Seine et ses bords*. But there is no direct connection between Marville the draughtsman and Marville the photographer. Anyone looking at his graphic work for insights into his photography would look in vain. The vignetted river scenes are often no more than glancing views of distant buildings and jetties seen over an expanse of calm water. They are less detailed accounts of Neuilly and Bercy than evocations of quiet days on the river, and if they have an echo in photography it is to be found in Camille Silvy's justifiably famous river scene of 1858 (p. 30). This is one of photography's most harmonious images, and in the context of the rock-and-rubble-strewn topography of the 1850s and 1860s, that quality is inevitably accentuated. Silvy, who was known as a successful portraitist, reinstated, in this one picture, a graceful style of landscape which had flourished in Britain and France – in the painting of Richard Parkes Bonington for example – from the 1820s through into the 1830s.

Gustave Le Gray, like Marville, had been a painter before turning to photography. In the 1850s he was a capable photographer of woodlands in the dark, leafy style of Barbizon painting which was then coming into vogue. Like the painters Constant Troyon and Théodore Rousseau he was interested in the effects of atmosphere and weather, and was one of the first photographers to record transient effects of light on the sea and clouds. His beech tree (p. 26) is in the Barbizon idiom. But why, with all the trees in the forest of Fontainebleau to choose from, did he single out this canted beech? Artists in the Barbizon group may have been interested in the details of forest life, but they preferred to represent the ambience of the place. In this instance Le Gray lingers over a particular shallow-rooted tree tipped towards an upright neighbour. John Constable, in his drawings of tenaciously clinging trees, was moved by just such a concern for individuality in nature, but it is rarely found in the art of the 1850s, and in photography such carefully apprehended specifics only reappear in the work of Atget around 1900, and then in the pictures of Paul Strand in the 1930s.

In the beginning photography was a marginal and unregulated activity with no canons of practice and with markets still to be found. Photographers had room to experiment, to work on impulse or to revive old modes, and as a result there is a noticeable inconsistency in style in the output of the early years. The first photographs of Le Gray and Marville were sold, along with other examples, in albums designed to show off the scope of the new medium. It was only in the later 1850s that photographers found subjects in which to specialize. As might be expected they were guided by existing practices, and in particular by the formats developed for the publication of steel engravings. These were popular during the 1830s and 1840s, especially as a means of reproducing topographical illustrations. Publishers stressed that their illustrations were 'drawn from nature', although the naturalism of steel engraving is often illusory, based on intricate stippling effects rather

CARLETON E. WATKINS / *Ponderosa, Yosemite National Park, n.d.*

than on any recording of details. Accompanying letterpress texts were very full and dealt with history, anthropology, art and literature, as well as providing a wealth of visitors' data on 'pleasing scenes'. Photographers adopted this format, although their texts were often more personal and detailed.

In photographic albums these texts have usually been disregarded, for photographs have been collected for their own sakes, but in the 1850s words and images were complementary. James Robertson's salt print of La Tchernaia Valley, Traktir Bridge (p. 32), appears to be an especially ordinary landscape, relieved by few details. It was, in fact, the site of one of the fiercest battles in the Crimean War, in which French Zouaves and Sardinians held a mass Russian infantry attack. Any contemporary familiar with the press descriptions could have peopled this empty space more than adequately, from the moment the French outposts were disturbed at morning coffee to the final inspection of casualties by 'curiosity-seeking persons'. Where common knowledge could not be assumed, the texts were correspondingly rich, as in Francis Frith's accounts of his photographic journeys in the Near East. Frith made several tours through Palestine, Sinai, Egypt and Ethiopia between 1856 and 1859, and the island of Philae in the Nile was one of his favourite sites (p. 33).

Although there are clear continuities between Frith's work and that of the steel engravers, there are also notable differences of emphasis. The preceding generation of writers had discussed their sites with scholarly detachment; Frith, by contrast, noted his own often picturesque experiences, and his books have the personal qualities of memoirs. In his photography, too, he took a personal approach, in that he emphasized foreground details and presented his pictures as spaces which might be entered and explored. In addition, he took some very large pictures, up to 16 by 20 inches (41 cm by 51 cm), and their effect is quite unlike anything achieved in steel engraving. These stately albumen prints, which continued to be made into the 1870s, are, quite literally, breath-taking. Whether by Francis Frith, Roger Fenton, or by the American survey photographers, such pictures constitute a new form of the sublime. It is not merely that they are physically large, but that their wide vistas are so comprehensively stilled and silenced.

The early American topographers Timothy H. O'Sullivan, William Henry Jackson and Carleton E. Watkins have secure places in the history of photography, for their pictures command respect. Yet for a long period their work was forgotten, and it only re-emerged in the 1930s because it seemed to prefigure the purist art of the Americans Edward Weston and Paul Strand. It was impressive and handsome, but otherwise discreet, and appears not to invite documentary analysis. Most historians and commentators simply recount the often very exciting lives of the photographers: O'Sullivan, for example, took pictures of battlefields during the American Civil War; Jackson was a bullwhacker and a vaquero before he became a commercial photographer; Watkins carried a cumbersome 18-by-22 inch camera through the more or less trackless West.

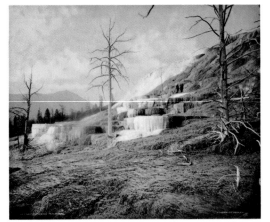

WILLIAM HENRY JACKSON / *Mammoth Hot Springs, Yellowstone, ca. 1880*

All these photographers worked on geographical and geological explorations and surveys organized by govern-ment agencies.

Illustrators had worked on early surveys, recording scenes on the trail, camplife, Indian villages, settlements and the vegetation. Their successors in photography were never so discursive. Unlike the illustrator-scientists who had preceded them, they were operatives who learned their demanding trade in the field. They were neither naturalists nor geologists, although often instructed to record particularly interesting vegetation or rock-formations, and lacking specialized interests, they concentrated on the largeness of the land and on its most spectacular features. In many cases they singled out and popularized sites which would become staples of American tourism: Watkins was the laureate of Yosemite in California, and did much to have it saved for the people in 1864 (p. 49); Jackson's images of Yellowstone helped it become the first national park in America, in March 1872.

American survey photography was a confrontational art in which the land featured as a challenging spectacle. Human figures crop up, and although ostensibly there as markers, they also present themselves boldly, as if intending to symbolize the human spirit undaunted. Their imaginings of conquest were amply fulfilled by the following generation of railway-builders with their ruthlessly imposed geometry; Jack-son's iron horse (p. 52) sports bones from the old pre-industrial order as a trophy. British contemporaries, by comparison, represented landscape as scenery, as domesticated space in which lords and ladies might take the air and enjoy each other's company (pp. 36–7).

The bold survey style had been fostered by an expansionist culture which was increasingly challenged as the century unfolded. The American West was so sparsely populated that it could be represented as virgin territory. In 1886, Theodore Roosevelt could describe the Indians as 'treacherous, revengeful and fiendishly cruel savages'. But contemporaries were beginning to look on them as true democrats who had also learned to live in harmony with their environment. Edward Curtis, a major photographer and student of Indian life, established contexts for his tribespeople, whom he showed as hunters, fishers and nomads. A group of these people ride at their ease through the Canyon de Chelly in 1904 (p. 86). By comparison, O'Sullivan's photograph of the same site shows it less as ambience or habitat than as a gigantic, harshly-lit spectacle (pp. 50–1).

Although Curtis hoped that his contemporaries might learn from the pious and artistic Indian, he was also working as an ethnologist, disinterestedly surveying and recording a disappearing way of life. In 1873 John Thomson's *Illustrations of China and Its People* was published, and it stands as the first major photographic survey of a people in context. It was near in tone to the work of the US survey photographers in

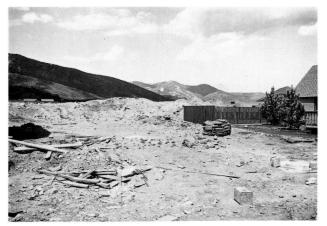

LEWIS BALTZ / From 'Park City Portfolio'. 1974

that it functioned as a guide and a prospectus to a region recently opened up to Western trade. To such a practical observer landscape was especially interesting for its evidence of farming or industrial or religious practices (p. 55). Its valleys and still lakes also recall the beauties and austerities of his native Scotland.

The examples of Thomson and Curtis point to two distinct and even contradictory views of landscape. For Thomson it was a necessary ground and support for society and it might be understood and calculated in terms of productivity and ease of access. For Curtis, and for most of his contemporaries, landscape existed in spiritual rather than practical terms. In Samuel Bourne's tranquil view of Kenilworth Castle (p. 46) a country-woman stands as if lost in contemplation by a still river. Evidently she is both impinged on by the place and assimilated into it, for her reflection fades and shimmers into the stream. In British art, figures on a similar scale blend into the delicate countryside of the enormously popular illustrator and painter Myles Birket Foster. Foster's was a pervasive influence in the late nineteenth century: Joseph Gale's *Sleepy Hollow* of 1887 (p. 62) is a vignette in the Foster style – the man and his horses, breaking from work on an autumn day, muse over their reflections. Nature's influence, in English hamlet or on Indian lake (p. 54), was benign and soothing.

The nature cult of the late nineteenth century as inaugurated by such artists as Birket Foster and Samuel Bourne was a romantic revival, and at first it involved little more than a reduced figure scale and abundant signs of circumambient light and weather. Soon painters who presumed a benevolent formative power in the countryside took peasant people as their subjects, for they lived closest to the earth and were most open to its influences. Peter Henry Emerson, an American who worked largely in East Anglia, was one of these believers. He hated modern urban life, and saw the fensmen as untainted survivors who might be used as an example to contemporaries. The photograph *Coming Home from the Marshes* (p. 63) appears in the first of his many books, *Life and Landscape on the Norfolk Broads* (London, 1886). In the letterpress Emerson gives pen-portraits of his characters and notes that they carry 'meaks', short scythes characteristic of the region. Although this looks like a candid picture, the fen people are posed – and posed, moreover, in a manner learned from contemporary French Naturalist painters, followers of Jean-François Millet. Emerson was ambitious for his art, and his ambition led him to imitate the best in contemporary painting; it also led him to experiment with platinum printing and photogravure, both of which were processes which diffused and accentuated light over the picture surface. Emerson explored light and ambience, both physical and cultural, and produced one of the most impressive bodies of work in the history of photography.

Although Emerson's contemporaries shared his preoccupations, few of them went to such extremes as he. The fenmen were shaped by light, landscape, culture and climate; Emerson tried to introduce all of this into his art. Henry Peach Robinson, a dedicated opponent of many of Emerson's widely publicized

theories, shared, at base, similar views on the formative powers of Nature, but in his art those powers are no more than indicated in, for instance, a picture which hints at the cry of gulls over the ocean (p. 59). Robinson's appliquéd gulls express a moment, and it is true that instantaneity was understood as photography's destiny from the very beginning; but it was sought out less for purely technical ends than because of its bearing on perception – the instant was the instant of perception. Breaking waves and clouds in motion were studied and captured by early photographers because they accentuated the unrepeatable moment. They were the expressions on Nature's face, just as streams and rivers constituted her voice (pp. 60–1).

Life was lived out in moments, and through the senses. Photographers, as other artists, were preoccupied by questions of sentience: How could apprehensions of actuality be expressed or acknowledged? Thomas Eakins' nude swimmers (p. 64), taken as a study for a painting, tell of, or suggest, the sharpness of river-water on skin and broken pebbles underfoot. John G. Bullock, more guardedly, touches on similar experiences by another river, where a child stretches on a grassy bank by a rutted road (p. 67). Physicality, or the effort involved in action, seems also to be Adam Clark Vroman's subject in the *Acoma Trail* (p. 65), on which a team of nattily dressed frontiersmen, or commercial travellers, demonstrate a set of steps, multiple-exposure style.

The moment might be no more than a precarious instant, or it might be drawn out and savoured. John Grabill's prospect over a Sioux Indian Encampment (p. 85) is a compilation of instants: fires smoke, horses drink, figures watch. The Walmsley brothers' flock of sheep catching the last rays of sun in a summer combe (pp. 68–9) also suggests the slow-paced time of evening. In a different sort of evanescent time Herbert Gleason's canoeist touches the mirror-surface of the lake with her finger tips (p. 82) and a flock of birds settles in a tree (p. 83). In a more intense moment, Kitty Tatch and her friend dance above the abyss at Yosemite (p. 87).

The most finely honed moments occurred in abstracting monochrome. Colour, by contrast, filled out and prolonged the instant, for it reduced contrast and resulted in a less legible picture. Monochrome made inscriptions of natural forms, whereas colour redeemed actuality: blue skies and green leaves presented themselves in something close to their original glory, and not merely as pale grounds. In autochrome, the earliest colour process in common use, the image was registered on sensitized starch grains held between sheets of glass. Intentionally or not, autochromes mimicked the granular effects of pointillist painting. Autochromes also suggested a fusion and blending of parts: in the beautiful French picture of a horse-drawn carriage on a country road (p. 81) the canopy, the road itself, house-wall and sky share the same stippled substance modulated by barely perceptible degrees from surface to surface.

More systematic photographers tried to look into Nature and beyond the moment. Although they, too, believed in the importance of environmental influences, they imagined these influences to be more transcendental than immediate. These photographers, who included Robert Demachy, Clarence White, Heinrich Kühn, the Hofmeister brothers and Alvin Langdon Coburn, looked for an art from which insignificant, peripheral details had been eliminated. They valued whatever was subjective, not because they were egocentric, but because the soul was tuned to divine creative principles and could identify these as they were manifest in appearances. Moreover, artists of this persuasion thought in terms of affinities or correspondences between objective, observable nature and human subjectivity. This idea is embodied in Heinrich Kühn's golden and green rendering of three children in a landscape (p. 90) in which the children group themselves as if in sympathy with the trees. Likewise Laura Gilpin's woman *On the Prairie* (p. 91) listens to a space envisaged by the artist as a ratio of 2:1. In Clarence White's symbol of *Morning* (p. 73), the woman in white who holds a transparent globe sways as if in opposition to the line of the dark tree.

The symbolist photographers worked musically, or with reference to rhythm and pattern. The rhythm was there to be identified by an artist with enough soul or insight. Demachy's trees, for example, make a sequence in the sky, like notes of music sounding in time, and their very particular, organic qualities are offset by a regular, even automatic, set of posts disposed on a hillside (p. 72). The Hofmeisters, in an arrangement of radical imbalances, are far more portentous or Wagnerian (pp. 74–5). Coburn's photogravure of Fountain Court (p. 70) is a more deliberate work of art, with its circular fountain set within an architectural triangle. His symbolist contemporaries referred to thought as a fountain. This particular picture was taken from the window of one of those contemporaries, the poet and critic Arthur Symons who had a flat in Fountain Court in the Temple, London.

Symbolists were sensitive to the God-given as it manifested itself in appearance. They were, necessarily, selfless artists, and one consequence of this selflessness was a common style which allowed little room for personal expression. As the symbolist style became more and more stereotyped after 1900, a new generation re-asserted privacy as a value; photography's long-standing interest in instantaneity was taken up again, but subtly changed.

One of the new observers of personal moments was the Hungarian André Kertész, whose earliest pictures, taken while serving in the Austro-Hungarian army, show the convivial life of peasants and soldiers. His subjects put their heads together, read and listen; they have private lives in which jokes are told and gossip is exchanged (p. 80). Life, for Kertész, was a life of individuals, and he was confirmed in his judgment on moving to Paris in the 1920s where the *intimiste* artists, Bonnard and Vuillard, had reverie and conversation for

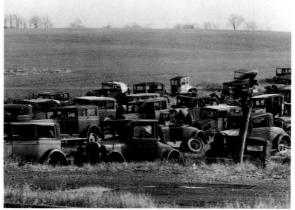

WALKER EVANS/*Jo's Auto Graveyard, 1936*

their subject. The background to this art was the threat embodied in modern urban and factory life, in which privacy was at a premium; this became especially evident during the First World War when production-line techniques came to Europe from the United States.

Modern life was orderly, and increasingly so as mechanization took over. In these conditions individuality was at risk, and perceptions were likely to be dulled. Emerson (p. 63), who excoriated the thoughtless townspeople who disrupted his rural paradise in East Anglia, had been one of the first photographers to protest. Many writers also responded, and stressed the importance of close observation of nature. Nature had been scrutinized before; where the new scrutiny differed was in its stress on personal observation of the transient. The photographic response was comparatively slow to develop, for scrutiny made exceptional demands.

The most sustained achievement in the art of close observation was that of Paul Strand, an American photographer and film-maker, who began with modernist and urban subjects around 1912. His intensity never faltered. The earliest of his pictures illustrated here (p. 106) is of wild iris at Center Lovell, Maine. It almost looks as though Strand has sought ambiguity and difficulty in his choice of such evenly lit leaves, slightly overlapped. However, there are tonal differences in the concave leaves, and the exact degree of their concavity can be measured from the cross-section of the twisted leaf to the right. Clinging droplets of water also say something about the plant surfaces, and the fern-frond helps one estimate the gaps between leaves.

Strand's photography always poses such problems of reading. He often excluded those co-ordinates which might make it possible to take a thing in at a glance; the plant's roots are screened, or the side of a building is thrown into shadow. In his photograph of a white horse by a gate in New Mexico (p. 100), an intricately barred and balanced gate is darkened into illegibility by the horse's shadow, and that shadow in turn makes it almost possible to gauge the sun's place in the sky. Over twenty years later in Egypt, and in a vastly different picture (pp. 152–3), similar difficulties are raised in a fragmentary foreground where a shadow is cast by a buttress obscured by boulders. It is also characteristic of Strand that his eye should be caught by such a clear separation of shadow and reflection as the boat's sail provides on the still river. The gently bellied sail also signals a breeze in that varnished stillness. Sometimes, he was more formal and playful, as in the Hebrides where an extensive landscape on South Uist (pp. 130–1) features dark horses on white water, a white horse on a dark ground, and a variety of buildings, one outlined against the sky, the others merged with the hillside. Strand's eye never ceased from 'thinking' and from seeking difficulties which might stimulate thought and surmise. All of his pictures offer a challenge; all have to be read on the basis of evidence which is never more than partial.

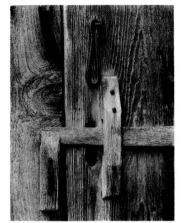

PAUL STRAND/*Latch, Vermont, 1944*

Although admired, Paul Strand established no school, and no other photographer ever put such a stress on precise calculation of space, distance and inclination. Those of his successors who cared as much for observation set about the problem afresh. The response of some Americans during the 1960s and 1970s was to photograph in very even light and to record within a narrow tonal range. In this respect they turned away from the vivacious contrasts which had marked photography in the 1940s and 1950s. In the new, subdued landscape-art, or new topographics, as it has been called, differences are not accented, and the picture surface is something to be searched.

George Tice, in a discreet view of two weathered Californian buildings, suggests how this search might be begun; he notes a simple pattern of paired elements: house-fronts, wheels, railings (p. 183). An observer has no choice but to check from item to item and to note such differences as the placing of windows and doors. At such a range the scene also becomes a matter of panes and bricks and planks, and even of grasses and leaves – as in the facing oak-tree (p. 182).

Robert Adams, author of *The New West* and *Denver* (Colorado Associated University Press, 1974 and 1977), makes fewer invitations to compare and contrast, but by working at long range and in bright light he, too, poses problems of legibility. Adams' evidence, and that of Lewis Baltz, author of *Park City* (Artspace Press, Albuquerque, New Mexico, 1980), has to be worked for. Theirs is not a consoling art, and they make no concessions to ease of reading. Both are concerned by heedless development and the ruination of landscape. Their art can only be understood by paying heed, and in this respect their formal means contribute to their wider, environmental objectives.

In Britain, on the other hand, the art of observation developed more disinterestedly, as something which was also delightful in its own right. Fay Godwin, the most widely published landscape photographer of the 1980s, is as preoccupied as her American counterparts by casual devastation of the countryside: in *The Saxon Shore Way, From Gravesend to Rye* (London, 1983) she focused on a particularly littered section of the British coastline. But her concern in that and in other books, such as *The Whisky Roads of Scotland* (London, 1981), is with a pedestrian's sense of distance. Her pictures, with their receding milestones and furrows, invoke the actuality of distances to be crossed. Ray Moore, more obliquely, points to similar experience in Cumbrian pictures where roads and their windings stand as analogues for time and choice, and any number of small happenings, accidents of light and shadow, recall momentary disturbances of consciousness. Photographed in half-light or across snow, Moore's images are never more than half-disclosed, which is to say that they, too, invite re-enactment and imagination (p. 175). If Moore was prompted at all, it was by the allusive art of the American Harry Callahan, who leaves no more than traces of the crowd, the ocean and the

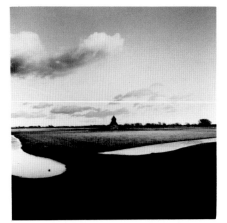

FAY GODWIN / *The Church of St Thomas à Becket, Fairfield, 1980*

weather in a characteristically nuanced picture of Cape Cod (p. 204). A catalyst of this art of observation are those absent masses whose footprints pattern that Cape Cod beach; they have ceased to observe, and it is observation that Strand and his successors have tried to sustain.

Observation was (and is) important because it gives rise to an understanding without which the land is nothing more than raw material. Observation of that sort is disinterested, and sustains harmony. But not all photographers are content to take things as they are, and moreover the symbolist aesthetic which was so formative in the years before the First World War entrenched a notion of the artist as a seer. Because of highly developed imaginative qualities the seer could read signatures in all things, but there were no objective controls over such reading. Powerful imaginations, especially that of the Californian Edward Weston, tended to see their own destinies inscribed in Nature and to understand landscape metaphorically. Weston, one of photography's most forceful artists, wrote on the importance of technical mastery and stressed that the medium was 'too honest . . . for recording superficial aspects of a subject'. The camera, properly handled, could reveal the essence of things.

Weston clung to the idea that in his art he was being faithful to objects, to the fabric of the world. He also believed that the camera-man should learn 'to see his subject matter in terms of the capacities of his tools and processes', and he also adjudged self-expression to be an illusion. Yet in describing his working processes, he also admitted to starting out 'with my mind as free from an image as the silver film on which I am to record, and I hope as sensitive'. In this state of mind, images are revealed to him. In essays, mainly from the 1930s, he says nothing more about the source of his revelations, which seem to be the result of an interaction between the inner voice of objects and an inner voice of his own, all mediated through the camera. The result was a very paradoxical art, simultaneously lucid and mysterious. Although capable of such dispassionate records as that of stakes thick on the edge of a country track (p. 102), he preferred more arresting subjects such as unfurling shells, writhing kelp or the visceral skin of peppers. Nature sometimes revealed a threatening side, as in the deeps and wrinkled light of China Cove (p. 124). A cloud looms up (p. 121), like some threatening force remembered from Wordsworth's boyhood. And Nature which has writhed and threatened also dies: Weston's art is rich in dead trees and other vegetation: dried timber strides forward from a living juniper in the Sierra Nevada (p. 103), and tidy boards and a placid cow mock the anguished skeleton of a tree at Pismo Beach (p. 114). Human connotations are never far away in Weston's art: his landscapes have their mouths and wounds and rippling flesh. In gesture and relationship (the frenzied dead tree, penned in a farmyard) they function as objective correlatives for personal feeling. If Weston's mind was free, it was only to give more scope to his subconscious.

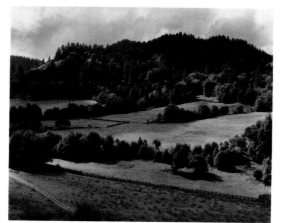

EDWARD WESTON / *Eel River Ranch, 1937*

In American landscape photography Weston's influence was powerful and enduring. He opened a space for revelation, ambiguity and metaphor. The skin-sand of William Garnett's erotic desert landscape (p. 151) refers back to Weston's sandscapes at Oceano and Death Valley, just as Minor White's expressively spiralling tree at Point Lobos in California (p. 141) recalls those tortured relics which Weston found on the same shore twenty years before. Wynn Bullock, likewise, evokes something of Weston's anguish in an agitated silhouette of a tree reaching out towards pale moonlight (p. 138), although Weston never allowed for such a balanced resolution of forces as this. Elements of his work also survive in the fastidious arrangements of Paul Caponigro, another American photographer who has worked with an insight into the essence and rhythm of Nature. In Caponigro's work, however, nothing subjective or bizarre interrupts natural patterns which are musically disposed (pp. 162, 164). In this respect Caponigro refers back beyond Weston to the formative influence of Alfred Stieglitz whose cloudscapes, which he called *Equivalents* (p. 95), represented Nature considered symphonically.

Stieglitz, Weston and the other seers and transcendentalists distinguished themselves, although not always and not always sharply, from those documentarists who looked primarily at the landscape as a construct. During the 1920s, for instance, when confidence in design was in the ascendant, Nature was studied for evidence of regularity; it was called on, in fact, to endorse design. Where Stieglitz's revelations in American photography were given by a God who was a thorough transcendentalist and composer, the Germans, who specialized in designer-photography, had their insights from an artificer. Albert Renger-Patzsch, a most outstanding photographer in this vein, pictured the natural world in constructed terms: a forest appears as a simplified stage-set (p. 107), and a cherry tree stands tidily in tidy fields (p. 109). In Britain during the 1940s, Bill Brandt developed in the first of these directions with simplified images of hills, tracks, isolated buildings and standing stones (pp. 116–17). His is a theatrical concept of the countryside in which one or two items carefully selected and placed stand for cultural riches from the past. The sources of Brandt's shadowy landscape-art are complex, and they include the surrealist theatre designs of De Chirico and the films of Alfred Hitchcock; but despite this he always focused on few items in simple relationships.

The Germans thought of the landscape in engineering terms, Bill Brandt envisaged it theatrically; Americans, in general, were more troubled by human involvement in the landscape, for that involvement had resulted in dustbowls (p. 98) and inhumane rationalization (p. 108). American man imposed grids and boundaries on the land: Weston's tomato farmers of 1937 (p. 104) thought systematically and on a large scale; David Plowden's Quebecqois graziers of 1969 thoroughly staked out their pastures (pp. 188–9). 'A fence can stand for something quite beautiful, for intent to use and cherish the enclosed earth; it can also stand

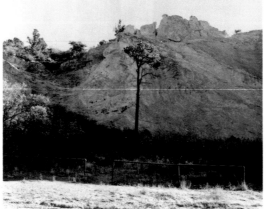

ROBERT ADAMS / *Garden of the Gods, El Paso County, Colorado, 1977*

for Right of Possession, for the power to do what you want to with what you've got, and to exclude.' The implication inherent in Imogen Cunningham's elegant *Northwest Native* (p. 99), whose hat-brim rhymes with the sweep of a fence, is of an affinity between man and his works. By comparison, Henri Cartier-Bresson's peasants in the Auvergne (p. 168) have become stooped like their oxen, and have adapted to Nature. European countryside and country people and their buildings, as celebrated by Cartier-Bresson and his contemporaries, have an earthy or a stony look. America, at least as seen through the eyes of Charles Sheeler (p. 126) and Wright Morris (p. 127), is a plain ground on which geometers have arranged their cubes and cones, strung their wires and laid their rails. David Plowden, author of *The Hand of Man on America* (1971), finds a textbook demonstration of the geometric impulse in a neat line of barns and houses positioned on a horizon in Illinois (p. 190).

Perhaps as a response to culture's impositions, photographers, especially in the United States, tried to restore an image of landscape as a whole, as constituted of earth, water, air and sky, rather than as a resource from which the artist selects significant fragments. Ansel Adams, with his sweeping images of mountains and lakes, was the most enduring of these 'new romantics' (p. 122). His visions recall a world before 'development', and hold out hopes for re-creation. Worked across a very wide tonal range, brought about by the action of light on rock, water and vapour, his pictures manifest continuity, a mingling together of all things. The social landscape is, by contrast, marked by sharp tonal contrasts, differences established in the interests of legibility. In Adams' art the country is considered redemptively, as original and ideal, and as a refutation of the world of wire and corrugated iron established by his contemporaries.

Europeans, too, were consoled by landscape. Alfred Eisenstaedt, a photo-journalistic witness in Europe during the 1930s, developed, perhaps as a consequence, a feeling for refuge imagery, embodied in his strongly guarded Norwegian idyll of 1966 (pp. 160–1). And the most lyrical of all Europeans was the Czech Josef Sudek, a photographer in Prague and a veteran of the First World War in which he had lost an arm. In the woods, cemeteries and gardens of that city Sudek dreamed a pastoral idyll into existence (p. 110). Modern sounds never break into the still air of Sudek's refuges. He was the most reserved of all these artists.

Sudek's was a pastoral art: his reverie in the quiet woods of Prague complemented and counteracted contemporary harshness. Few of the artists represented here have withdrawn so completely. Although many share Sudek's misgivings, it is equally clear that the look of the modern world is fascinating and inescapable. Ideal landscape may be made up of primal rocks and forests, but William Garnett's view of the desert (p. 174) has more to do with the culture of atoms and molecules than with the Garden of Eden. Richard Misrach's flash-lit desert tree (p. 198) belongs to lurid fiction rather than to pastoral. Here we see exemplified the two extremes in the dynamic of modern landscape.

Plates

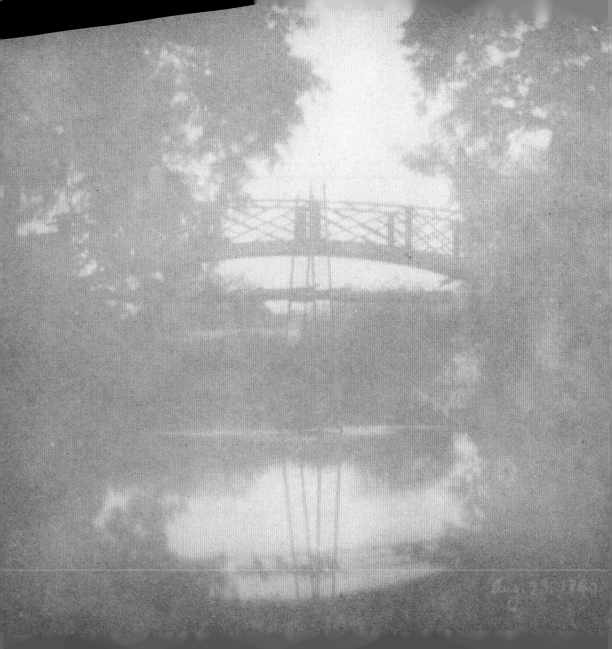

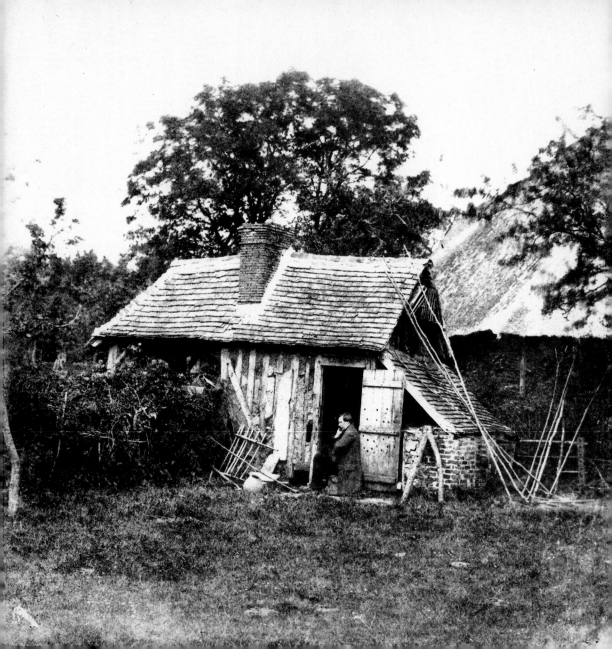

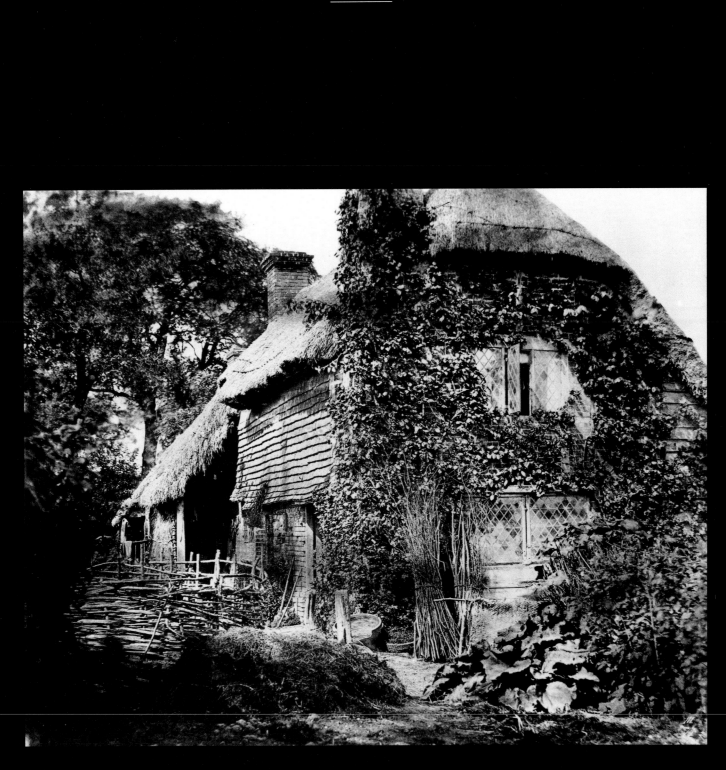

ANONYMOUS *(probably British)* A COUNTRY COTTAGE / *Gelatin silver print, ca. 1980, from a calotype negative, ca. 1850*

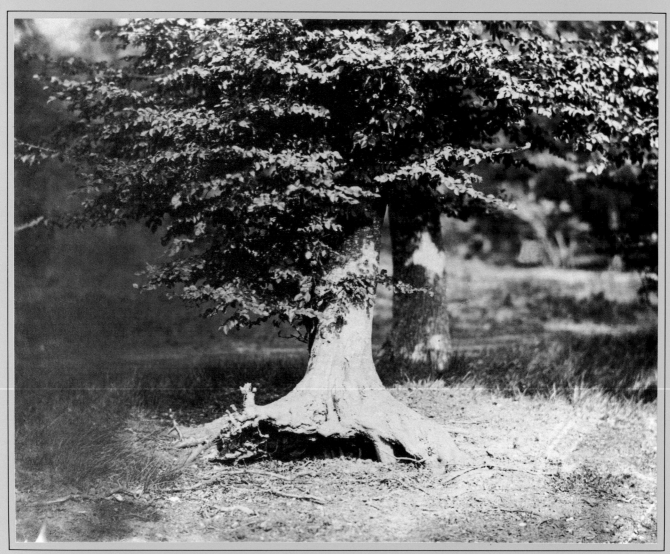

GUSTAVE LE GRAY

BEECH TREE/*Albumen print, 1855–1857*

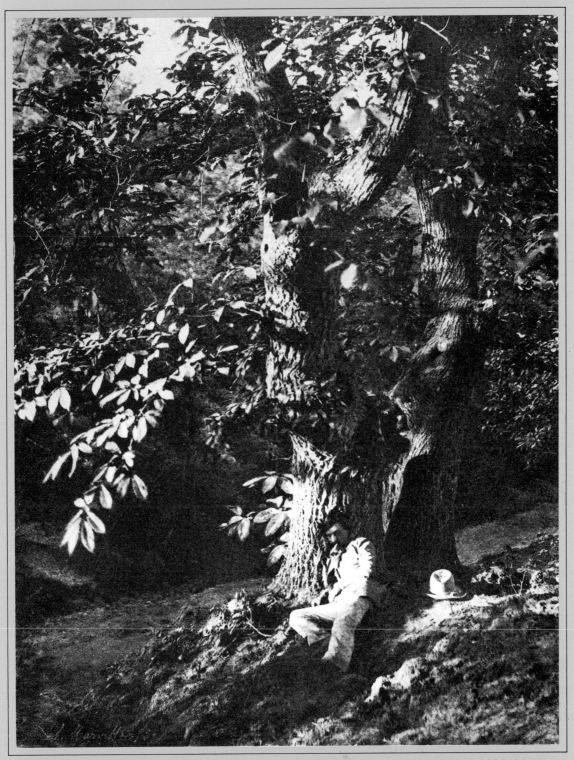

CHARLES MARVILLE YOUNG MAN RECLINING BENEATH A HORSE-CHESTNUT TREE/ *Salt print, 1853*

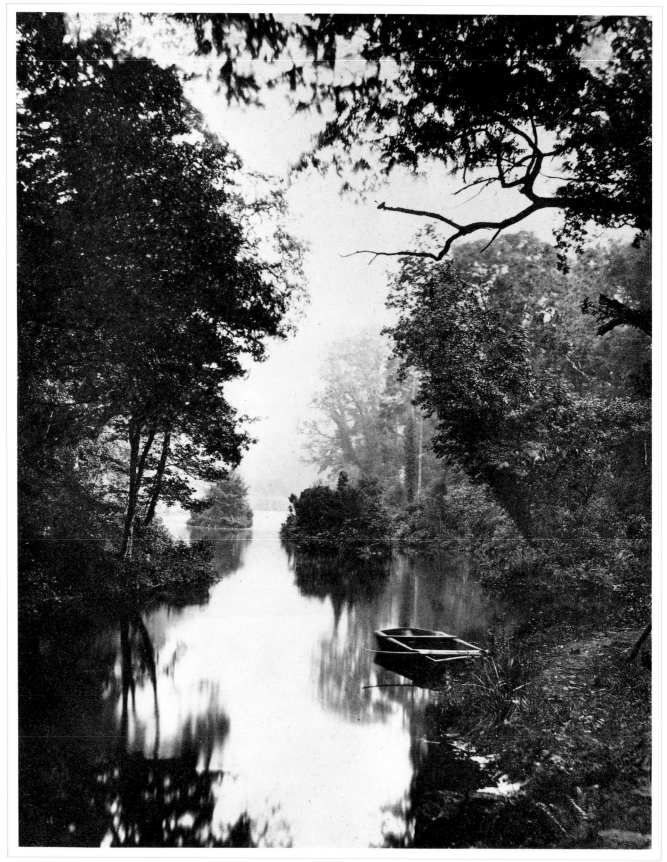

PHILIP H. DELAMOTTE

EVENING/*Probably albumen print. ca. 1854*

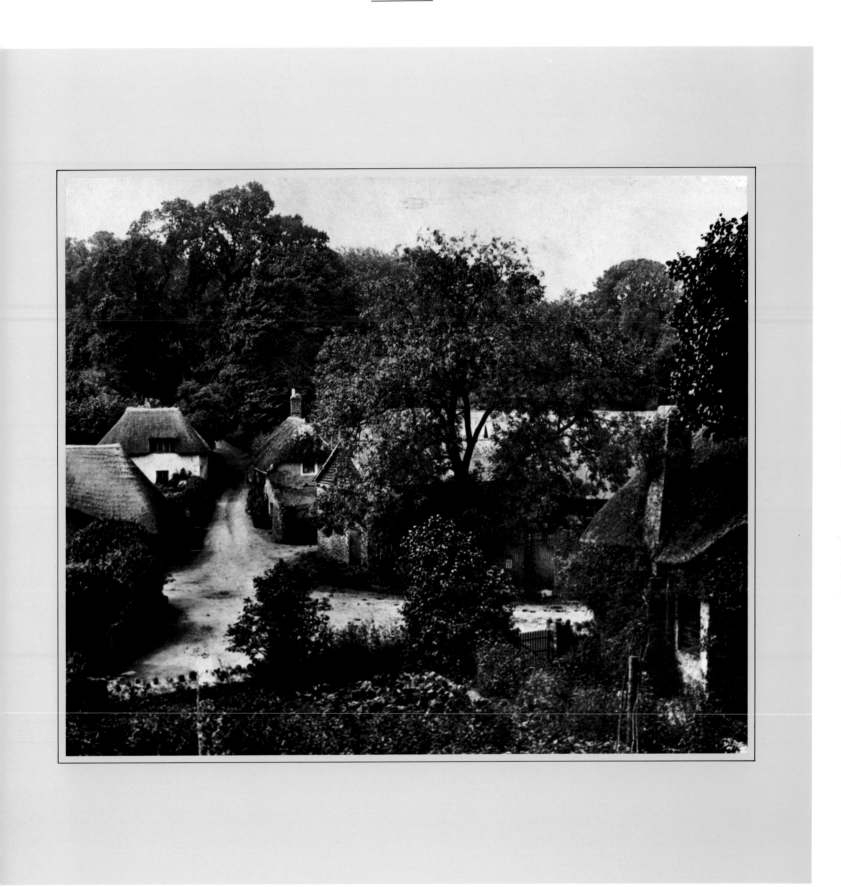

FRANCIS BEDFORD

COCKINGTON VILLAGE/*Albumen print. 1850s*

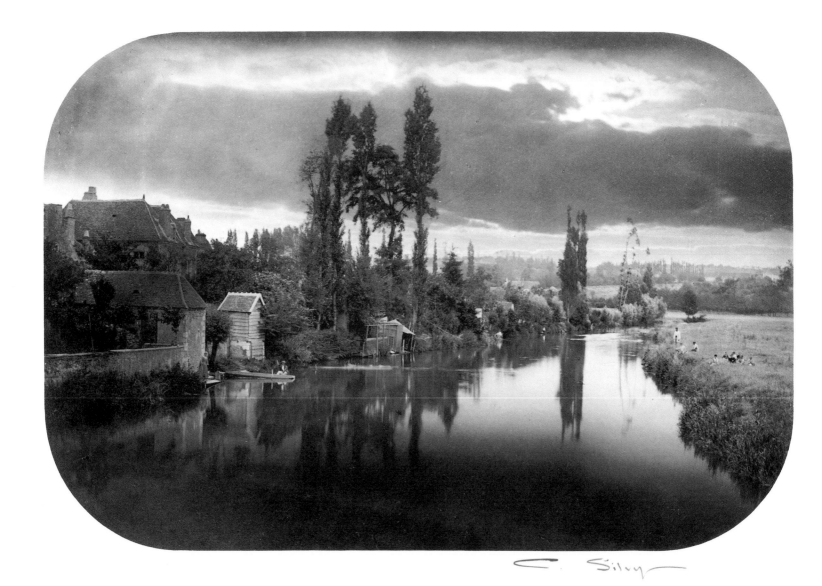

CAMILLE SILVY

RIVER SCENE/*Albumen print, 1858*

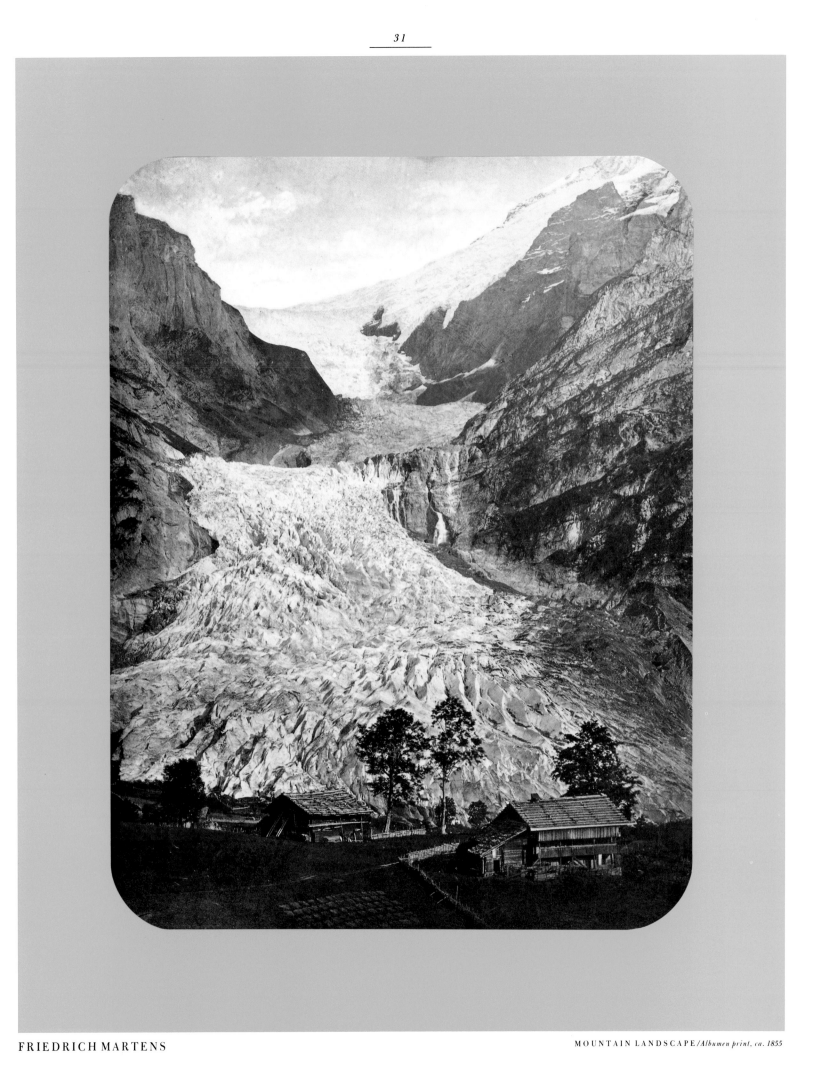

FRIEDRICH MARTENS

MOUNTAIN LANDSCAPE/*Albumen print, ca. 1855*

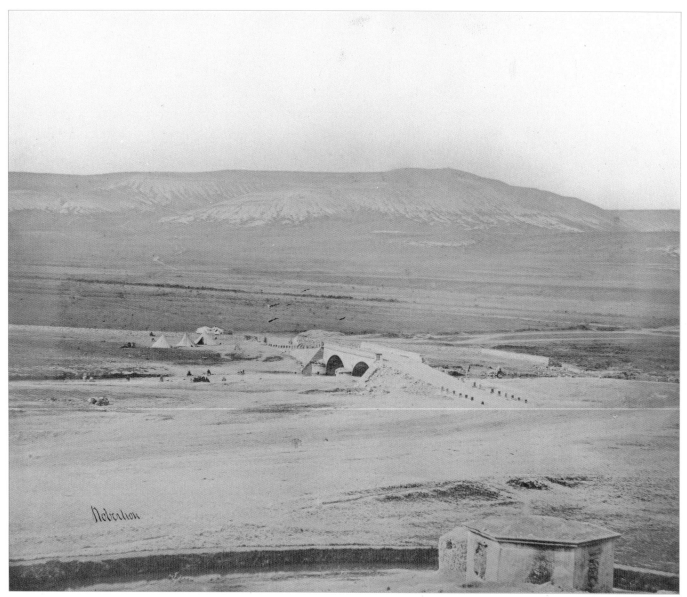

JAMES ROBERTSON LATCHERNAIA VALLEY, TRAKTIR BRIDGE (CRIMEA) / *Salt print, 1855*

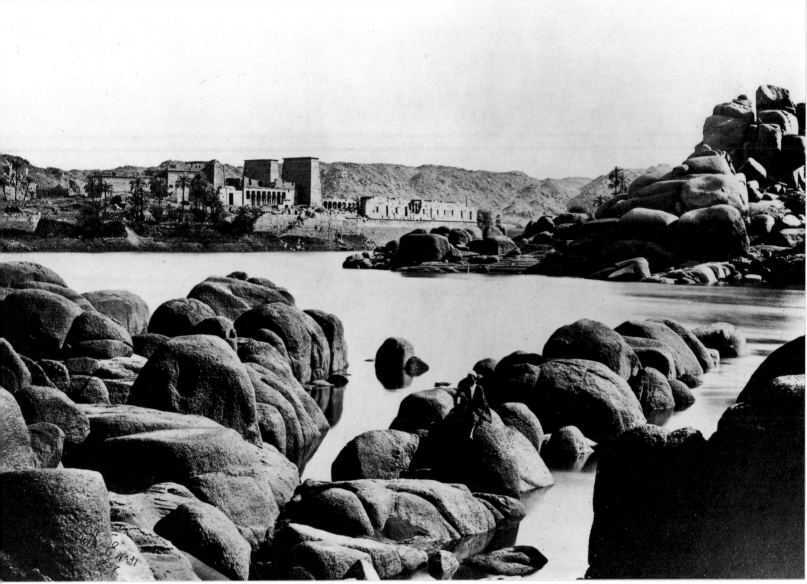

RANCIS FRITH THE APPROACH TO PHILAE, EGYPT /*Albumen print, 1859–1860*

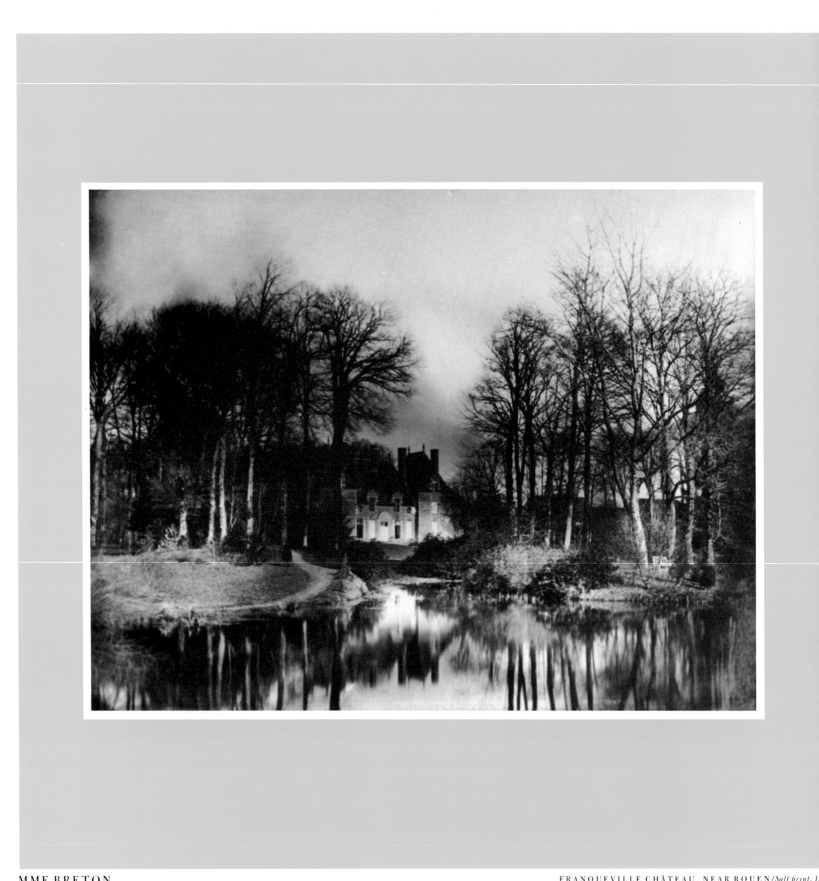

MME BRETON FRANQUEVILLE CHÂTEAU, NEAR ROUEN/*Salt print, 1*

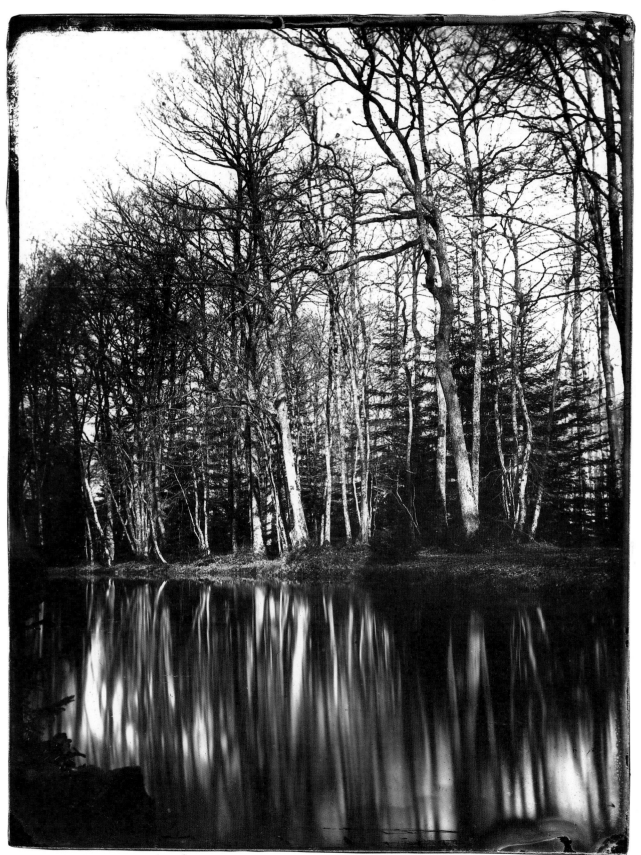

LOUIS ALPHONSE DE BRÉBISSON STUDY OF TREES REFLECTED IN WATER/*Albumen print, 1855*

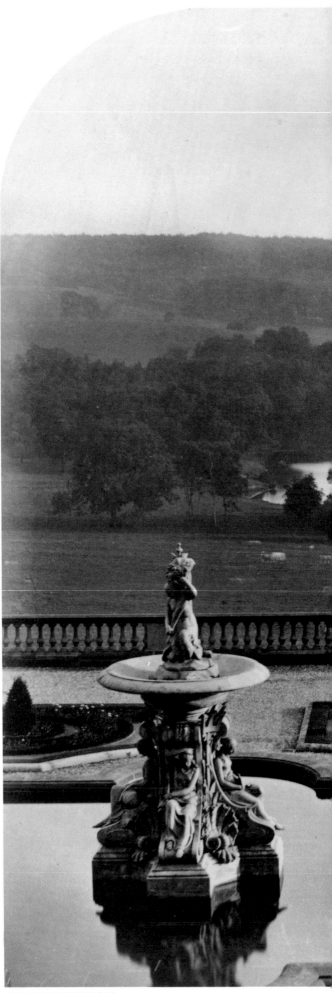

ROGER FENTON

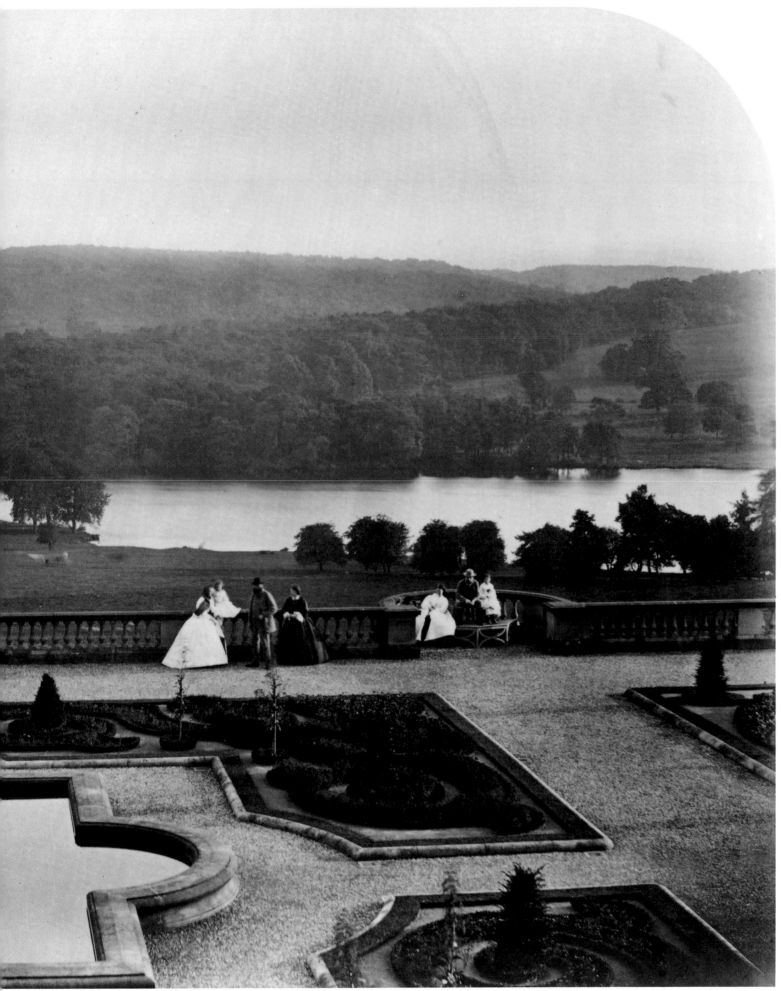

THE TERRACE AND PARK, HAREWOOD HOUSE (ENGLAND)/*Albumen print, 1861*

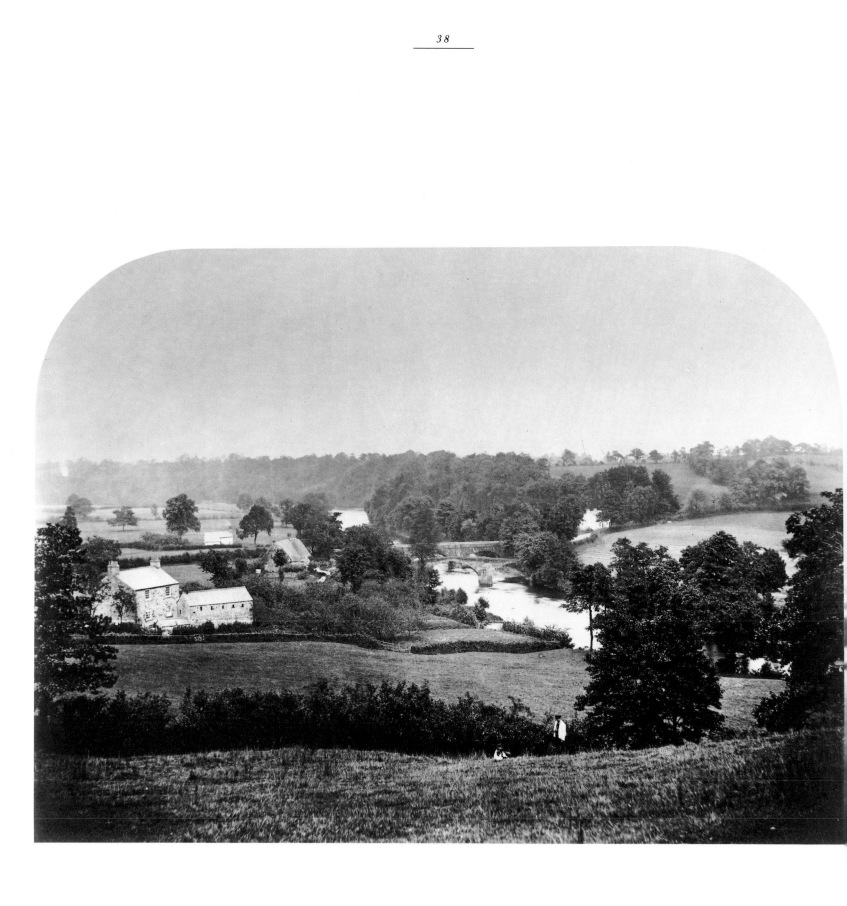

ROGER FENTON

DOUBLE BRIDGE ON THE HODDER (ENGLAND) / *Albumen print, 1858*

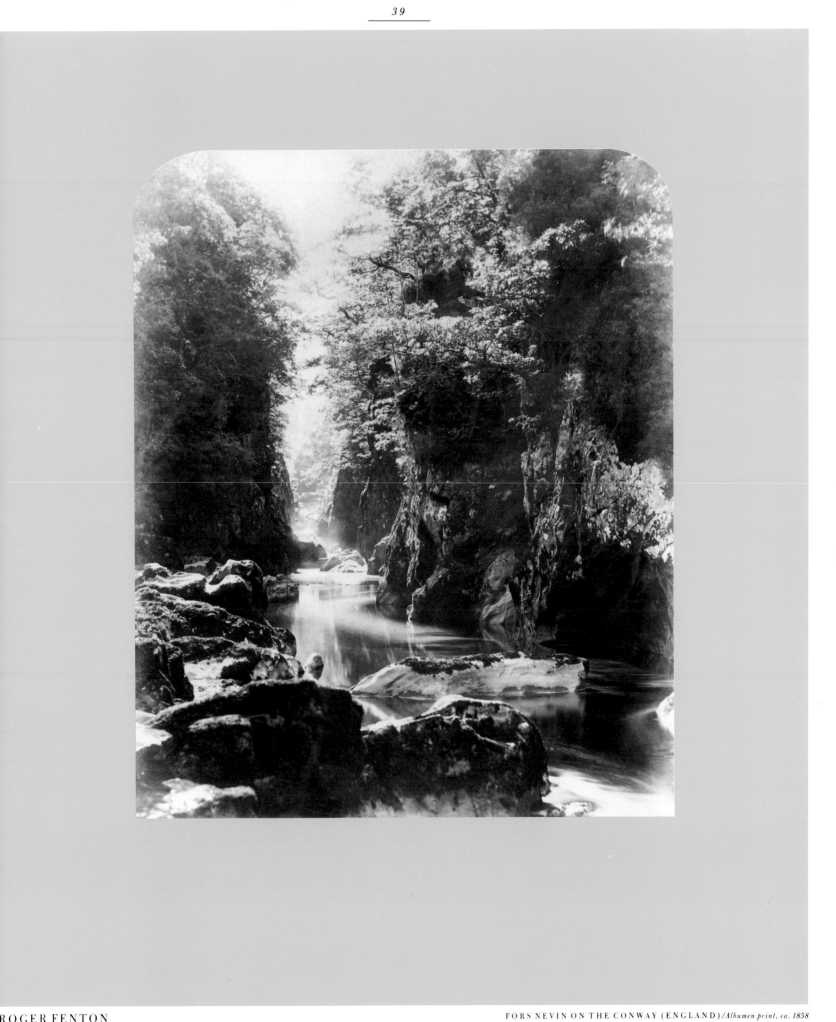

ROGER FENTON

FORS NEVIN ON THE CONWAY (ENGLAND)/*Albumen print, ca. 1858*

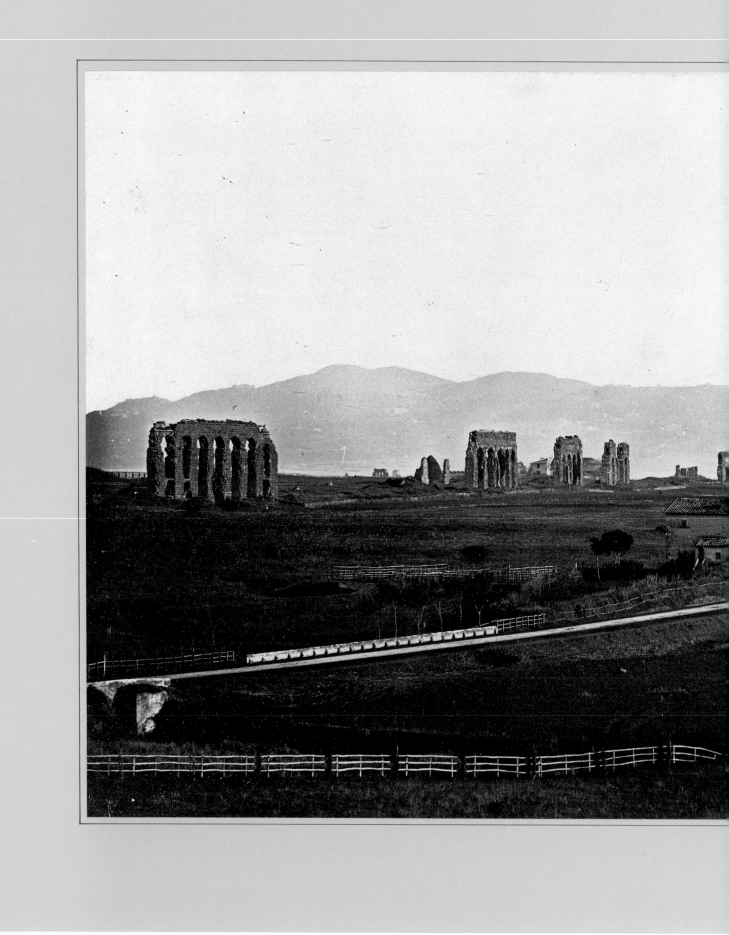

ROBERT MACPHERSON

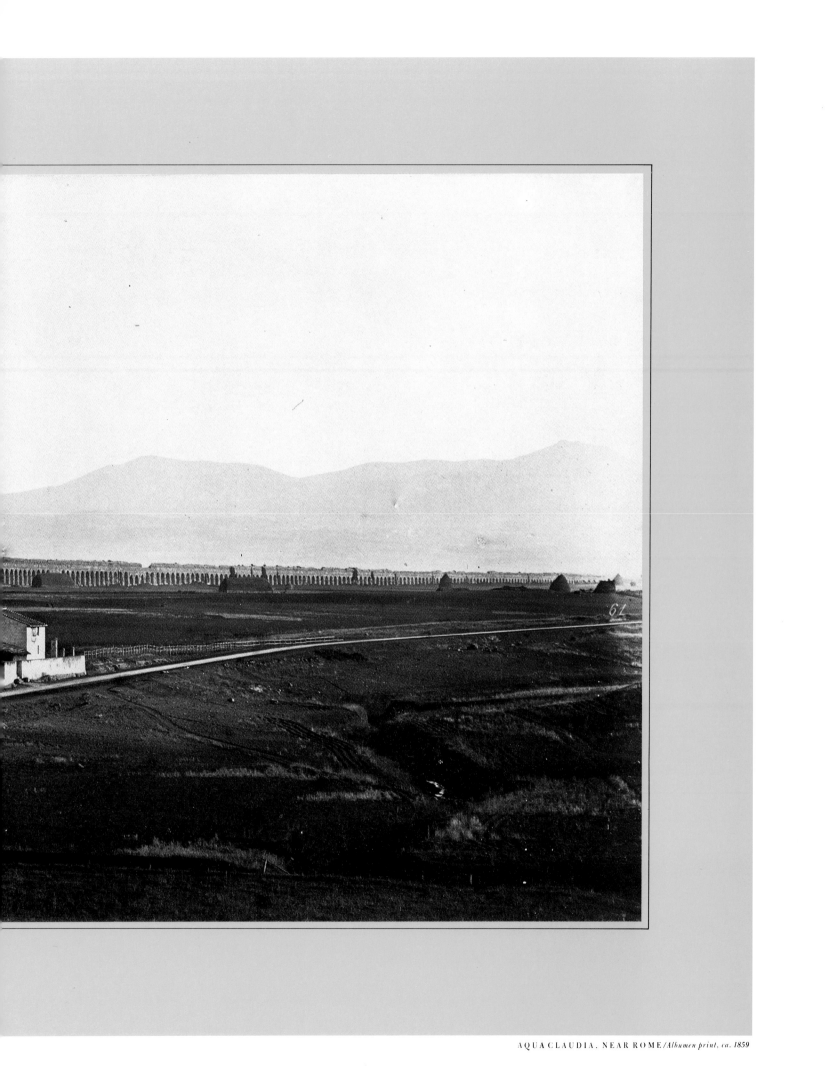

AQUA CLAUDIA, NEAR ROME/*Albumen print, ca. 1859*

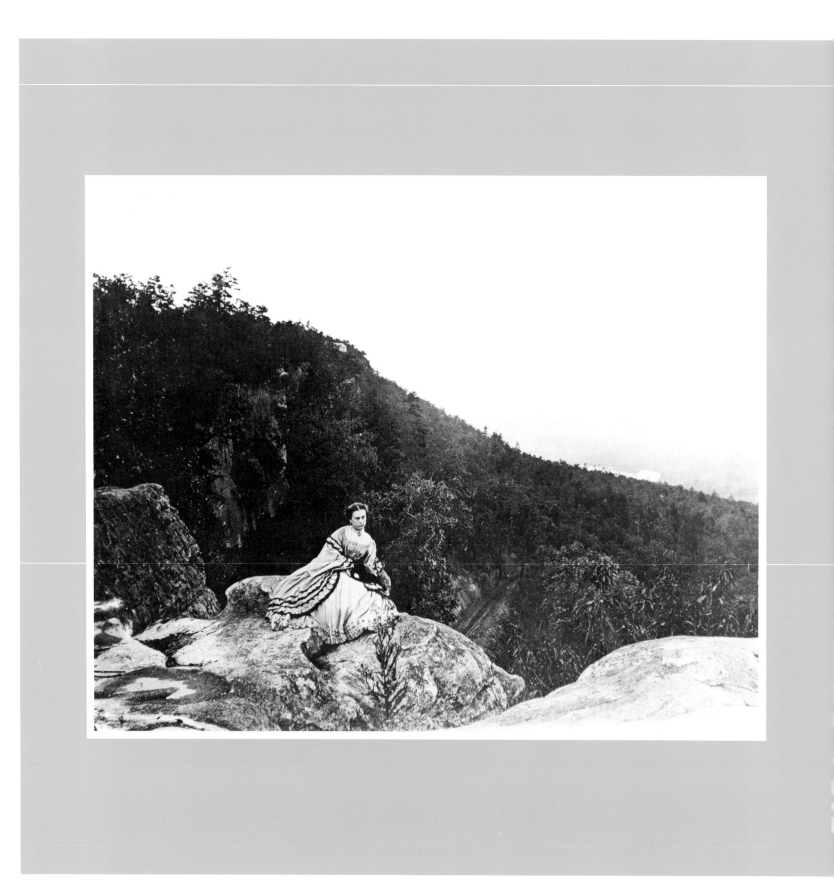

ANONYMOUS *(Brady Studio)* MISS EDWARDS ON LOOKOUT MOUNTAIN/*Gelatin silver print, n.d., from a wet-collodion negative, 1860s*

ROBERT MACPHERSON GROTTO OF NEPTUNE, ITALY/*Albumen print, ca. 1862*

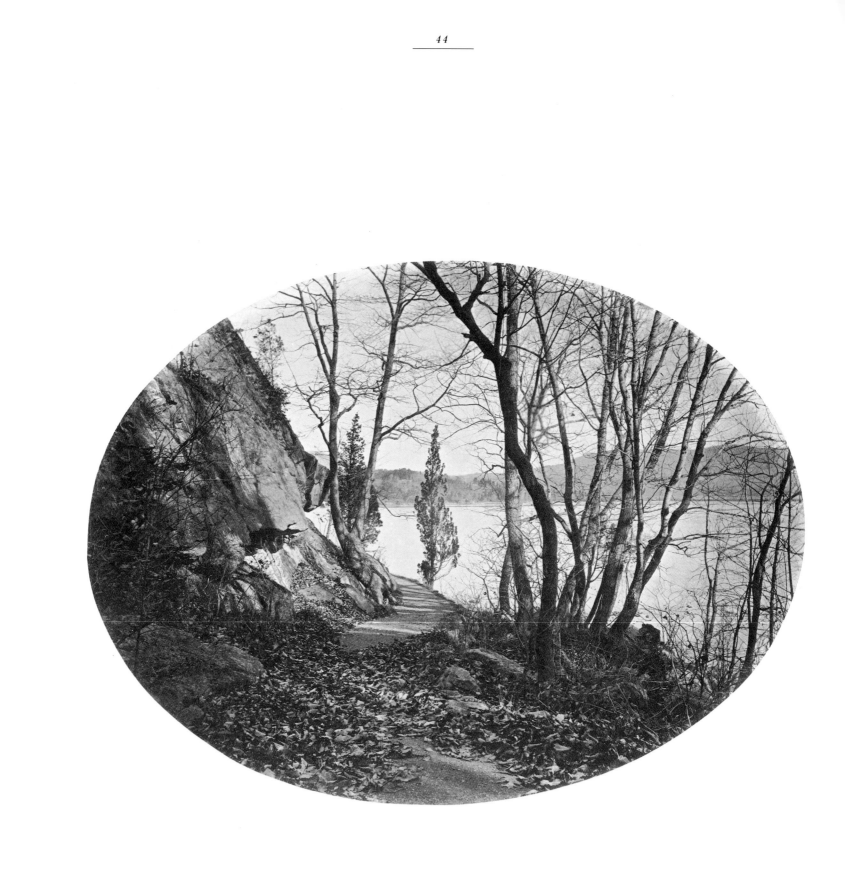

[GEORGE K.?] WARREN FLIRTATION WALK AND THE HUDSON RIVER, WEST POINT, NEW YORK AND ENVIRONS/*Albumen print, 1868*

HERMANN VOGEL

BRIDGE NEAR THE KING'S MEMORIAL/*Probably albumen print, 1866*

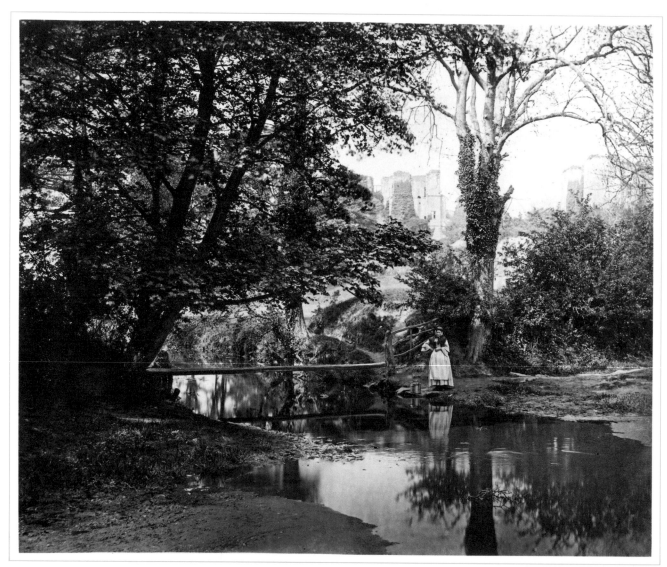

SAMUEL BOURNE KENILWORTH CASTLE (ENGLAND)/*Albumen print, 1860s–1870s*

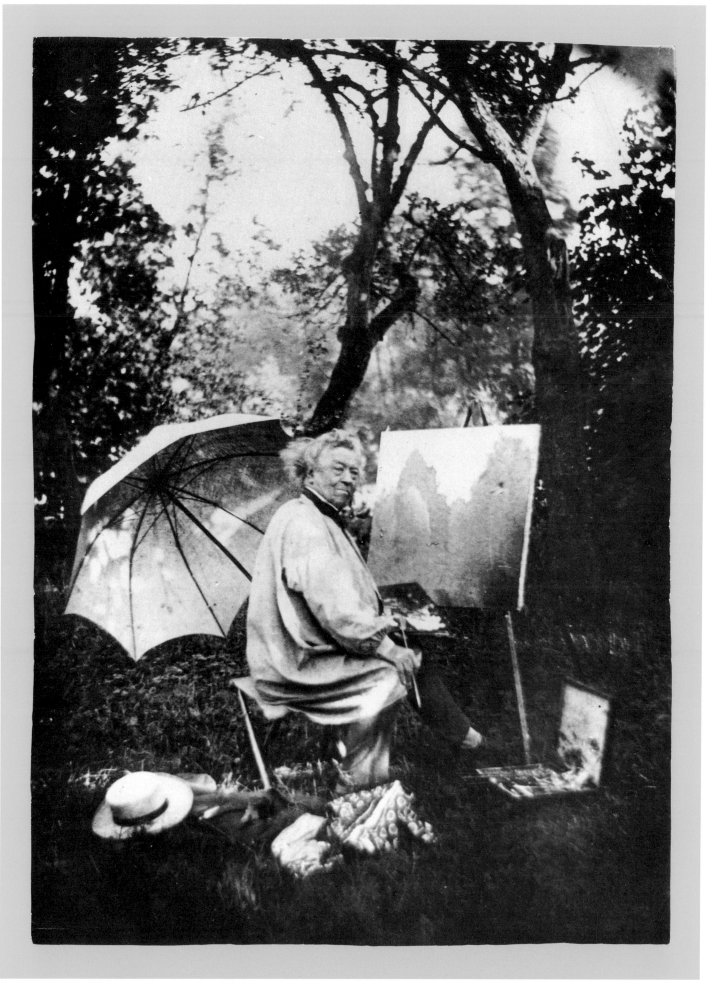

ANONYMOUS *(probably French)* JEAN-BAPTISTE COROT/*Probably albumen print, ca. 1870*

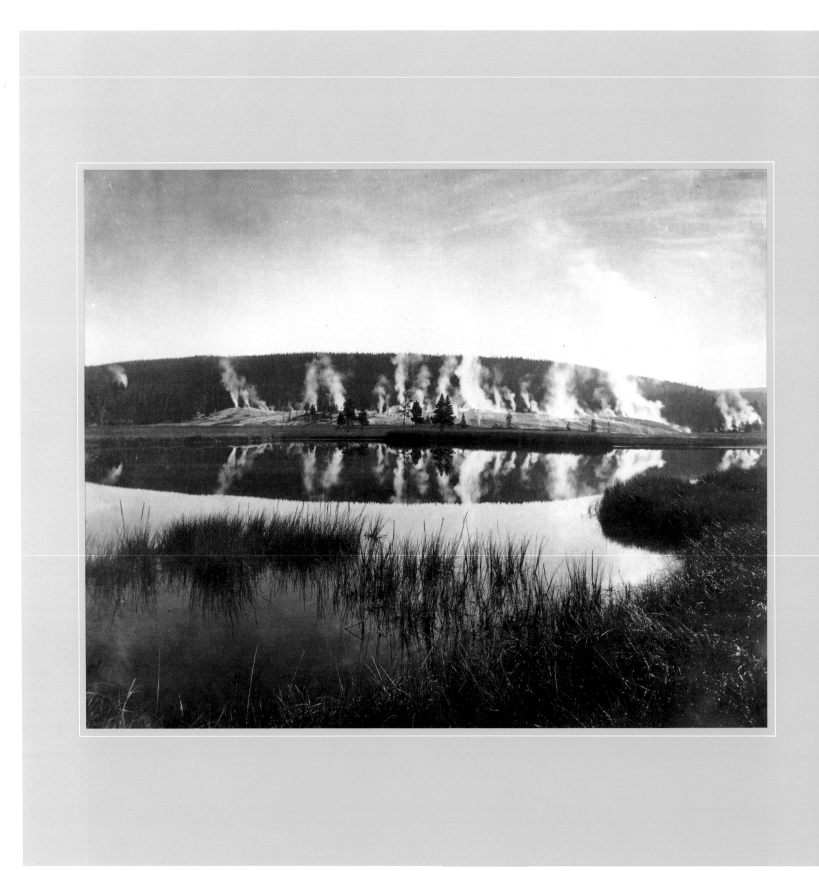

JOHN HILLERS

BEEHIVE GROUP OF GEYSERS/*Albumen print, 187*

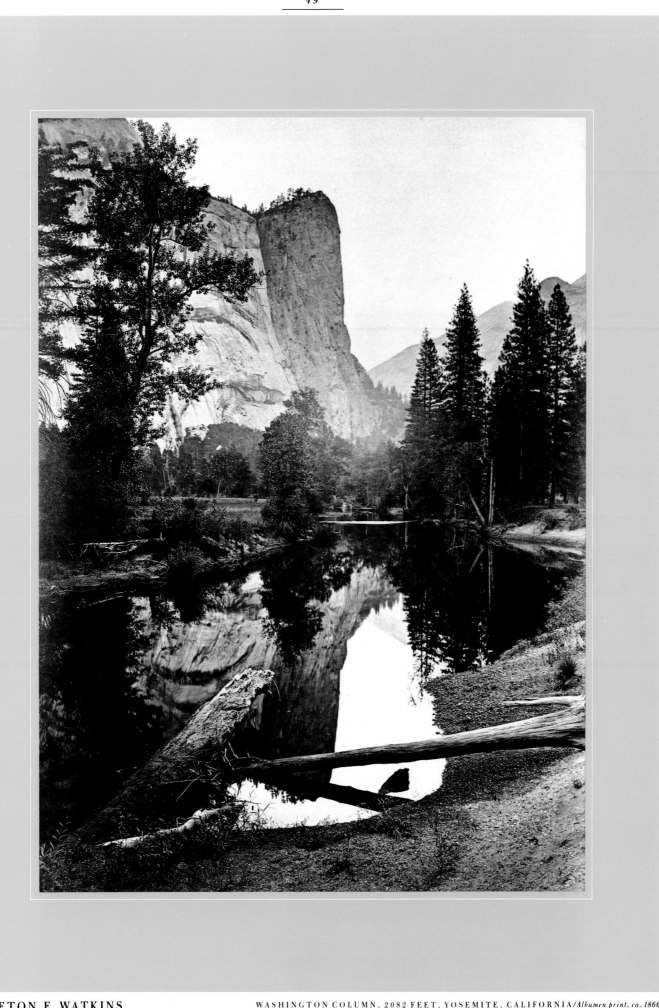

CARLETON E. WATKINS WASHINGTON COLUMN, 2082 FEET, YOSEMITE, CALIFORNIA/*Albumen print, ca. 1866*

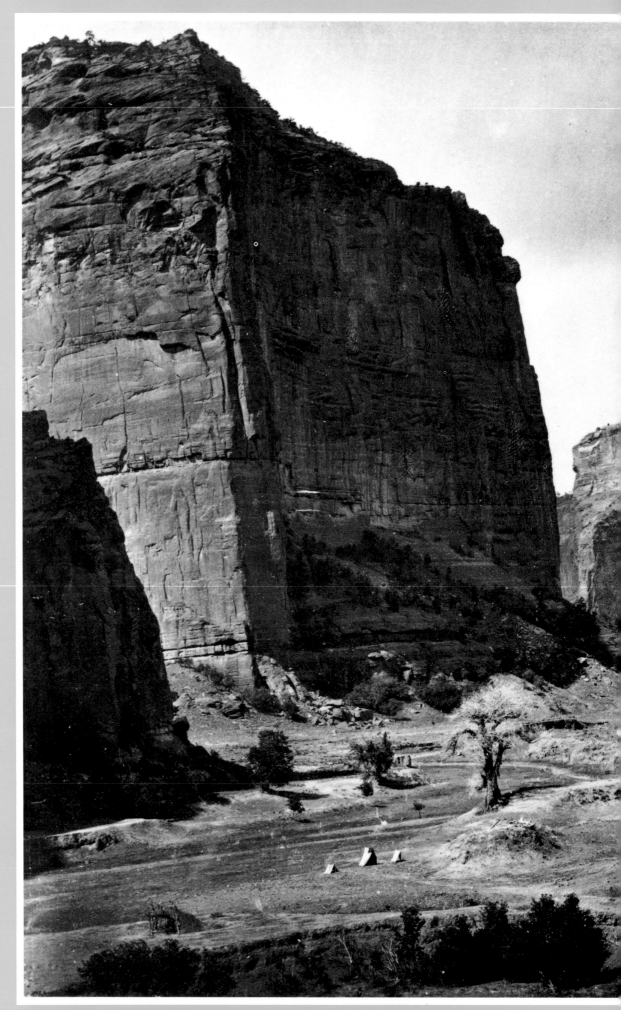

TIMOTHY H. O'SULLIVAN

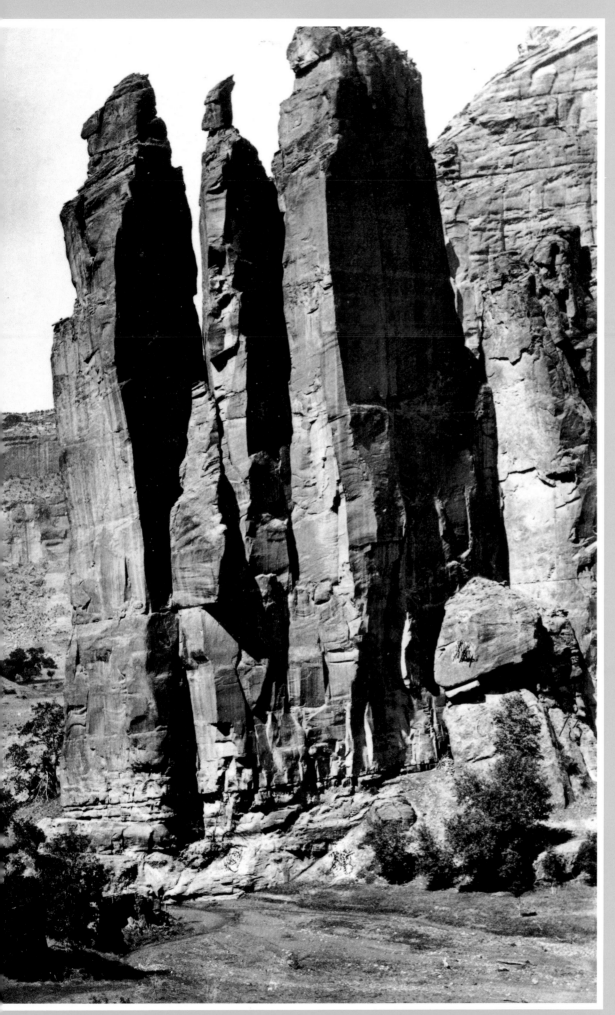

CANYON DE CHELLY, WALLS OF THE GRAND CANYON, ABOUT 1200 FEET HIGH (ARIZONA)/*Albumen print, 1873*

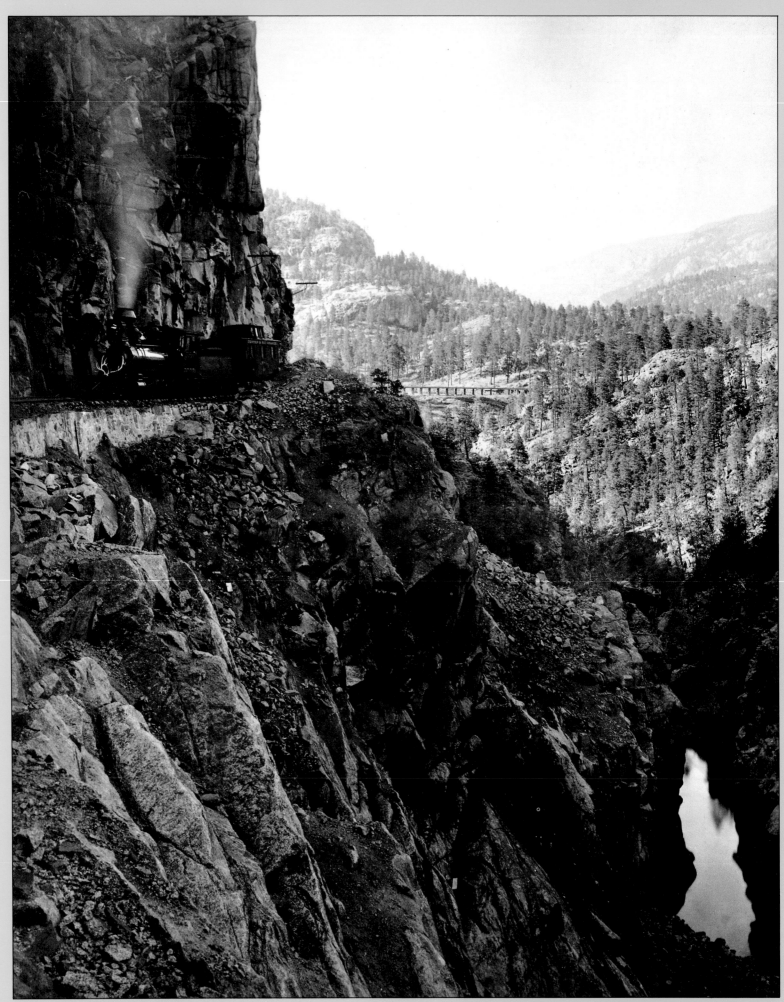

WILLIAM HENRY JACKSON

CANYON OF THE RIO LAS ANIMAS (COLORADO)/*Albumen print, 1882*

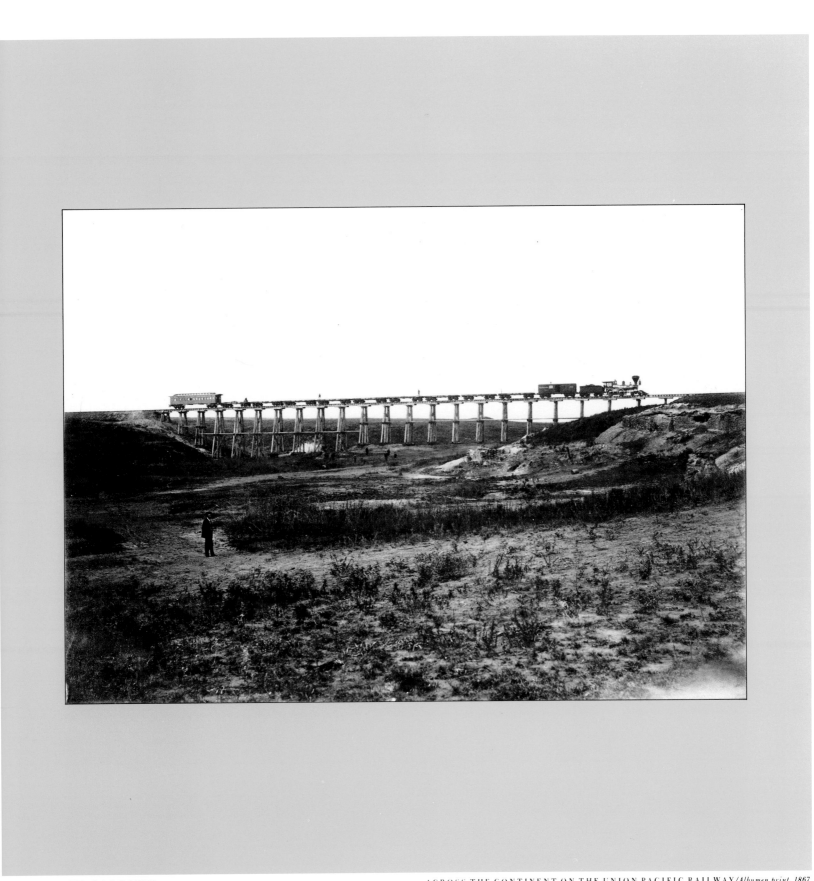

ALEXANDER GARDNER ACROSS THE CONTINENT ON THE UNION PACIFIC RAILWAY/*Albumen print, 1867*

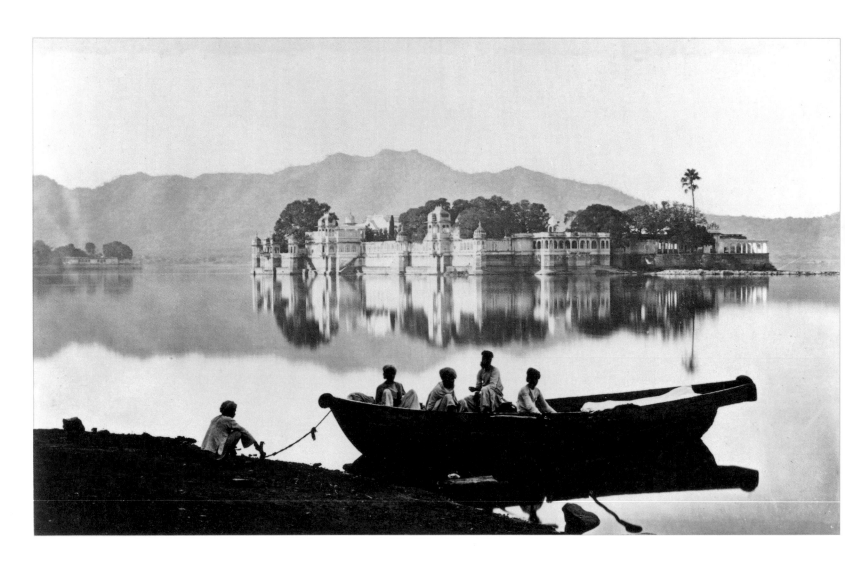

COLIN MURRAY

THE WATER PALACE, UDAIPUR, INDIA/*Albumen print, 187*

JOHN THOMSON

YUAN-FU MONASTERY, NEAR FOO-CHOW, CHINA/*Collotype, ca. 1873*

FRANCIS FRITH

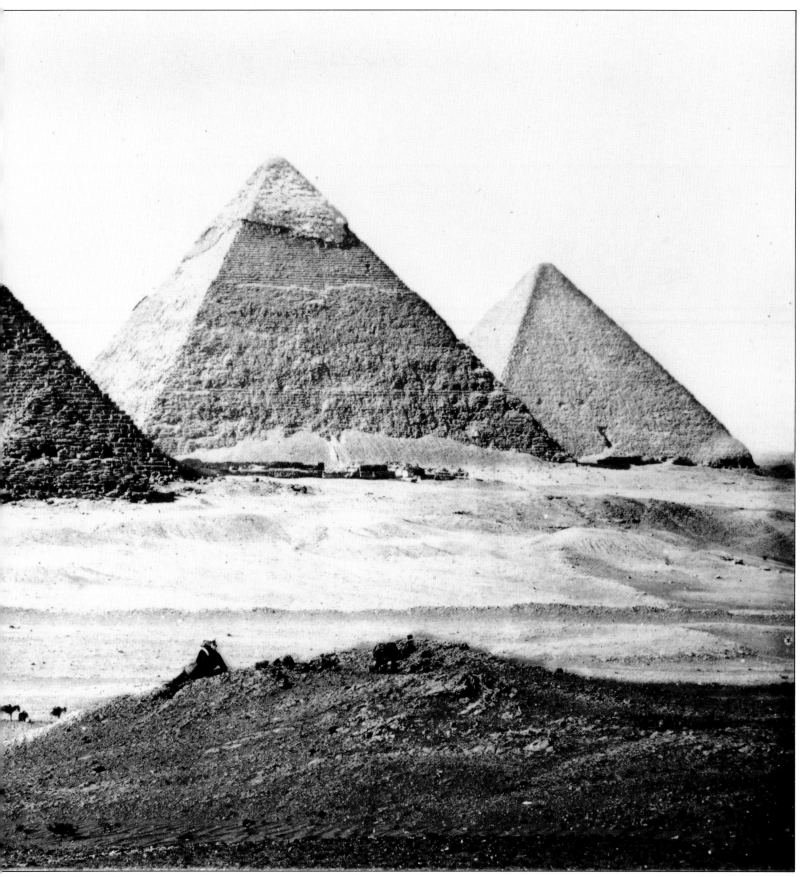

THE PYRAMIDS OF GIZA (EGYPT) /*Albumen print, ca. 1856*

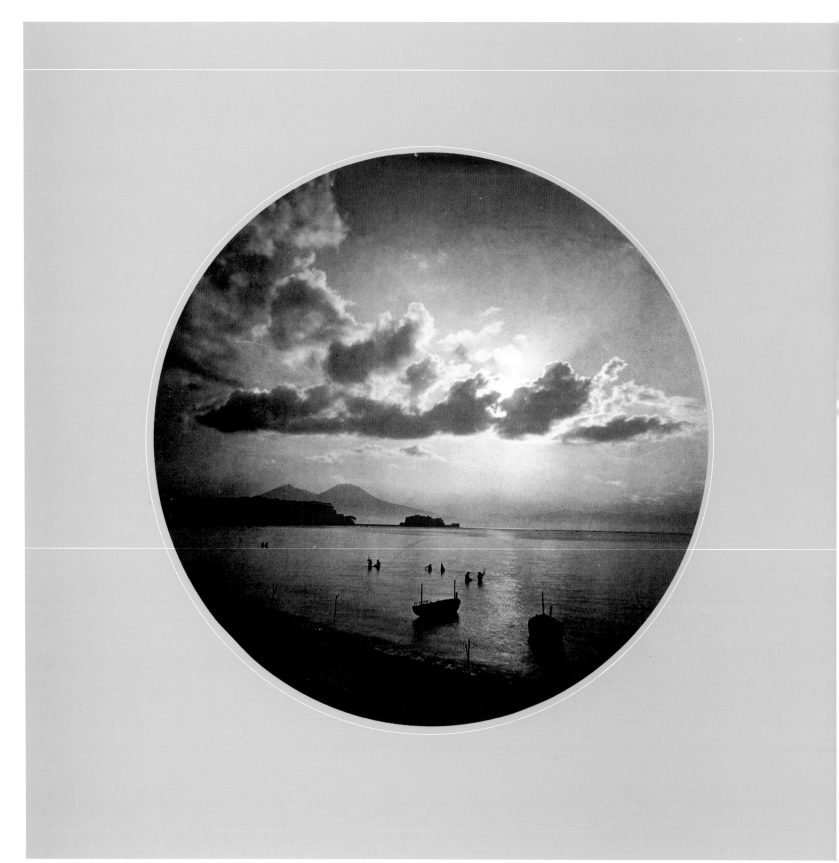

A.H.P. STUART-WORTLEY

CLOUD STUDY, NAPLES, ITALY/*Albumen print, 1861*

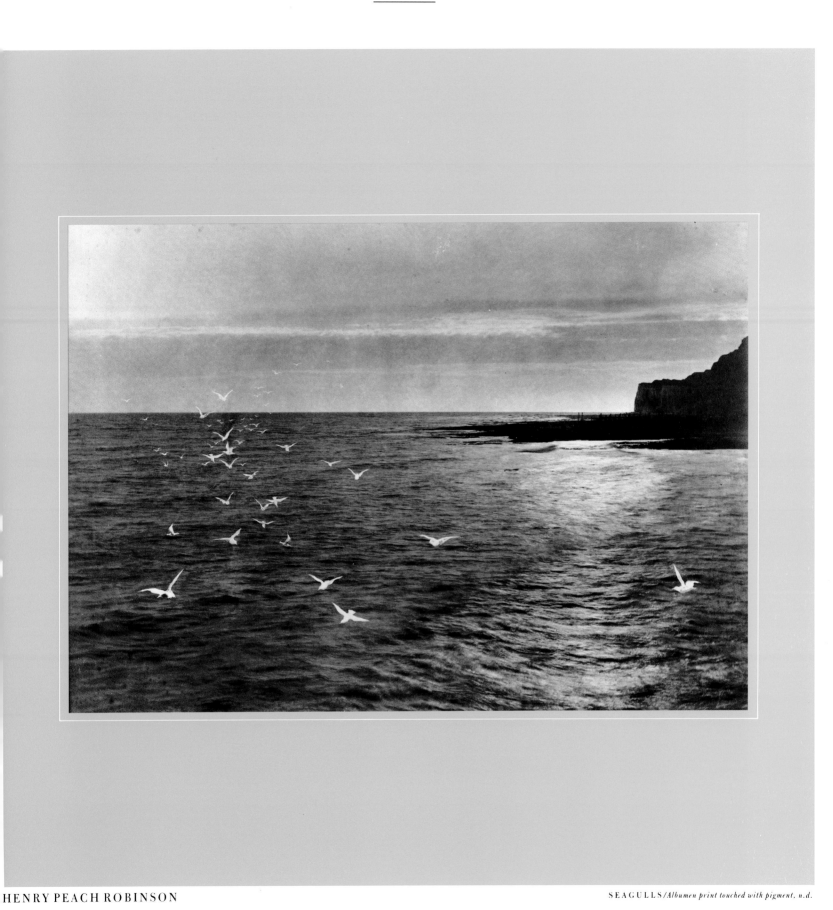

HENRY PEACH ROBINSON

SEAGULLS/*Albumen print touched with pigment. n.d.*

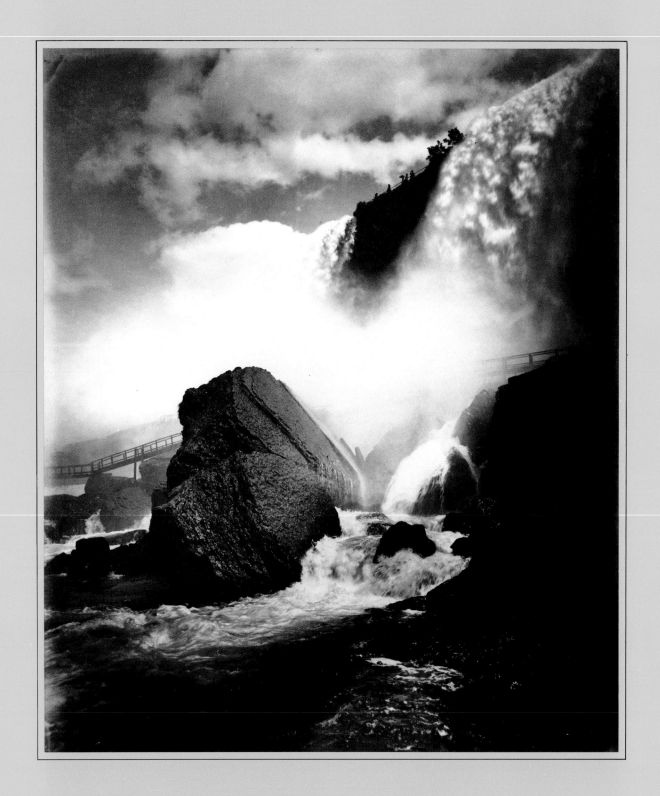

GEORGE BARKER NIAGARA FALLS (NEW YORK AND ONTARIO, CANADA)/*Albumen print, 1888*

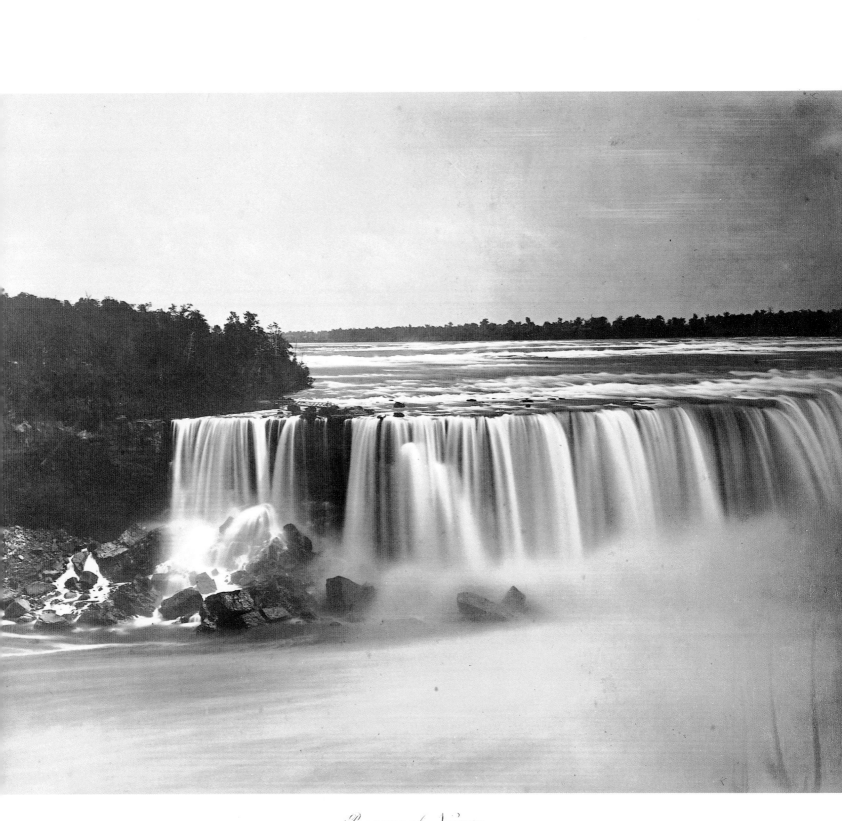

Panorama of Niagara

NIAGARA FALLS (NEW YORK AND ONTARIO, CANADA)/*Albumen print mounted on linen, n.d.*

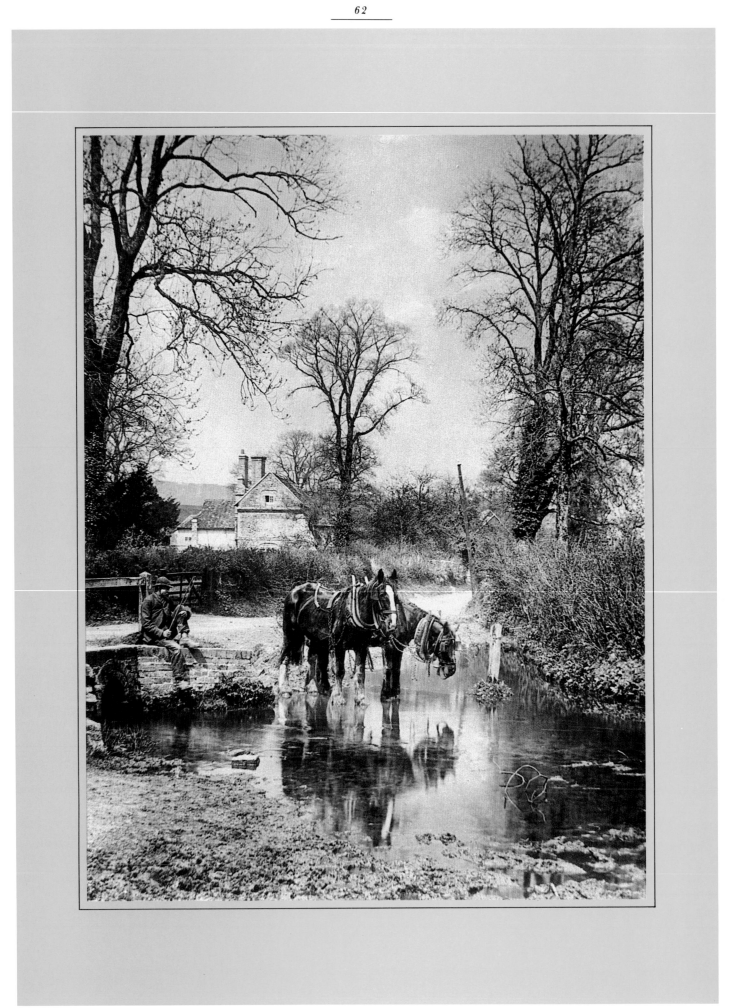

JOSEPH GALE

SLEEPY HOLLOW/ *Gelatin silver print, 1887*

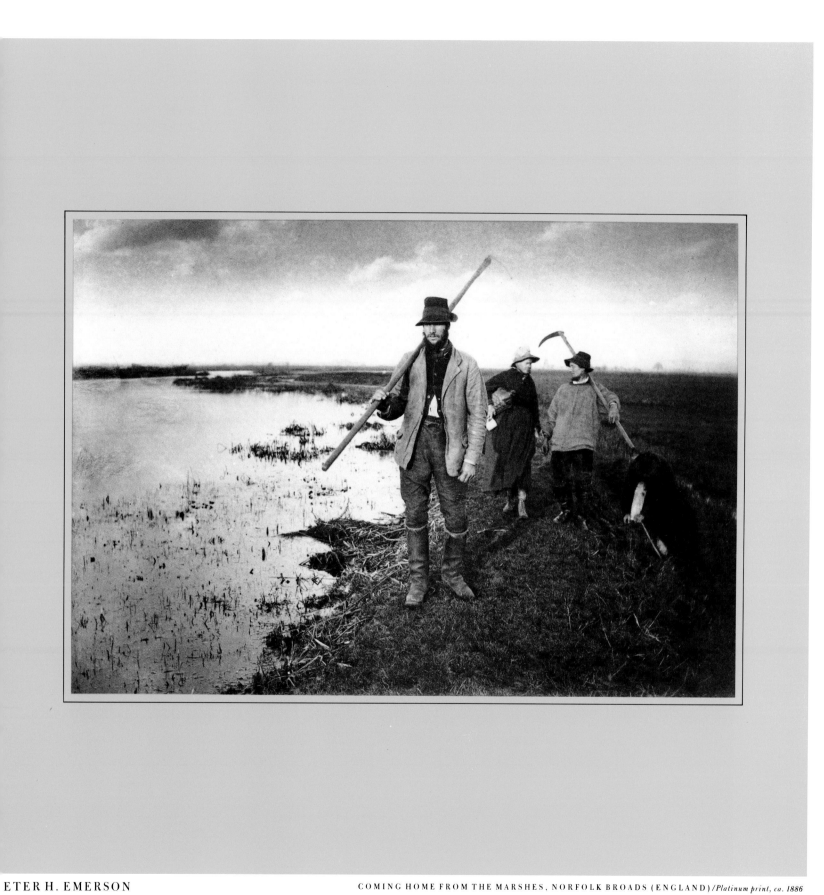

ETER H. EMERSON COMING HOME FROM THE MARSHES, NORFOLK BROADS (ENGLAND) /*Platinum print, ca. 1886*

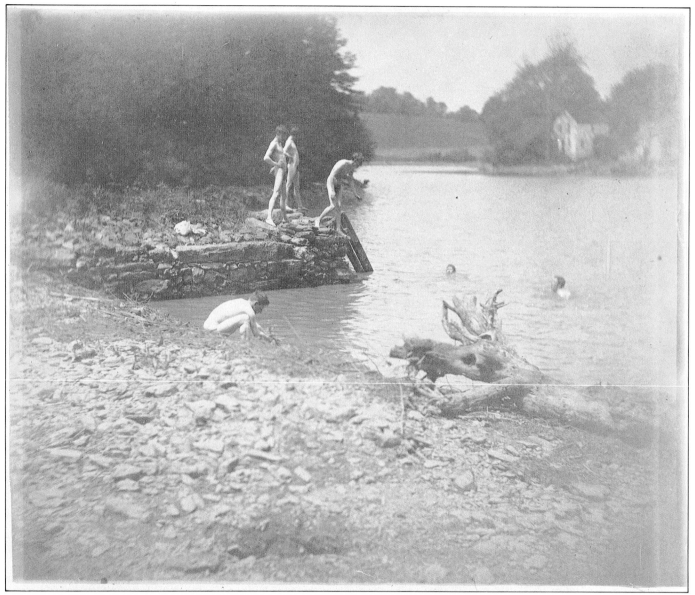

THOMAS EAKINS

STUDY FOR OIL PAINTING *THE SWIMMING HOLE* / *Albumen print, ca. 1883*

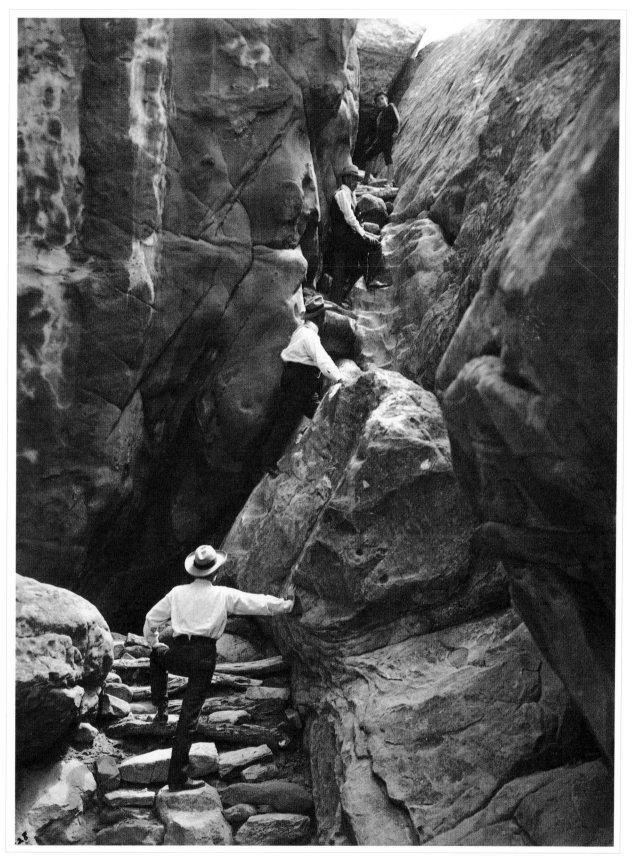

ADAM CLARK VROMAN

ACOMA TRAIL/*Albumen print, ca. 1909*

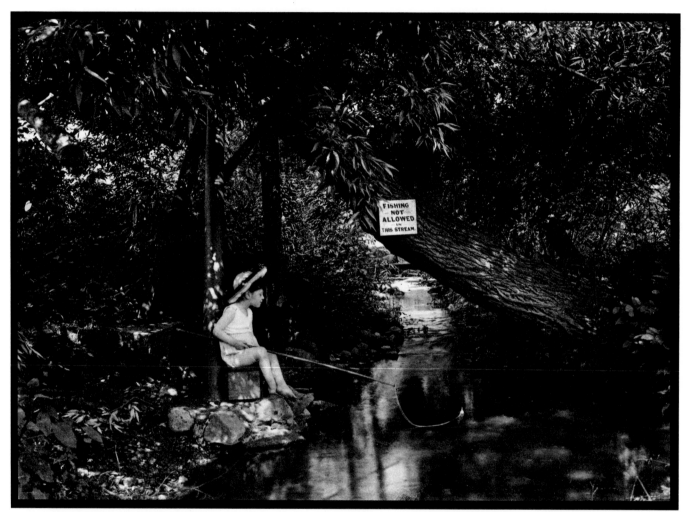

WILLIAM LYMAN UNDERWOOD　　　　　　　THE LONE FISHERMAN, BELMONT, MASSACHUSETTS/*Platinum print, 1896*

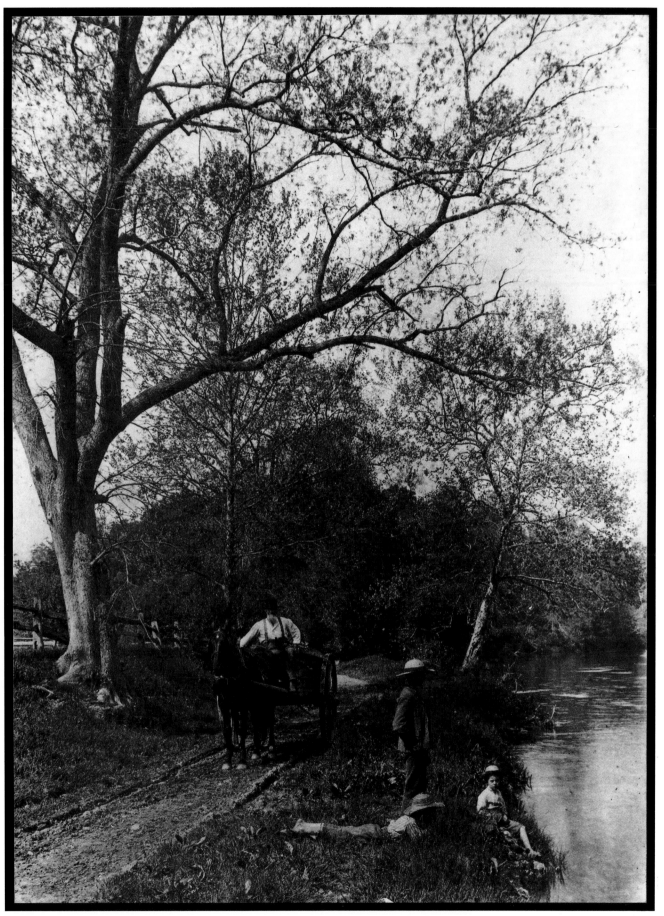

JOHN G. BULLOCK
CHILDREN ALONG A RIVER, CART ON A ROAD/*Possibly gelatin silver print, n.d.*

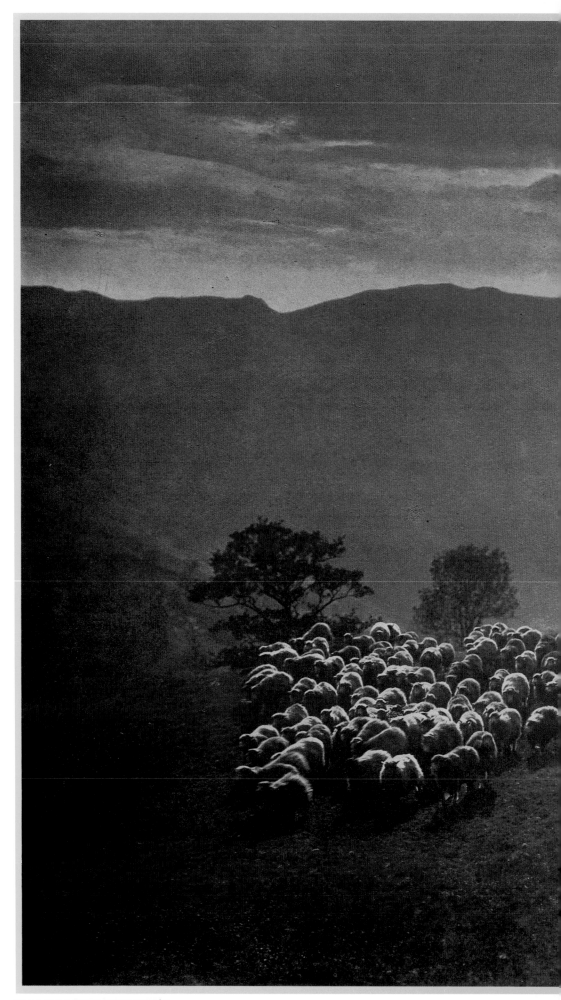

WALMSLEY BROTHERS

A LONELY VALLEY/*Toned gelatin silver print, ca. 1890*

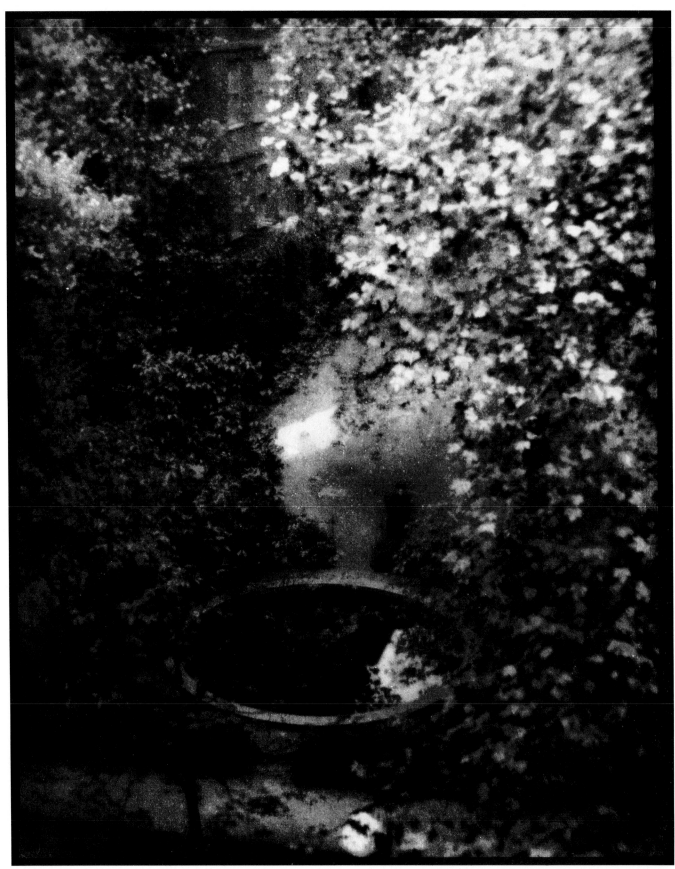

ALVIN LANGDON COBURN

FOUNTAIN COURT, LONDON/*Photogravure, 1904–1906*

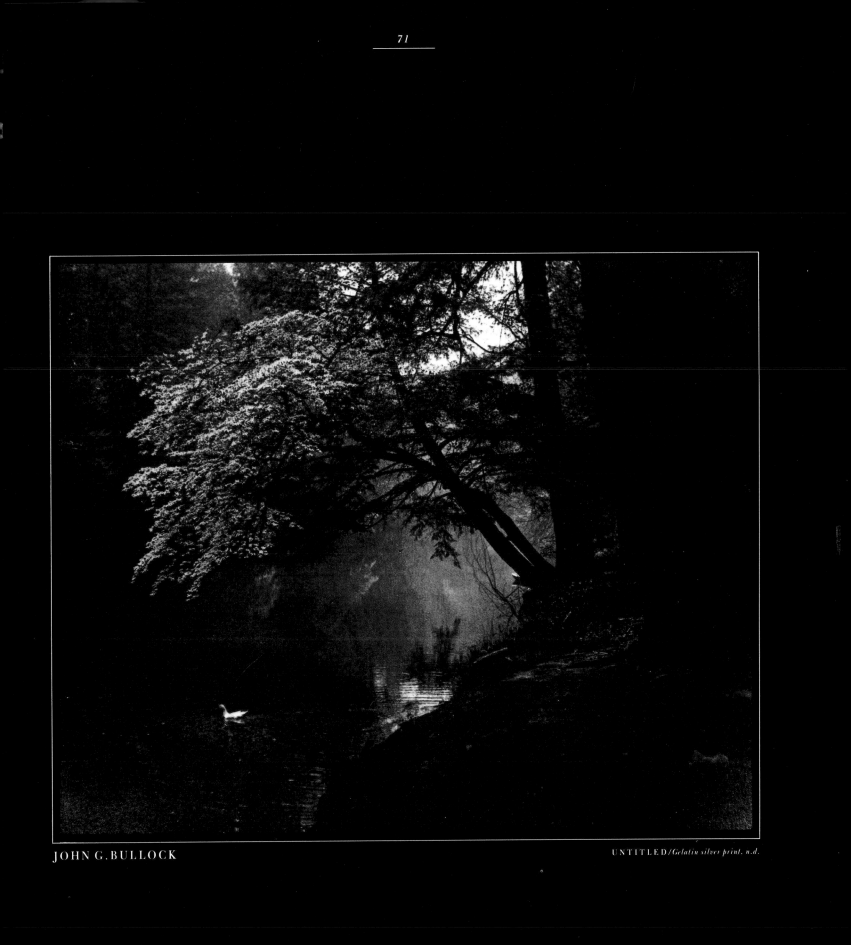

JOHN G. BULLOCK UNTITLED/*Gelatin silver print, n.d.*

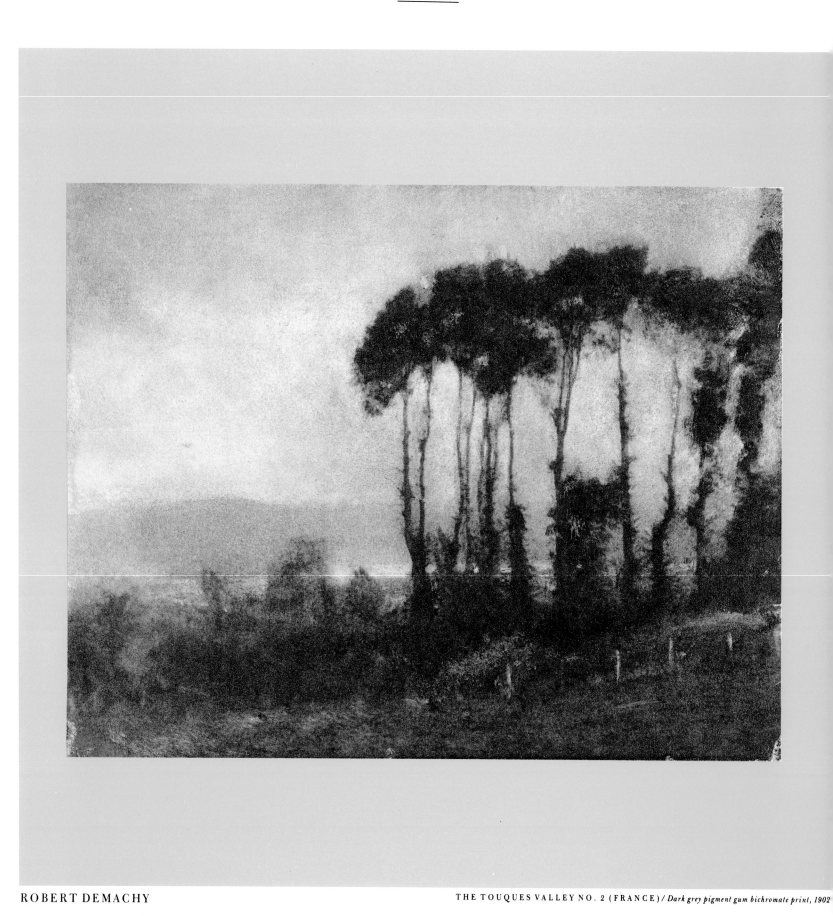

ROBERT DEMACHY

THE TOUQUES VALLEY NO. 2 (FRANCE) / *Dark grey pigment gum bichromate print, 1902*

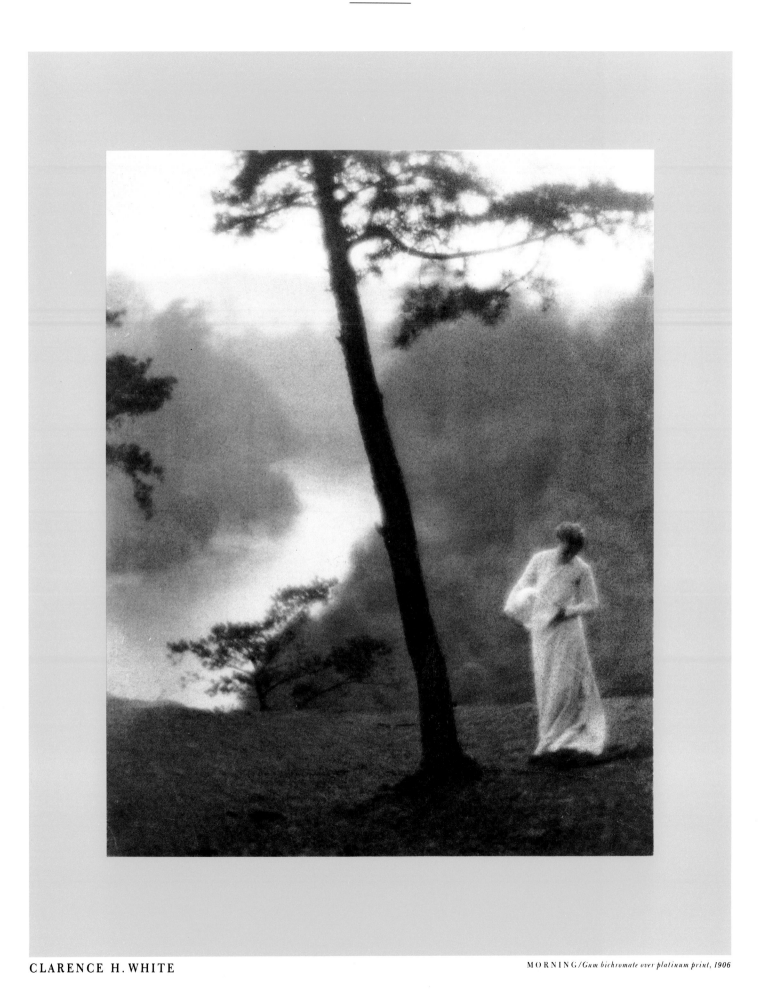

CLARENCE H. WHITE

MORNING/*Gum bichromate over platinum print, 1906*

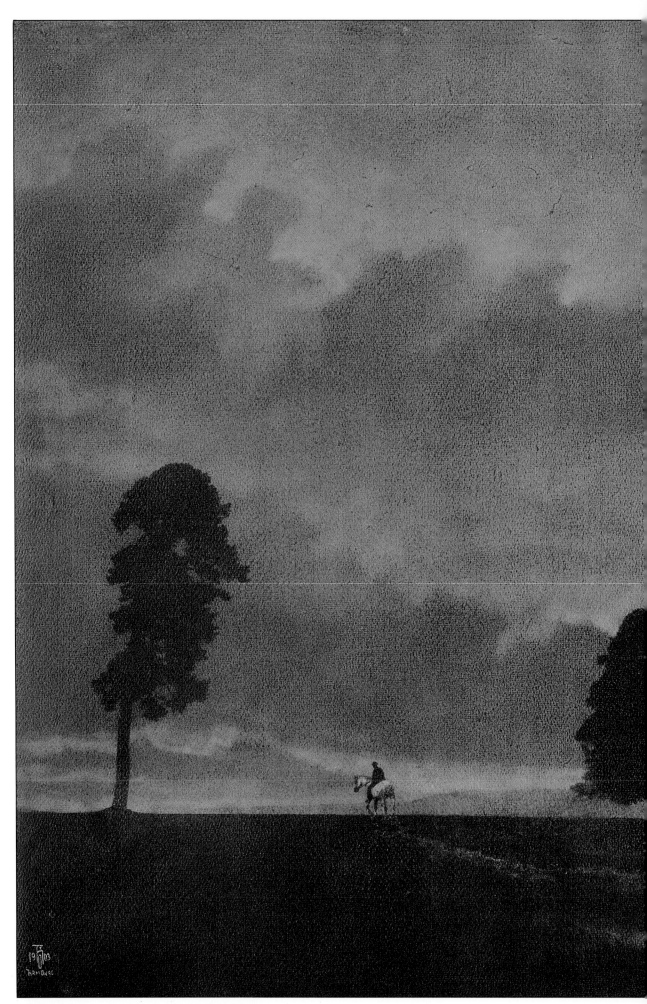

THEODOR and OSKAR HOFMEISTER

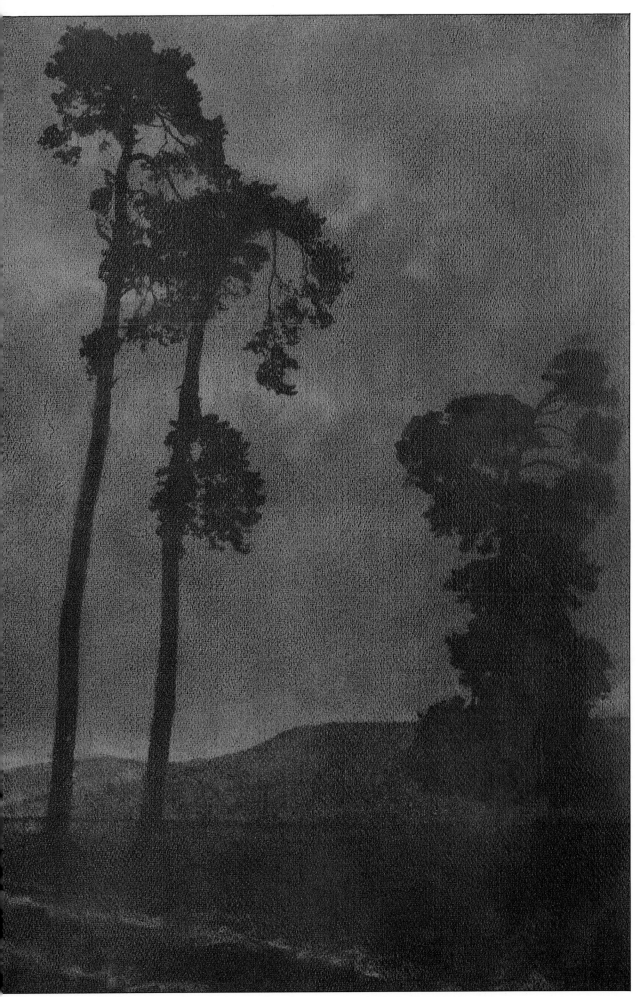

SOLITARY HORSEMAN/*Blue pigment gum bichromate print, 1903*

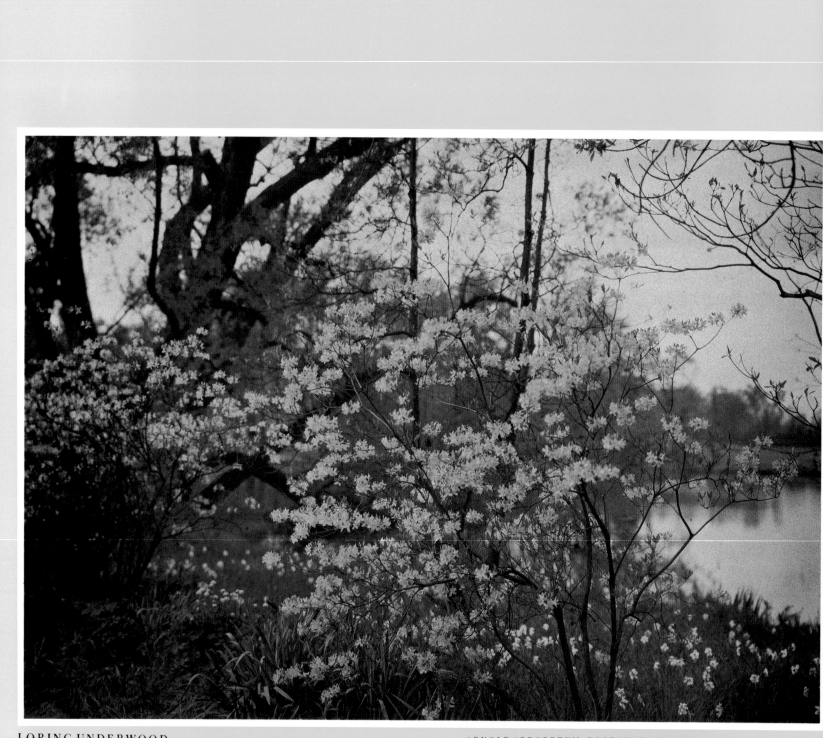

LORING UNDERWOOD

ARNOLD ARBORETUM, BOSTON, MASSACHUSETTS/*Autochrome, ca. 1908–191*

KARL STRUSS AUTUMN, LONG ISLAND, NEW YORK/*Dye transfer print, ca. 1981 from autochrome, 1910*

PAUL NADAR

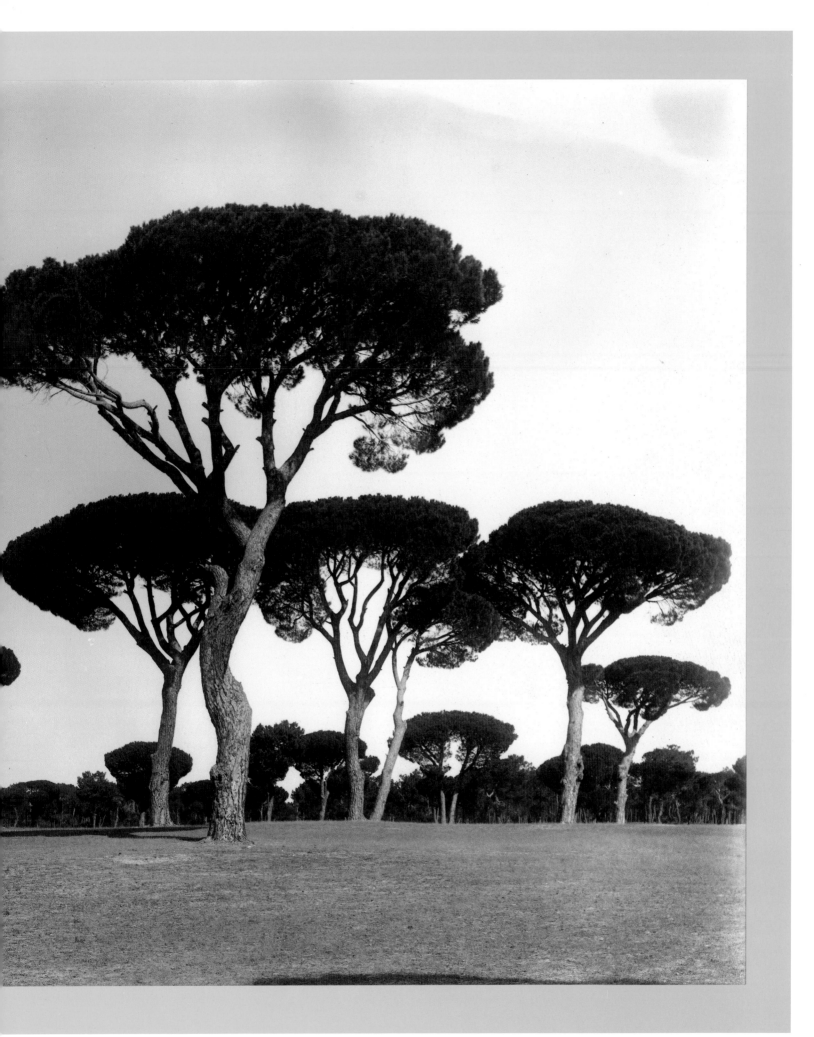

STUDY OF PINES, 1895–1905 /*Gelatin silver print, n.d. from gelatin bromide glass plate negative, 1895–1905*

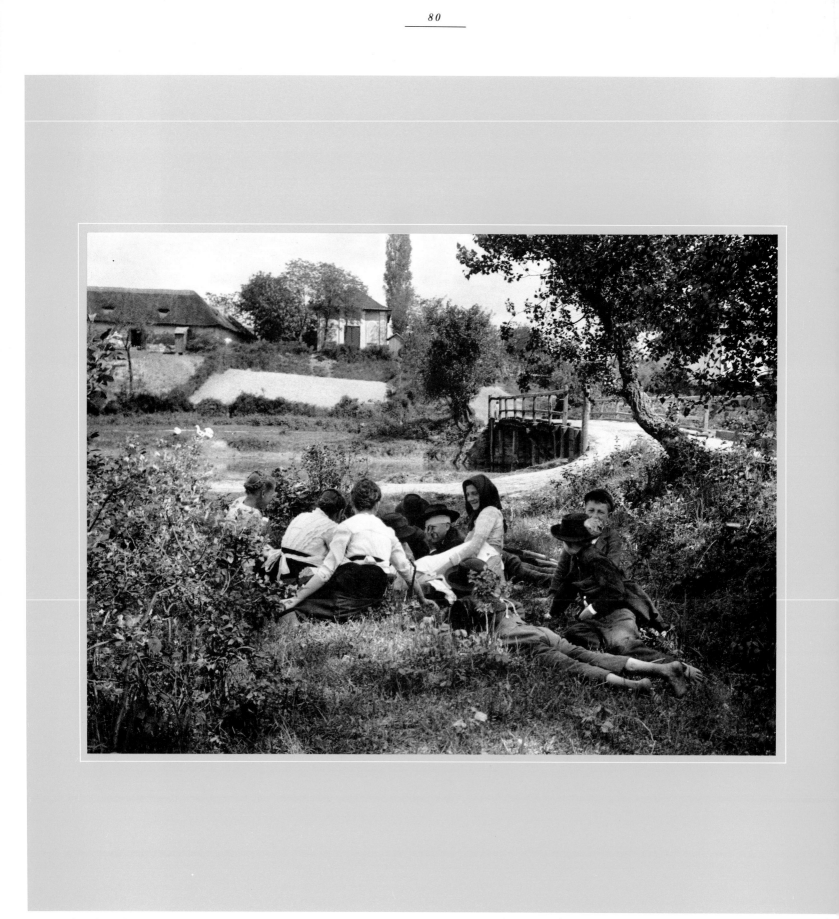

ANDRÉ KERTÉSZ SUNDAY AFTERNOON, DUNA HARASZTI, HUNGARY/*Gelatin silver print, 1919*

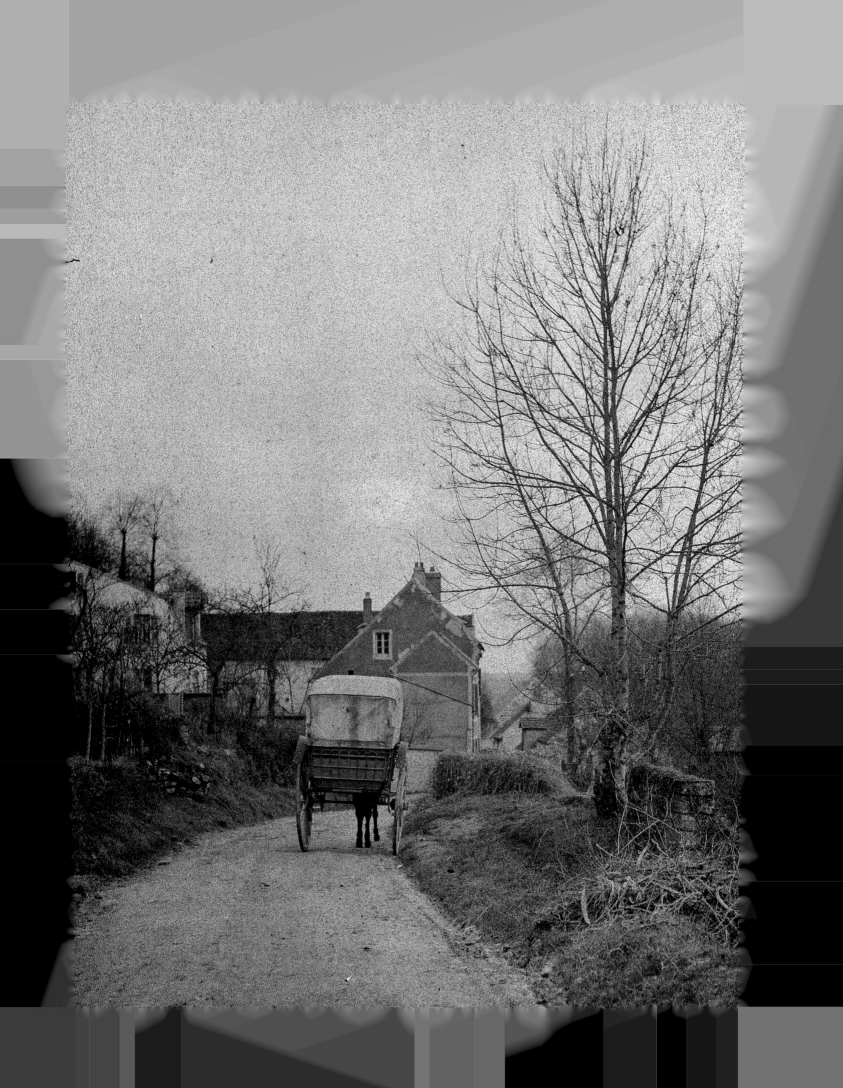

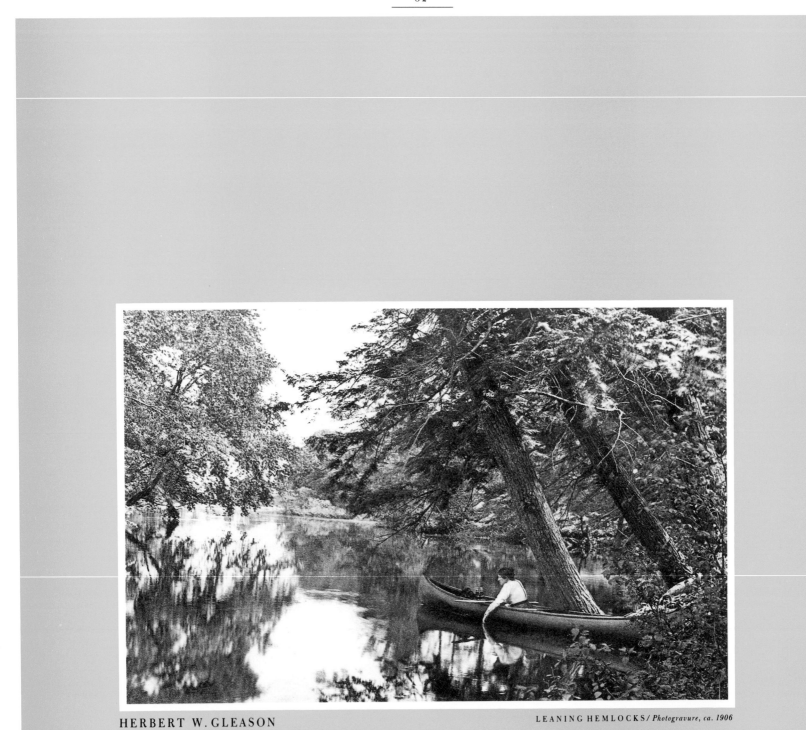

HERBERT W. GLEASON

LEANING HEMLOCKS / *Photogravure, ca. 1906*

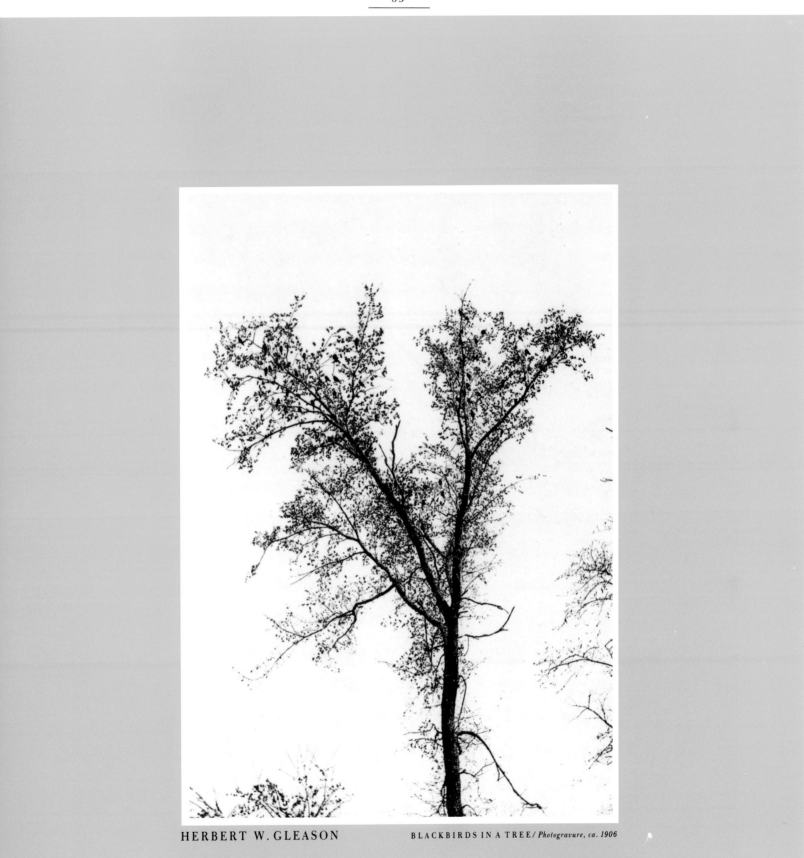

HERBERT W. GLEASON BLACKBIRDS IN A TREE / *Photogravure, ca. 1906*

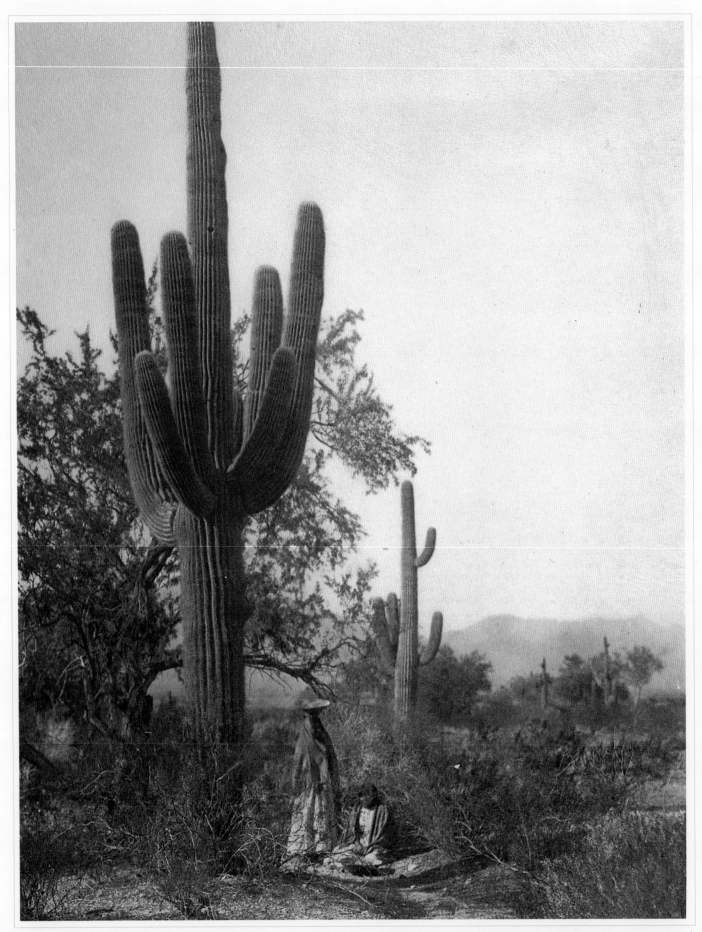

EDWARD S. CURTIS SAGUARO HARVEST, PIMA (ARIZONA) / *Photogravure on tissue. n.d.*

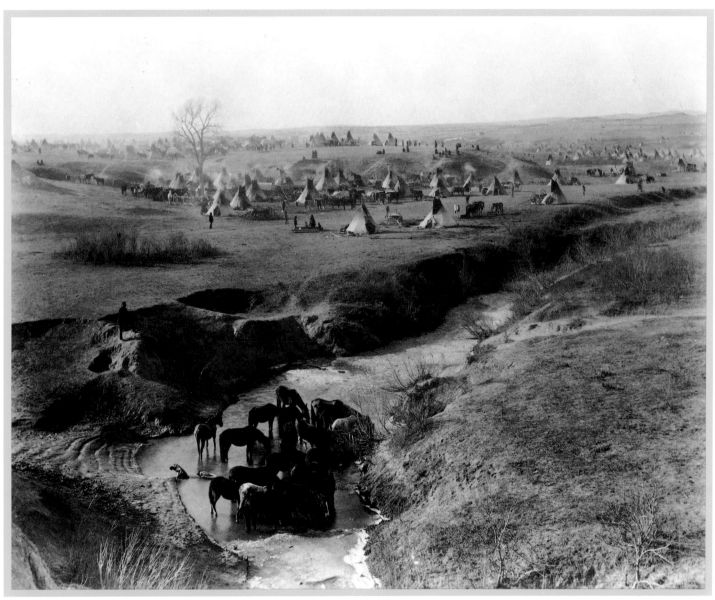

JOHN C.H. GRABILL

SIOUX [INDIAN] ENCAMPMENT, DAKOTA TERRITORY/ *Albumen print, ca. 1891*

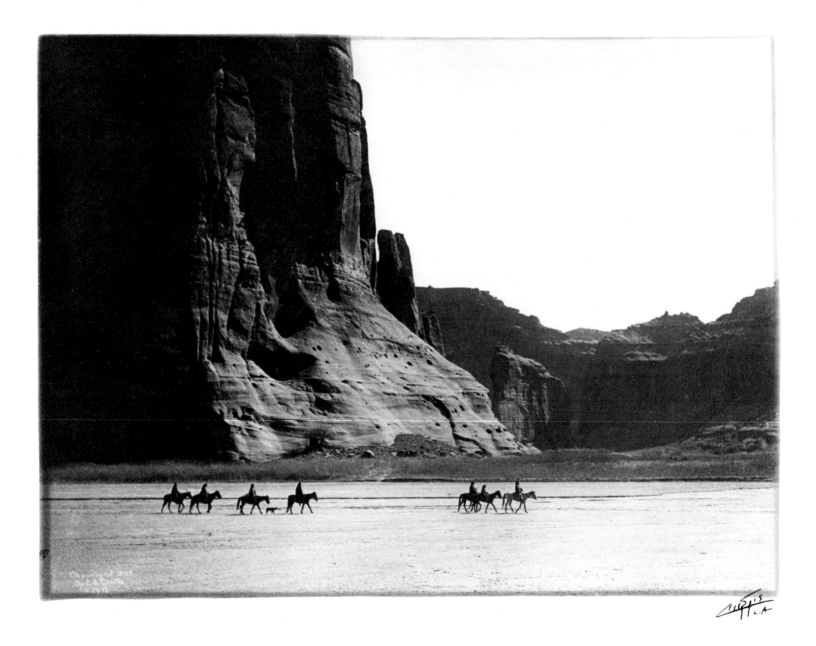

EDWARD S. CURTIS

CANYON DE CHELLY (ARIZONA)/*Toned gelatin silver print, 1904*

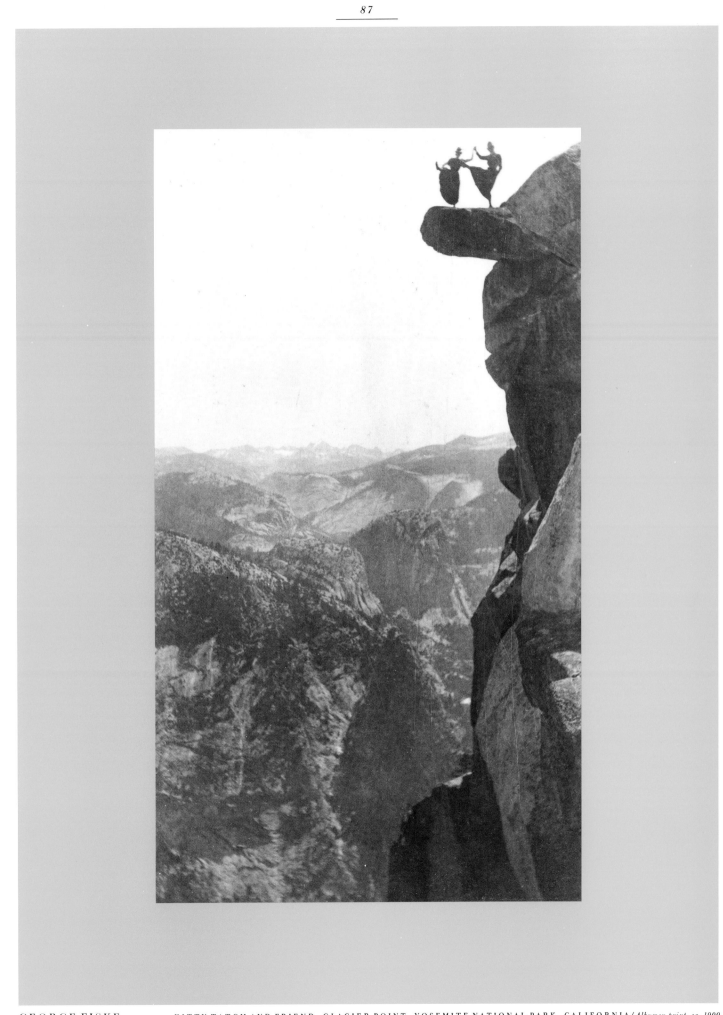

GEORGE FISKE KITTY TATCH AND FRIEND, GLACIER POINT, YOSEMITE NATIONAL PARK, CALIFORNIA/*Albumen print, ca. 1900*

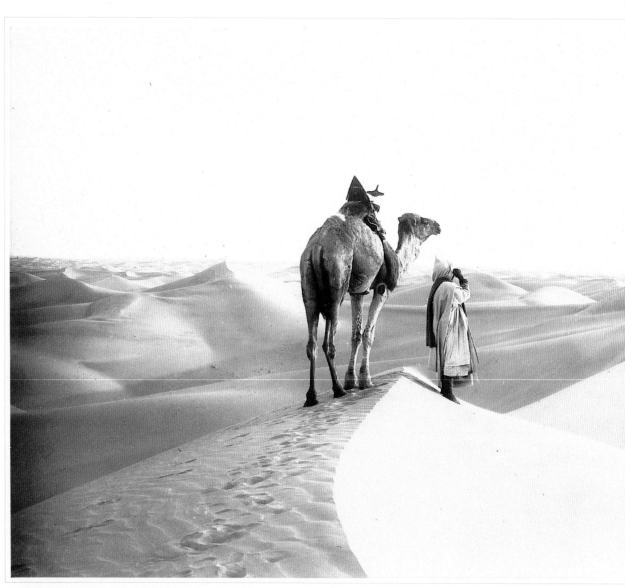

A. BOUGAULT

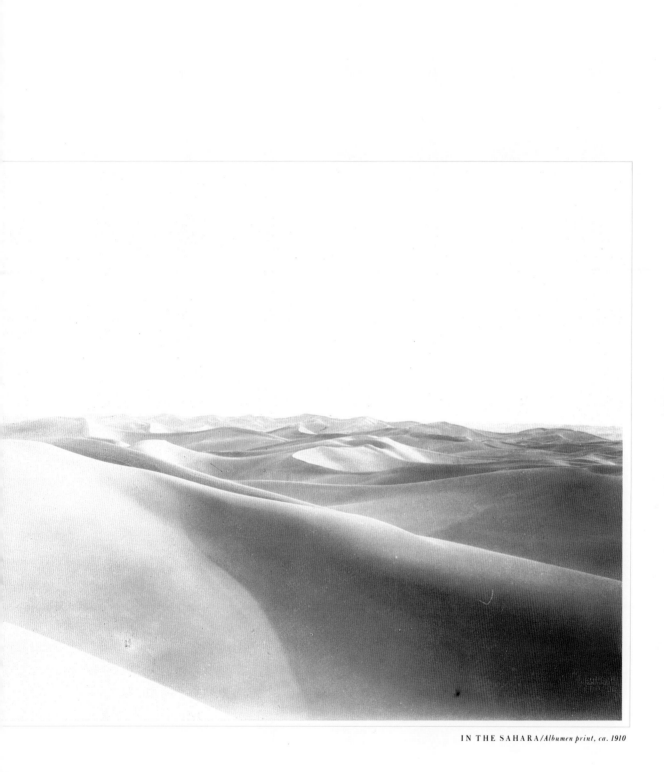

IN THE SAHARA/*Albumen print, ca. 1910*

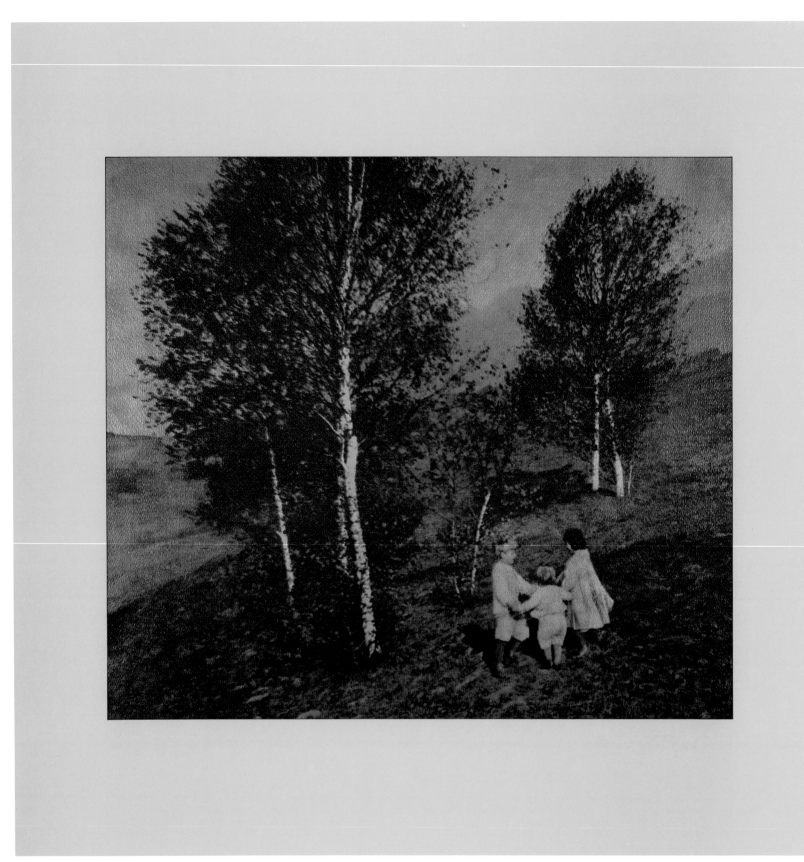

HEINRICH KÜHN THREE CHILDREN IN A LANDSCAPE/*Gum bichromate print. ca. 190*

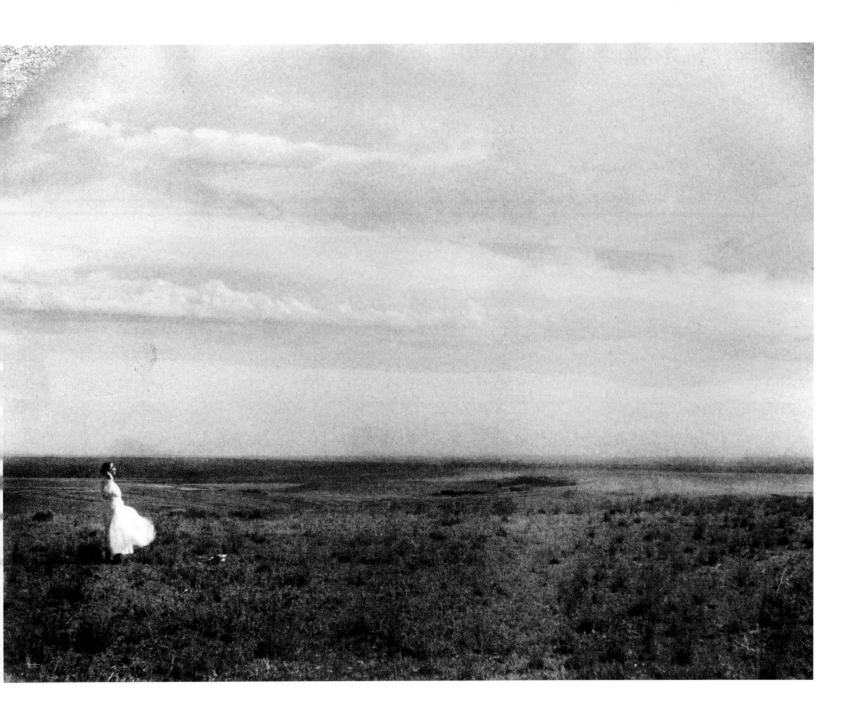

LAURA GILPIN

ON THE PRAIRIE/*Platinum print. 1919*

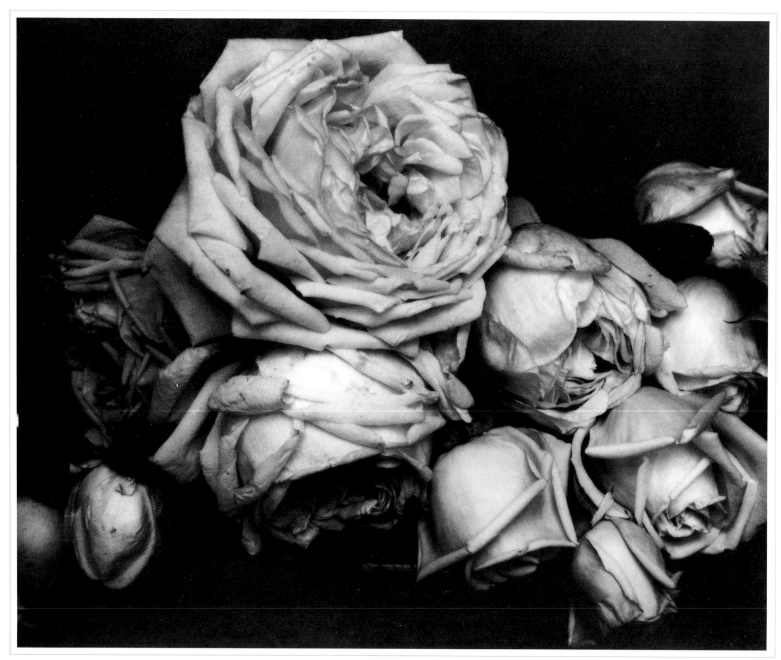

EDWARD STEICHEN HEAVY ROSES, VOULANGIS, FRANCE/*Gelatin silver print, 1914*

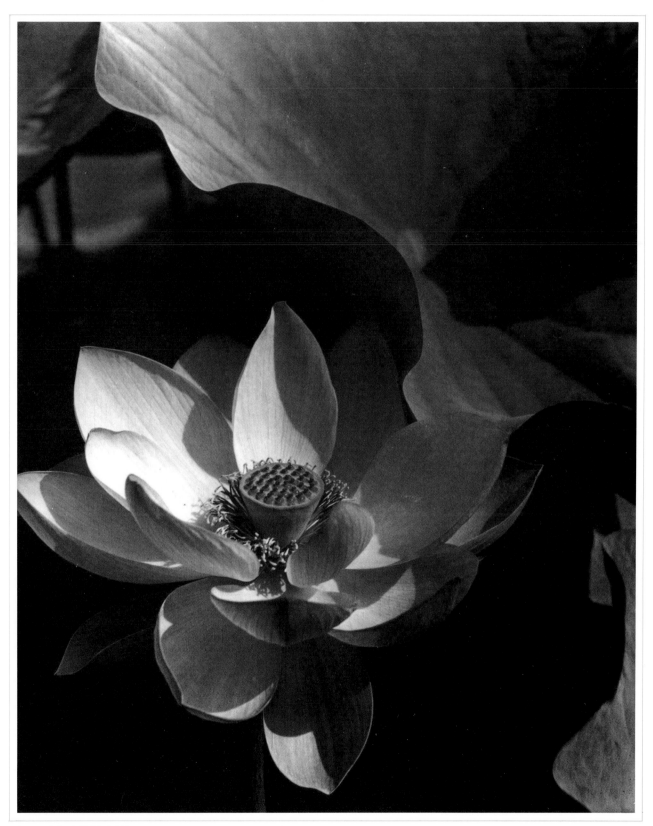

EDWARD STEICHEN THE LOTUS/*Gelatin silver print, 1923*

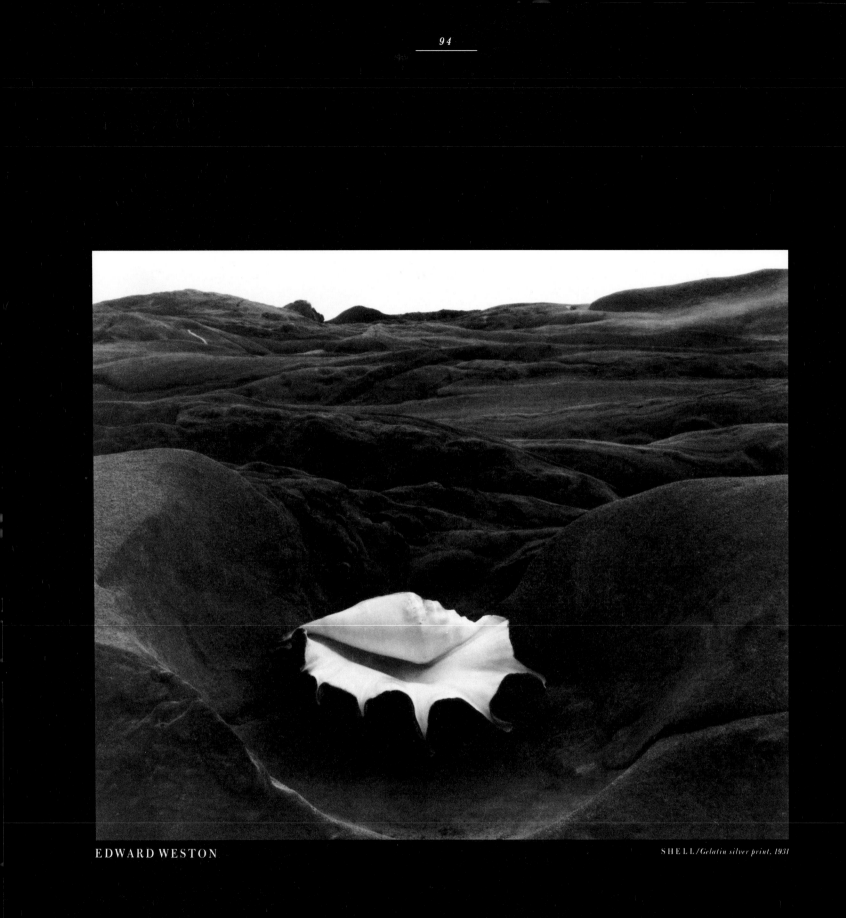

EDWARD WESTON SHELL/*Gelatin silver print, 1931*

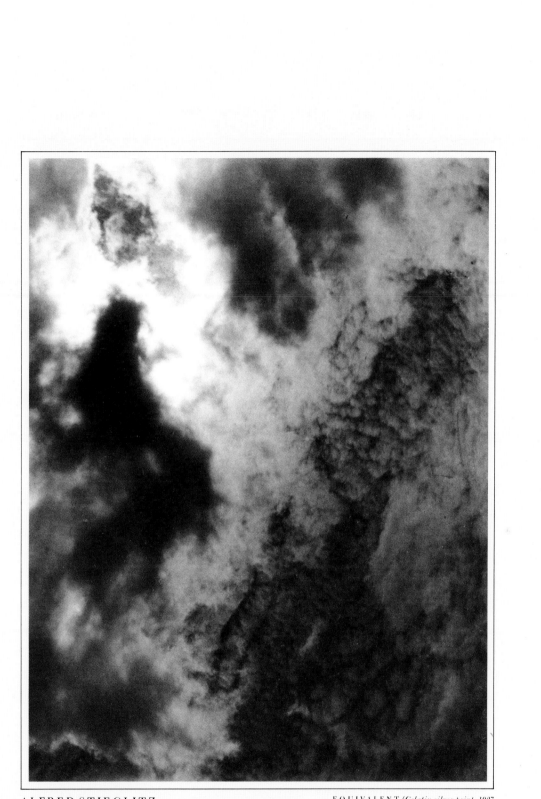

ALFRED STIEGLITZ EQUIVALENT/*Gelatin silver print, 1927*

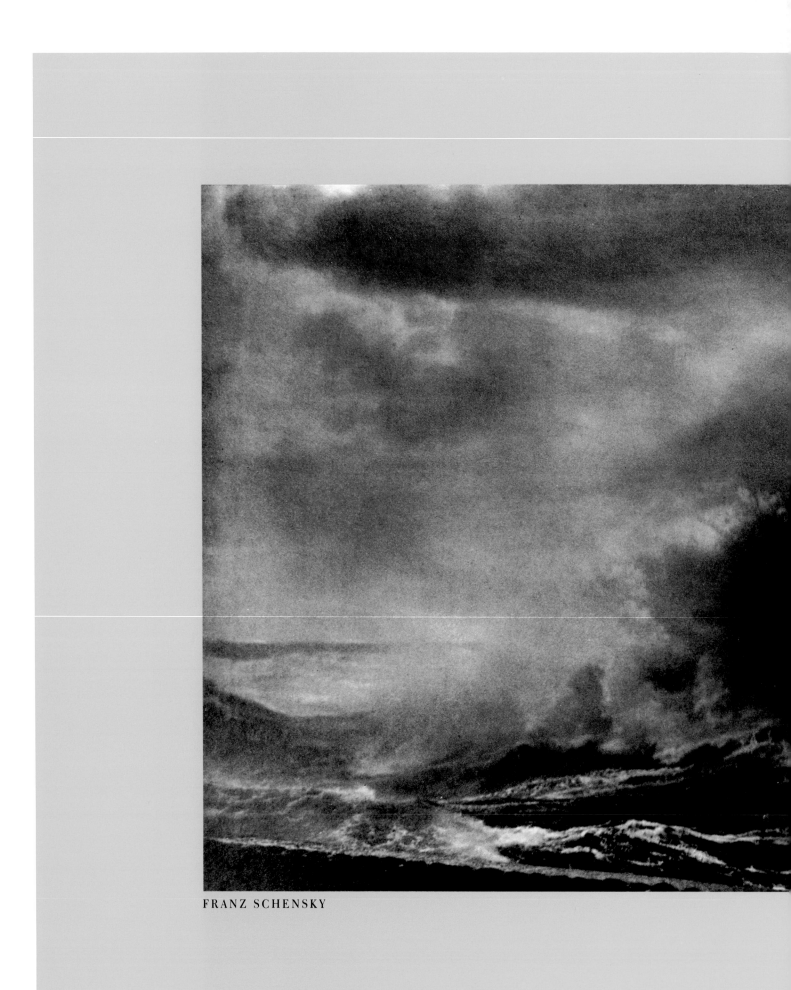

FRANZ SCHENSKY

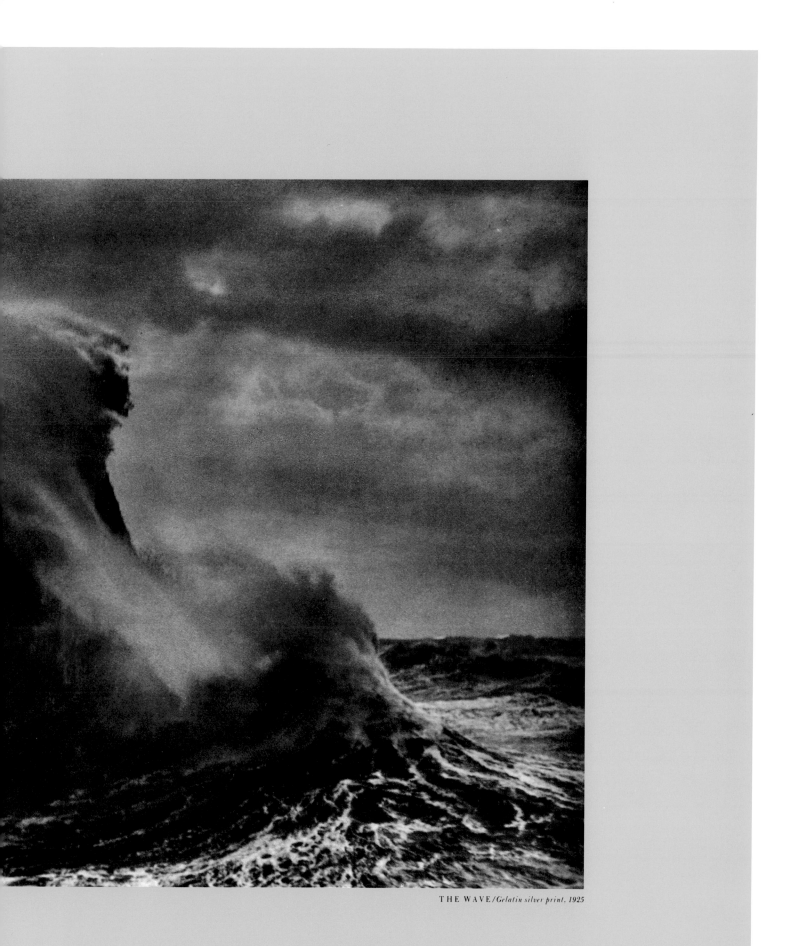

THE WAVE/*Gelatin silver print, 1925*

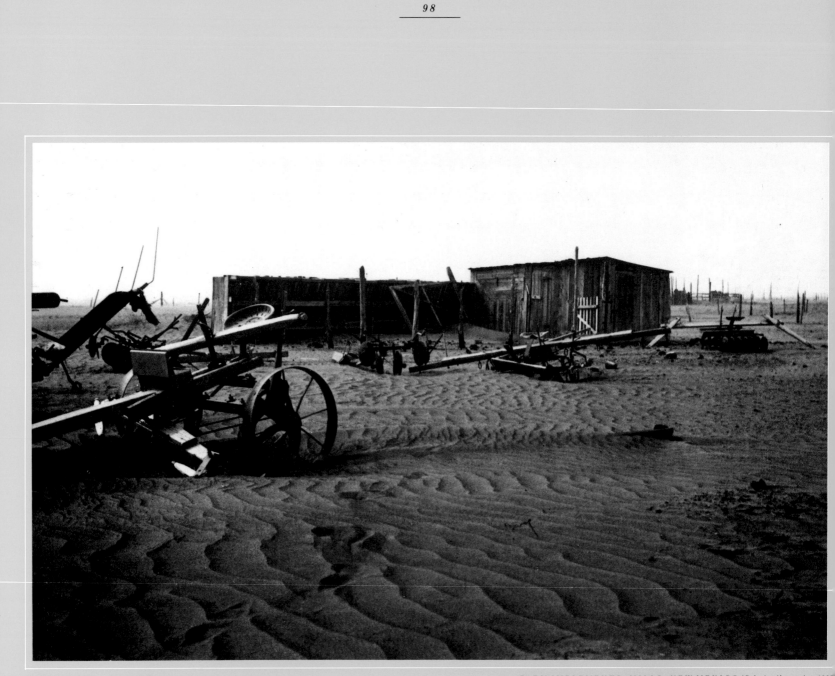

DOROTHEA LANGE FARM IMPLEMENTS, MILLS, NEW MEXICO/*Gelatin silver print, 1935*

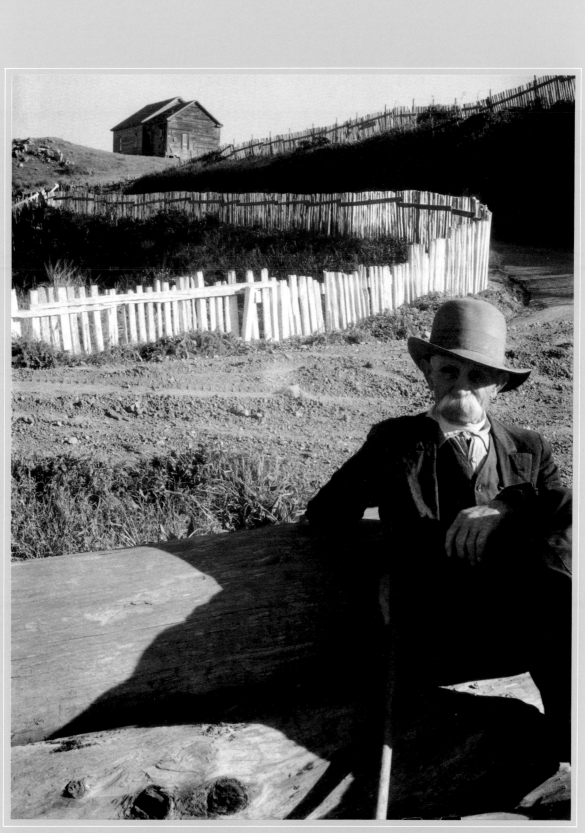

IMOGEN CUNNINGHAM

NORTHWEST NATIVE/*Gelatin silver print, 1934*

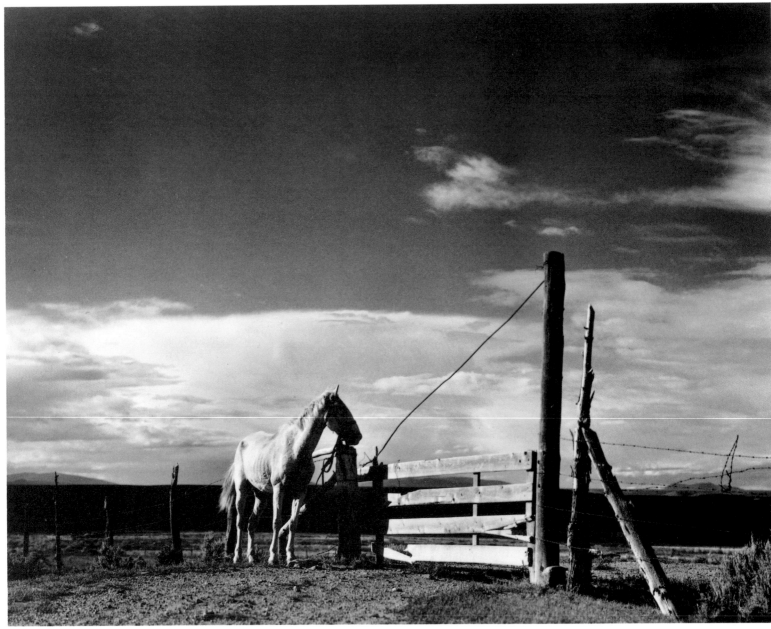

PAUL STRAND WHITE HORSE, RANCHOS DE TAOS, NEW MEXICO/*Gelatin silver print, ca. 1976 from negative, 1932*

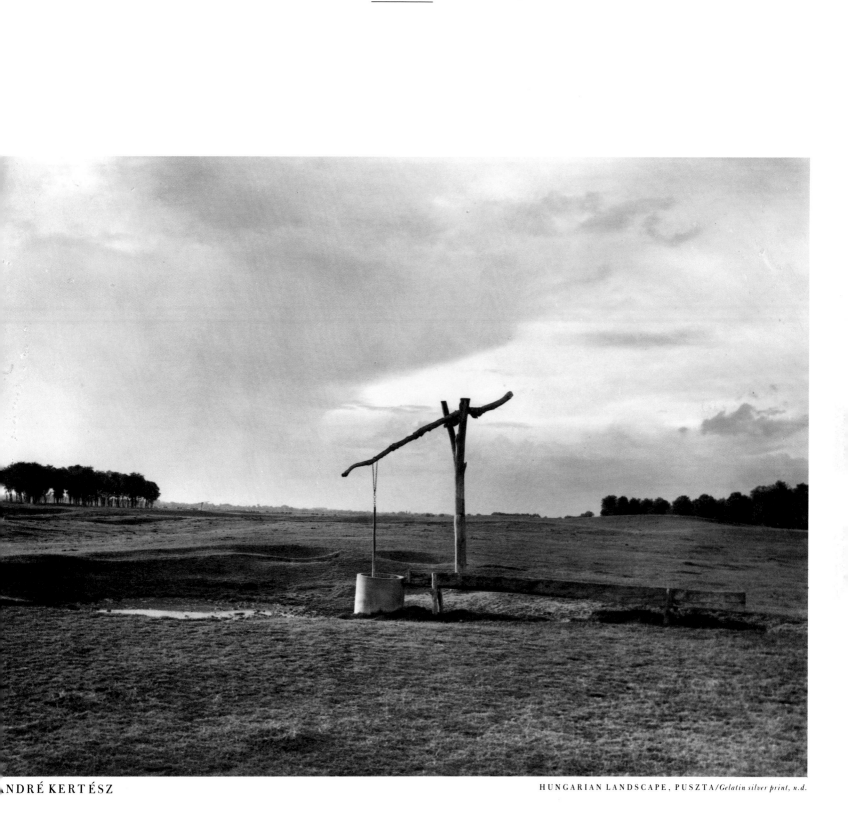

ANDRÉ KERTÉSZ HUNGARIAN LANDSCAPE, PUSZTA/*Gelatin silver print, n.d.*

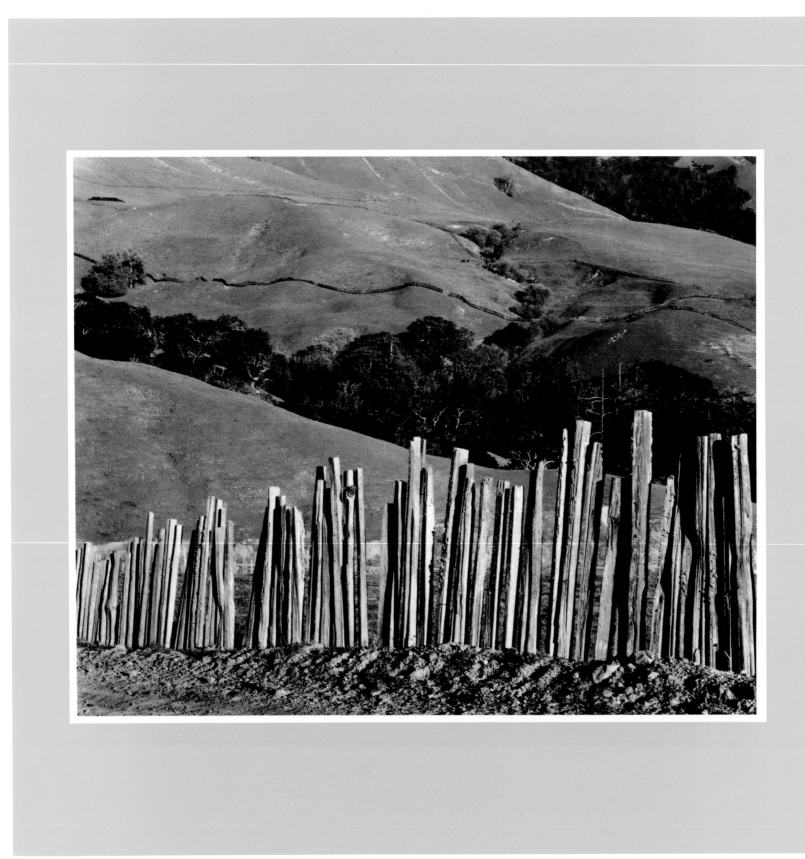

EDWARD WESTON OLD BIG SUR ROAD (CALIFORNIA)/*Gelatin silver print, 195*

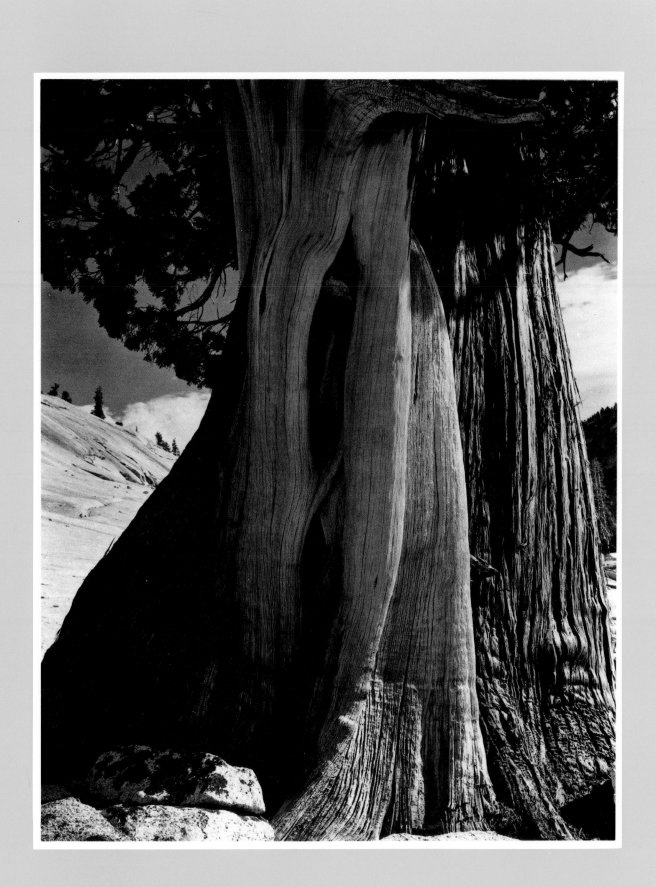

EDWARD WESTON

JUNIPER, SIERRA NEVADA, CALIFORNIA/*Gelatin silver print, 1937*

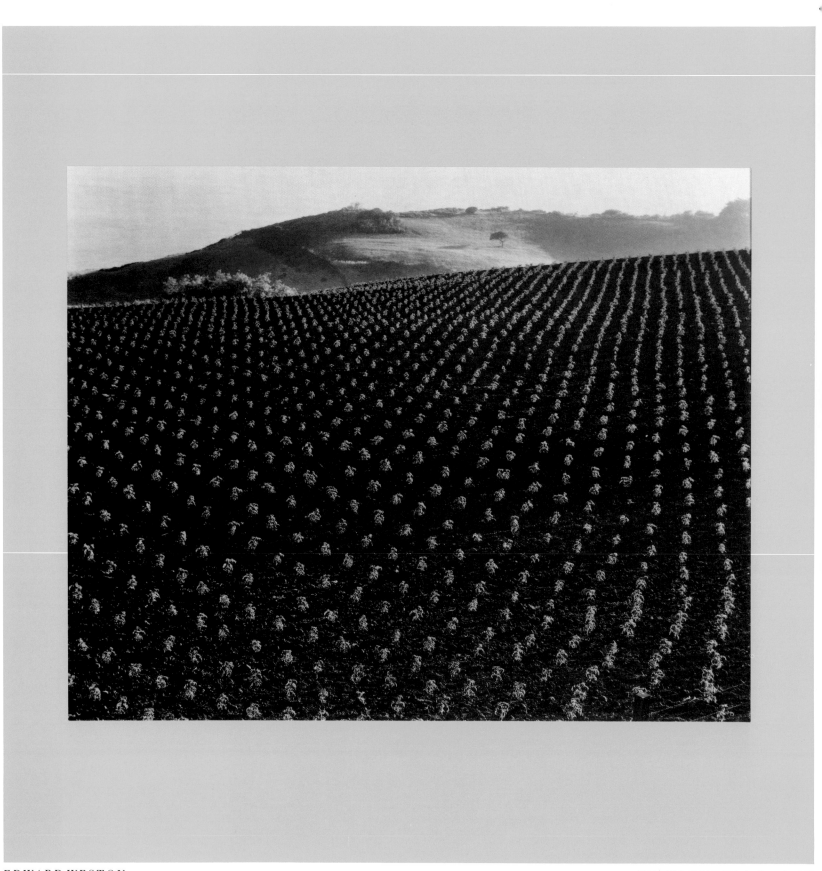

EDWARD WESTON

TOMATO FIELD/*Gelatin silver print, 1937*

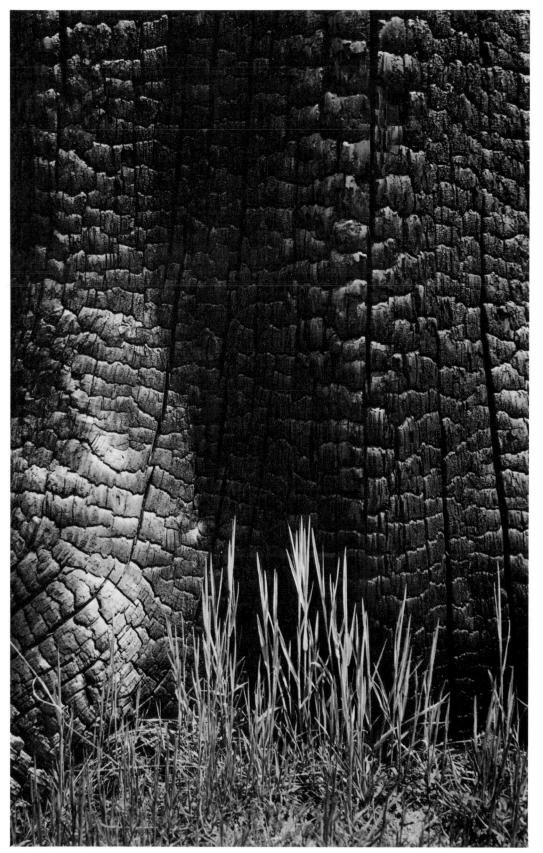

ANSEL ADAMS

BURNT STUMP AND NEW GRASS, SIERRA NEVADA,
CALIFORNIA/*Gelatin silver print, 1932*

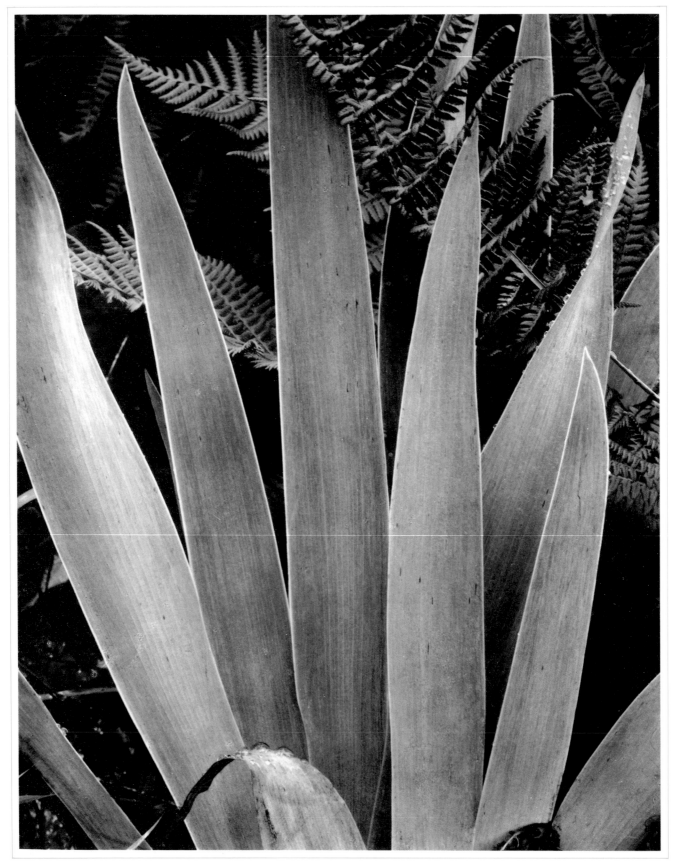

PAUL STRAND WILD IRIS, CENTER LOVELL, MAINE, 1927/*Gelatin silver print, 1927*

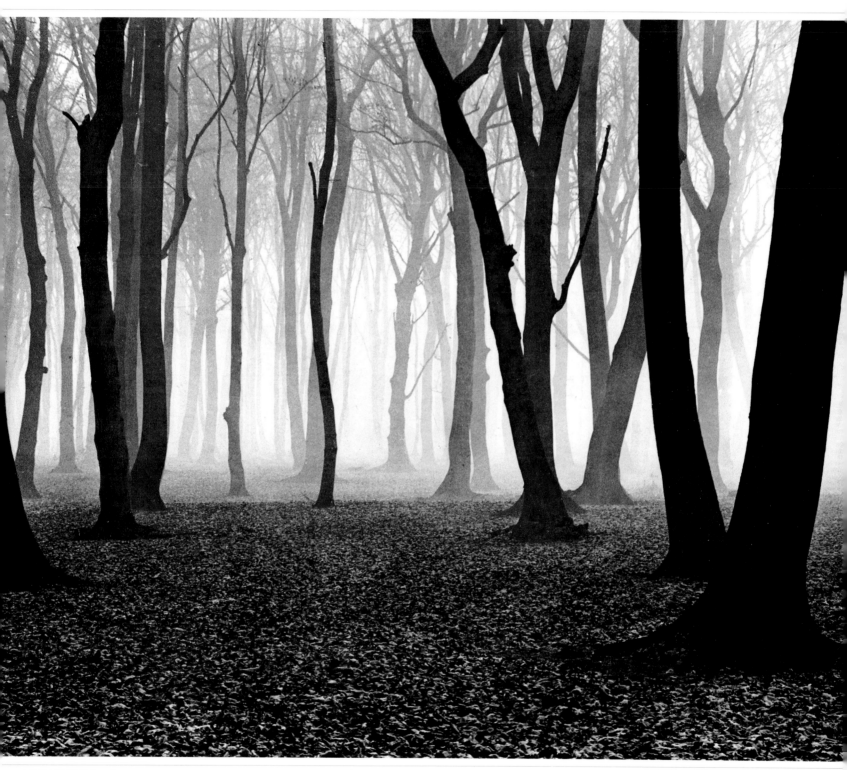

ALBERT RENGER-PATZSCH

BEECH FOREST IN AUTUMN/ *Gelatin silver print, 1936*

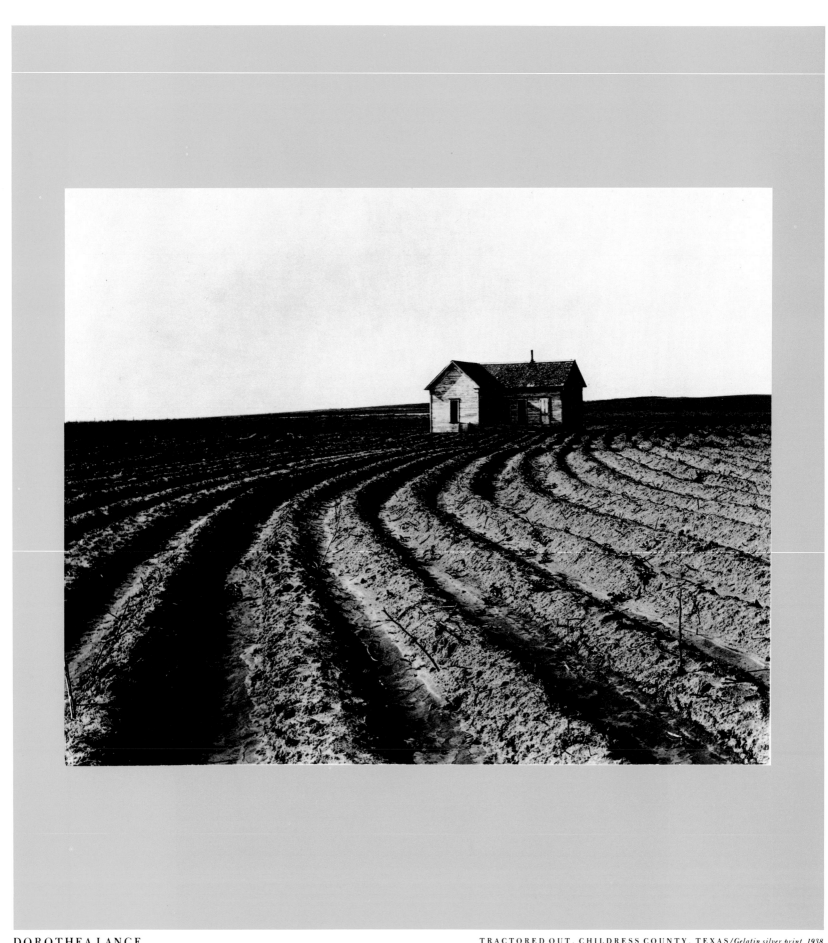

DOROTHEA LANGE

TRACTORED OUT, CHILDRESS COUNTY, TEXAS/*Gelatin silver print, 1938*

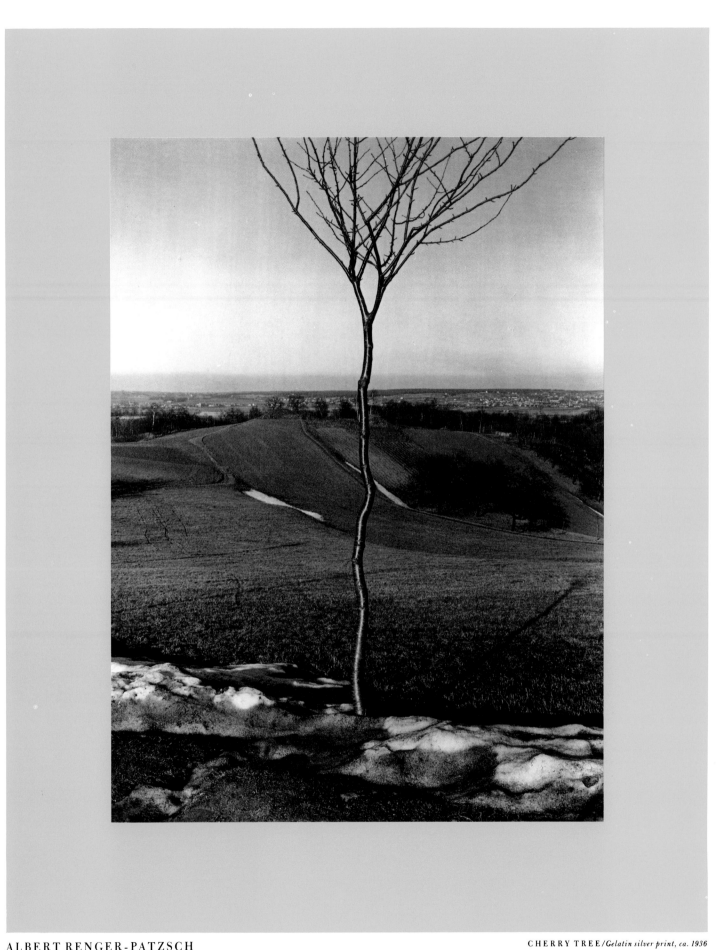

ALBERT RENGER-PATZSCH

CHERRY TREE/*Gelatin silver print, ca. 1936*

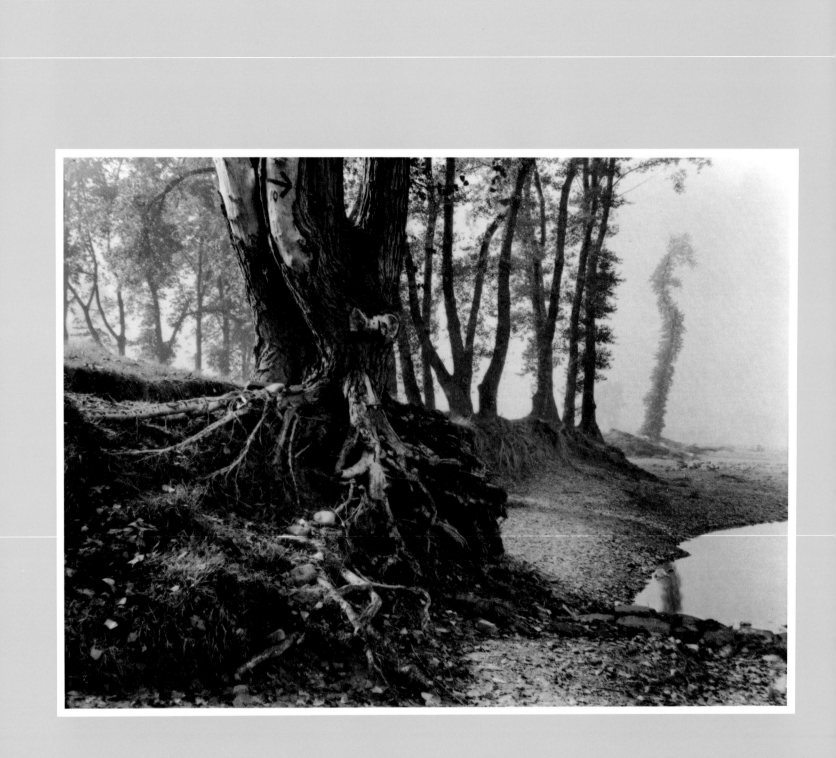

JOSEF SUDEK A WALK ON TROJA ISLAND (CZECHOSLOVAKIA) / *Gelatin silver print, 1940–1945*

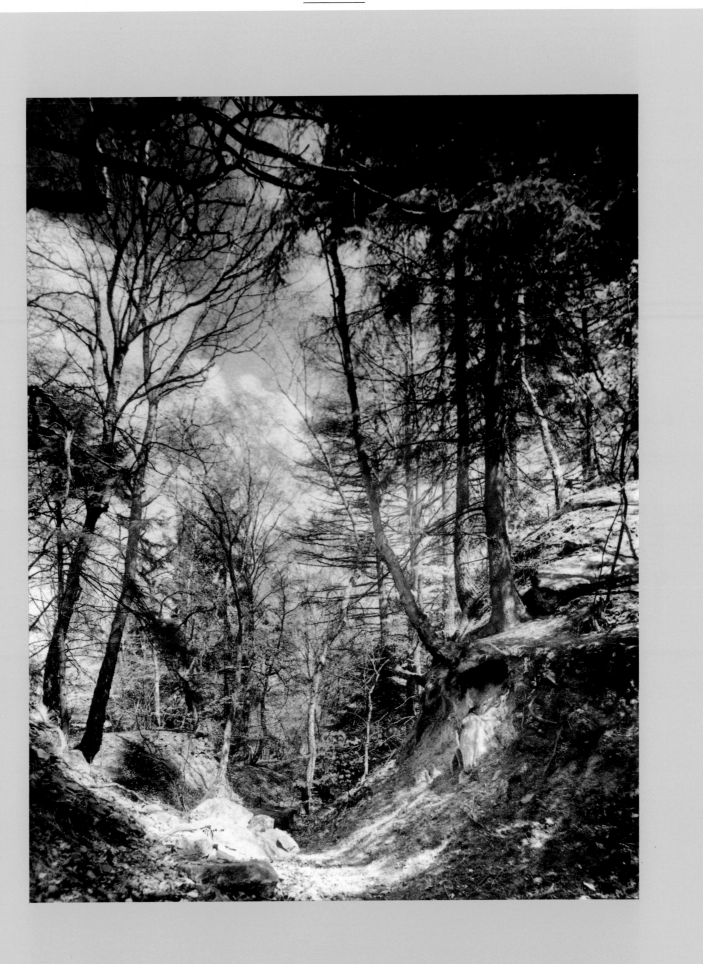

AUGUST SANDER

LANDSCAPE IN THE SIEBENGEBIRGE (GERMANY) / *Gelatin silver print, 1930s*

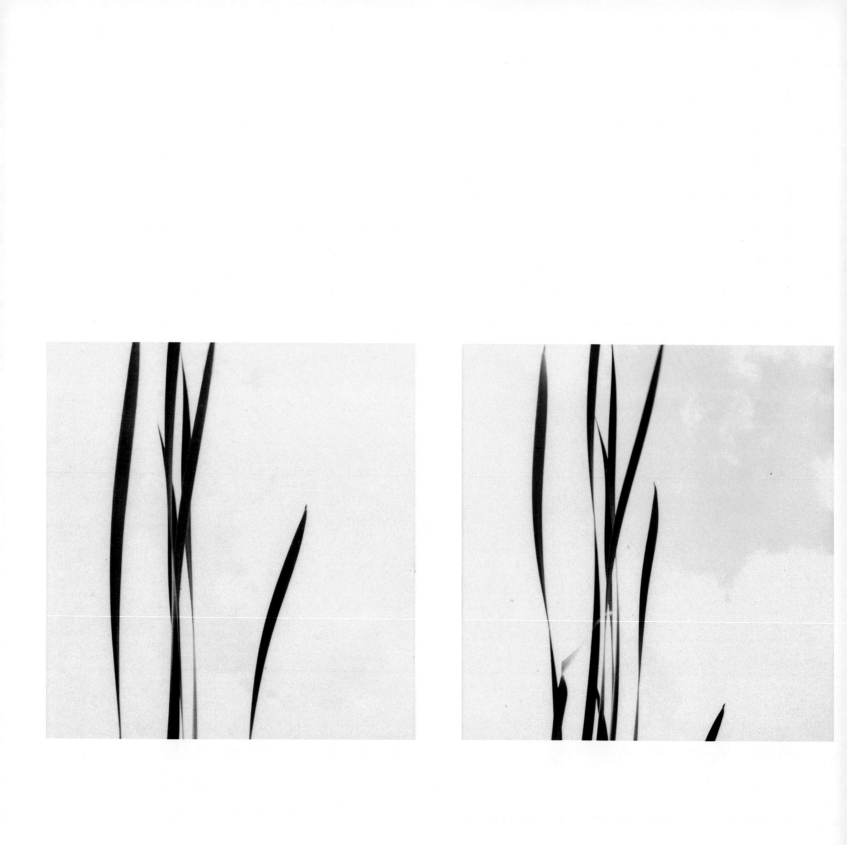

HARRY CALLAHAN

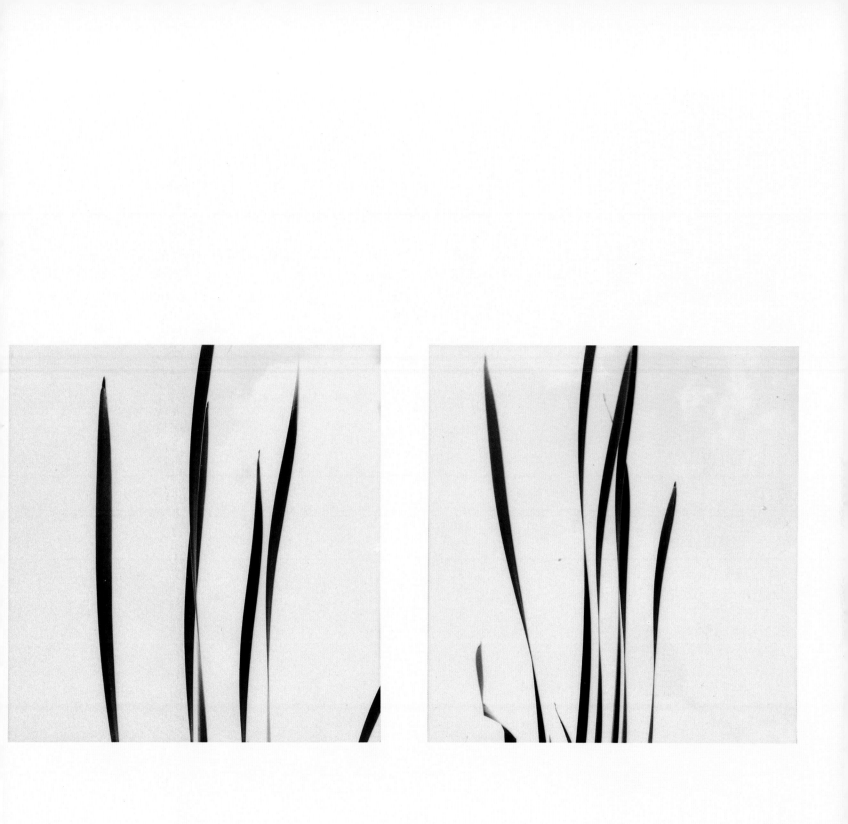

CATTAILS AGAINST THE SKY/*Gelatin silver print, 1948*

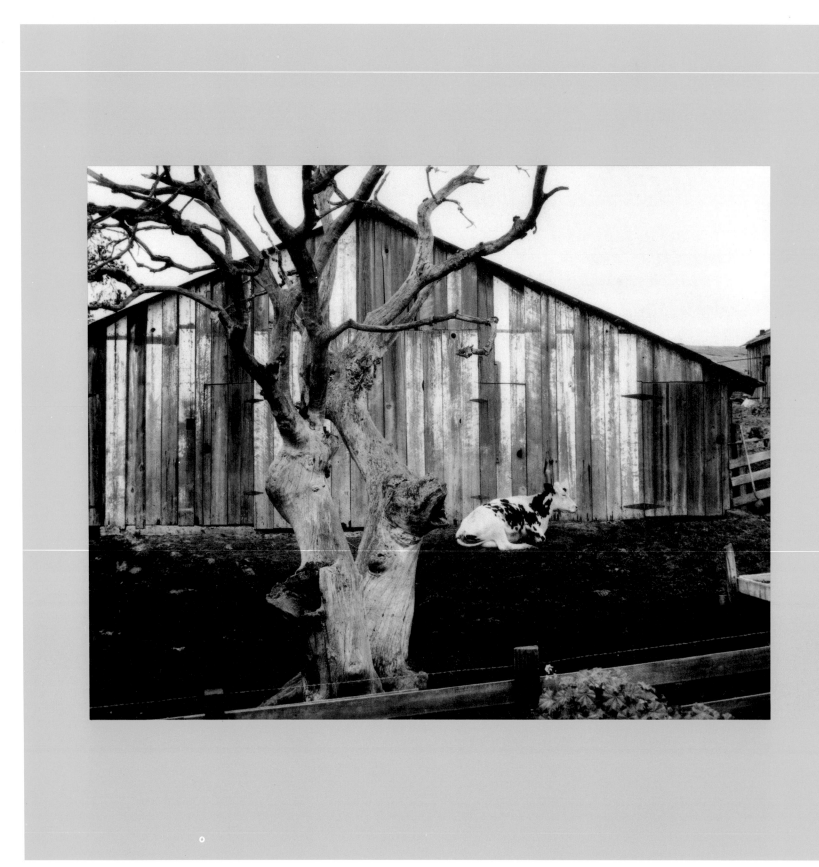

EDWARD WESTON

BARN, PISMO BEACH, CALIFORNIA/*Gelatin silver print, 193*

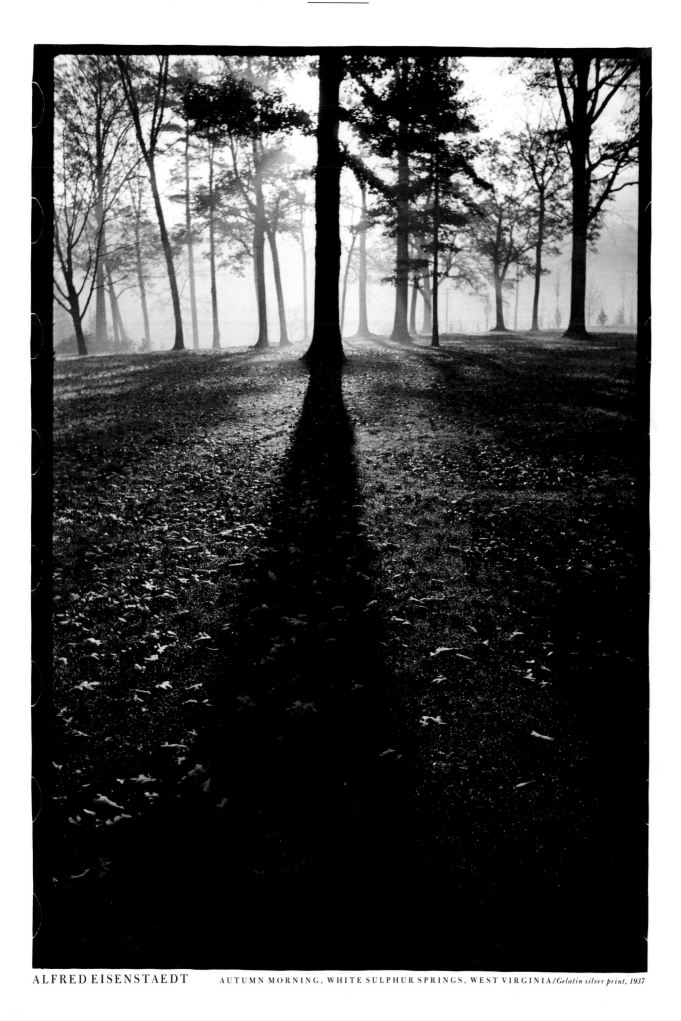

ALFRED EISENSTAEDT AUTUMN MORNING, WHITE SULPHUR SPRINGS, WEST VIRGINIA/*Gelatin silver print, 1937*

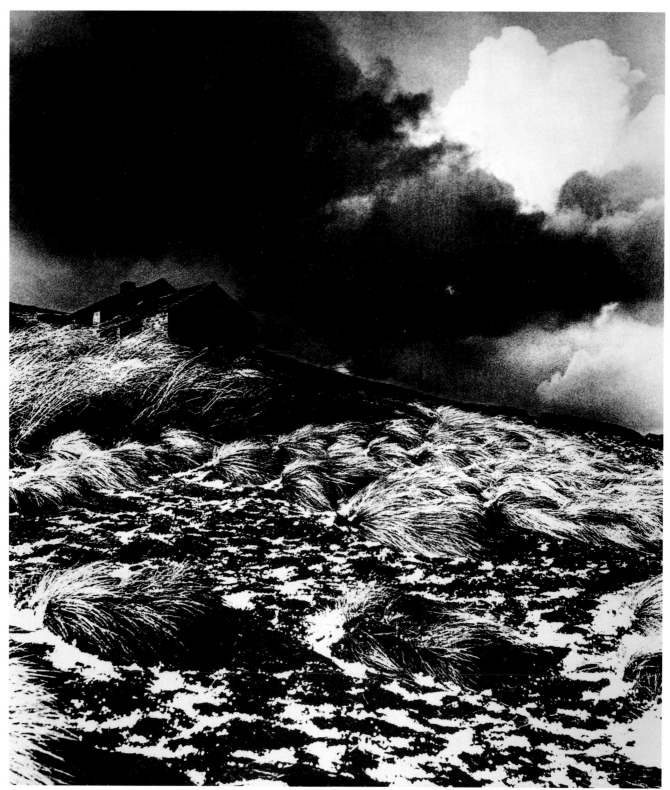

BILL BRANDT TOP WITHENS, WEST RIDING, YORKSHIRE/ *Gelatin silver print, 1945*

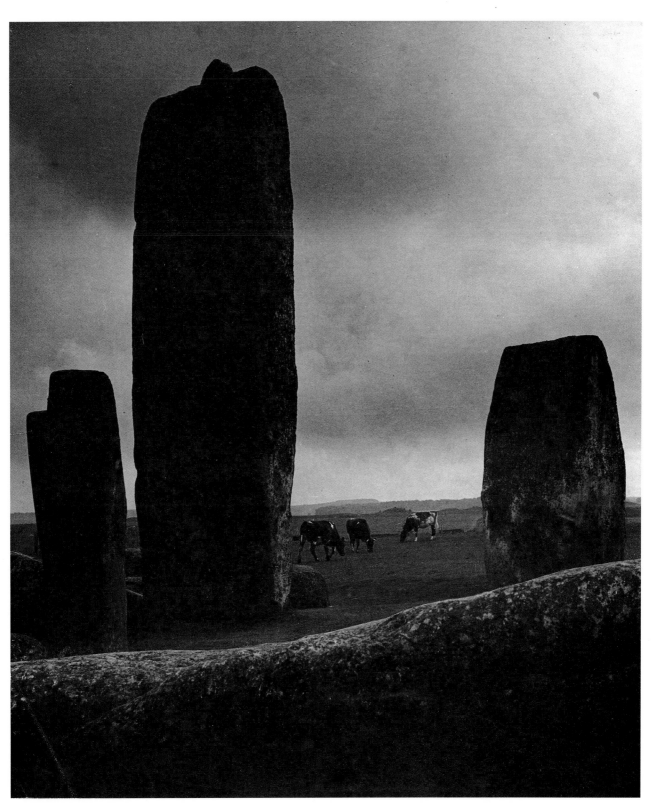

BILL BRANDT

STONEHENGE/*Gelatin silver print, 1940s*

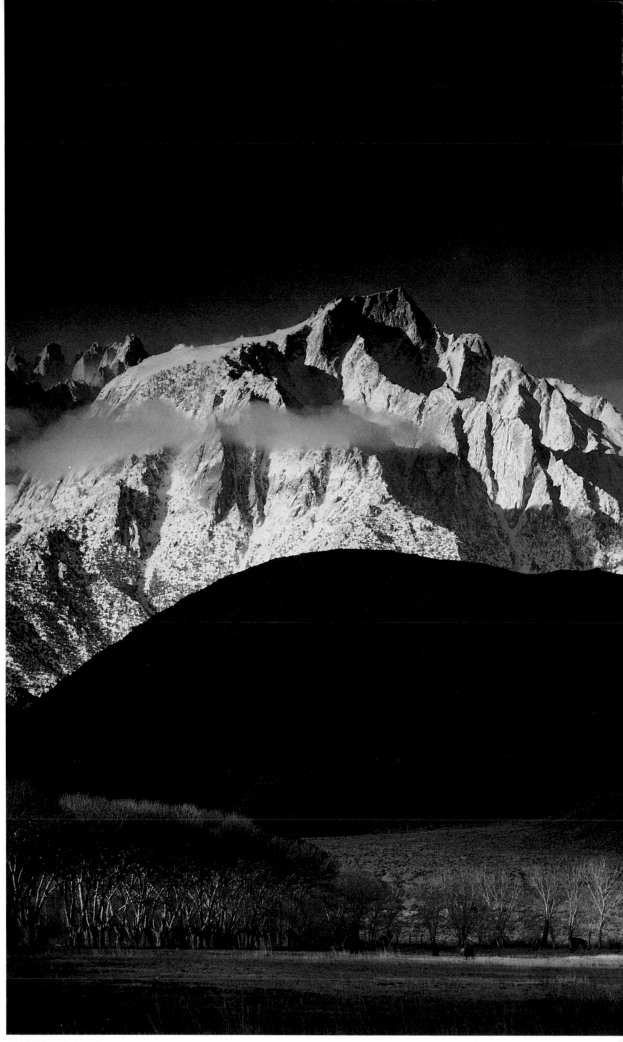

ANSEL ADAMS

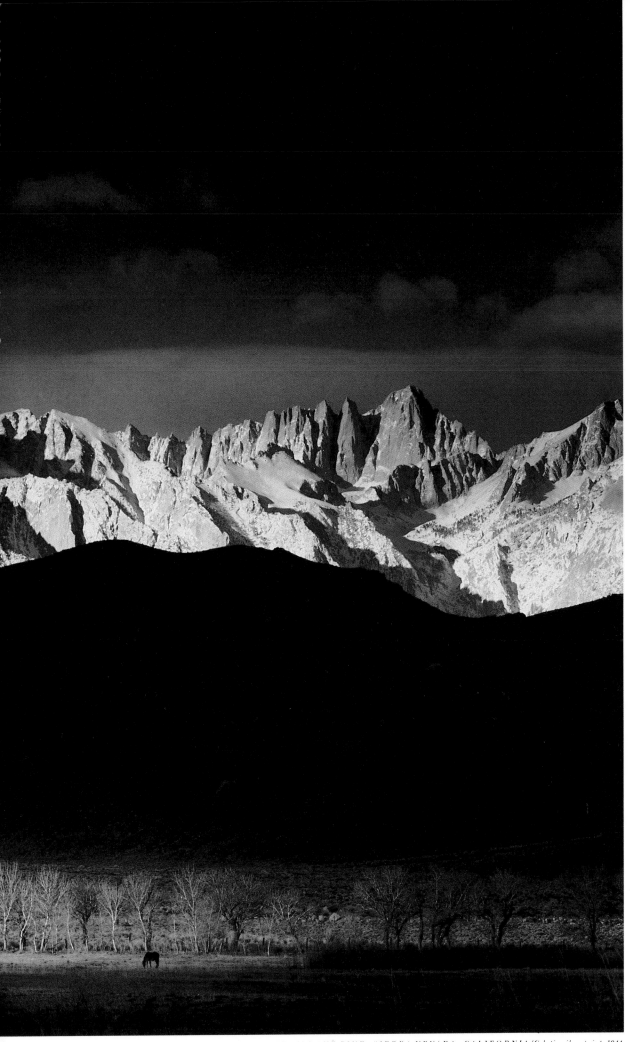

WINTER SUNRISE, FROM LONE PINE, SIERRA NEVADA, CALIFORNIA/*Gelatin silver print, 1944*

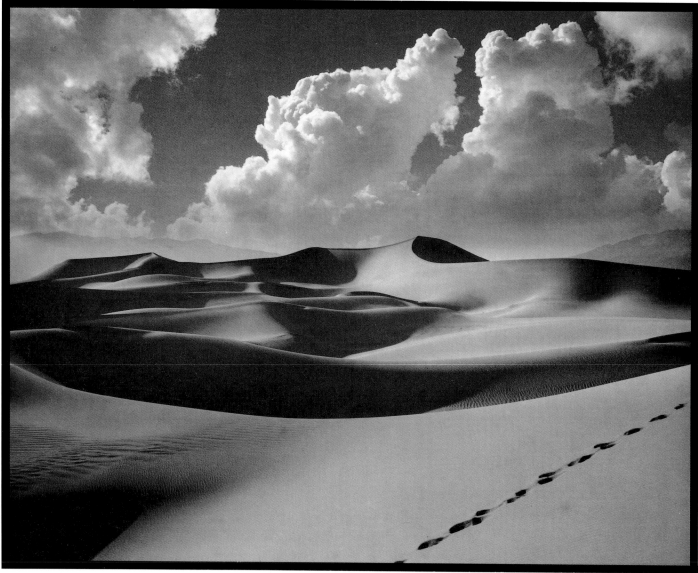

RAY ATKESON SAND DUNES, DEATH VALLEY NATIONAL MONUMENT, CALIFORNIA/*Gelatin silver print, 1940s*

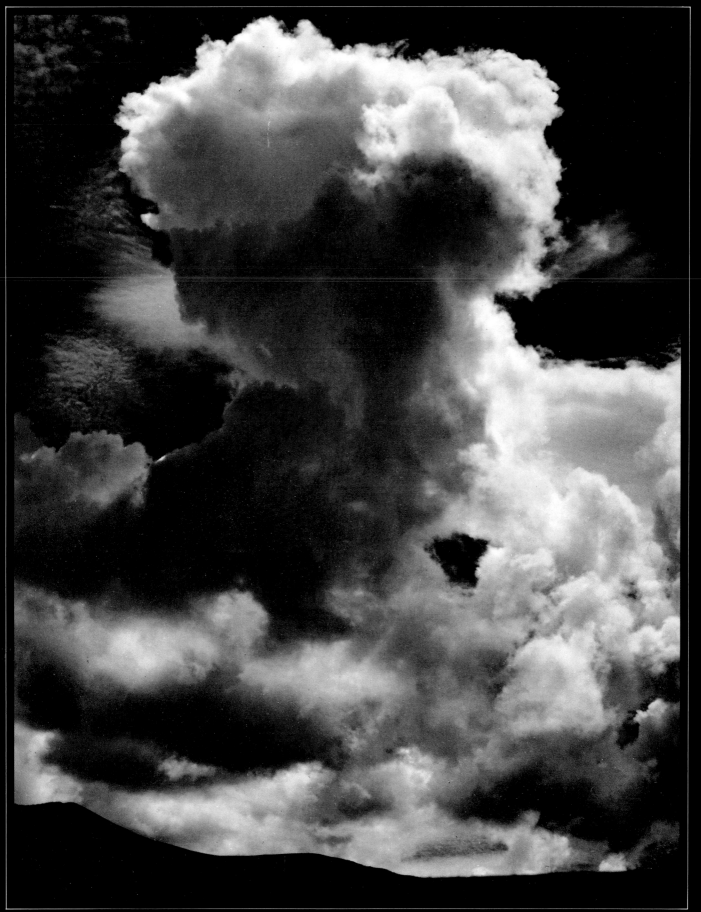

EDWARD WESTON

CLOUD/*Gelatin silver print, 1936*

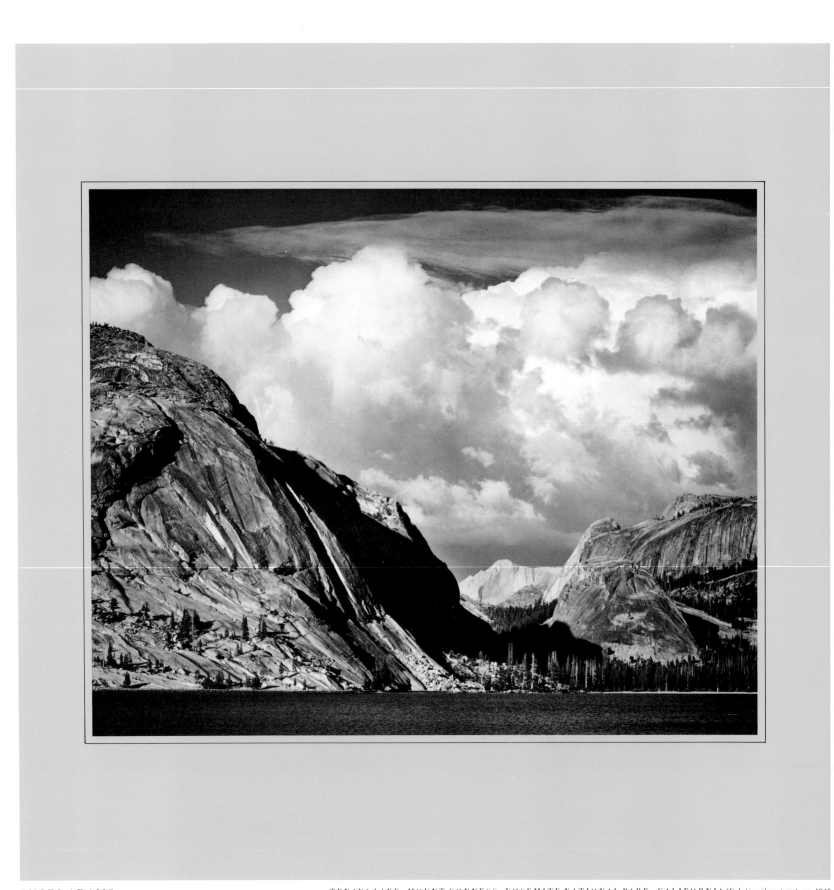

ANSEL ADAMS TENAYA LAKE, MOUNT CONNESS, YOSEMITE NATIONAL PARK, CALIFORNIA/*Gelatin silver print, ca. 1946*

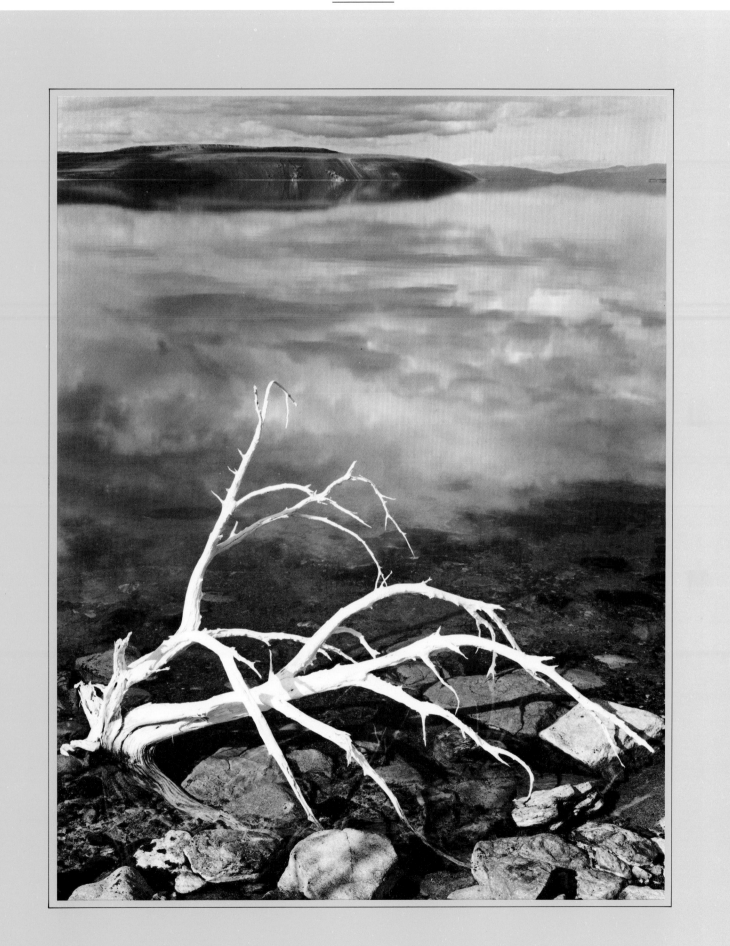

ANSEL ADAMS WHITE BRANCHES, MONO LAKE, CALIFORNIA/*Gelatin silver print, 1947*

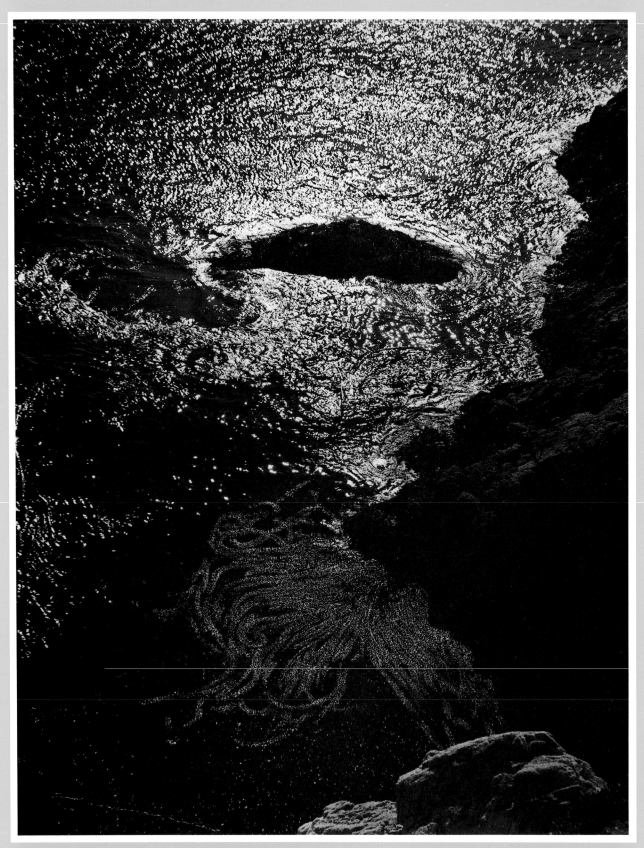

EDWARD WESTON CHINA COVE/*Gelatin silver print, 1940*

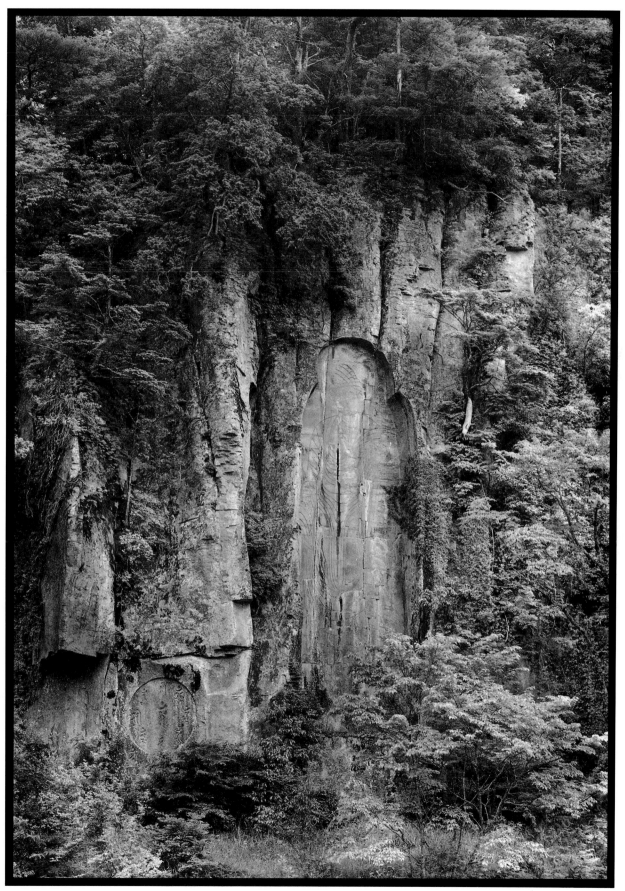

KEN DOMON BUDDHIST CARVING AT OHNO TEMPLE, NARA, JAPAN/*Gelatin silver print, 1941*

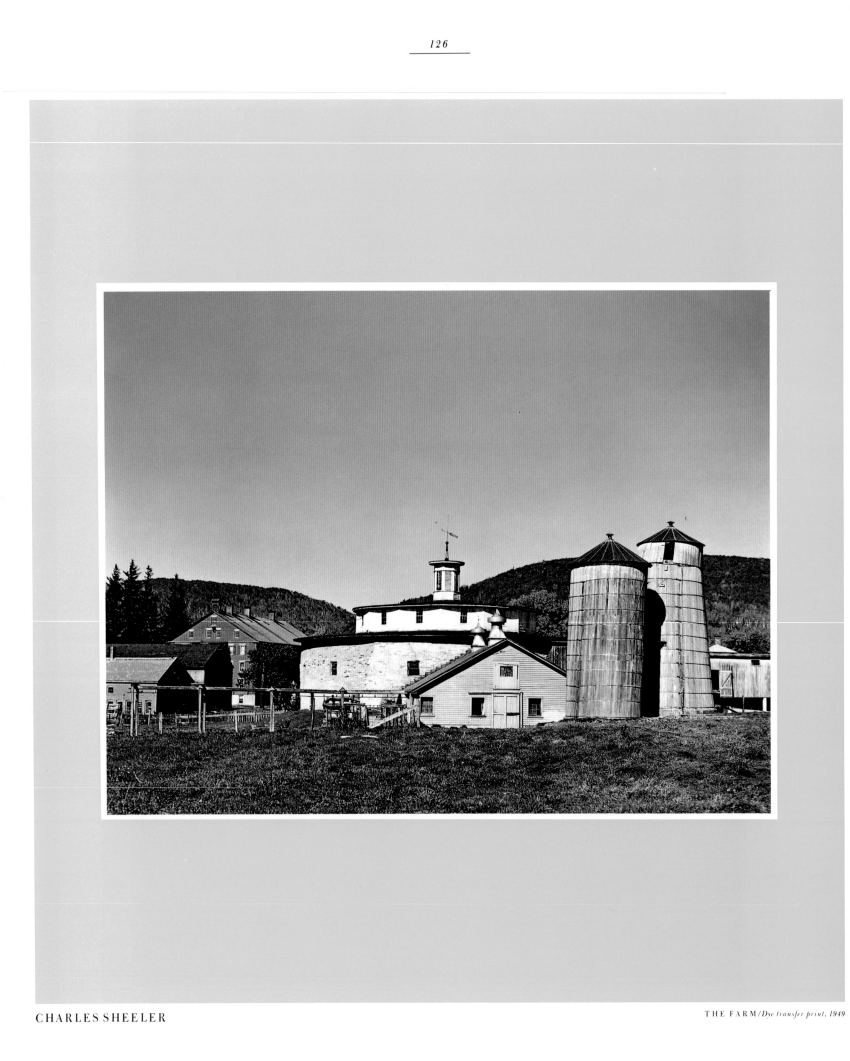

CHARLES SHEELER

THE FARM/*Dye transfer print, 1949*

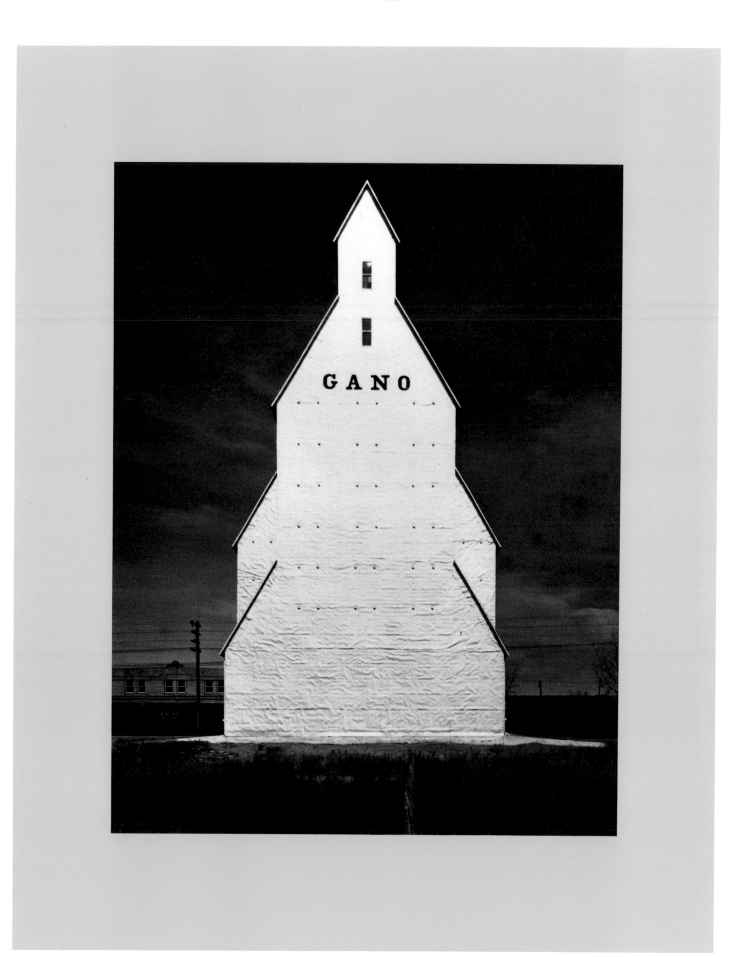

WRIGHT MORRIS GANO GRAIN ELEVATOR, WESTERN KANSAS/*Gelatin silver print. 1940*

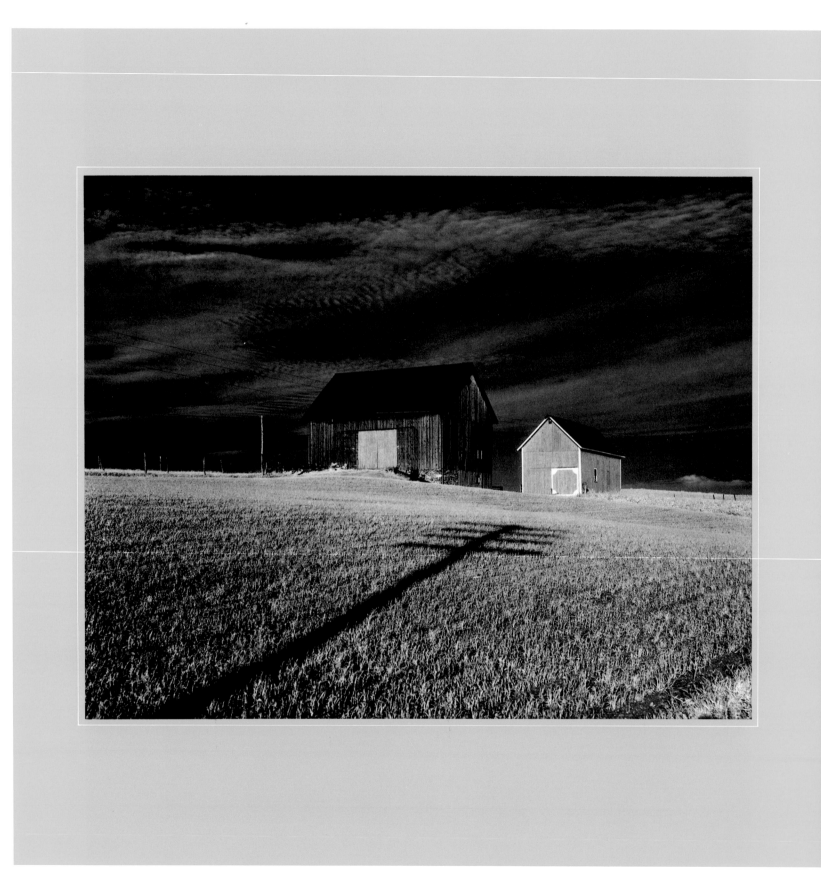

MINOR WHITE TWO BARNS AND SHADOW, DANSVILLE, NEW YORK/*Gelatin silver print. 1955*

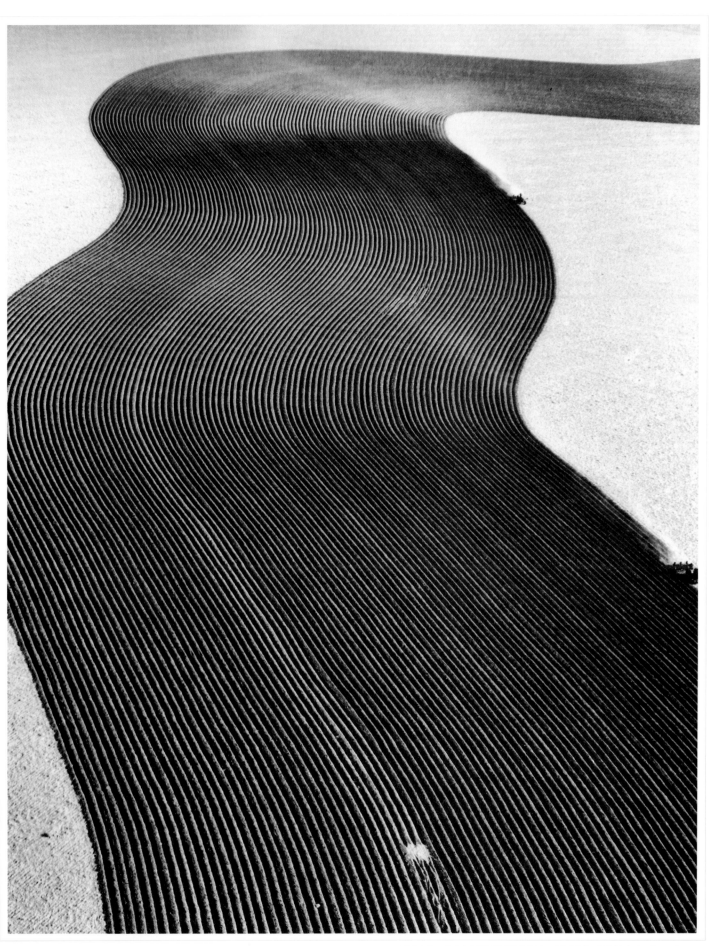

MARGARET BOURKE-WHITE FURROWS TO CONSERVE SOIL, COLORADO/*Gelatin silver print, 1954*

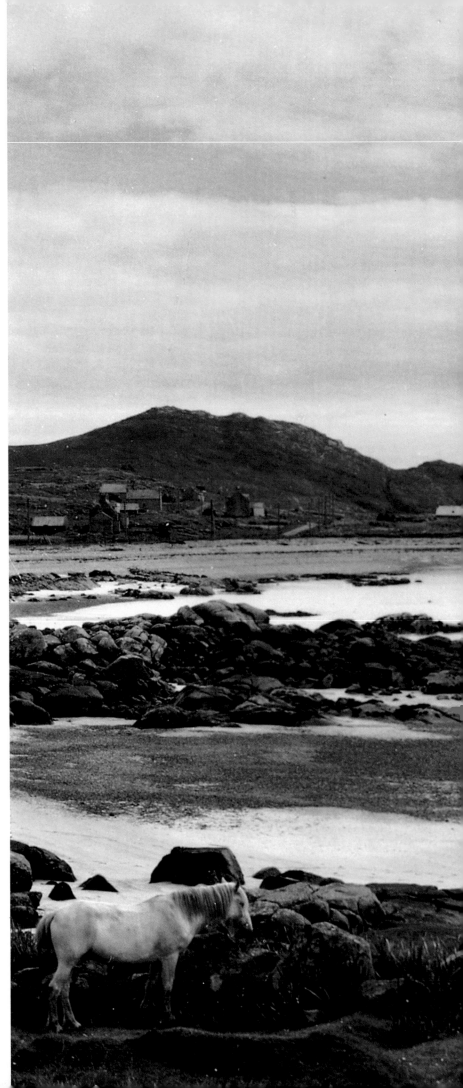

PAUL STRAND

TIR A'MHURAIN, SOUTH UIST, HEBRIDES, 1954/*Gelatin silver print, 1954*

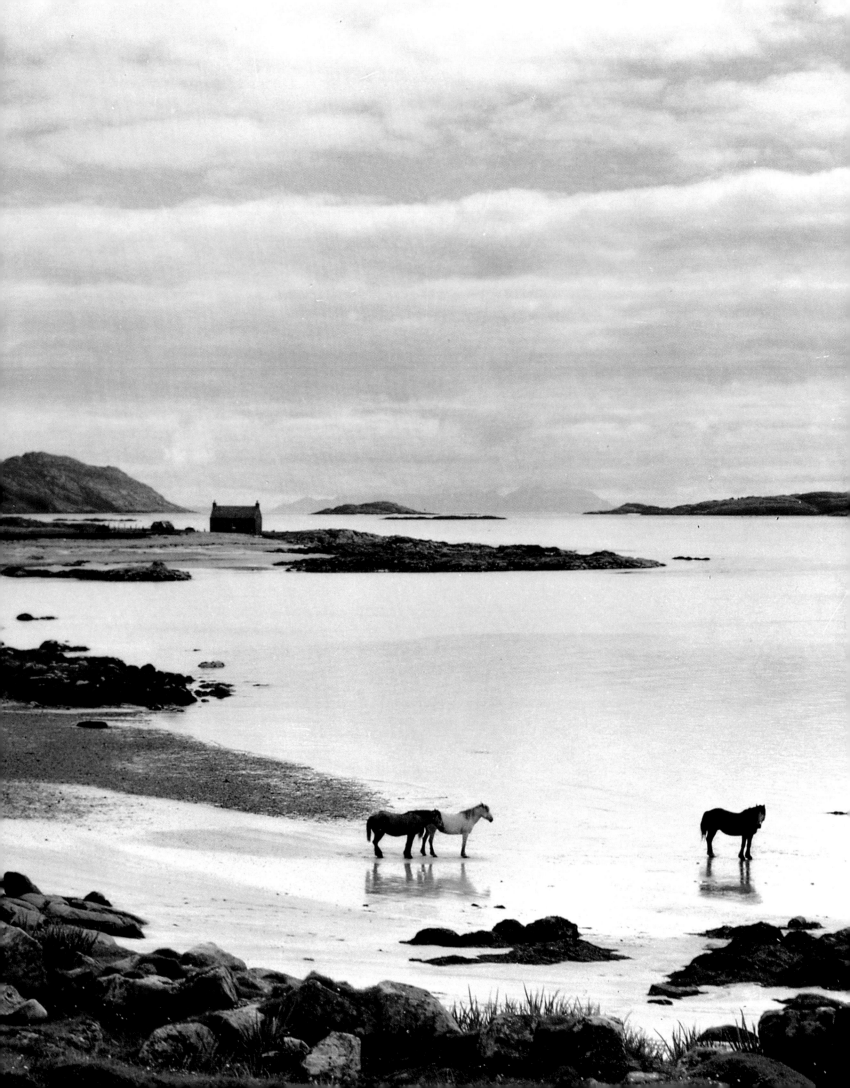

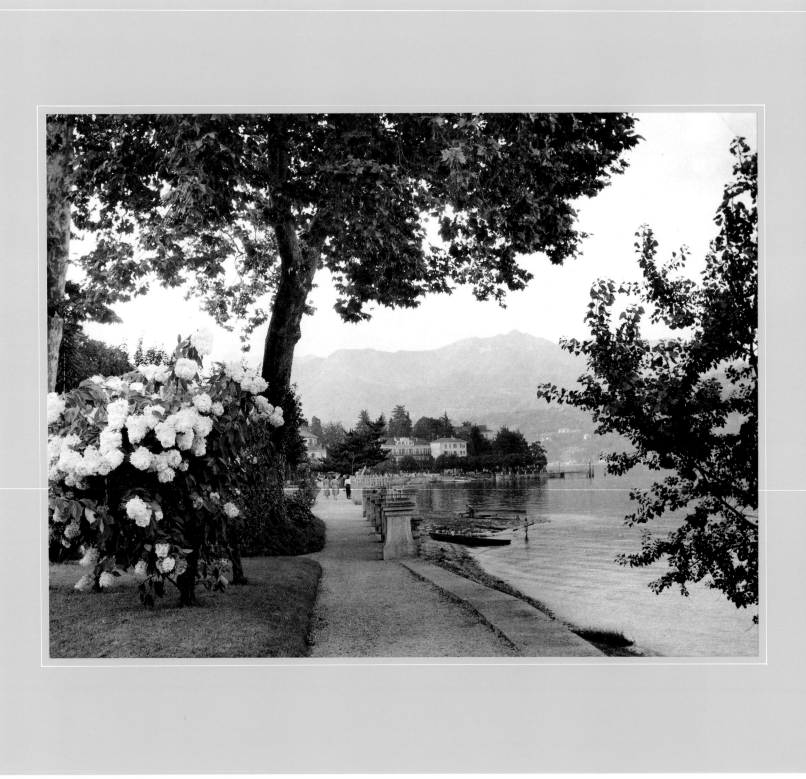

IVAN DMITRI

STRESA, LAKE MAGGIORE, ITALY/*Gelatin silver print, 1950*

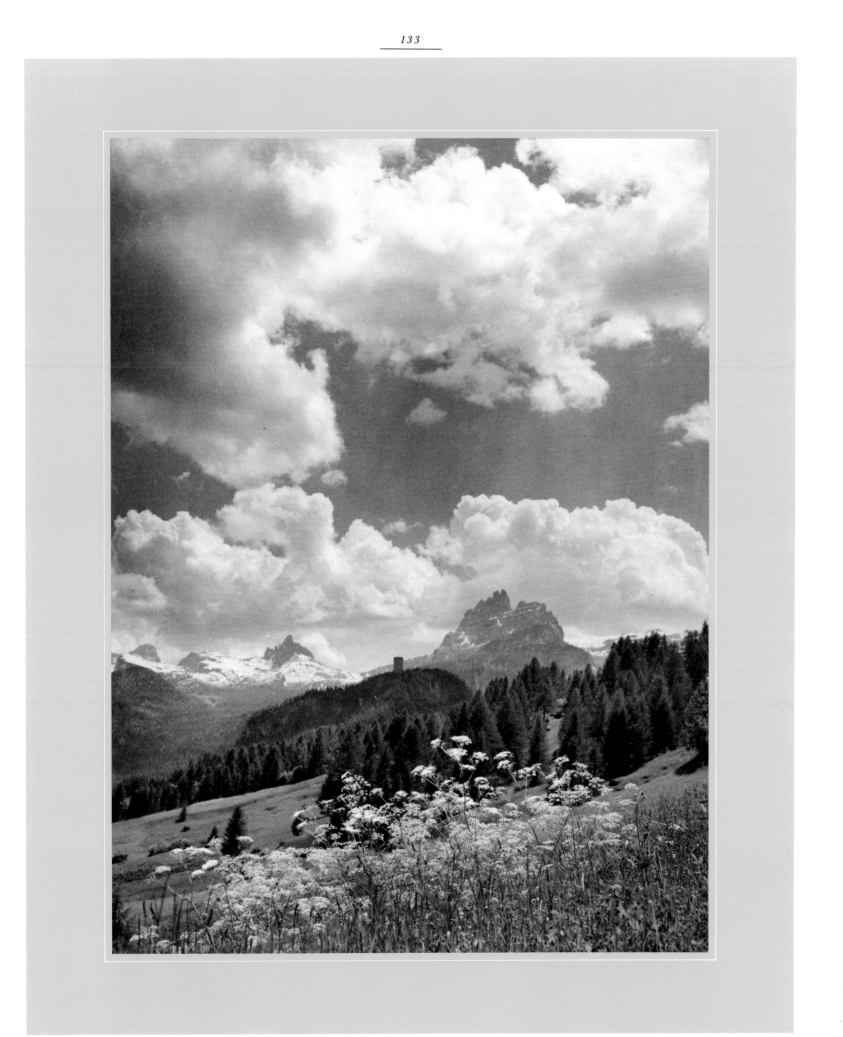

T.Y. CROWELL

SUMMER IN THE DOLOMITES (ITALY)/*Gelatin silver print, 1950s*

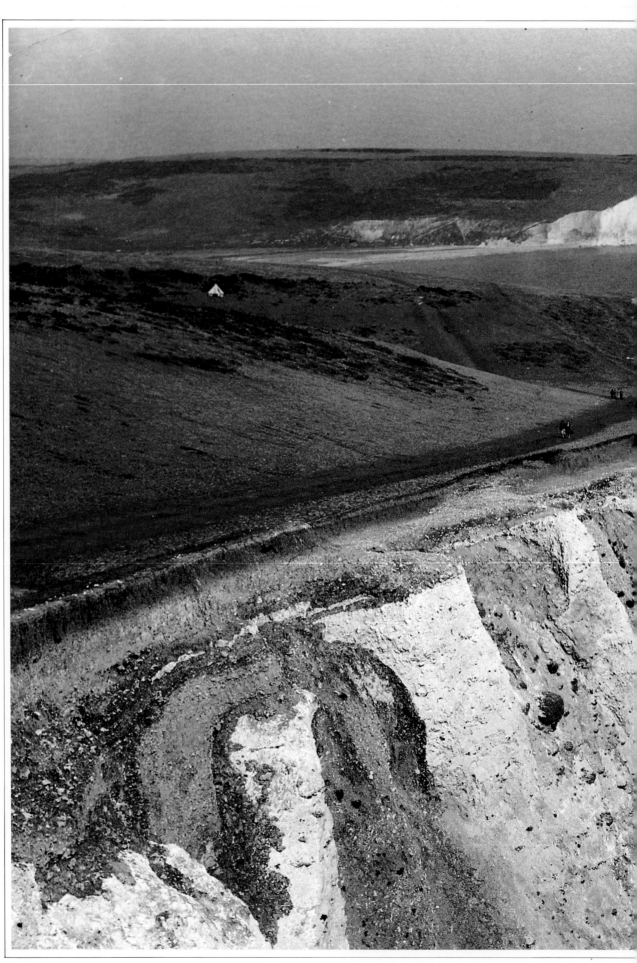

J. DIXON-SCOTT

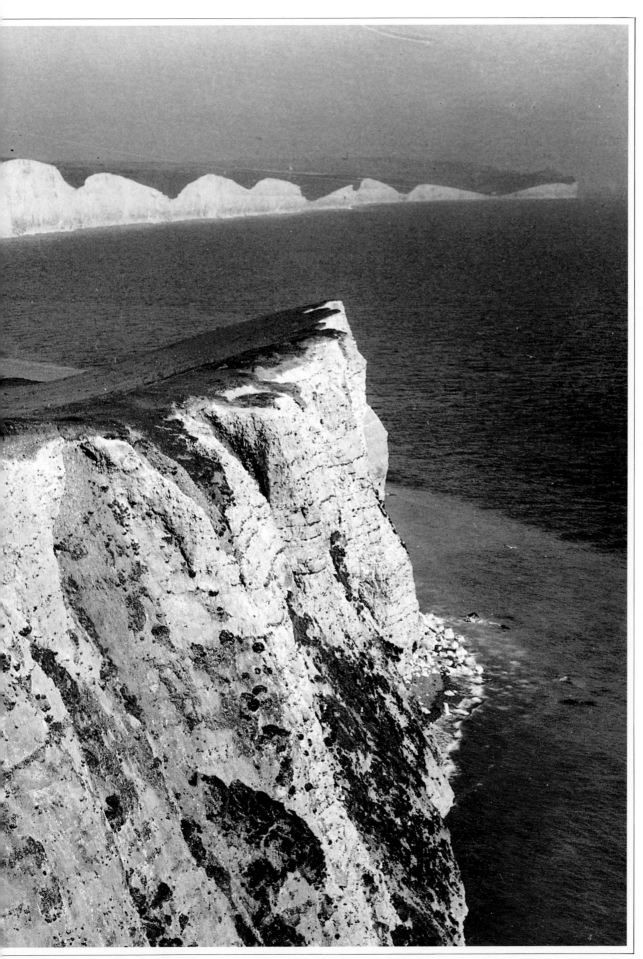

THE 'SEVEN SISTERS', SUSSEX, ENGLAND / *Gelatin silver print, 1950s*

PAUL STRAND L'ARMENÇON, CUZY, YONNE, BURGUNDY, FRANCE, 1951/*Gelatin silver print, 1951*

TREES ALONG A FRENCH CANAL / *Dye transfer print, 1951*

IRVING PENN

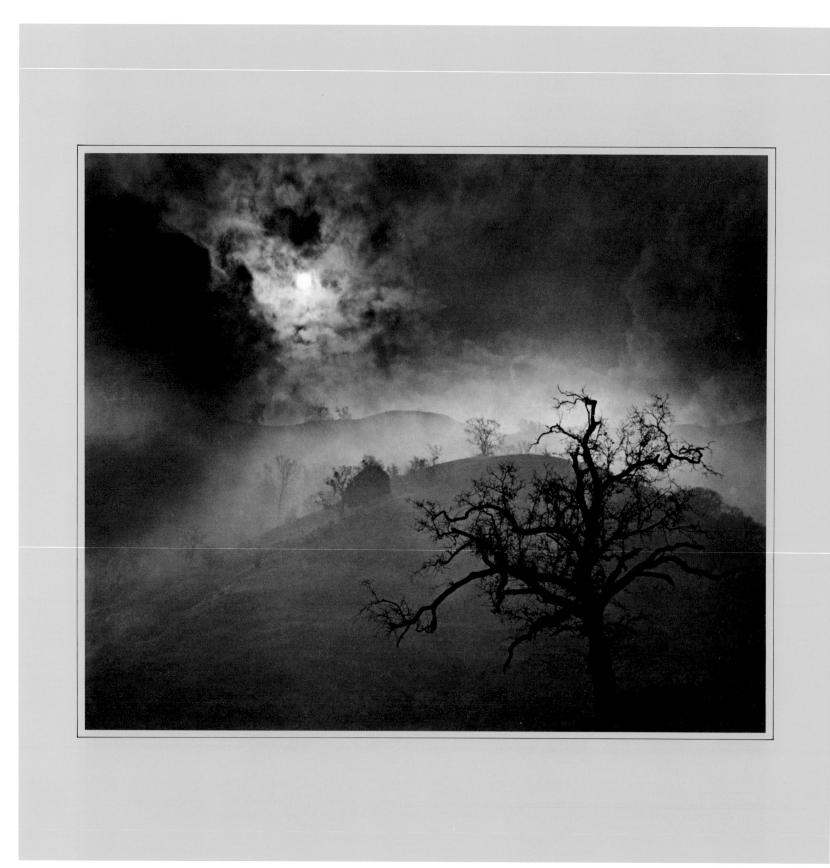

WYNN BULLOCK

STARK TREE/*Gelatin silver print, 1956*

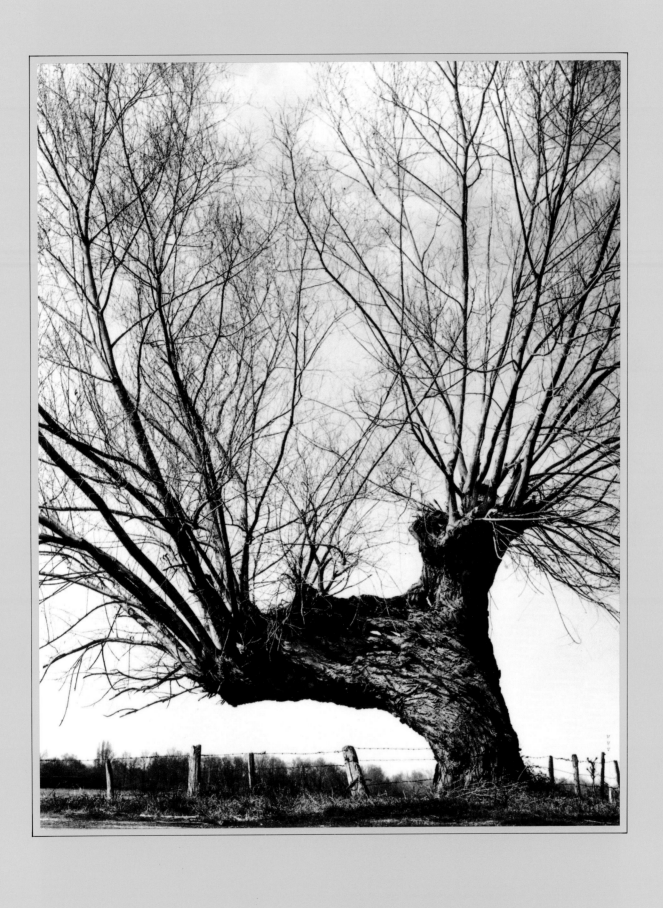

ANDREAS FEININGER

EUROPEAN WILLOW/*Gelatin silver print, ca. 1959*

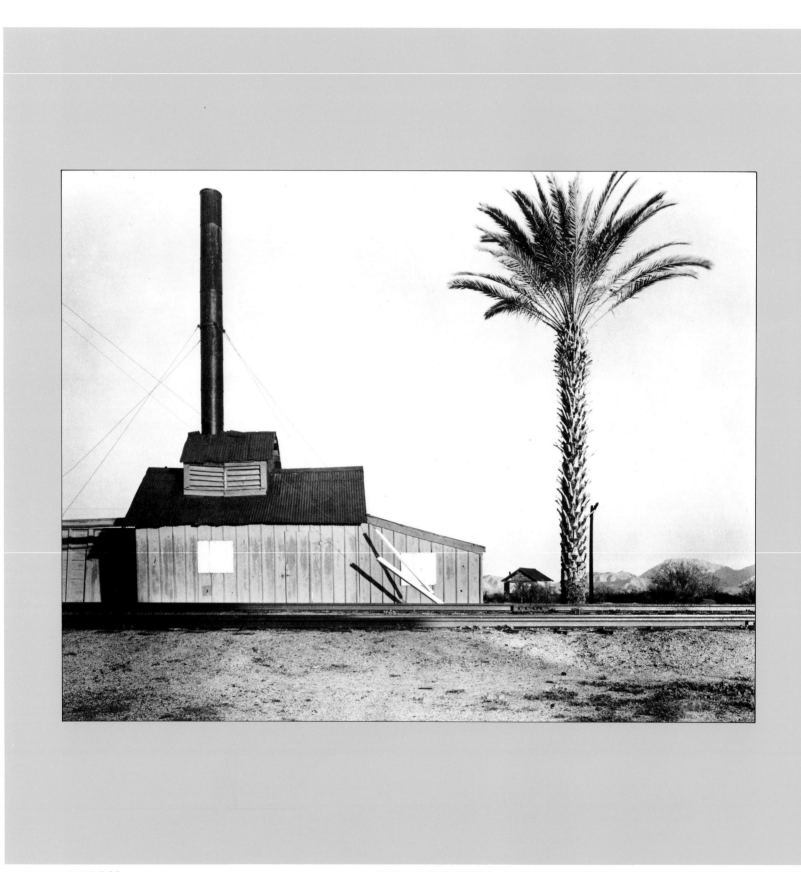

WRIGHT MORRIS

POWER HOUSE AND PALM TREE, NEAR LORDSBURG, NEW MEXICO/*Gelatin silver print, 19*

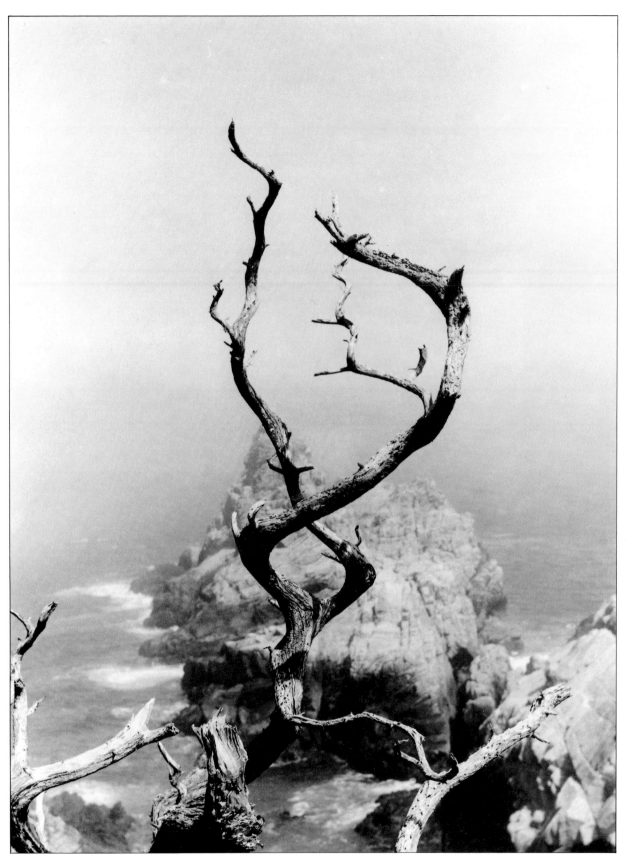

MINOR WHITE TWISTED TREE, POINT LOBOS, CALIFORNIA/*Gelatin silver print, 1951*

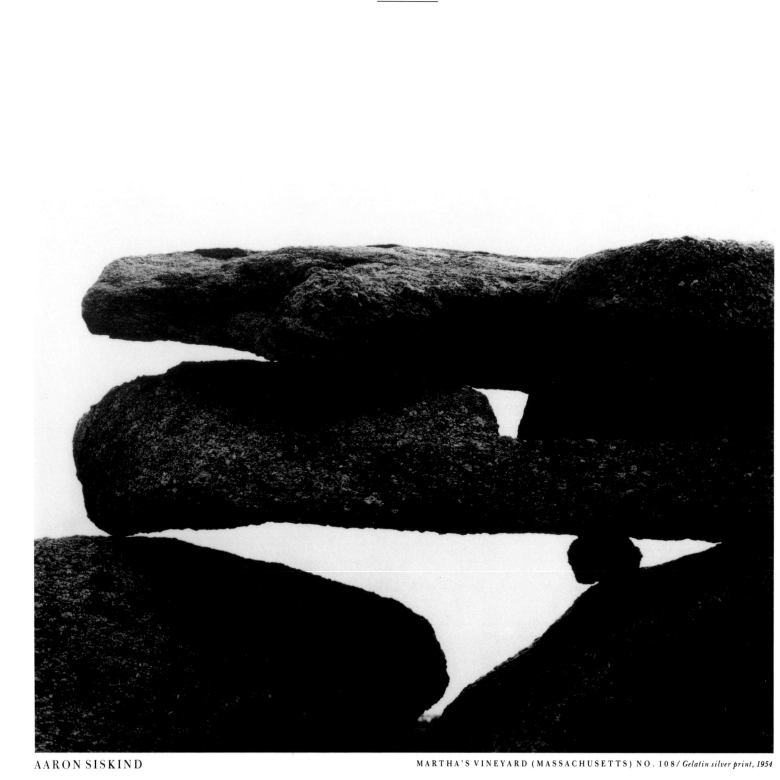

AARON SISKIND MARTHA'S VINEYARD (MASSACHUSETTS) NO. 108/ *Gelatin silver print, 1954*

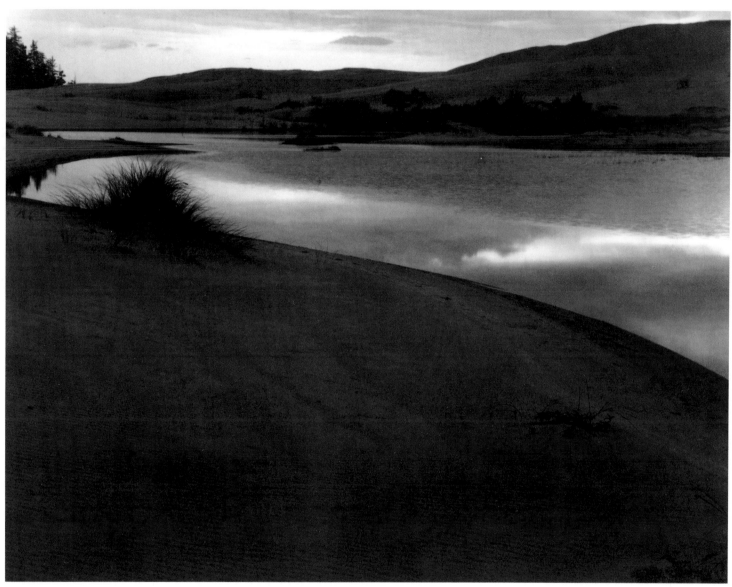

JACK WELPOTT OREGON COAST/*Gelatin silver print, 1955*

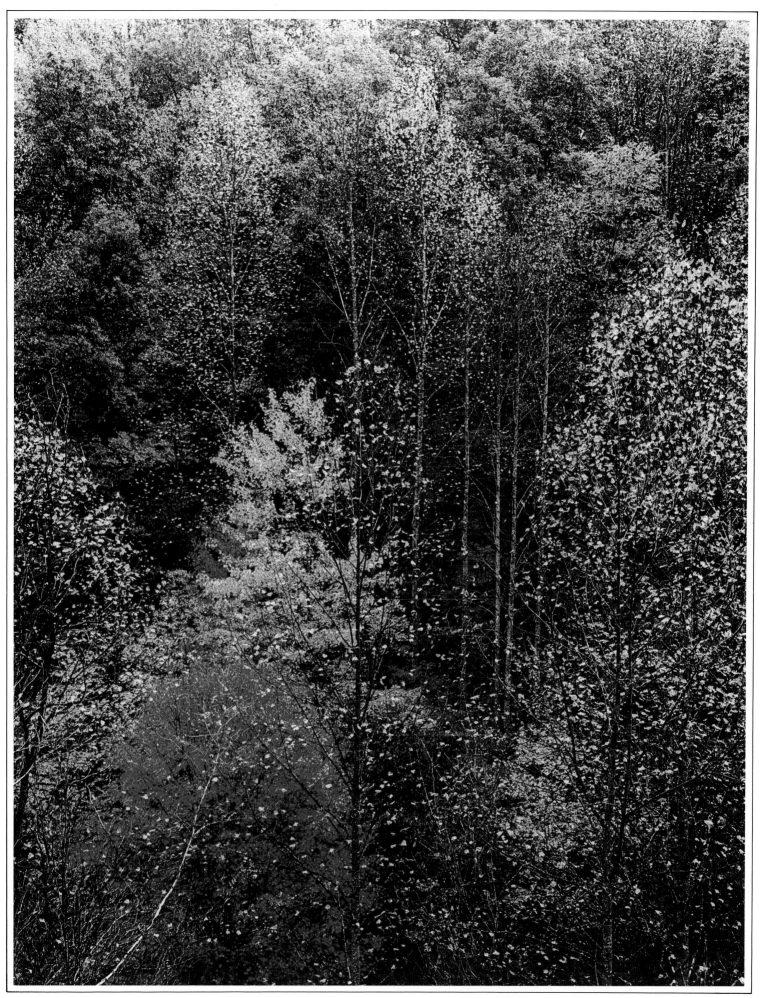

ELIOT PORTER COLOURFUL TREES, GREAT SMOKY MOUNTAINS PARK, TENNESSEE/ *Dye transfer print, 1967*

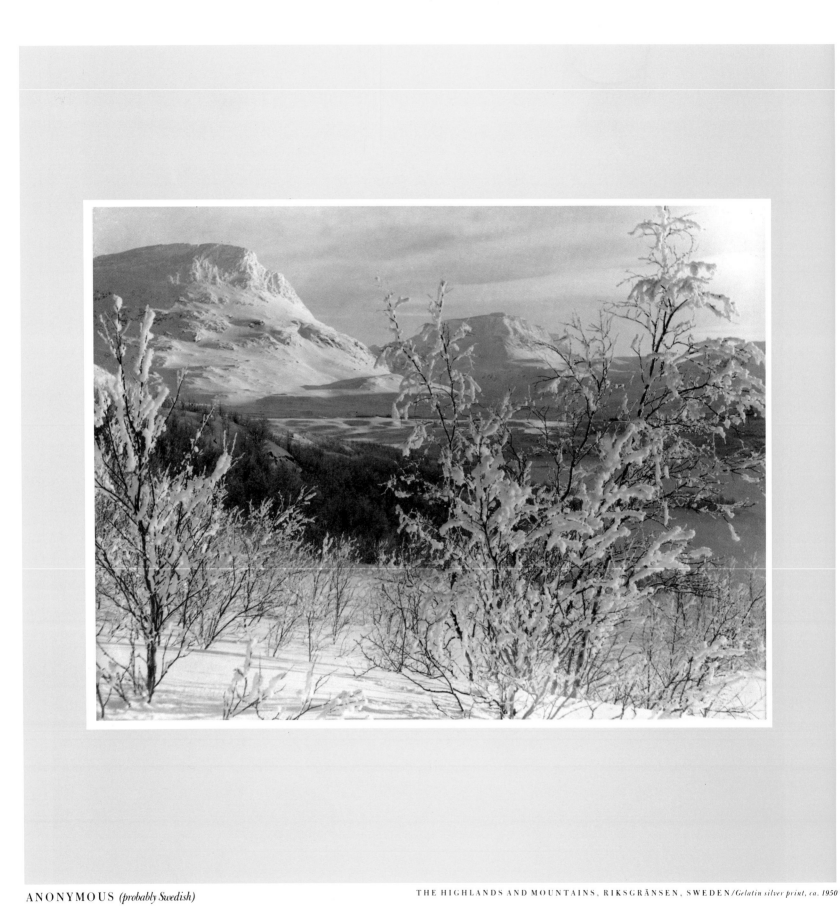

ANONYMOUS *(probably Swedish)* THE HIGHLANDS AND MOUNTAINS, RIKSGRÄNSEN, SWEDEN/*Gelatin silver print, ca. 1950*

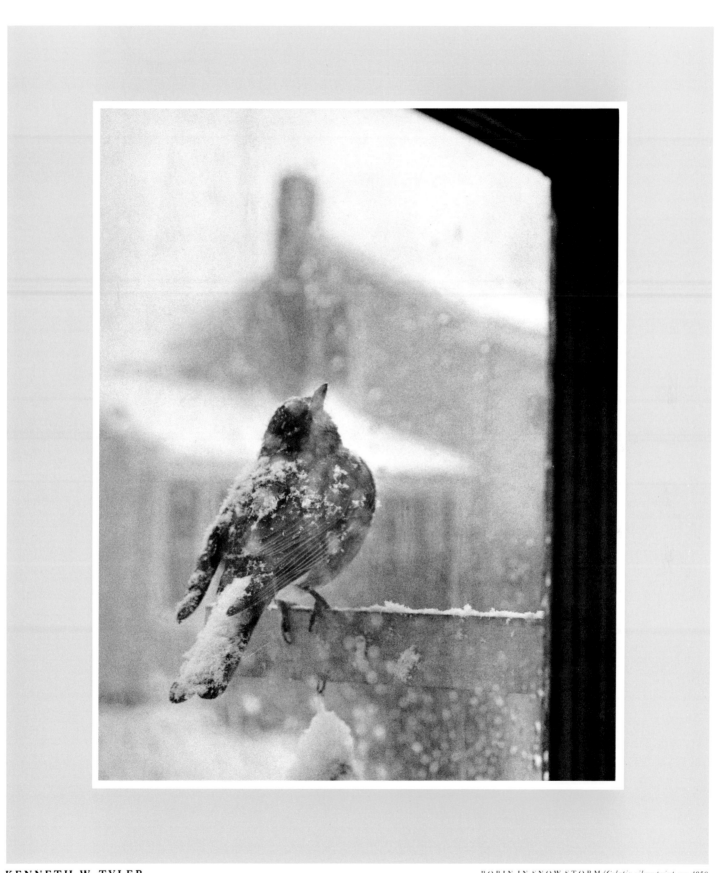

KENNETH W. TYLER

ROBIN IN SNOW STORM/*Gelatin silver print, ca. 1958*

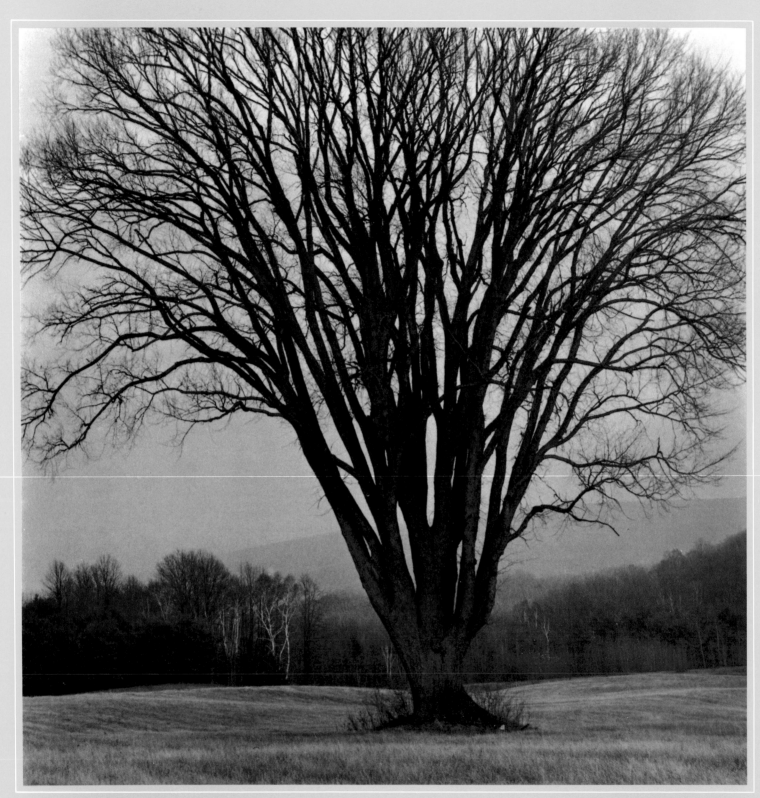

RALPH STEINER

UNTITLED/*Gelatin silver print, ca. 1960*

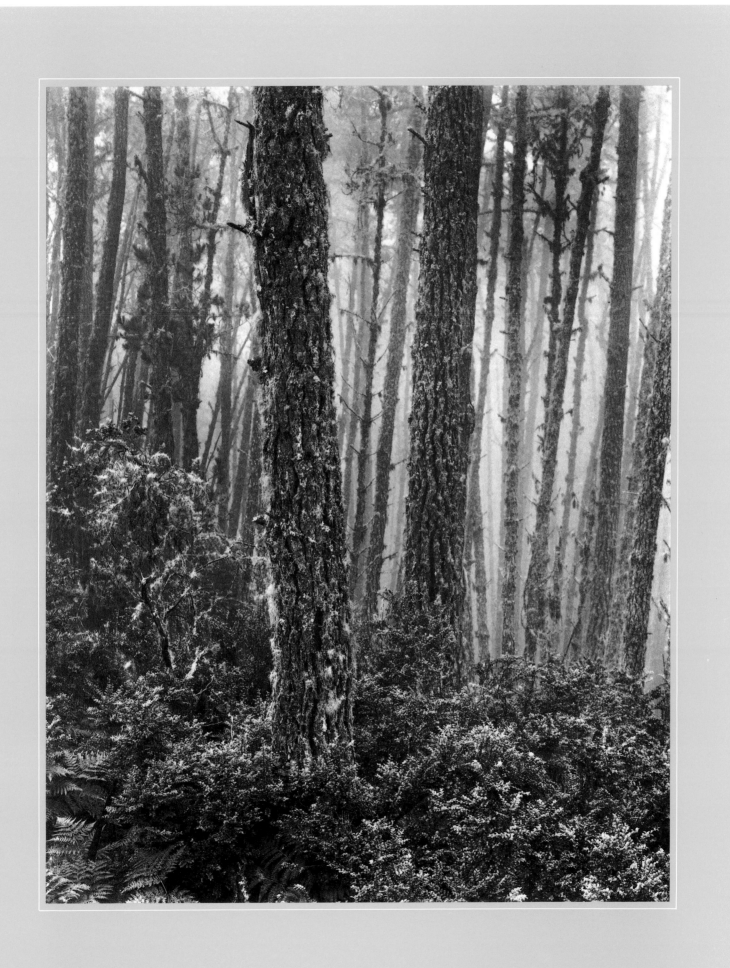

WYNN BULLOCK

DEL MONTE FOREST (CALIFORNIA)/*Gelatin silver print, 1956*

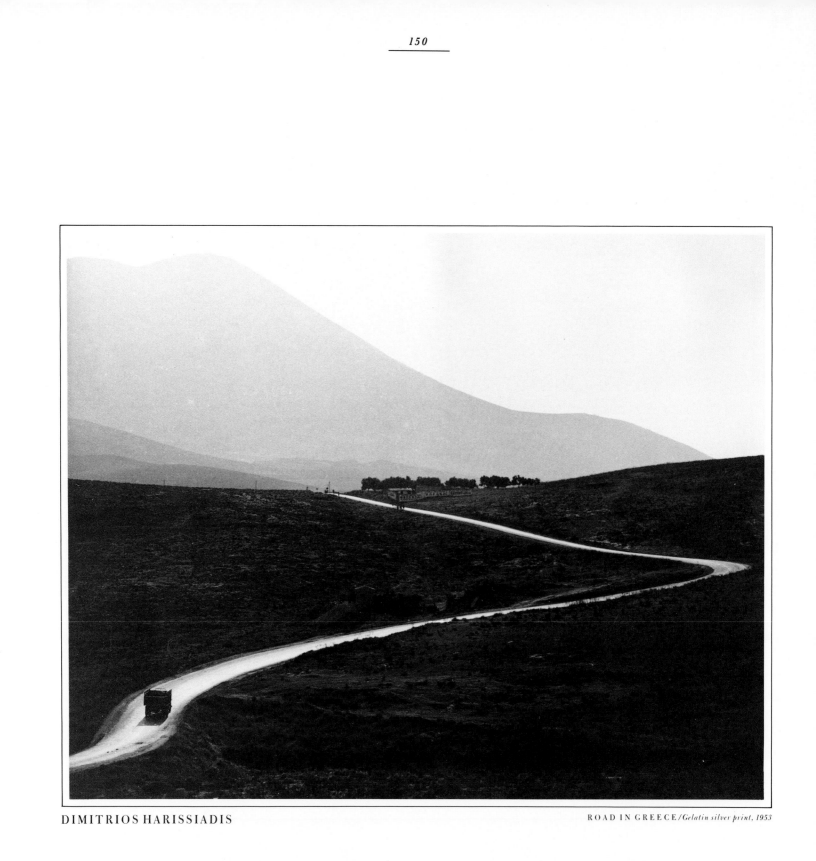

DIMITRIOS HARISSIADIS

ROAD IN GREECE/*Gelatin silver print, 1953*

WILLIAM A. GARNETT

SAND DUNE WITH SAGEBRUSH, DEATH VALLEY, CALIFORNIA/*Gelatin silver print, 1954*

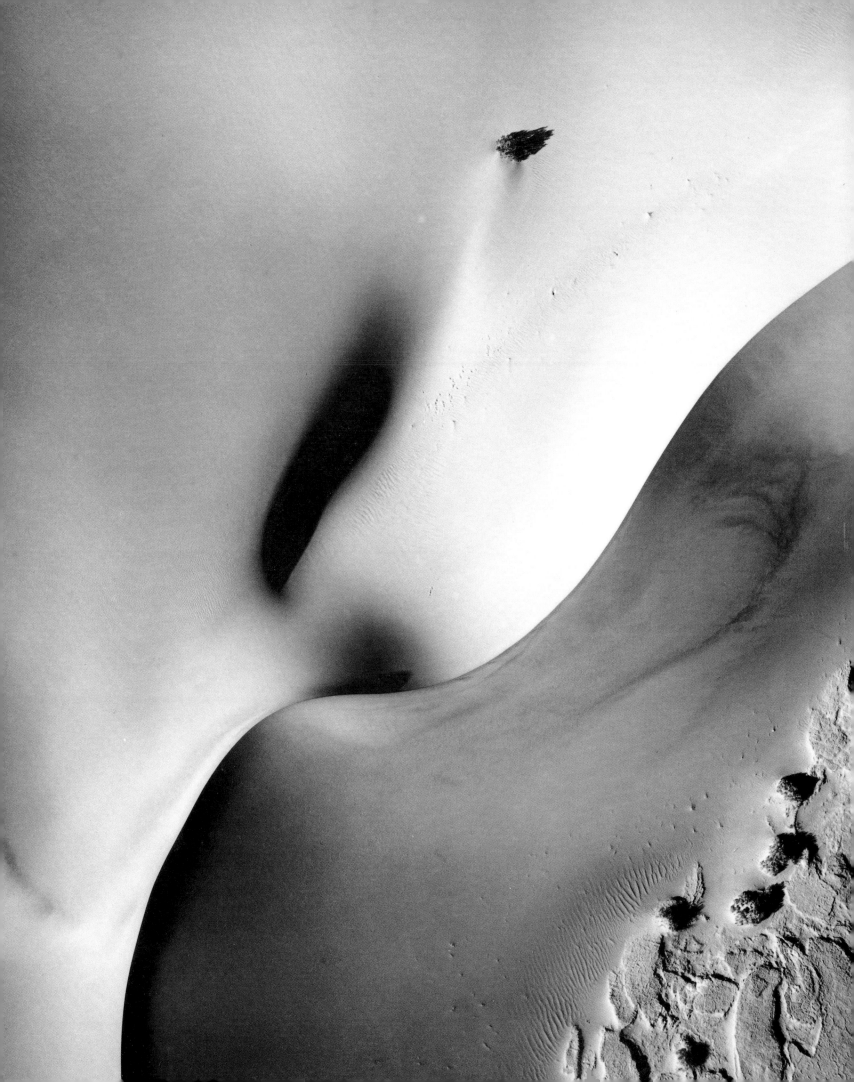

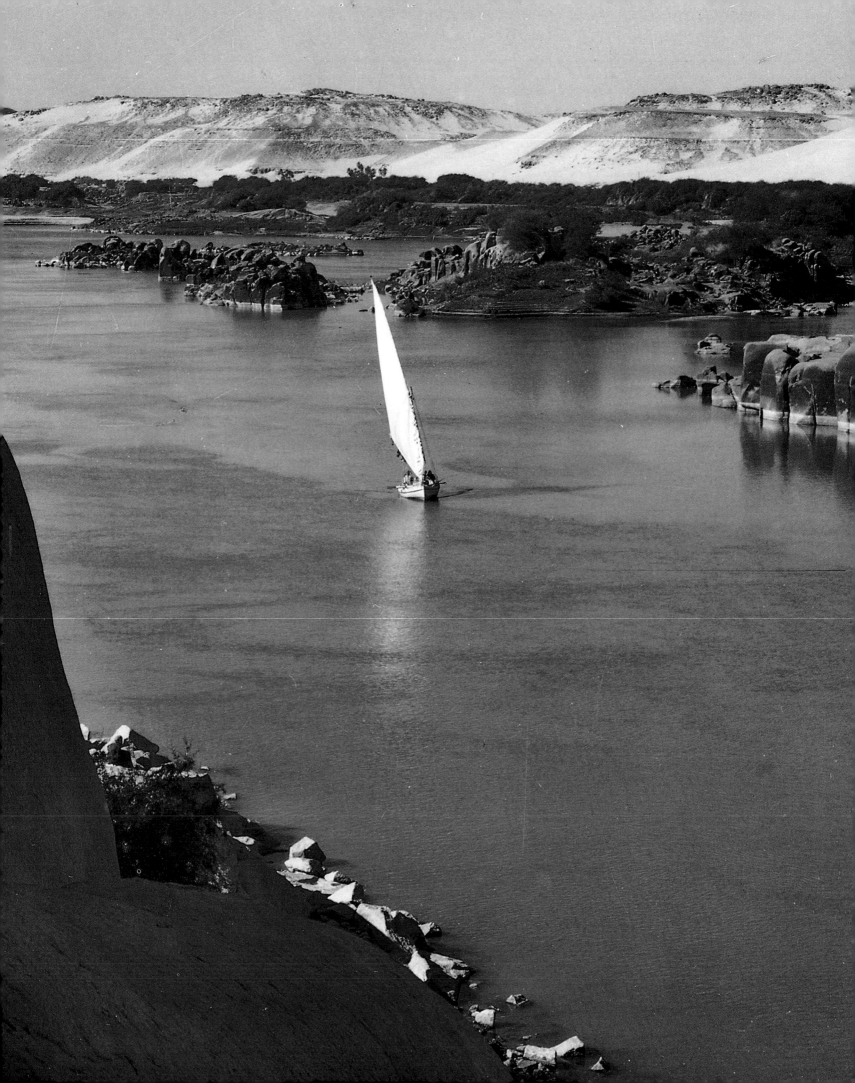

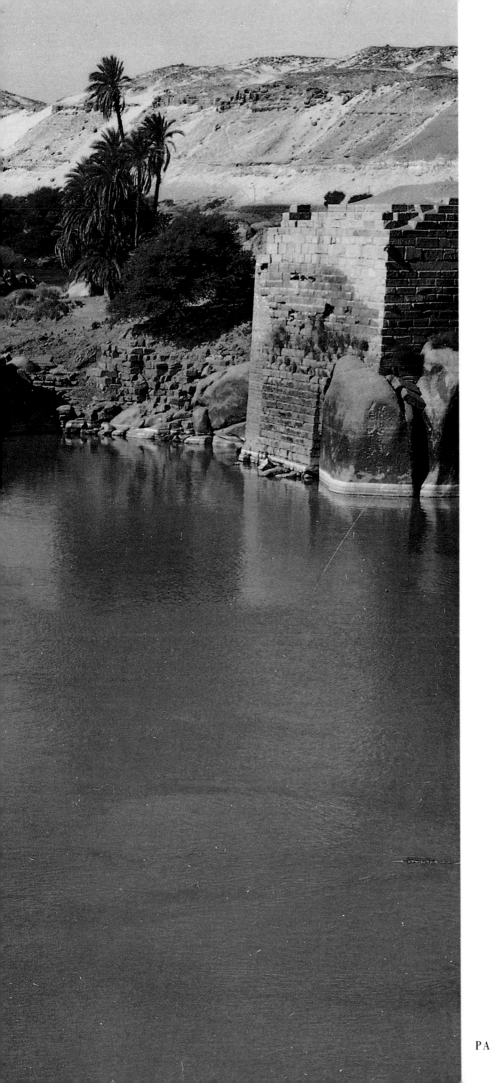

PAUL STRAND THE NILE AT ASWAN, EGYPT / *Gelatin silver print, 1959*

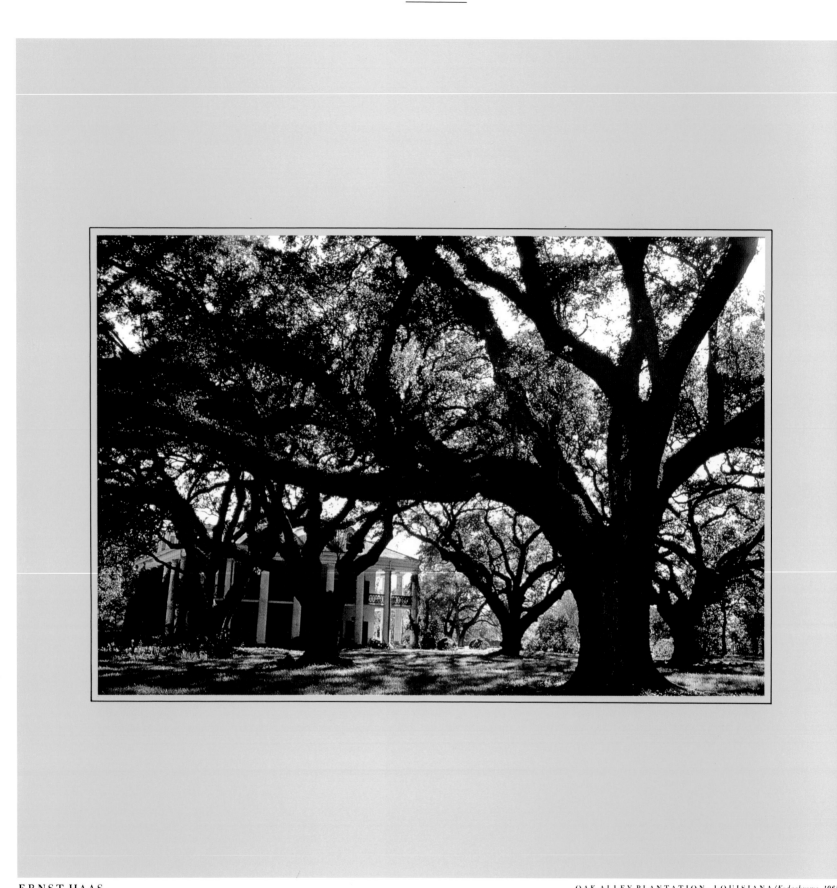

ERNST HAAS

OAK ALLEY PLANTATION, LOUISIANA/*Kodachrome, 1961*

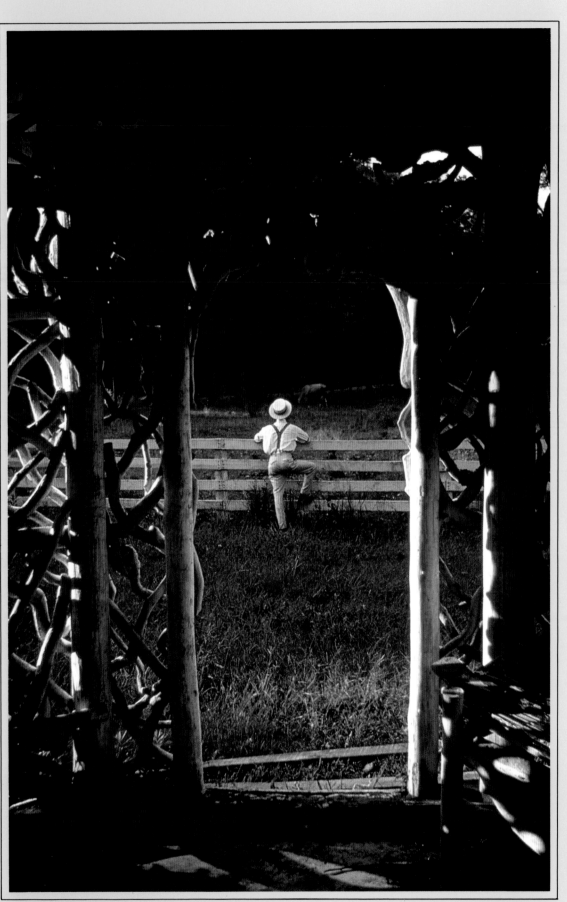

ERNST HAAS KNOXVILLE, TENNESSEE/*Kodachrome, 1962*

ERNST HAAS

ASPEN, COLORADO/*Kodachrome, 1980*

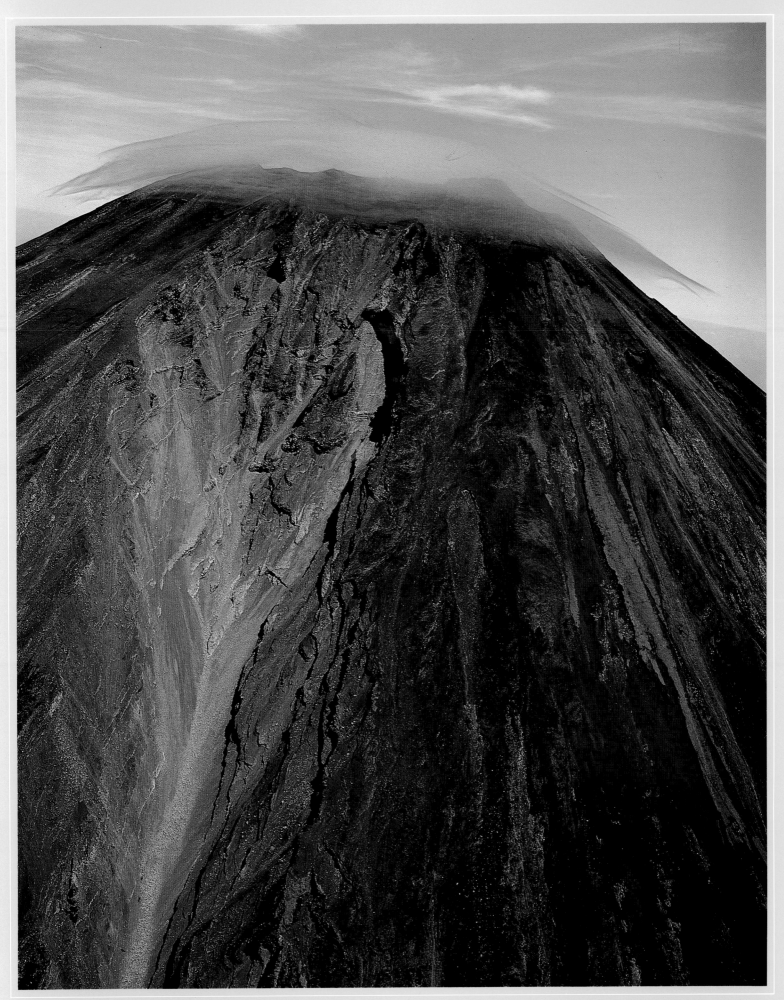

HIROSHI HAMAYA

ASH SLIDES RADIATING FROM THE SUMMIT
OF MOUNT FUJI (JAPAN)/*Dye transfer print, 1961*

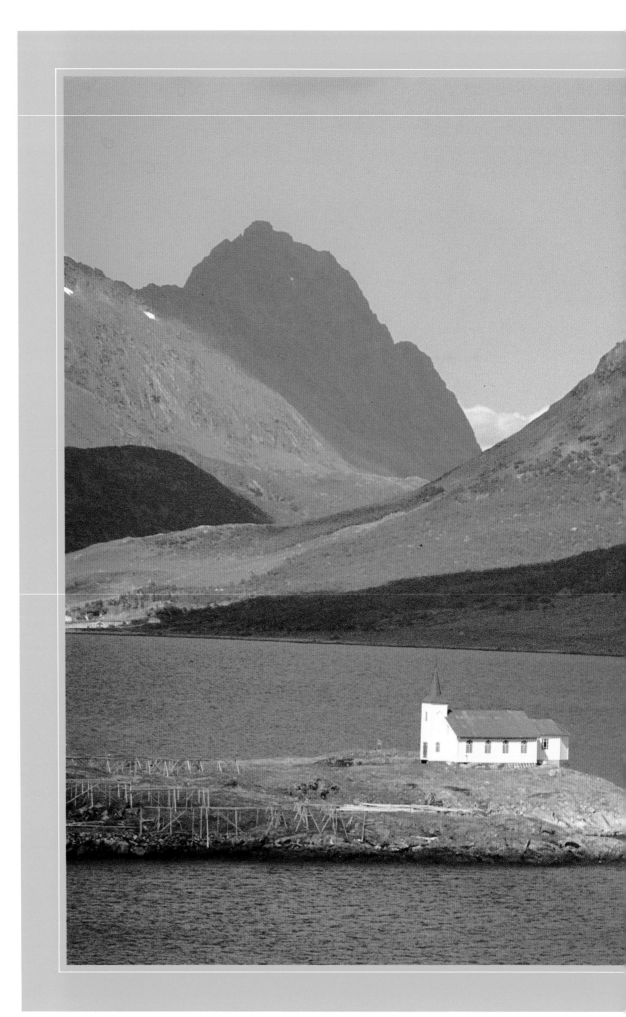

ALFRED EISENSTAEDT

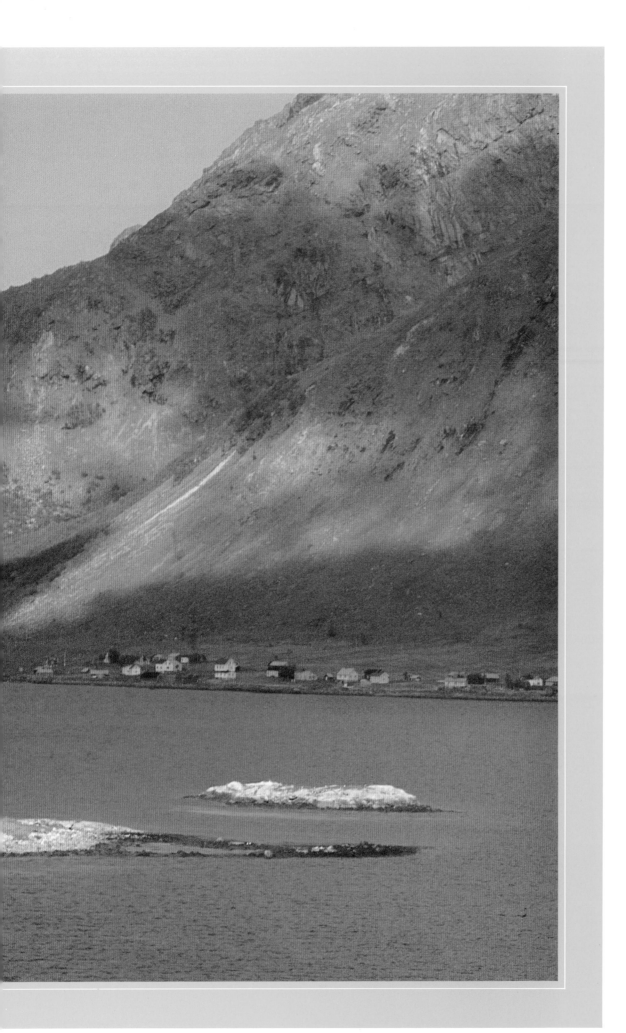

LOFOTEN ISLAND, NORWAY/*Kodachrome, 1966*

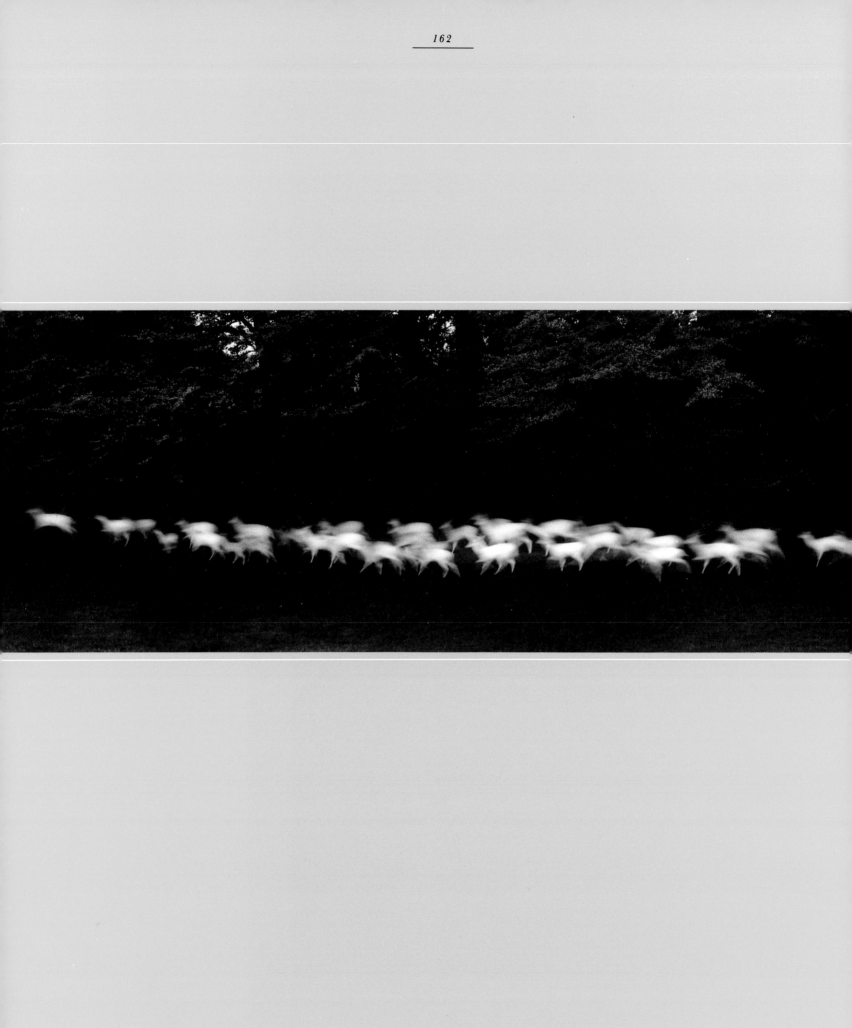

PAUL CAPONIGRO RUNNING WHITE DEER, COUNTY WICKLOW, IRELAND / *Gelatin silver print, 1970s, from negative, 1967*

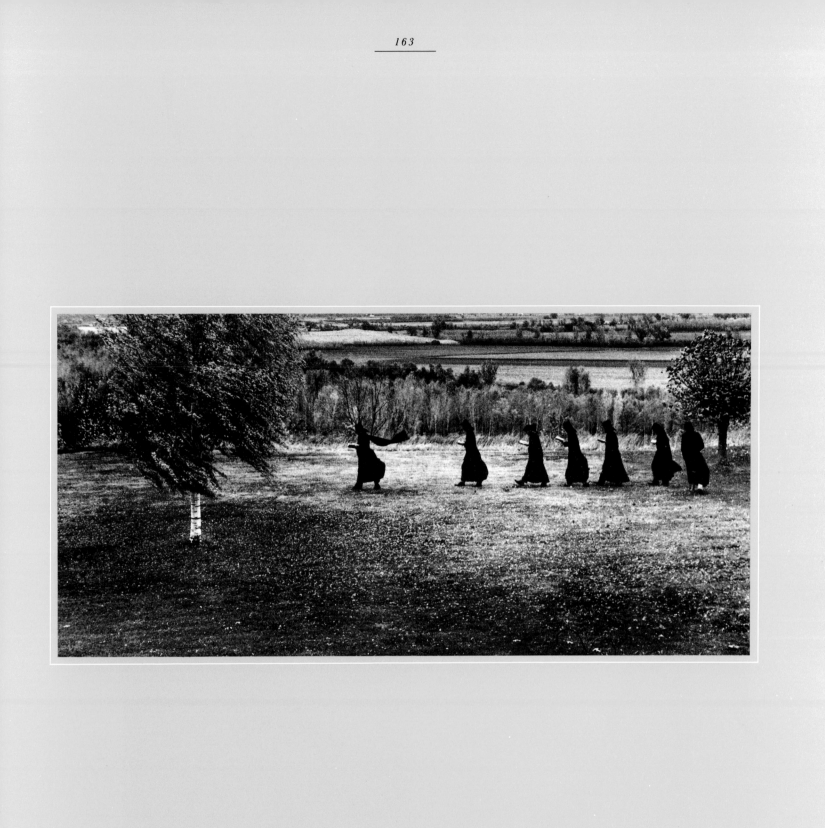

GORDON PARKS **BENEDICTINE MONKS RECITING PRAYERS IN MONASTERY, ATCHENSON, KANSAS**/ *Gelatin silver print, 1955*

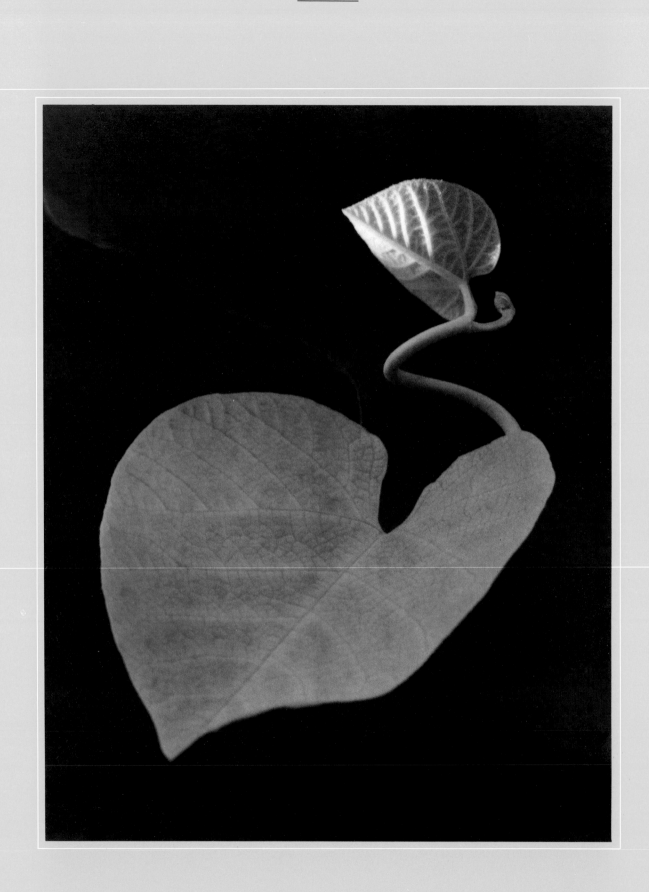

PAUL CAPONIGRO

BREWSTER, NEW YORK/*Gelatin silver print, 1963*

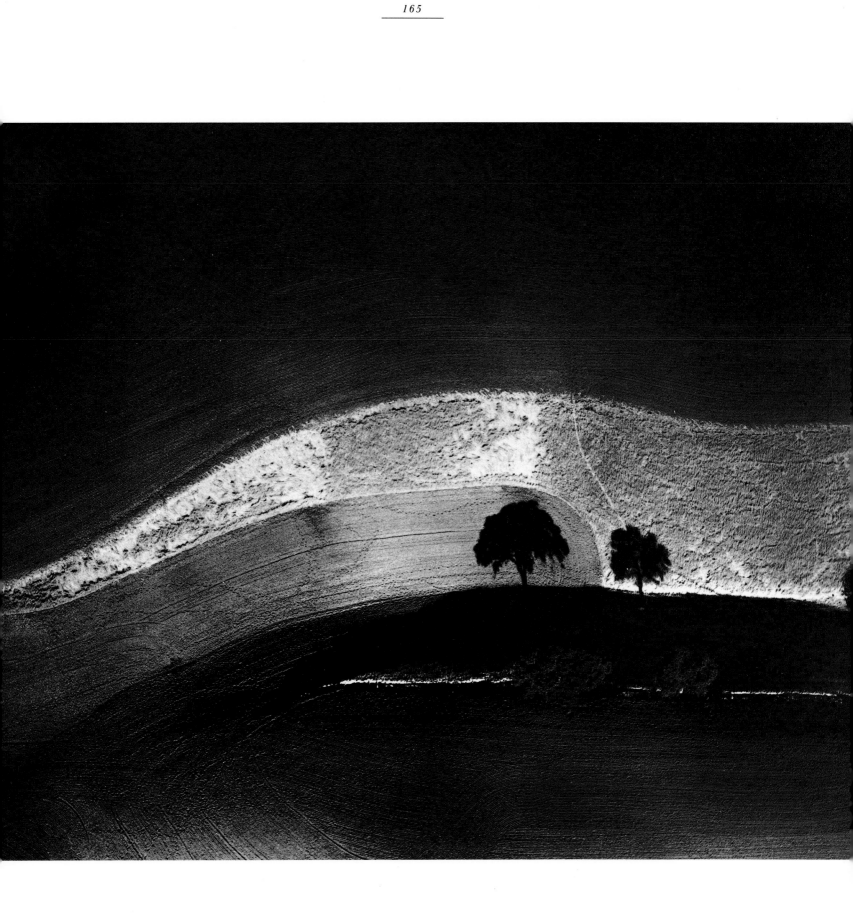

WILLIAM A. GARNETT TWO TREES ON HILL WITH SHADOWS, PASO ROBLES, CALIFORNIA/ *Gelatin silver print, 1975*

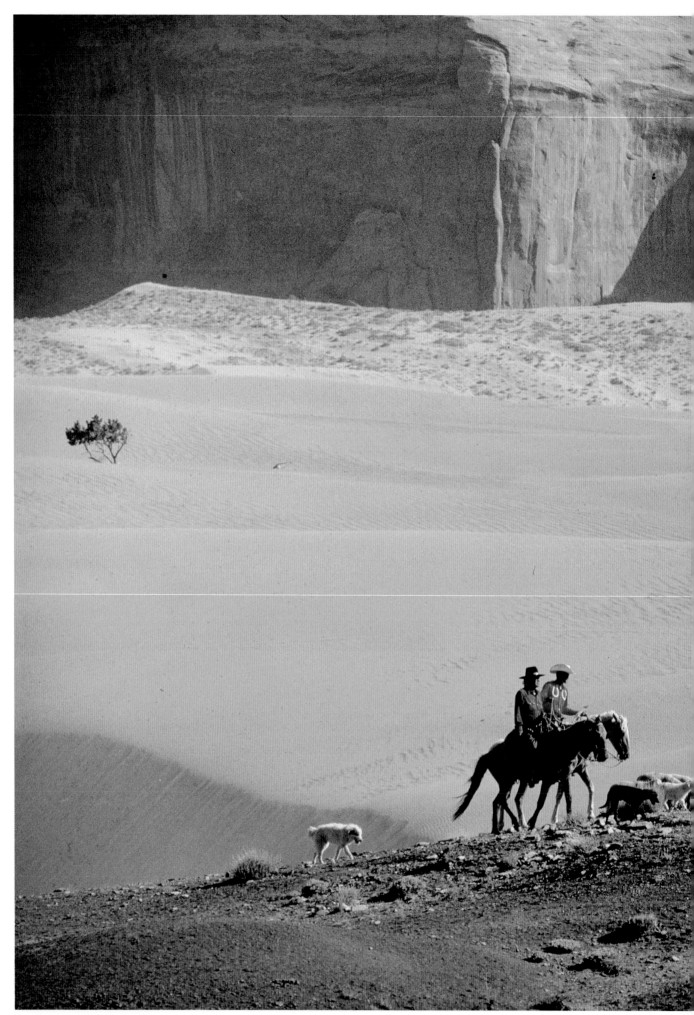

JOHN LEWIS STAGE

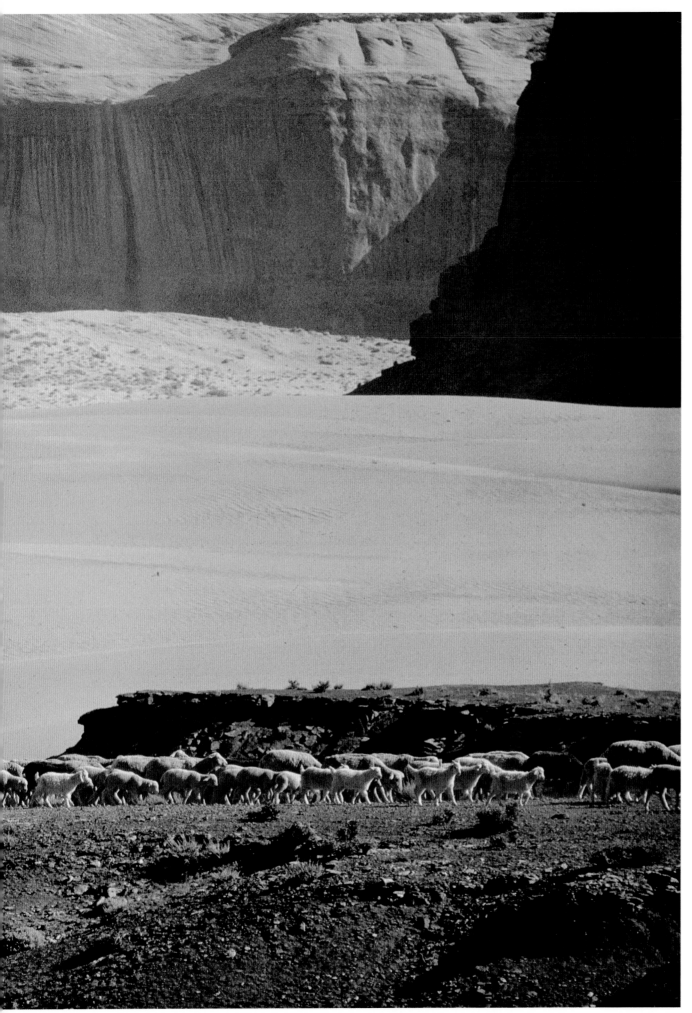

SHEEPHERDERS IN MONUMENT VALLEY, UTAH/ *Kodachrome, 1970*

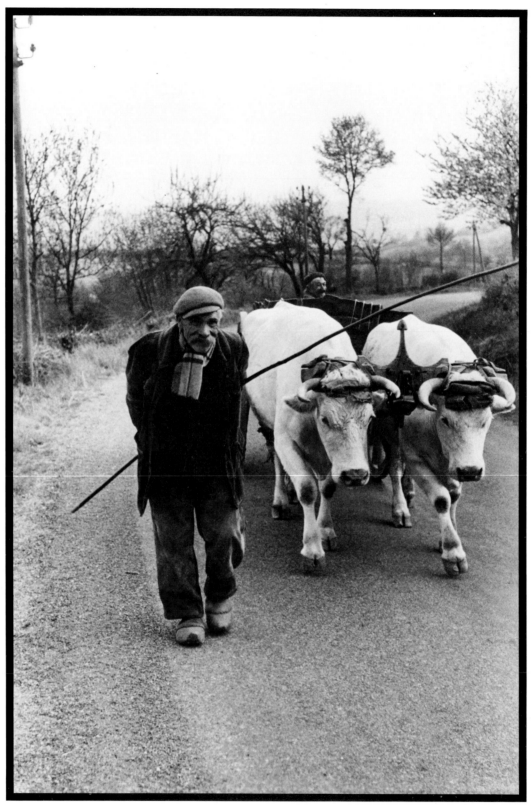

HENRI CARTIER-BRESSON TWO FRENCH PEASANTS TAKE THEIR OXEN TO THE FIELDS OF
CLERMONT-FERRAND, NEAR AUVERGNE/*Gelatin silver print, 1960*

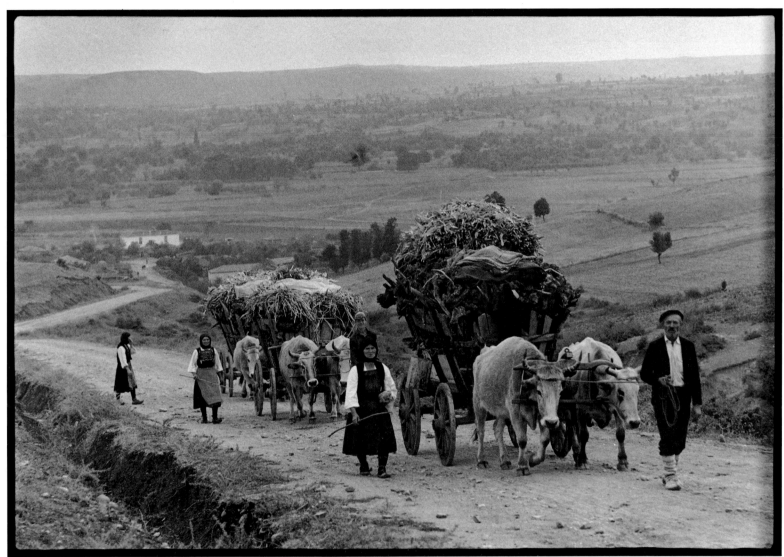

COSTA MANOS

GREEK PEASANTS/*Gelatin silver print, 1964*

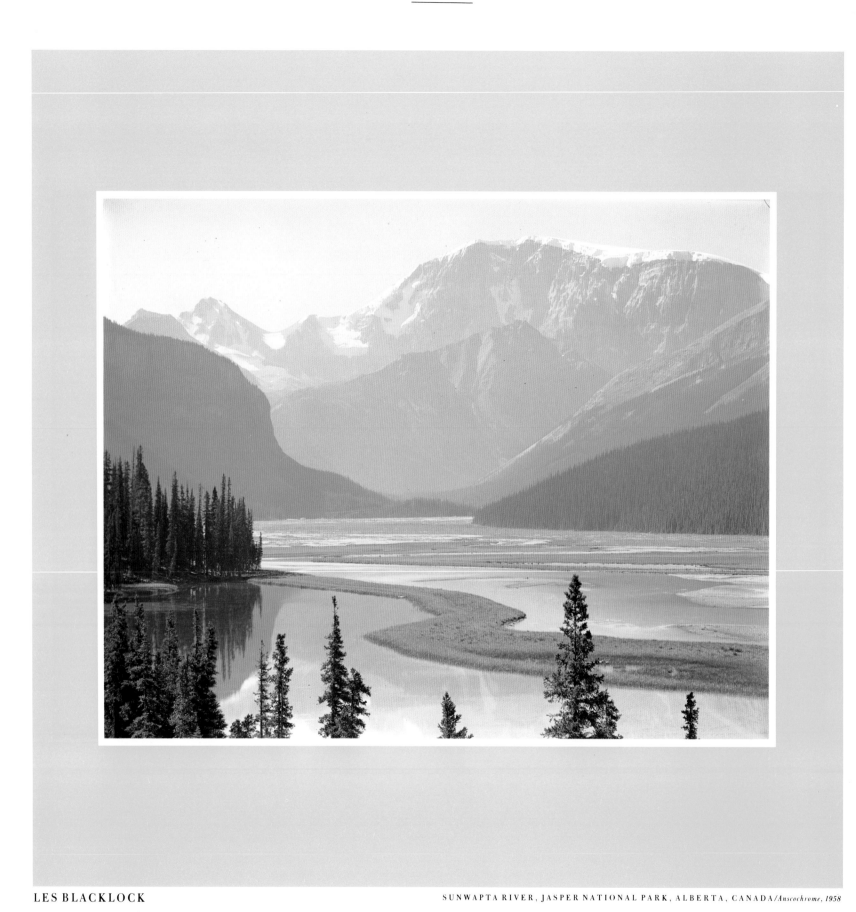

LES BLACKLOCK

SUNWAPTA RIVER, JASPER NATIONAL PARK, ALBERTA, CANADA/*Anscochrome, 1958*

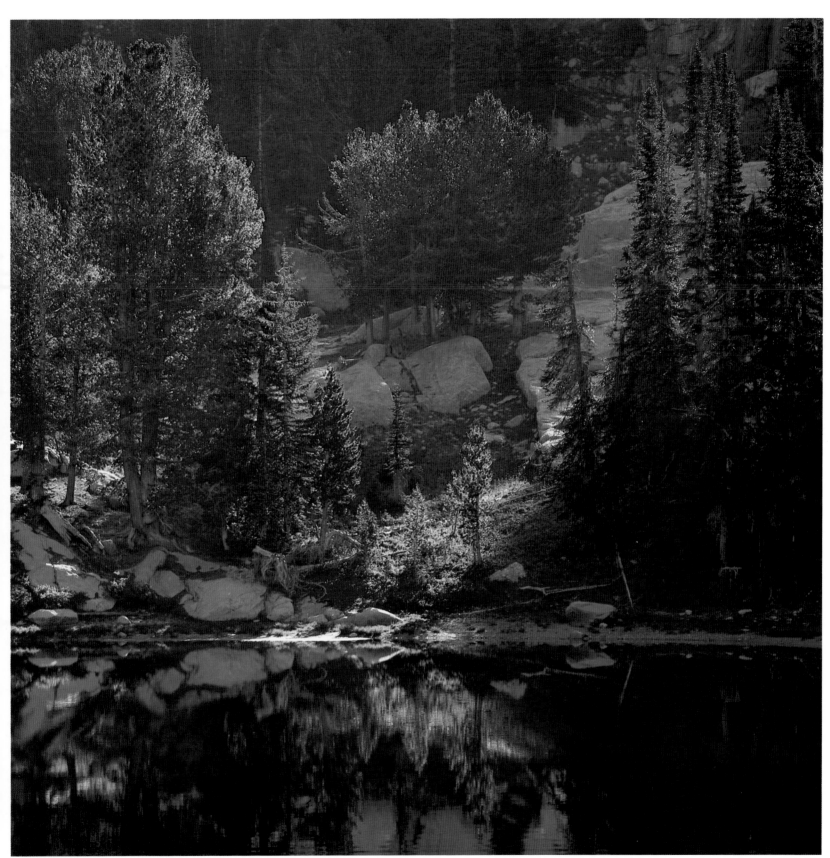

BOYD NORTON ALPINE LAKE, WESTERN TETON RANGE, WYOMING/*Ektachrome. ca. 1966*

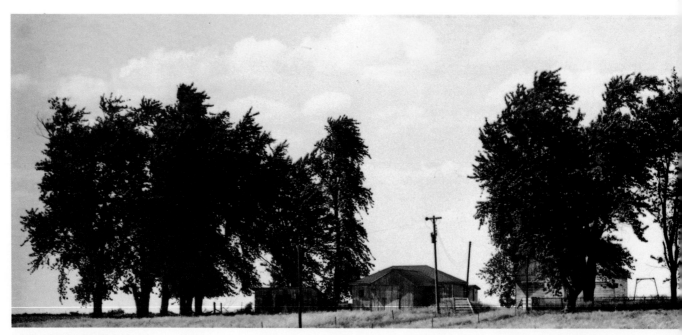

ART SINSABAUGH

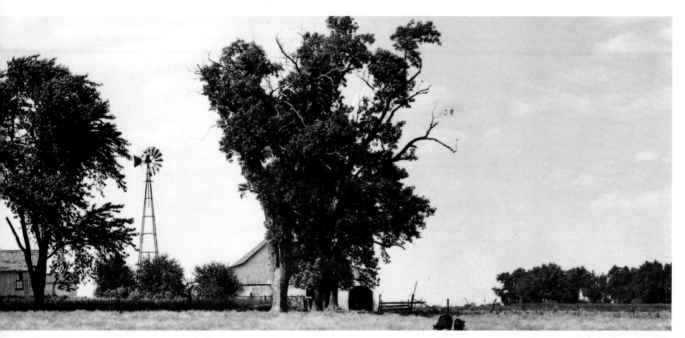

MIDWEST LANDSCAPE NO. 5/*Gelatin silver print, 1960s*

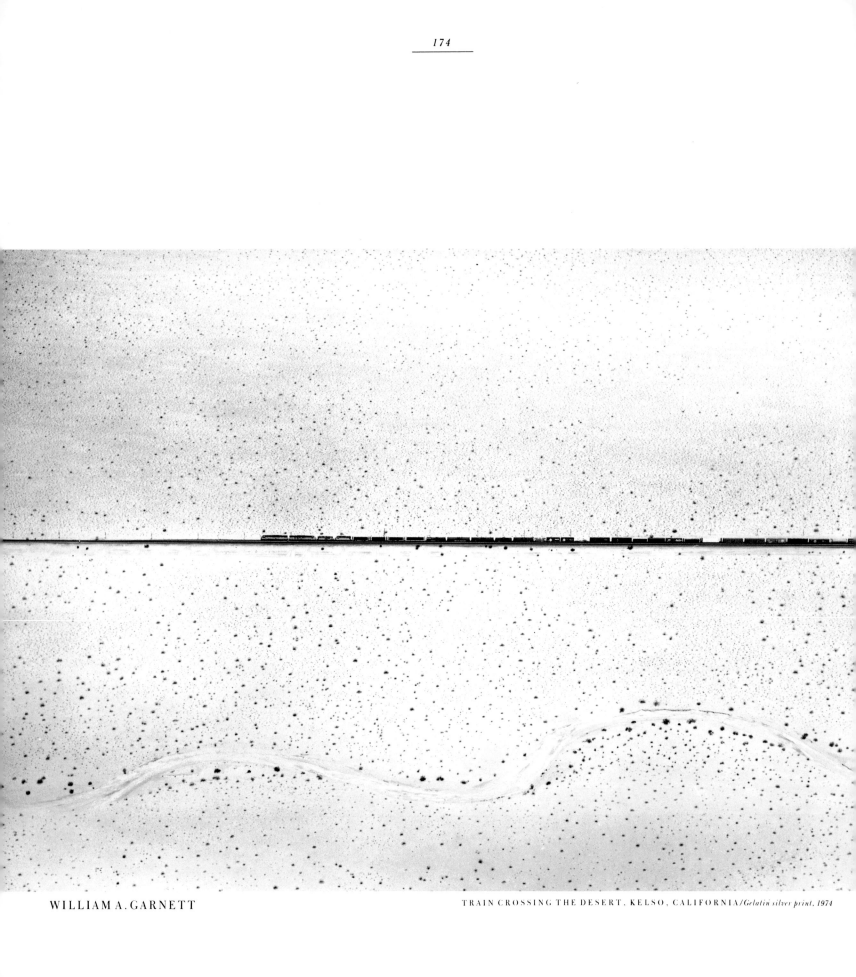

WILLIAM A. GARNETT TRAIN CROSSING THE DESERT, KELSO, CALIFORNIA/*Gelatin silver print*, 1974

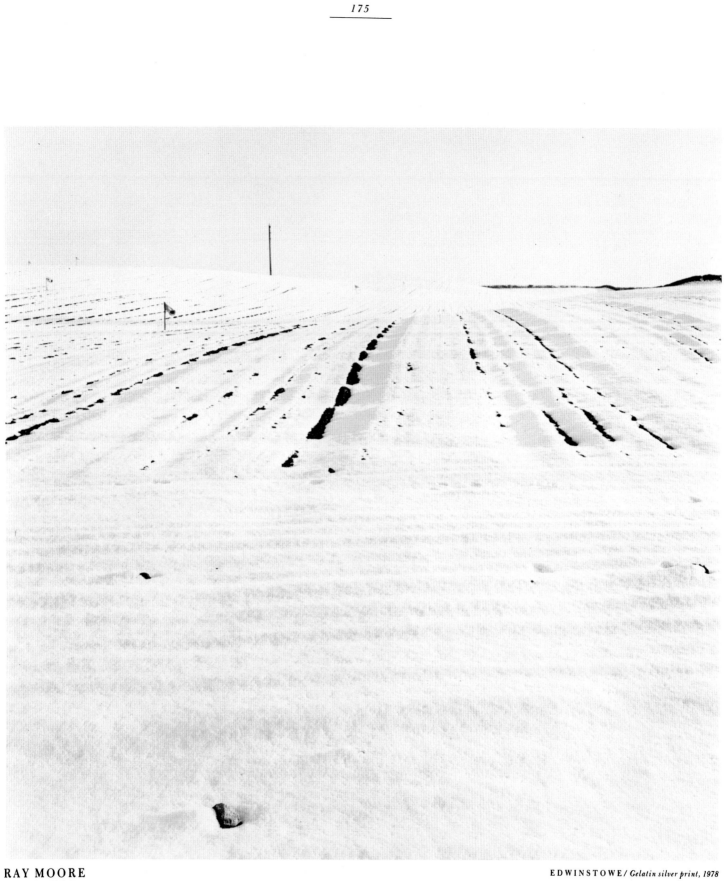

RAY MOORE

EDWINSTOWE / *Gelatin silver print, 1978*

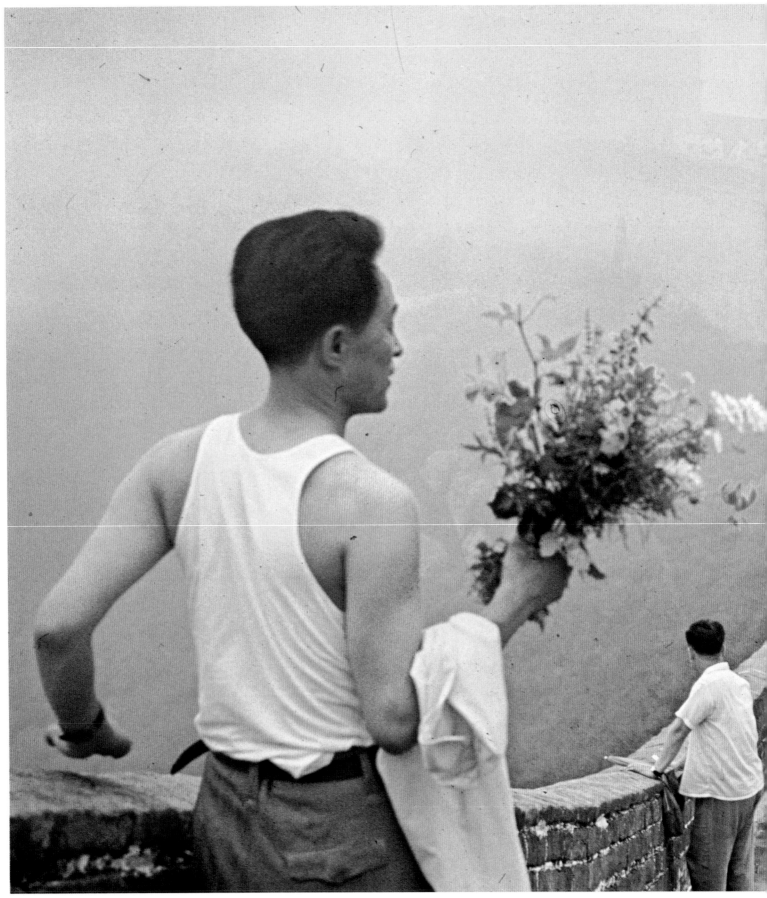

MARC RIBOUD

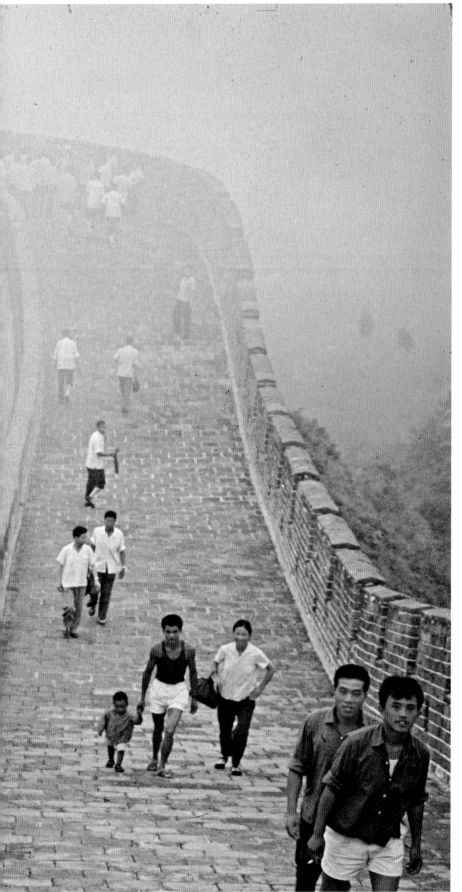

GREAT WALL, CHINA/*Probably Kodachrome, 1960s*

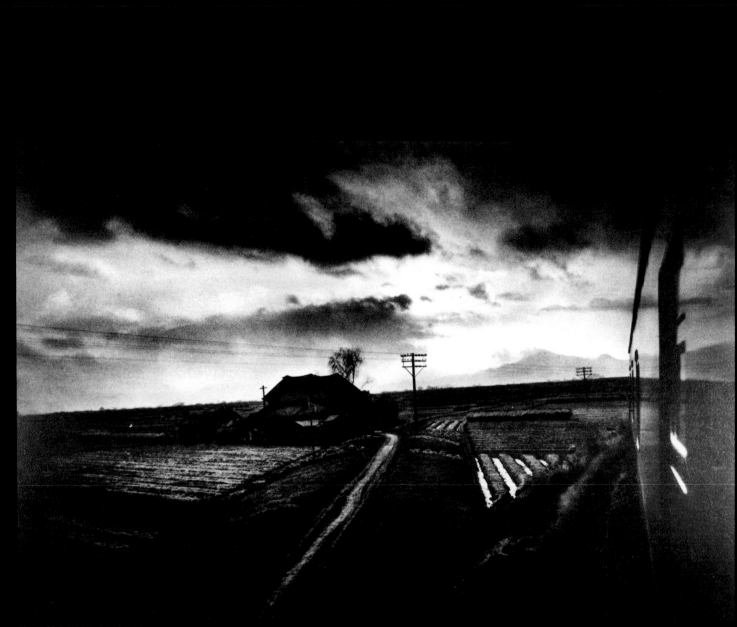

W. EUGENE SMITH

JAPAN FROM THE WINDOW OF A TRAIN/*Gelatin silver print, 1961*

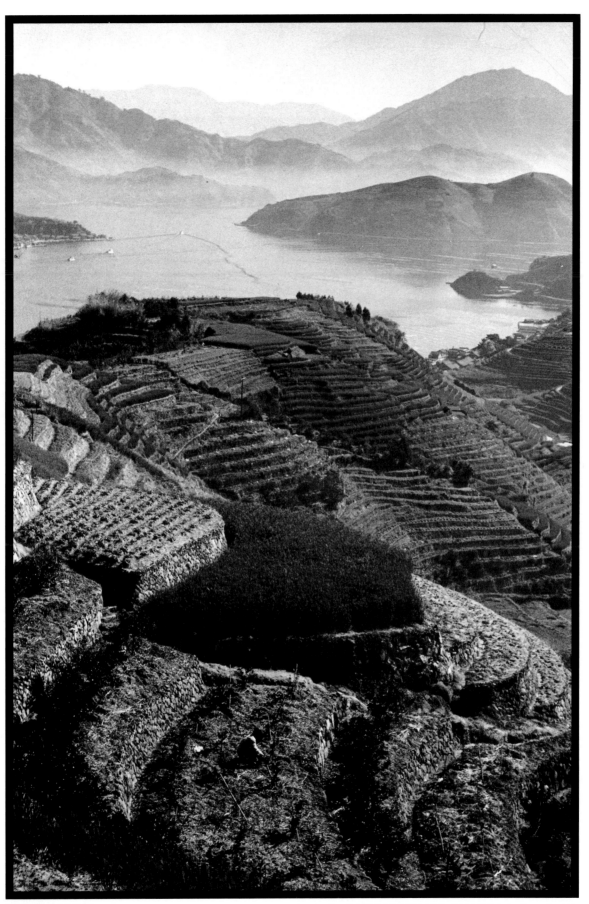

BURT GLINN SOUTH END OF SHIKOKU ISLAND, JAPAN/*Gelatin silver print, 1961*

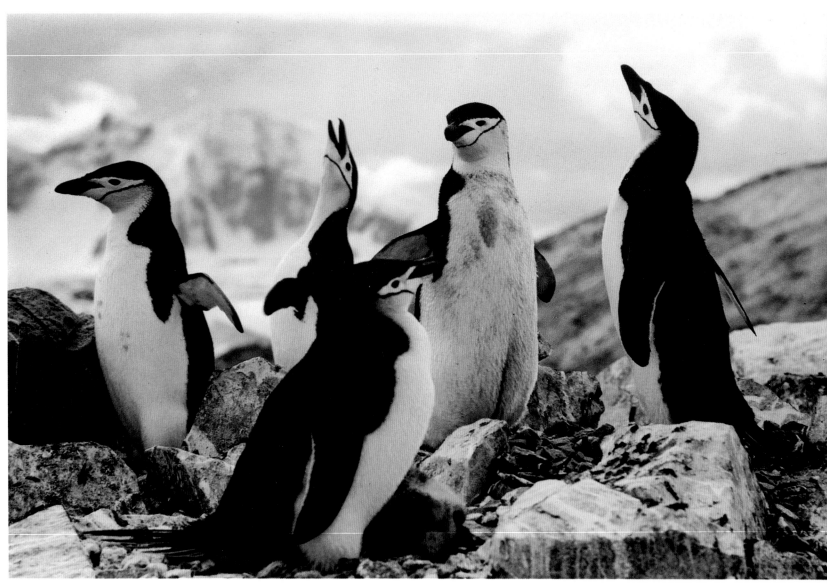

ELIOT PORTER CHINSTRAP PENGUINS, COUVERVILLE ISLAND/ *Dye transfer print, ca. 1978, from transparency, 1975*

ELIOT PORTER BLUE-FOOTED BOOBY, GALAPAGOS ISLAND (EQUADOR)/ *Dye transfer print, ca. 1977, from transparency, 1966*

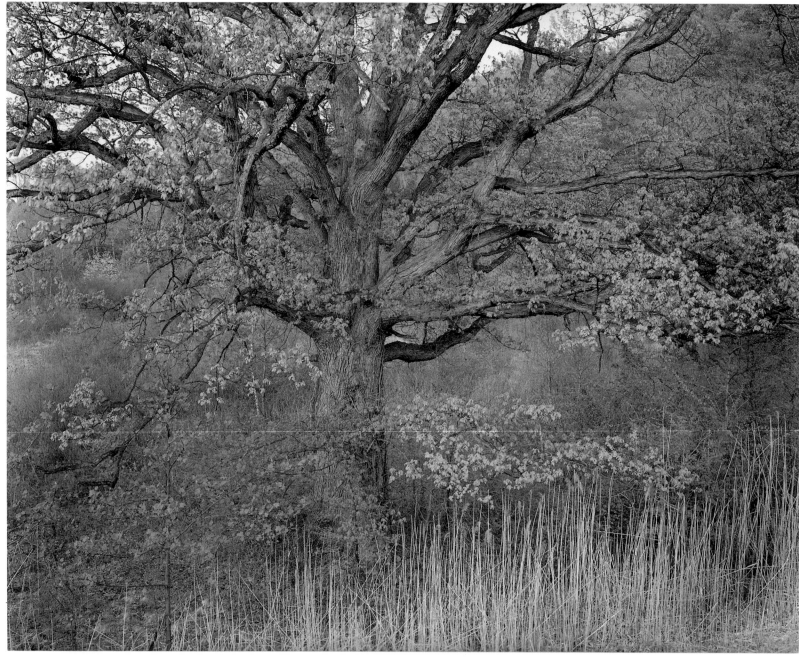

GEORGE TICE

OAK TREE, HOLMDEL, NEW JERSEY/*Gelatin silver print, 1970*

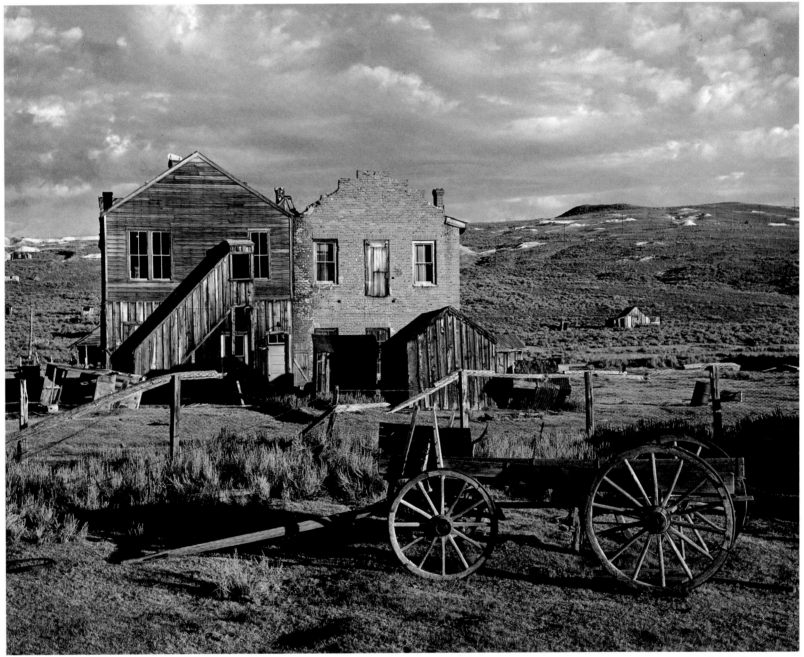

GEORGE TICE

WAGON AND BUILDINGS, BODIE, CALIFORNIA/*Gelatin silver print, 1965*

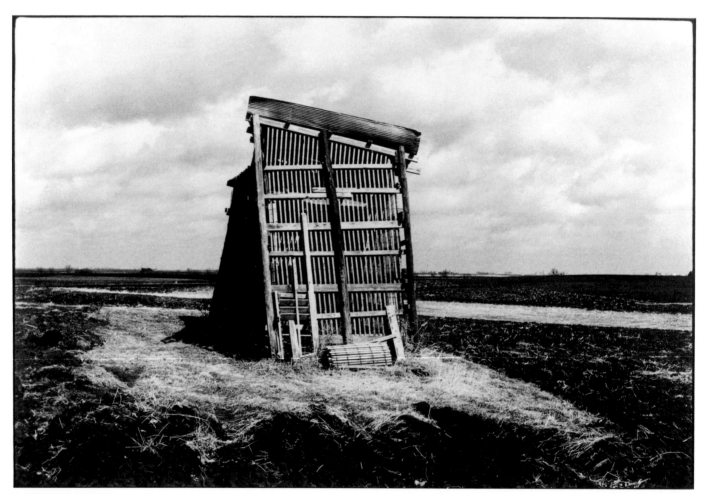

ROBERT FLICK

ILLINOIS LANDSCAPE 7 4 / Gelatin silver print, 1974

COLE WESTON

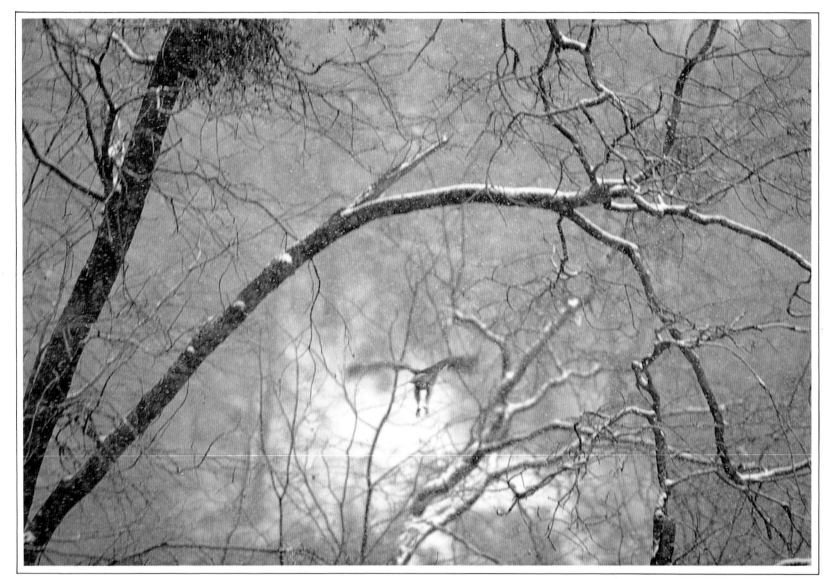

ERNST HAAS

EAGLE IN WINTER/*Kodachrome, 1966*

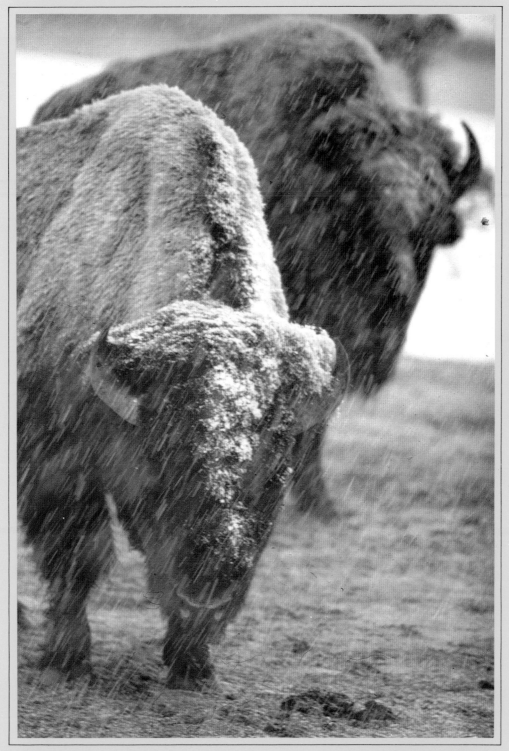

ERNST HAAS BUFFALO IN SNOW/*Kodachrome, 1966*

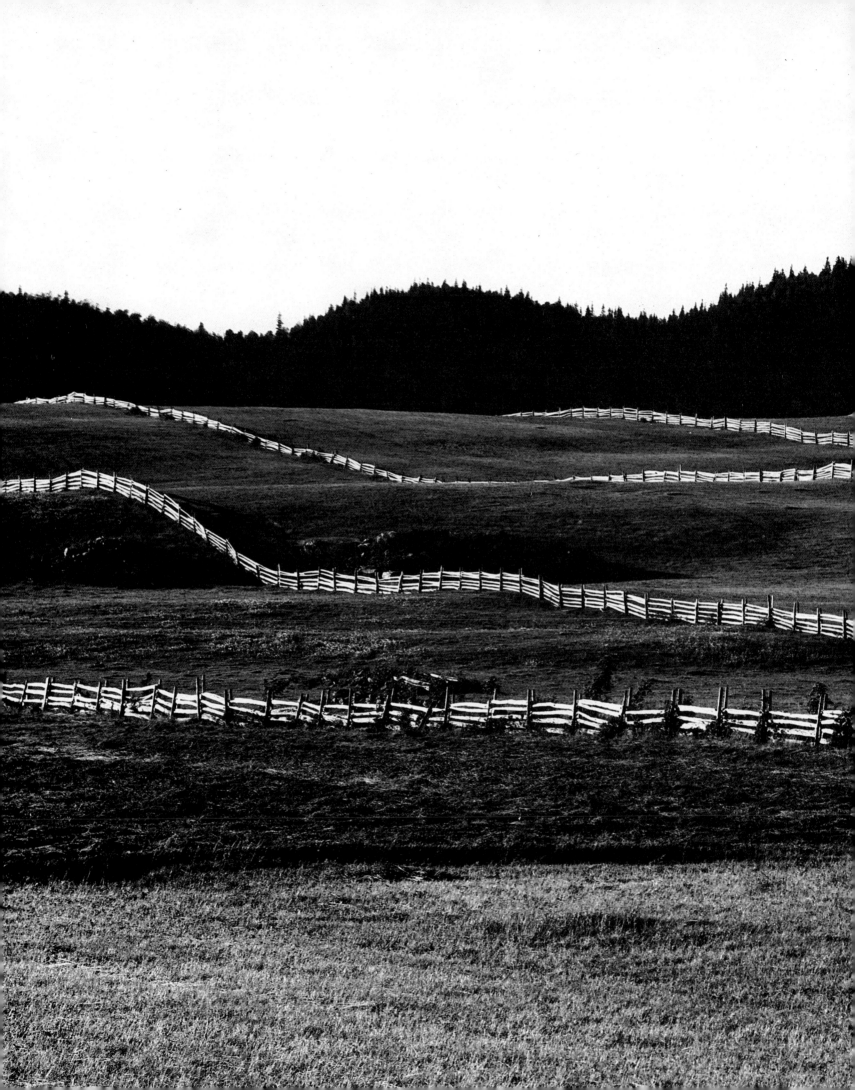

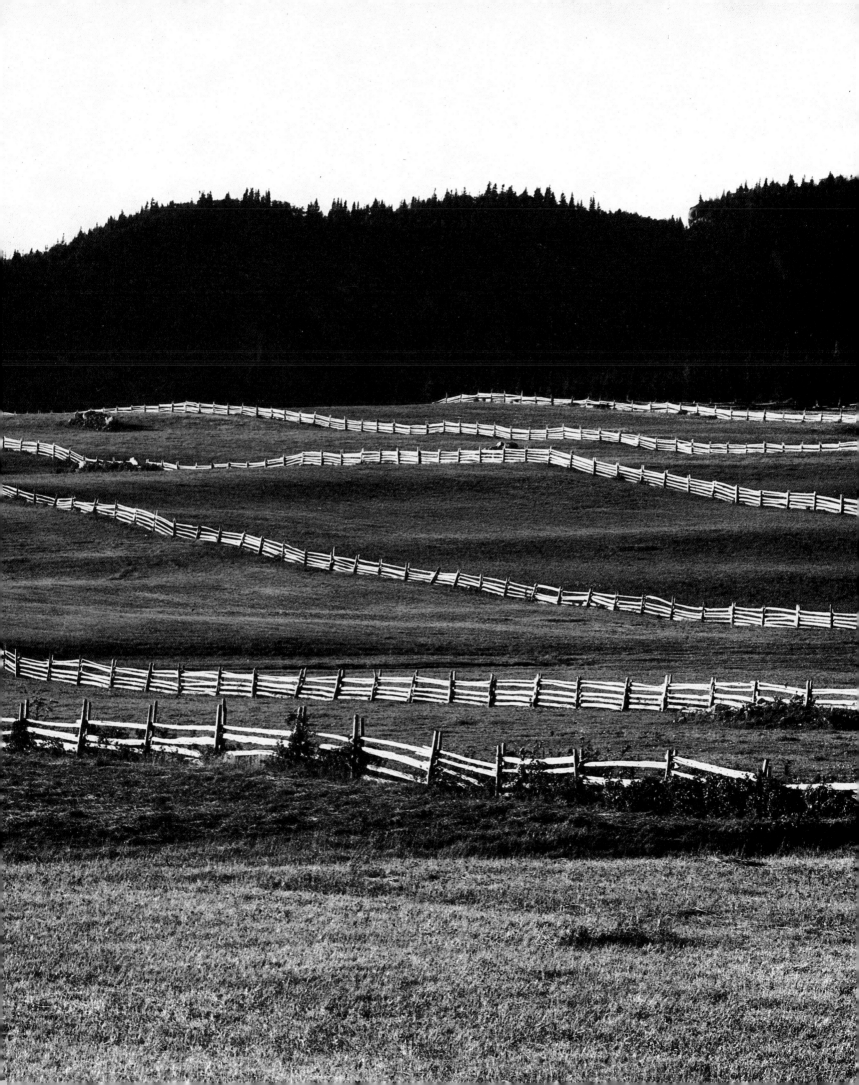

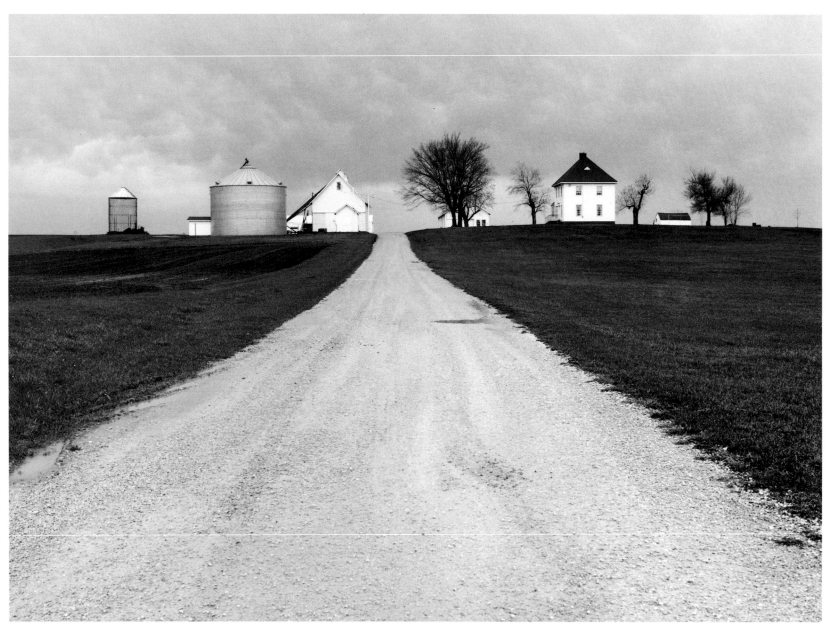

DAVID PLOWDEN

previous spread:
DAVID PLOWDEN FARMLAND NEAR RIMOUSKI, QUEBEC, CANADA/*Gelatin silver print, 1969*

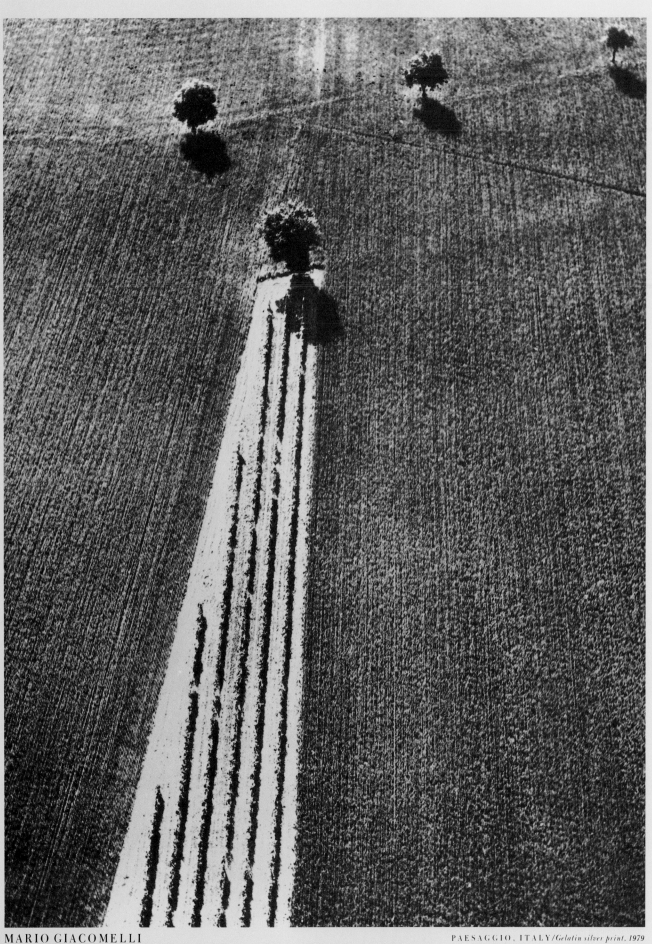

MARIO GIACOMELLI PAESAGGIO, ITALY/*Gelatin silver print. 1979*

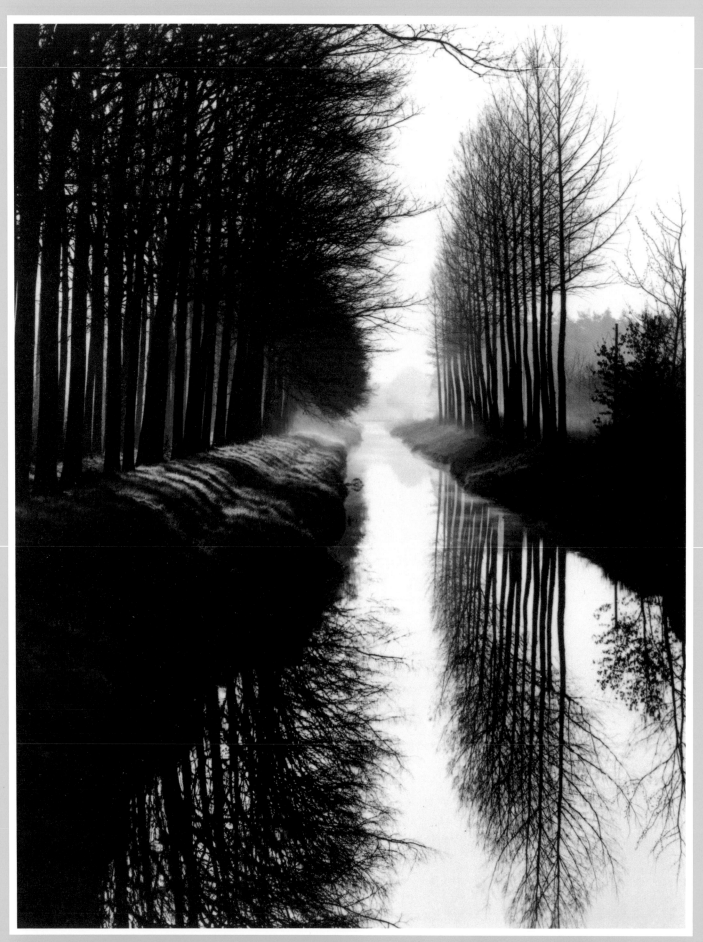

BRETT WESTON

CANAL, HOLLAND/*Gelatin silver print, 1971*

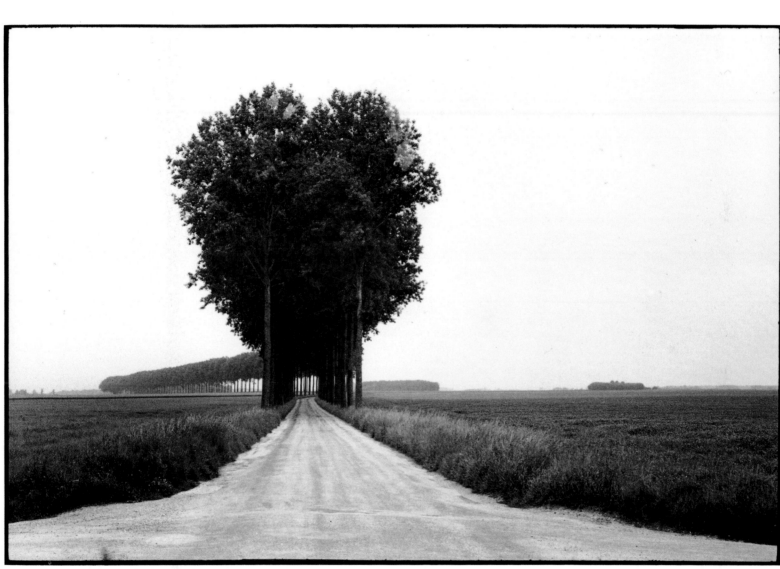

HENRI CARTIER-BRESSON

BRIE, FRANCE/*Gelatin silver print, 1968*

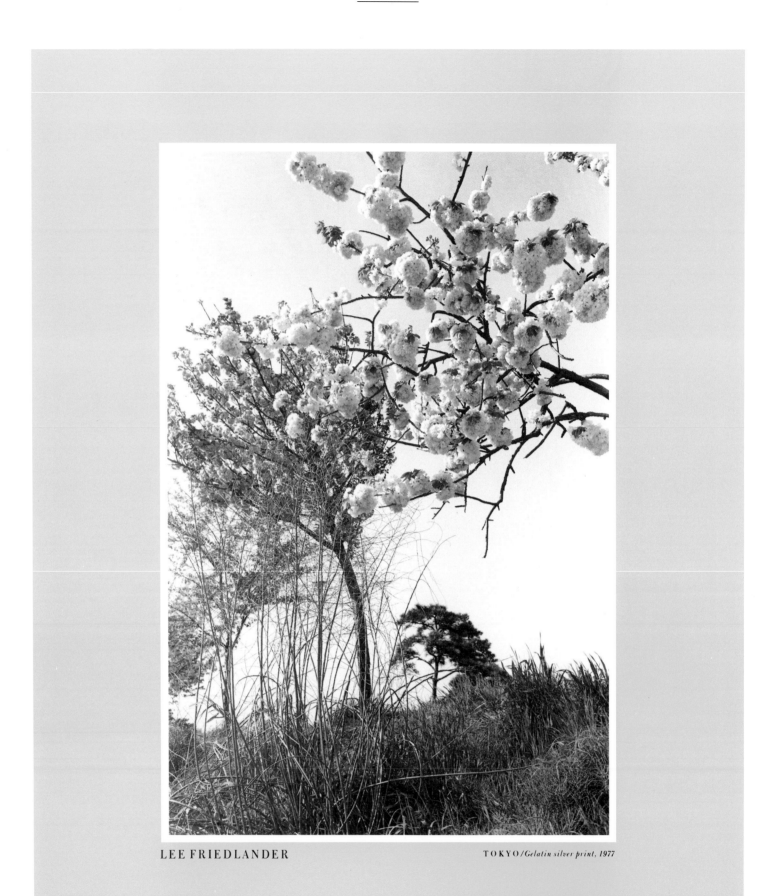

LEE FRIEDLANDER TOKYO/*Gelatin silver print, 1977*

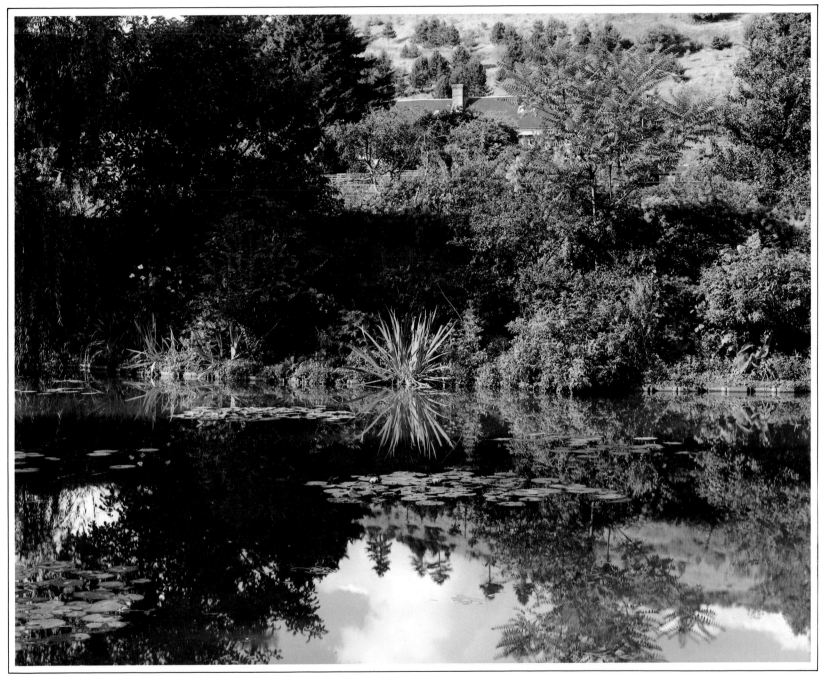

STEPHEN SHORE

GIVERNY, FRANCE/*Ektacolor print, 1981*

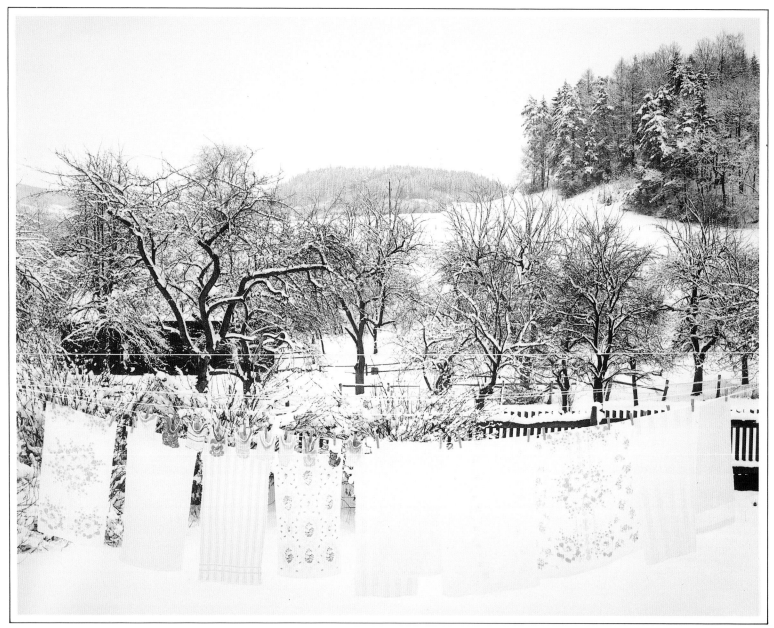

ALFRED SEILAND

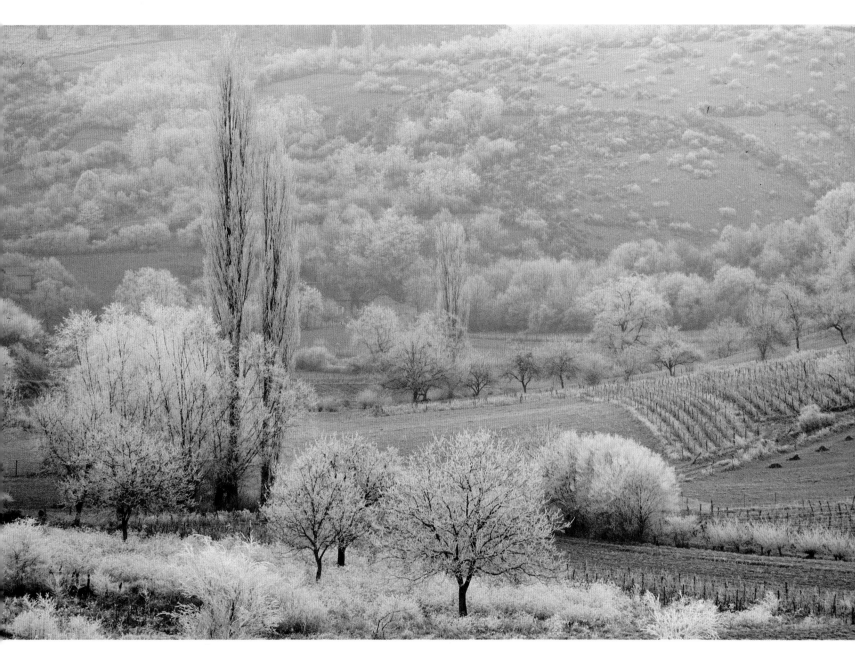

FRANK HORVAT LANDSCAPE IN EASTERN FRANCE/*Kodachrome, 1977*

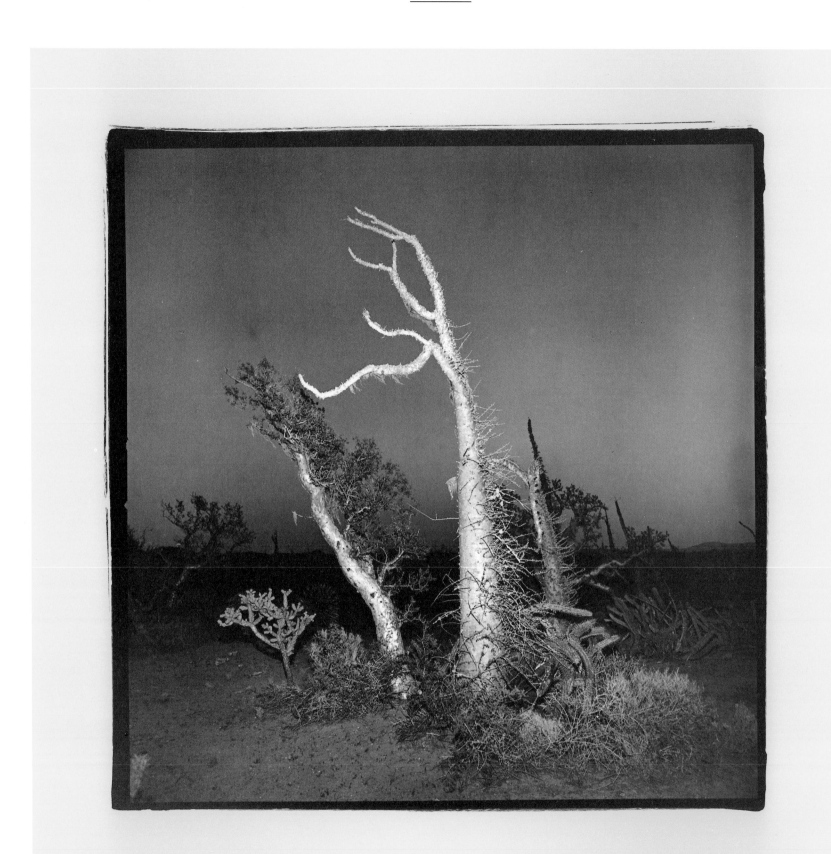

RICHARD MISRACH

BOOJUM NO. 2/*Split-toned gelatin silver print, 1977*

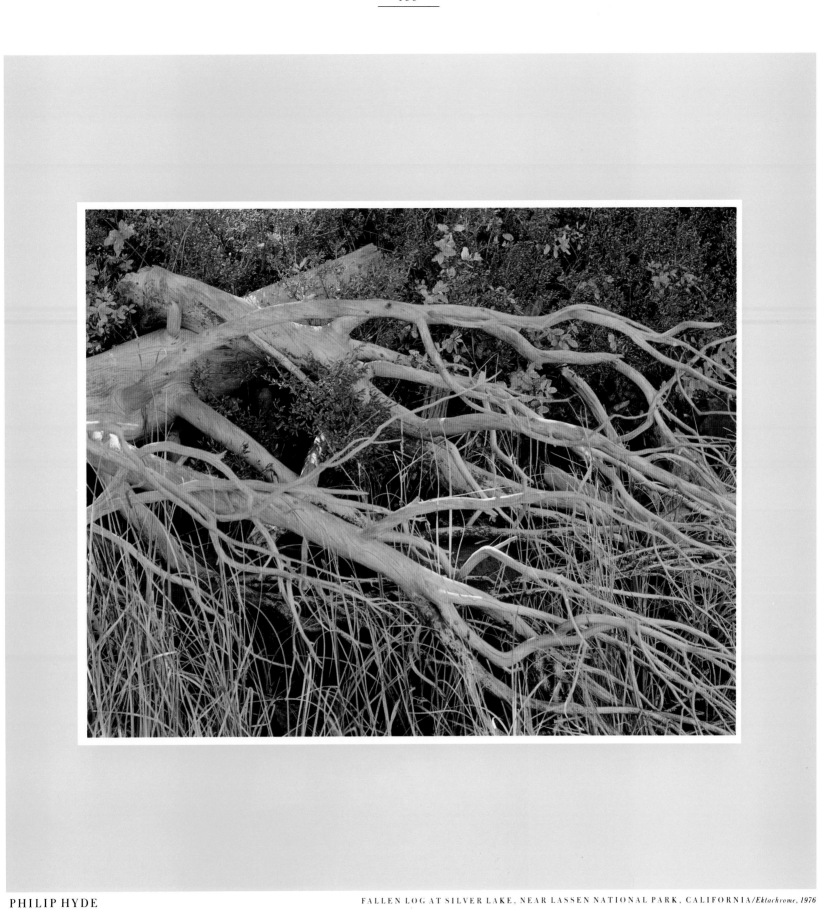

PHILIP HYDE FALLEN LOG AT SILVER LAKE, NEAR LASSEN NATIONAL PARK, CALIFORNIA/*Ektachrome, 1976*

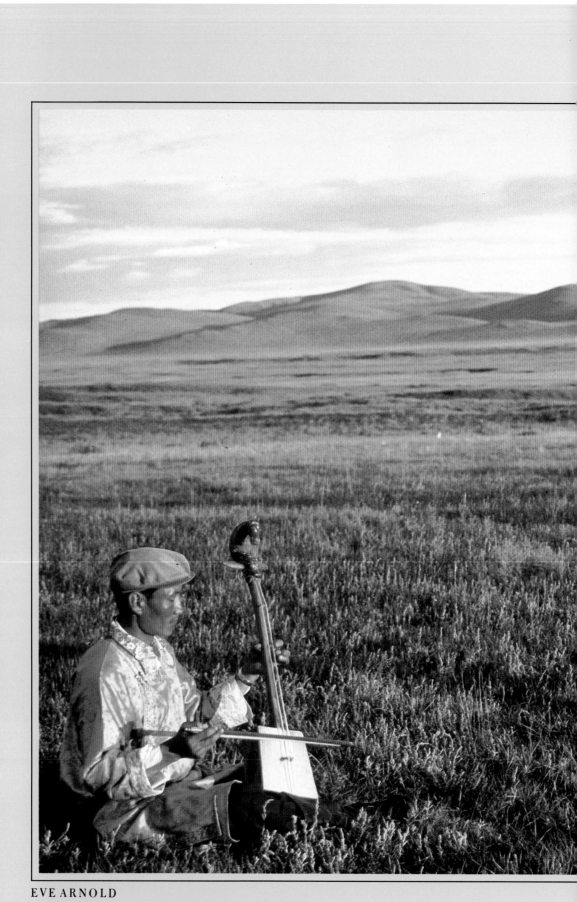

EVE ARNOLD

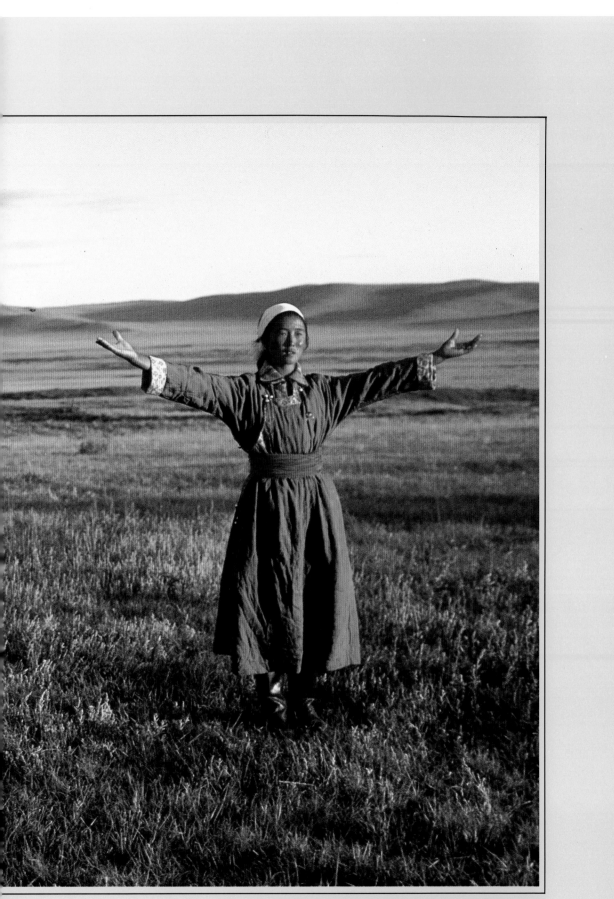

SONG AT DUSK, INNER MONGOLIA/*Kodachrome, 1979*

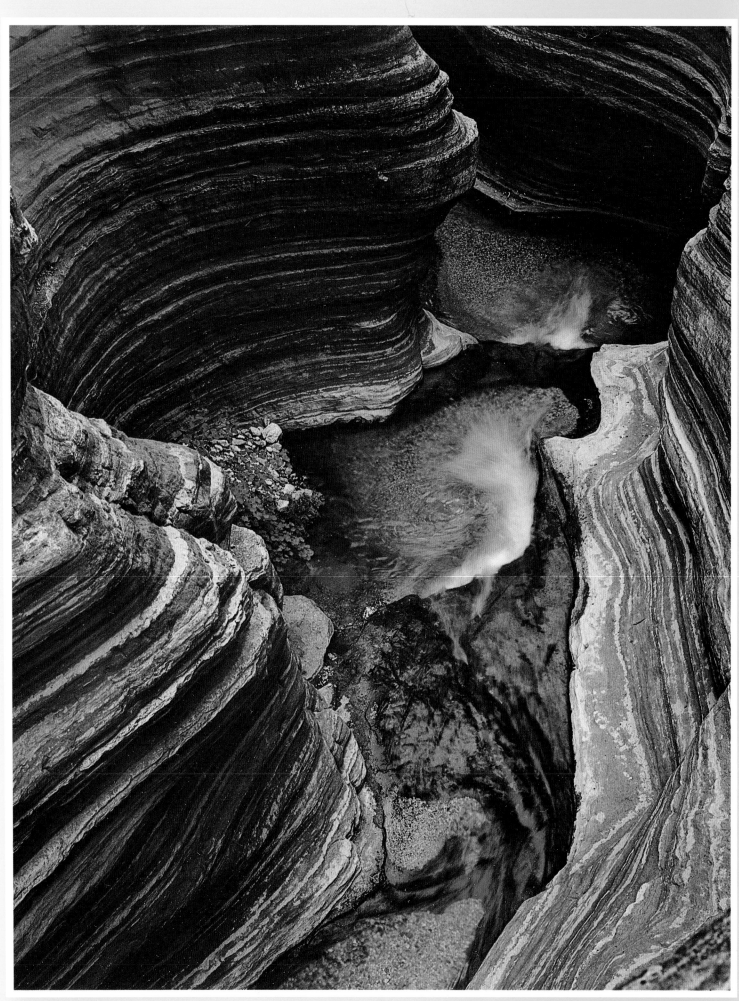

ELIOT PORTER CHASM AT DEER CREEK, GRAND CANYON, ARIZONA/ *Dye transfer print, ca. 1979, from transparency, 1967*

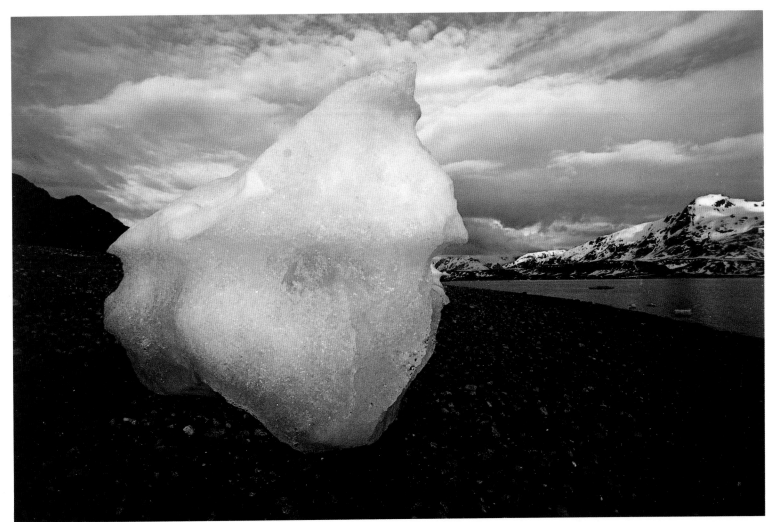

DEAN BROWN

GLACIER BAY, ALASKA/*Dye transfer print, 1971*

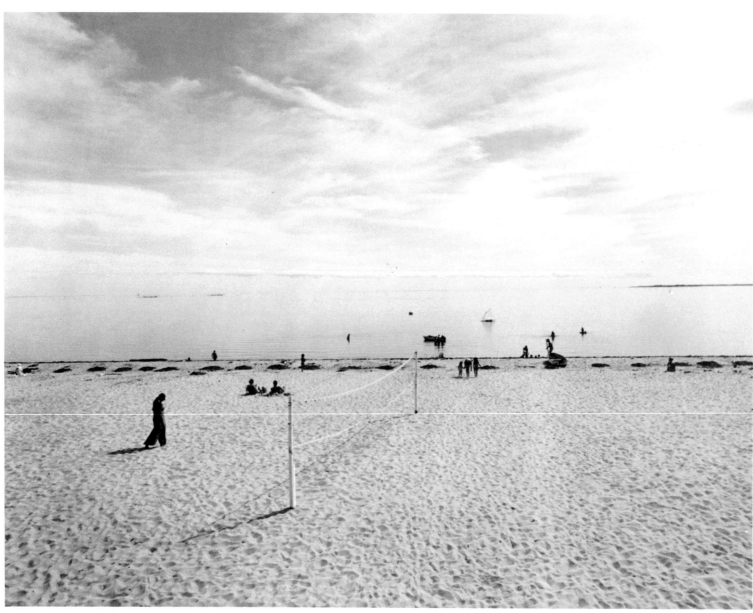

HARRY CALLAHAN

CAPE COD (MASSACHUSETTS)/*Gelatin silver print, 1972*

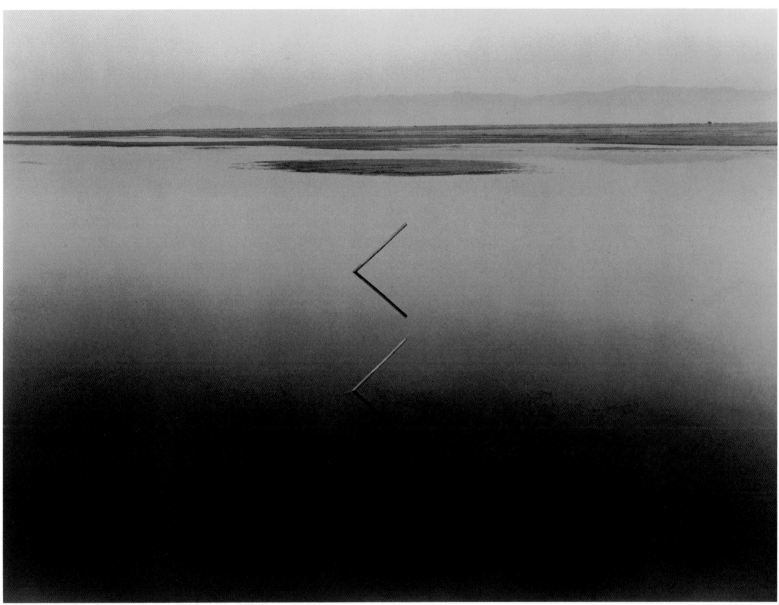

JOHN PFAHL

GREAT SALT LAKE ANGLES, GREAT SALT LAKE, UTAH/*Dye-coupler (Type C) print, 1977*

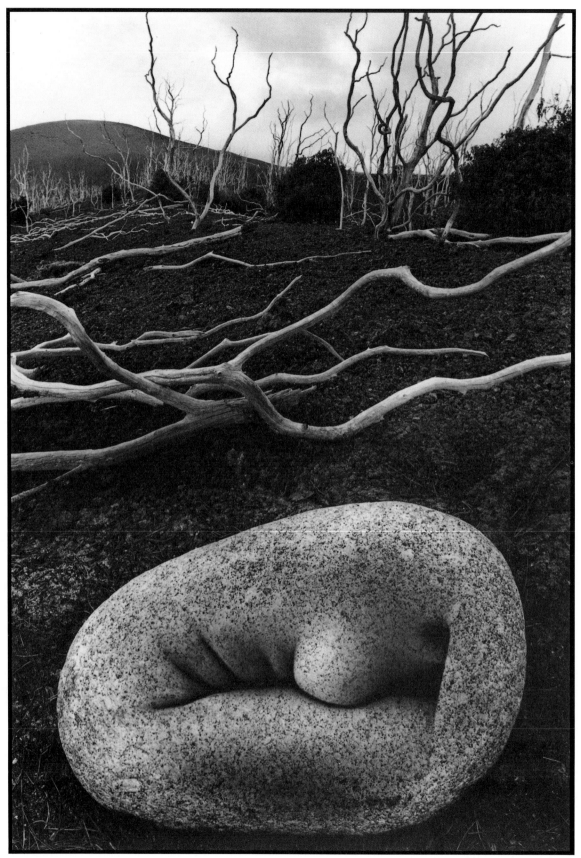

JERRY N. UELSMANN

UNTITLED/*Gelatin silver print, 1977*

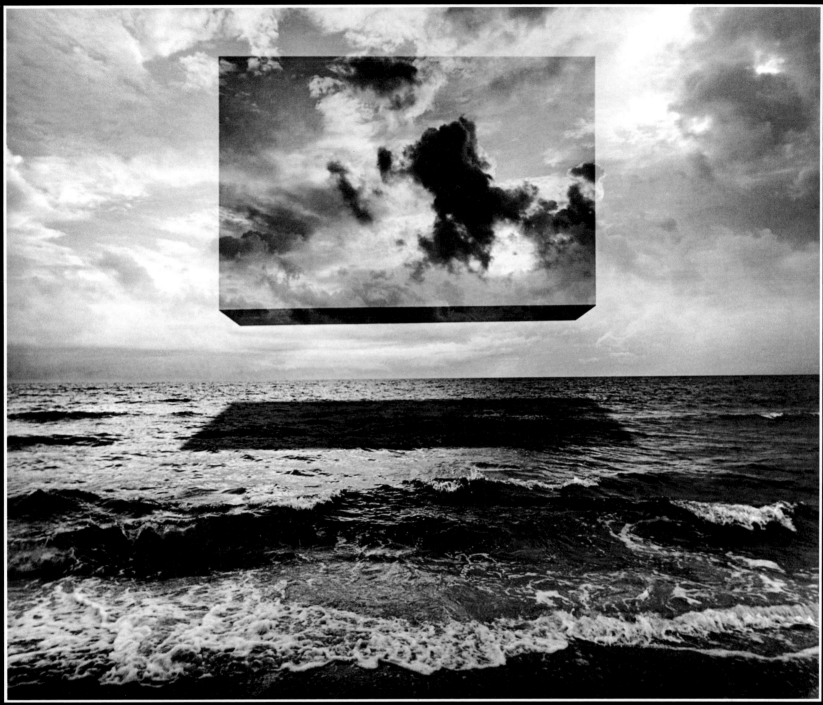

JERRY N. UELSMANN

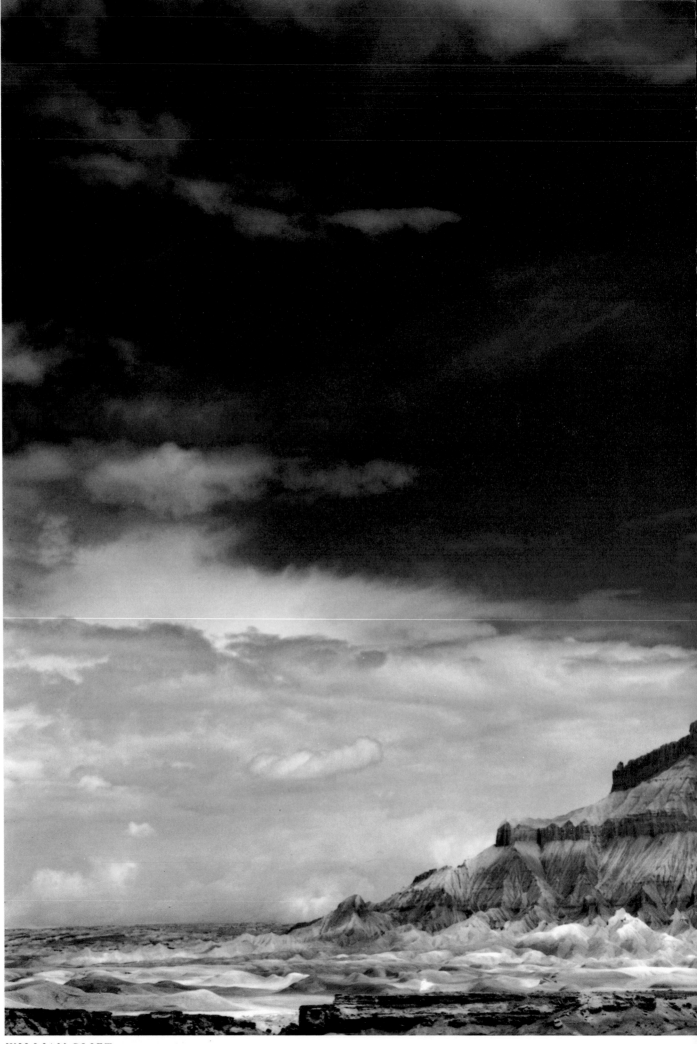

WILLIAM CLIFT

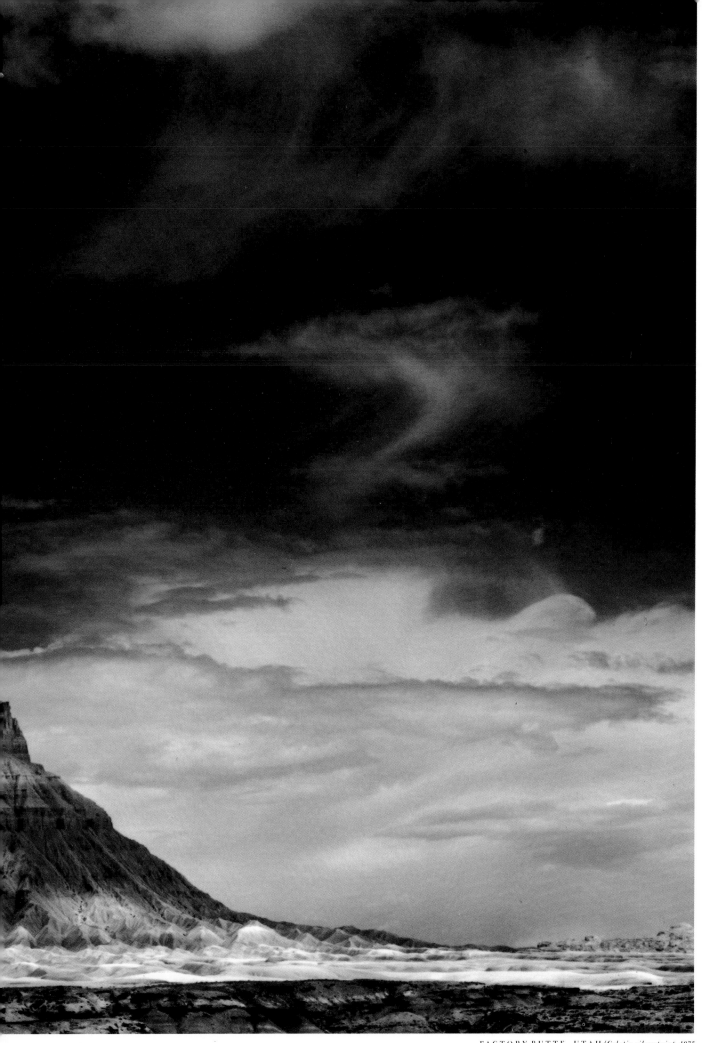

FACTORY BUTTE, UTAH/*Gelatin silver print, 1975*

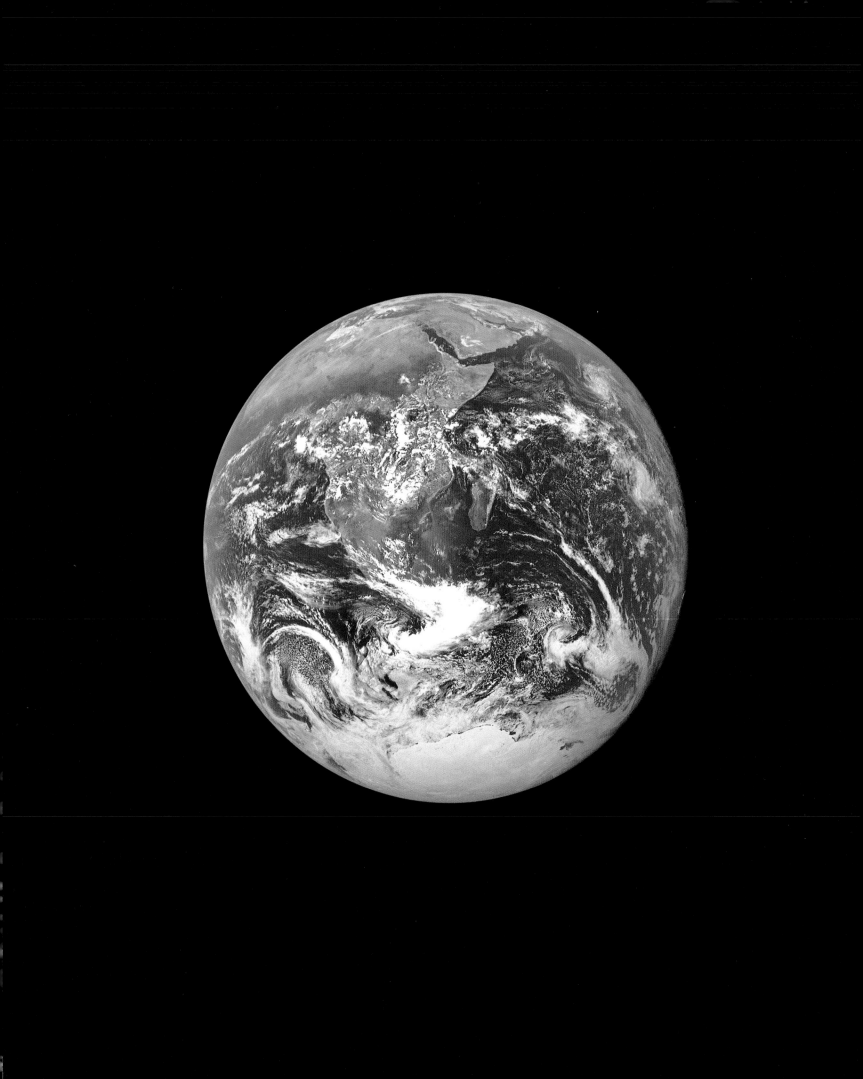

Plate List

80/ ANDRÉ KERTÉSZ *Sunday Afternoon, Duna Haraszti, Hungary*. Gelatin silver print, 1919. Susan Harder Gallery, New York. © André Kertész.

81/ ANONYMOUS (FRENCH) *Horse-drawn Carriage on a Country Road, France*. Autochrome, 1906–1913. Société Française de Photographie/Fotogram, Paris.

82/ HERBERT W. GLEASON *Leaning Hemlocks*. Photogravure, ca. 1906. Collection Sam Wagstaff, New York.

83/ HERBERT W. GLEASON *Blackbirds in a Tree*. Photogravure, ca. 1906. Collection Sam Wagstaff, New York.

84/ EDWARD S. CURTIS *Saguaro Harvest, Pima* [Arizona]. Photogravure on tissue, n.d. Private collection, New York.

85/ JOHN C.H. GRABILL *Sioux* [Indian] *Encampment, Dakota Territory*. Albumen print, ca. 1891. Library of Congress, Washington, D.C.

86/ EDWARD S. CURTIS *Canyon de Chelly* [Arizona]. Toned gelatin silver print, 1904. Amon Carter Museum, Fort Worth, Texas.

87/ GEORGE FISKE *Kitty Tatch and Friend Doing the High Kick on Overhanging Rock, Glacier Point, Yosemite National Park, California*. Albumen print, ca. 1900. U.S. Department of the Interior, National Park Service, Yosemite National Park.

88–9/ A. BOUGAULT *In the Sahara*. Albumen print, ca. 1910. Collection Stephen White, Los Angeles, California.

90/ HEINRICH KÜHN *Three Children in a Landscape*. Gum bichromate print, ca. 1902. Collection Harriet and Noel Levine, New York.

91/ LAURA GILPIN *On the Prairie*. Platinum print, 1919. Amon Carter Museum, Fort Worth, Texas.

92/ EDWARD STEICHEN *Heavy Roses, Voulangis, France*. Gelatin silver print, 1914. Museum of Modern Art, New York. Reprinted with the permission of Joanna T. Steichen.

93/ EDWARD STEICHEN *The Lotus*. Gelatin silver print, 1923. International Museum of Photography at George Eastman House, Rochester, New York. Reprinted with the permission of Joanna T. Steichen.

94/ EDWARD WESTON *Shell*. Gelatin silver print, 1931. International Museum of Photography at George Eastman House, Rochester, New York. © 1981 Arizona Board of Regents, Center for Creative Photography.

95/ ALFRED STIEGLITZ *Equivalent*. Gelatin silver print, 1927. Zabriskie Gallery, New York.

96–7/ FRANZ SCHENSKY *The Wave*. Gelatin silver print, 1925. Museum für Kunst und Gewerbe, Hamburg, West Germany.

98/ DOROTHEA LANGE *Farm Implements, Mills, New Mexico*. Gelatin silver print, 1935. Courtesy Janet Lehr Inc., New York.

99/ IMOGEN CUNNINGHAM *Northwest Native*. Gelatin silver print, 1934. The Imogen Cunningham Trust, Berkeley, California. © 1974 Imogen Cunningham Trust.

100/ PAUL STRAND *White Horse, Ranchos de Taos, New Mexico*. Gelatin silver print, ca. 1976 from negative, 1932. San Francisco Museum of Modern Art, Purchase. © 1971, 1982, Paul Strand Foundation, as published in Paul Strand: *A Retrospective Monograph, The Years 1915–1968*, Aperture, Millerton, 1971.

101/ ANDRÉ KERTÉSZ *Hungarian Landscape, Puszta*. Gelatin silver print, n.d. Susan Harder Gallery, New York. © André Kertész.

102/ EDWARD WESTON *Old Big Sur Road* [California]. Gelatin silver print, 1933. Collection Van Deren Coke, San Francisco, California. © 1981 Arizona Board of Regents, Center for Creative Photography.

103/ EDWARD WESTON *Juniper, Sierra Nevada, California*. Gelatin silver print, 1937. International Museum of Photography at George Eastman House, Rochester, New York. © 1981 Arizona Board of Regents, Center for Creative Photography.

104/ EDWARD WESTON *Tomato Field*. Gelatin silver print, 1937. International Museum of Photography at George Eastman House, Rochester, New York. © 1981 Arizona Board of Regents, Center for Creative Photography.

105/ ANSEL ADAMS *Burnt Stump and New Grass, Sierra Nevada, California*. Gelatin silver print, 1932. Courtesy the artist. © 1982 Ansel Adams Publishing Rights Trust.

106/ PAUL STRAND *Wild Iris, Center Lovell, Maine, 1927*. Gelatin silver print, 1927. © 1983 The Paul Strand Foundation, Aperture, Millerton, New York.

107/ ALBERT RENGER-PATZSCH *Beech Forest in Autumn*. Gelatin silver print, 1936. Art Institute of Chicago, Chicago, Illinois, Joseph and Helen Regenstein Foundation Gift. © 1984 Galerie Wilde, Köln, West Germany.

108/ DOROTHEA LANGE *Tractored Out, Childress County, Texas*. Gelatin silver print, 1938. International Museum of Photography at George Eastman House, Rochester, New York.

109/ ALBERT RENGER-PATZSCH *Cherry Tree*. Gelatin silver print, 1929. Museum of Modern Art, New York. Purchased as the gift of Paul F. Walter. © 1984 Galerie Wilde, Köln, West Germany.

110/ JOSEF SUDEK *A Walk on Troja Island* [Czechoslovakia]. Gelatin silver print, 1940–1945. From *Sudek* by Sonja Bullaty. © 1978 Josef Sudek.

111/ AUGUST SANDER *Landscape in the Siebengebirge* [Germany]. Gelatin silver print, 1930s. The Metropolitan Museum of Art, New York, Gift of Mr. and Mrs. Pirie MacDonald and Mr. and Mrs. Everett Tutchings, by exchange. © Estate of August Sander and Sander Gallery Inc., New York.

112–13/ HARRY CALLAHAN *Cattails Against the Sky*. Gelatin silver print, 1948. Peter MacGill Company. © 1964 Harry Callahan.

114/ EDWARD WESTON *Barn, Pismo Beach, California*. Gelatin silver print, 1935. Center for Creative Photography, University of Arizona, Tucson. © 1981 Arizona Board of Regents, Center for Creative Photography.

115/ ALFRED EISENSTAEDT *Autumn Morning, White Sulphur Springs, West Virginia*. Gelatin silver print, 1937. Courtesy the artist.

116/ BILL BRANDT *Top Withens, West Riding, Yorkshire*. Gelatin silver print, 1945. Philadelphia Museum of Art, Philadelphia, Pennsylvania. Alfred Stieglitz Fund.

117/ BILL BRANDT *Stonehenge*. Gelatin silver print, 1940s. Private collection, New York.

118–19/ ANSEL ADAMS *Winter Sunrise, from Lone Pine, Sierra Nevada, California*. Gelatin silver print, 1944. Courtesy the artist. © 1982 The Ansel Adams Publishing Rights Trust.

120/ RAY ATKESON *Sand Dunes, Death Valley National Monument, California*. Gelatin silver print, 1940s. Private collection, New York.

121/ EDWARD WESTON *Cloud*. Gelatin silver print, 1936. Collection Graham Nash, Pasadena, California. © 1981 Arizona Board of Regents, Center for Creative Photography.

122/ ANSEL ADAMS *Tenaya Lake, Mount Conness, Yosemite National Park, California*. Gelatin silver print, ca. 1946. Courtesy the artist. © 1982 Ansel Adams Publishing Rights Trust.

123/ ANSEL ADAMS *White Branches, Mono Lake, California*. Gelatin silver print, 1947. Courtesy the artist. © 1982 Ansel Adams Publishing Rights Trust.

124/ EDWARD WESTON *China Cove*. Gelatin silver print, 1940. Philadelphia Museum of Art, Philadelphia, Pennsylvania. Purchased: Alice Newton Osborne Fund. © 1981 Arizona Board of Regents, Center for Creative Photography.

125/ KEN DOMON *Buddhist Carving at Ohno Temple, Nara, Japan*. Gelatin silver print, 1941. Courtesy the artist. © Ken Domon.

126/ CHARLES SHEELER *The Farm*. Dye transfer print, 1949. Grapestake Gallery, San Francisco, California.

127/ WRIGHT MORRIS *Gano Grain Elevator, Western Kansas*. Gelatin silver print, 1940. Weston Gallery Inc., Carmel, California. © Wright Morris.

128/ MINOR WHITE *Two Barns and Shadow, Dansville, New York*. Gelatin silver print, 1955. Reproduction courtesy Minor White Archive, Princeton University, Princeton, New Jersey. © 1982 Trustees of Princeton University.

129/ MARGARET BOURKE-WHITE *Furrows to Conserve Soil, Colorado*. Gelatin silver print, 1954. Margaret Bourke-White, *Life* Magazine. © 1954 Time Inc.

130–1/ PAUL STRAND *Tir A'Mhurain, South Uist, Hebrides, 1954*. Gelatin silver print, 1954. © 1962, 1971, 1976, 1982, Paul Strand Foundation as published in *Portfolio IV*, Aperture, Millerton, New York, 1982.

132/ IVAN DMITRI *Stresa, Lake Maggiore, Italy*. Gelatin silver print, 1950s. Private collection, New York.

133/ T. Y. CROWELL *Summer in the Dolomites* [Italy]. Gelatin silver print, 1950s. Private collection, New York.

134–5/ J. DIXON-SCOTT *The 'Seven Sisters', Sussex, England*. Gelatin silver print, 1950s. Private collection, New York.

136/ PAUL STRAND *L'Armençon, Cuzy, Yonne, Burgundy, France, 1951*. Gelatin silver print, 1951. © 1950, 1971, 1980 Paul Strand Foundation as published in Paul Strand: *La France de Profil*. La Guilde du Livre, Lausanne, 1952.

137/ IRVING PENN *Trees Along a French Canal*. Dye transfer print, 1951. Museum of Modern Art, New York. Gift of the photographer.

138/ WYNN BULLOCK *Stark Tree*. Gelatin silver print, 1956. Center for Creative Photography, University of Arizona, Tucson. © 1971 Wynn and Edna Bullock Trust.

139/ ANDREAS FEININGER *European Willow*. Gelatin silver print, ca. 1959. Center for Creative Photography, University of Arizona, Tucson. © 1968 Andreas Feininger.

140/ WRIGHT MORRIS *Power House and Palm Tree, near Lordsburg, New Mexico*. Gelatin silver print, 1940. Weston Gallery Inc., Carmel, California.

141/ MINOR WHITE *Twisted Tree, Point Lobos, California*. Gelatin silver print, 1951. Reproduction courtesy Minor White Archive, Princeton University, Princeton, New Jersey. © 1982 Trustees of Princeton University.

142/ AARON SISKIND *Martha's Vineyard* [Massachusetts] *No. 108*. Gelatin silver print, 1954. Center for Creative Photography, University of Arizona, Tucson. © Aaron Siskind.

143/ JACK WELPOTT *Oregon Coast*. Gelatin silver print, 1955. Center for Creative Photography, University of Arizona, Tucson. © 1984 Jack Welpott.

145/ ELIOT PORTER *Colourful Trees, Newfound Gap Road, Great Smoky Mountains Park, Tennessee, October 1967*. Dye tranfer print, 1967. The Metropolitan Museum of Art, New York, Gift of Eliot Porter in honor of David H. McAlpin, 19798 (1979.625.45).

146/ ANONYMOUS (PROBABLY SWEDISH) *The Highlands and Mountains, Riksgränsen, Sweden*. Gelatin silver print, ca. 1950. Private collection, New York.

147/ KENNETH W. TYLER *Robin in Snow Storm*. Gelatin silver print, ca. 1958. Private collection, New York.

148/ RALPH STEINER *Untitled*. Gelatin silver print, ca. 1960. Harcus Gallery, Boston, Massachusetts.

149/ WYNN BULLOCK *Del Monte Forest* [California]. Gelatin silver print, 1956. Boston Museum of Fine Arts, Boston, Mass. © 1971 Wynn and Edna Bullock Trust.

150/ DIMITRIOS HARISSIADIS *Road in Greece*. Gelatin silver print, 1953. Art Institute of Chicago, Chicago, Illinois.

151/ WILLIAM A. GARNETT *Sand Dune with Sagebrush, Death Valley, California*. Gelatin silver print, 1954. Courtesy the artist. © 1954 William A. Garnett.

152–3/ PAUL STRAND *The Nile at Aswan, Egypt*. Gelatin silver print, 1959. © 1969, 1976, Paul Strand Foundation as published in Paul Strand: *Sixty Years of Photographs*, Aperture, Millerton, New York, 1976.

154/ ERNST HAAS *Oak Alley Plantation, Louisiana*. Kodachrome, 1961. Courtesy the artist. © Ernst Haas.

155/ ERNST HAAS *Knoxville, Tennessee*. Kodachrome, 1962. Courtesy the artist. © Ernst Haas.

156-7/ ERNST HAAS *Aspen, Colorado*. Kodachrome, 1980. Courtesy the artist. © Ernst Haas.

159/ HIROSHI HAMAYA *Ash Slides Radiating from the Summit of Mount Fuji* [Japan]. Dye transfer print, 1961. Courtesy the artist. © 1961 Hiroshi Hamaya.

160–1/ ALFRED EISENSTAEDT *Lofoten Island, Norway*. Kodachrome, 1966. Courtesy the artist.

162/ PAUL CAPONIGRO *Running White Deer, County Wicklow, Ireland*. Gelatin silver print, 1970s, from negative, 1967. Christie's East, New York. © Paul Caponigro.

163/ GORDON PARKS *Benedictine Monks Reciting Morning Prayers in Monastery, Atchenson, Kansas*. Gelatin silver print, 1955. Courtesy the artist.

164/ PAUL CAPONIGRO *Brewster, New York*. Gelatin silver print, 1963. Courtesy the artist. © Paul Caponigro.

165/ WILLIAM A. GARNETT *Two Trees on Hill with Shadows, Paso Robles, California*. Gelatin silver print, 1975. Collection Sam Wagstaff, New York. © 1975 William A. Garnett.

166–7/ JOHN LEWIS STAGE *Sheepherders in Monument Valley, Utah*. Kodachrome, 1970. Courtesy the artist. © 1970 John Lewis Stage.

168/ HENRI CARTIER-BRESSON *Two French Peasants Take Their Oxen to the Fields of Clermont-Ferrand, near Auvergne*. Gelatin silver print, 1960. © Henri Cartier-Bresson/Magnum Photos Inc.

169/ COSTA MANOS *Greek Peasants*. Gelatin silver print, 1964. © Costa Manos/Magnum Photos Inc.

170/ LES BLACKLOCK *Sunwapta River, Jasper National Park, Alberta, Canada*. Anscochrome, 1958. Courtesy the artist. © Les Blacklock.

171/ BOYD NORTON *Alpine Lake, Western Teton Range, Wyoming*. Ektachrome, ca. 1966. Courtesy the artist. © 1980 Boyd Norton.

172–3/ ART SINSABAUGH *Midwest Landscape No. 5 (edition 1/3)*. Gelatin silver print, 1960s. Worcester Art Museum, Worcester, Massachusetts. © Art Sinsabaugh.

174/ WILLIAM A. GARNETT *Train Crossing the Desert, Kelso, California*. Gelatin silver print, 1974. Courtesy the artist. © 1974 William A. Garnett.

175/ RAY MOORE *Edwinstowe*. Gelatin silver print, 1978. Courtesy the artist. © Ray Moore.

176–7/ MARC RIBOUD *Great Wall, China*. Probably Kodachrome, 1960s. Courtesy the artist. © Marc Riboud.

178/ W. EUGENE SMITH *Japan from the Window of a Train*. Gelatin silver print, 1961. Weston Gallery Inc., Carmel, California. © 1961 W. Eugene Smith.

179/ BURT GLINN *South End of Shikoku Island, Japan*. Gelatin silver print, 1961. © Burt Glinn/Magnum Photos Inc.

180/ ELIOT PORTER *Chinstrap Penguins, Couverville Island*. Dye transfer print, ca. 1978, from transparency, 1975. Daniel Wolf Inc., New York. © Eliot Porter.

181/ ELIOT PORTER *Blue-footed Booby, Galapagos Island* [Equador]. Dye transfer print, ca. 1977, from transparency, 1966. Daniel Wolf Inc., New York. © Eliot Porter.

182/ GEORGE TICE *Oak Tree, Holmdel, New Jersey*. Gelatin silver print, 1970. Courtesy the artist. © 1975 George Tice.

183/ GEORGE TICE *Wagon and Buildings, Bodie, California*. Gelatin silver print, 1965. Courtesy the artist. © 1975 George Tice.

184/ ROBERT FLICK *Illinois Landscape 74*. Gelatin silver print, 1974. Center for Creative Photography, University of Arizona, Tucson. © Robert Flick.

185/ COLE WESTON *Deserted House, Oregon*. Dye-coupler (Type C) print, 1975. Courtesy the artist. © 1975 Cole Weston.

186/ ERNST HAAS *Eagle in Winter*. Kodachrome, 1966. Courtesy the artist. © Ernst Haas.

187/ ERNST HAAS *Buffalo in Snow*. Kodachrome, 1966. Courtesy the artist. © Ernst Haas.

188–9/ DAVID PLOWDEN *Farmland near Rimouski, Quebec, Canada*. Gelatine silver print, 1969. Courtesy the artist. © 1971 David Plowden.

190/ DAVID PLOWDEN *Will County, Illinois*. Gelatin silver print, 1981. Courtesy the artist. © 1982 David Plowden.

191/ MARIO GIACOMELLI *Paesaggio, Italy*. Gelatin silver print, 1979. Courtesy Bristol Workshops in Photography, Bristol, Rhode Island. © 1979 Mario Giacomelli.

192/ BRETT WESTON *Canal, Holland*. Gelatin silver print, 1971. Christie's East, New York. © Brett Weston.

193/ HENRI CARTIER-BRESSON *Brie, France*. Gelatin silver print, 1968. © Henri Cartier-Bresson/Magnum Photos Inc.

194/ LEE FRIEDLANDER *Tokyo*. Gelatin silver print, 1977. Courtesy the artist. © 1977 Lee Friedlander.

195/ STEPHEN SHORE *Giverny, France*. Ektacolor print, 1981. Private collection, New York. © 1981 Stephen Shore.

196/ ALFRED SEILAND *Winter Landscape, Proleb, Austria*. Kodachrome, 1981. H.F. Manès Gallery, New York. © 1981 Alfred Seiland.

197/ FRANK HORVAT *Landscape in Eastern France*. Kodachrome, 1977. Courtesy the artist. © Frank Horvat.

198/ RICHARD MISRACH *Boojum No. 2*. Split-toned gelatin silver print, 1977. Courtesy the photographer. © 1977 Richard Misrach.

199/ PHILIP HYDE *Fallen Log at Silver Lake, near Lassen National Park, California*. Ektachrome, 1976. Courtesy the artist. © 1976, 1982 Philip Hyde.

200–1/ EVE ARNOLD *Song at Dusk, Inner Mongolia*. Kodachrome, 1979. © Eve Arnold/Magnum Photos Inc.

202/ ELIOT PORTER *Chasm at Deer Creek, Grand Canyon, Arizona*. Dye transfer print, ca. 1979, from transparency, 1967. Daniel Wolf Inc., New York. © Eliot Porter.

203/ DEAN BROWN *Glacier Bay, Alaska*. Dye transfer print, 1971. Dean Brown Archives, Center for Creative Photography, Tucson, Arizona. © 1982 Carol Brown.

204/ HARRY CALLAHAN *Cape Cod* [Massachusetts]. Gelatin silver print, 1972. Center for Creative Photography, University of Arizona, Tucson. © 1976 Harry Callahan.

205/ JOHN PFAHL *Great Salt Lake Angles, Great Salt Lake, Utah*. Dye-coupler (Type C) print, 1977. Freidus Ordover Gallery, New York. © 1977 John Pfahl.

206/ JERRY N. UELSMANN *Untitled*. Gelatin silver print, 1977. Center for Creative Photography, University of Arizona, Tucson. © Jerry Uelsmann.

207/ JERRY N. UELSMANN *Untitled*. Gelatin silver print, 1980. Courtesy the artist. © 1980 Jerry Uelsmann.

208–9/ WILLIAM CLIFT *Factory, Butte, Utah*. Gelatin silver print, 1975. Courtesy the artist. © 1975 William Clift.

210/ NASA *The Earth, from the Mediterranean to Antarctica*. (From the Apollo 17 Spacecraft). Special thin-base Ektachrome, 1972. National Aeronautic and Space Administration (NASA), Washington, D.C.

Biographies

ANSEL ADAMS *American, 1902–1984/Pages 105, 118–19, 122, 123*

Ansel Adams had a longer and more publicized career than any other living American photographer, gaining renown for his impeccably printed celebrations of the Western landscape. In 1916 Adams made his first photographs in the Yosemite Valley, an experience that significantly affected the direction of his career.

He was influenced by soft-focus pictorialism, but soon after meeting Paul Strand in 1930, he embraced the 'purist' aesthetic of 'straight' photography. In 1932, with Edward Weston, Imogen Cunningham, and others, he founded the F/64 group, which insisted on sharp focus in all details of the image. By the 1940s Adams had stated his photographic philosophy and codified his Zone System of printing that was disseminated in a series of influential handbooks. In 1939, with David McAlpin and Beaumont Newhall, Adams collaborated in the foundation of the Photography Department of The Museum of Modern Art, New York.

He was long associated with the Sierra Club, and his photographs of the Sierra Nevada mountains, Yosemite Valley, the desert regions of California and New Mexico, and other national parks and monuments, served the cause of conservation as much as they did photography.

Although best known for his landscapes, Adams also made many formal portraits, and photographed Japanese-Americans interned in California during the Second World War and the Utah Mormons (with Dorothea Lange).

ROBERT ADAMS *American, born 1937/Page 20*

Since the early 1970s Robert Adams has regularly exhibited his photographs at such august institutions as The Museum of Modern Art, New York. While the objectivity and dispassionate descriptiveness that mark his landscape photographs recall the 19th-century work of photographers such as Timothy H. O'Sullivan, Adams does not avoid the signs of encroaching civilization: tract-housing, motels, tyre-tracks, atmospheric pollution. His exploration of the discrepancies between the West's idyllic past and its troubled present has been carried out in three books: *The New West* (1974), *Denver* (1977), and *From the Missouri West* (1980).

EVE ARNOLD *American, born 1913/Pages 200–1*

Eve Arnold's photo essays for *Life*, *Look* and other magazines have focused on a range of subjects – from the Queen of England to potato-pickers on Long Island, from a nomad bride in Afghanistan to Hollywood stars, from babies dying of starvation in Zululand to the courtesans of Arabian harems. Her portraits of the Archbishop of Canterbury, Rudolph Nureyev, Joan Crawford, Clark Gable, Margaret Thatcher, and Indira Gandhi are equally esteemed.

Arnold's 1980 book *In China* resulted from a forty-thousand-mile, six-month-long trip to China, which took her to Tibet and Inner Mongolia as well as the more frequently travelled regions. An exhibition based on the book opened at the Brooklyn

Museum and toured the United States. Other books include *The Unretouched Woman* and *Flashback . . . the 50s.* Her most recent book is *In America.*

RAY ATKESON *American, born 1907/Page 120*
A professional photographer since 1929, Atkeson has specialized in creative pictorial outdoor photography. He works primarily in colour in a 4 x 5-inch format, although he employs smaller, hand-held cameras as well. Based in Portland, Oregon, he has photographed throughout the US and abroad. His photographs have appeared in virtually every American periodical concerned with the outdoors, and he has illustrated a series of 11 lavishly produced books dealing with America's regional heritage.

LEWIS BALTZ *American, born 1945/Page 13*
Born and raised in California, and a graduate of the San Francisco Art Institute and Claremont Graduate School, Baltz has established his reputation with two major publications. *The New Industrial Parks Near Irvine, California* (1975) offered a scrupulously formal examination of commercial architecture under construction. *Park City* (1975) presented a rigorous series of images dealing with the establishment of a new housing tract in Nevada. Filling his photographs with a wealth of details that are compelling and sometimes contradictory, Baltz, like the photographer Robert Adams, sees the contemporary American West primarily as material for 'sceptical landscapes,' which acknowledge the passing of the Western ideal.

GEORGE BARKER *American, active 1880s/Page 60*

FRANCIS BEDFORD *British, 1816–1894/Page 29*
Like many other 19th-century photographers, Bedford was professionally trained in the traditional graphic arts, both as a painter and lithographer. His earliest known photographs, principally topographic views, date from the 1850s. One of the early members of the Royal Photographic Society, Bedford was the one selected by Queen Victoria to accompany the Prince of Wales on his tour of the Near East in 1862. A selection of 210 of these views were exhibited on his return to Britain, and for years afterward prints from these negatives were published and sold. In addition to his well-known views of the Near East, Bedford specialized in landscapes of Britain, architectural views of cathedrals, and picturesque photographs of monuments and ruins.

LES BLACKLOCK *American, born 1921/Page 170*
'Blacklock Nature Photography' is the enterprise created by Les Blacklock and his family, who live deep in the woods of northern Minnesota. Specialists in outdoor views and wildlife photography, they have published 8 books on outdoor subjects since 1969.

A. BOUGAULT *Probably French, active 1910s/Pages 88–89*

MARGARET BOURKE-WHITE *American, 1904–1971/Page 129*
Born in New York, Margaret Bourke-White attended a number of colleges before discovering that her real talent lay in photography. After studying at the Clarence White School of Photography in New York, she began to photograph the American industrial scene in the late 1920s. Her work quickly attracted the attention of the publisher Henry Luce, who in 1929 hired her as the first staff photographer for his new magazine *Fortune.* In 1936, when Luce founded *Life,* Bourke-White became one of its original and most widely acclaimed photographers. In a working career that lasted into the 1950s, she travelled to every corner of the globe, from Hitler's Germany to Gandhi's India. Her photographs epitomized the photojournalistic approach, emphasizing strong graphic forms, bold contrasts, and a keen awareness of the expressiveness of the human face. A tireless photographic perfectionist, she helped shape the look of photojournalism during its most exciting period.

SAMUEL BOURNE *British, 1834–1912/Page 46*
Originally a photographer in Nottingham, England, Bourne was led to seek his fortune in India in 1861. There he joined in partnership with Charles Shepherd and established the firm of Bourne and Shepherd, which supplied photographic views of Indian cities, architecture, and countryside to a largely British clientèle. An indefatigable traveler, in the mid-1860s Bourne journeyed three times into the Himalayas in search of spectacular mountain views, leading expeditions that might include up to 54 Indian bearers. Not long after, the journals that Bourne kept during these photographic expeditions were published in *The British Journal of Photography,* and, along with his highly regarded photographs, helped establish his reputation.

BRADY STUDIO *American, active 1840s–1860s/Page 42*
The celebrated American photographer Mathew B. Brady (1823–1896) opened his first portrait studio in New York in 1844, followed by a second in Washington, DC in 1858. Brady's long-standing interest in using photography to illuminate the historical record was evident as early as 1845, when he set out to photograph the leading public figures of the day. In 1861, at the outbreak of the Civil War, he sent a number of photographers into the field to document the course of that conflict. Because of the long exposures and difficult chemical processes involved in photography then, battle scenes were not recorded. More customary were views before or after the main battles, or around the fringes of the action. Because Brady's name alone was stamped on the resulting prints, it remains difficult to identify the individual photographers responsible for many of the images. This lack of individual credit prompted several of Brady's photographers to leave his employ to strike out on their own.

BILL BRANDT *British, 1904–1983/Pages 116, 117*
After an apprenticeship with Man Ray in Paris for several months in 1930, Bill Brandt returned to England where he worked as a photojournalist. Throughout the thirties he

also produced three photography books chronicling lower-, middle-, and upper-class British life. Although working in a 'straight' reportorial mode, his photographs of this period are frequently marked by a disturbing, subtle element of strangeness and disease: the legacy of French surrealism. After the war, Brandt largely abandoned photojournalism, and the surrealist aspect of his work became progressively dominant – nowhere more so than in his nudes.

LOUIS ALPHONSE DE BRÉBISSON *French, 1798–1872/Page 35*
Brébisson is representative of the well-to-do Second Empire amateurs who did so much both to popularize photography and to expand its aesthetic boundaries. He took up photography as early as 1839 and progressed from daguerreotype and the paper-negative processes to the various wet-plate and dry-plate methods. An indefatigable inventor and experimenter, he published several photographic treatises, invented a printing frame, suggested improvements for collodion photography, and produced botanical photomicrographs. His deep interest in the natural sciences led him to explore the ways in which photography could aid the work of the naturalist. His enthusiasm for nature and cultivated aesthetic sense resulted in a number of sophisticated landscape studies taken in the region of his ancestral château in Falaise.

MME BRETON *French, active 1860s/Page 34*

DEAN BROWN *American, 1936–1973/Page 203*
Brown's portraits of musicians, singers and conductors were regularly featured in magazines like *Opera News,* and his photographs of gardens, houses, and landscapes appeared frequently in magazines like *Holiday.* His finest photographs remain his wilderness landscapes, which after 1969 were presented as small dye-transfer prints. In the summer of 1973, while photographing in the White Mountains of New Hampshire, Brown died in a climbing accident.

JOHN G. BULLOCK *American, 1854–1939/Pages 67, 71*
An amateur pictorialist photographer, Bullock was one of the founding members of the Photo-Secession just after the turn of the century. In 1879 he joined a drug and chemical firm in Philadelphia, where he subsequently became active in the Photographic Society of Philadelphia. He exhibited regularly in the Philadelphia photographic salons and, from the early 1890s, in international salons of pictorial photography as well.

WYNN BULLOCK *American, 1902–1975/Pages 138, 149*
In the late 1930s, Bullock moved to Los Angeles from his native Chicago and began to study photography at the Los Angeles Art Center School. There, influenced by the work of Moholy-Nagy and Man Ray, he first experimented with solarization. In the following years Bullock supported himself by portraiture and commercial assignments, but continued actively to pursue his personal photography, becoming a master of experimental techniques. After meeting Edward Weston in 1948, however, Bullock moved toward a more realistic style, working with a large-format view camera. In the following years, his best-known photographs included many expressive nudes and nature studies.

HARRY CALLAHAN *American, born 1912/Pages 112–13, 204*
By any reckoning Callahan is one of the most talented and productive American photographers of this century. In 1946 he accepted an invitation to teach at Chicago's Bauhaus-oriented Institute of Design where he, Aaron Siskind and Arthur Siegel fashioned a highly successful program of photographic instruction. In Chicago Callahan employed various experimental and formally innovative strategies (multiple exposure, serial presentation and dramatically dark lighting) to capture the look and feel of the urban experience. Attracted to vernacular architecture, Callahan has also photographed streets and buildings in New England – after 1977, exclusively in colour.

PAUL CAPONIGRO *American, born 1932/Pages 162, 164*
After briefly studying music at Boston University, Caponigro became an apprentice commercial photographer. He then served in the army, and subsequently returned to Boston where he worked as a freelance photographer and continued his photographic studies under Alfred W. Richter and Minor White. Following a one-man exhibition at Eastman House, Caponigro became a consultant in the photo-research department of the Polaroid Corporation. In 1966 Caponigro was awarded a Guggenheim grant to portray Ireland's megaliths, dolmens, and other ancient monuments.

HENRI CARTIER-BRESSON *French, born 1908/Pages 168, 193*
Cartier-Bresson initially studied with the cubist painter André Lhote. In 1930 he began to photograph seriously, finding in photography a means of drawing that 'carves and shapes reality in an instant'. He first acquired a 35mm Leica camera in 1933 and quickly developed a method of working almost intuitively with the small camera. Cartier-Bresson is inevitably associated with his notion of the 'decisive moment', that split second when all of the visual elements before the photographer are in temporary equilibrium, and which the photographer must be prepared to anticipate and seize. During the 1930s he regularly supplied picture stories to the leading illustrated periodicals of Europe, and in 1947 he was one of the founding members of the Magnum photo-cooperative. Cartier-Bresson has always insisted that his main interest lies with the single photographic image and its potential for revelation and poetic expression.

WILLIAM CLIFT *American, born 1944/Pages 208–9*
Between 1963 and 1975 Clift principally photographed Boston architecture. In 1975 he was among those commissioned by the Seagram Corporation to travel in the Southwest to portray county courthouses. Currently Clift lives in Santa Fe, New Mexico, and has turned to landscapes as his chief subject.

ALVIN LANGDON COBURN *American, 1882–1966/Page 70*

At the age of 21 Coburn already enjoyed acclaim on both sides of the Atlantic, and was welcomed to the Photo Secession and the Linked Ring. His earliest success sprang from his portraits of British literary personalities such as G.B. Shaw and W.B. Yeats, a series published as *Men of Mark*. But Coburn proved an equally sympathetic interpreter of landscape and the city. His poeticized soft-focus images of New York, London, Paris and Venice transformed urban subjects into highly stylized, nearly abstract studies of shape and shadow. Coburn's bold compositional devices – derived equally from the study of Japanese prints and Whistler's work – were considered unorthodox by his contemporaries.

T.Y. CROWELL *American, active 1950s/Page 133*

IMOGEN CUNNINGHAM *American, 1883–1976/Page 99*

During a long and prolific career that began in 1901, Imogen Cunningham defied easy categorization. She produced pictorialist nudes and portraits, became one of the founding members of the F/64 group, created a series of classic studies of plants, made celebrity portraits, studies of dancers, and experimented with manipulated prints and double exposures.

EDWARD S. CURTIS *American, 1868–1952/Pages 5, 84, 86*

In 1896 Curtis embarked on a self-assigned lifetime project to create a visual record of every tribe of North American Indians. He produced the monumental *North American Indian* between 1907 and 1930: it comprises 20 volumes and contains 1,500 photogravures. Curtis' immersion in the daily life, customs, costumes, and rituals of his subjects was unrivaled among photographers of Indian life. But his idealizing vision, while sympathetic, has been recently found to lack documentary authenticity because he frequently posed and costumed his subjects.

HUMBERT DE MOLARD *French, 1800–1874/Page 24*

Humbert de Molard was a distinguished amateur photographer who sought to improve many early photographic processes. He is believed to have participated in the earliest experiments of Nicéphore Niepce in 1846 and 1847, and in 1850 he demonstrated to the satisfaction of the French Academy of Science that his new and improved version of the albumen process was nearly as fast as the collodion.

PHILIP H. DELAMOTTE *British, 1821–1889/Page 28*

Son of the painter William Delamotte, Philip Delamotte spent the bulk of his professional career as a teacher of drawing and perspective at King's College, London. Today he is remembered chiefly for his remarkable photographic documentation of the construction of the Crystal Palace at the Universal Exhibition of 1855, but he was an active photographer for nearly twenty years. In addition to making his own photographs, he printed the work of others, and for a time taught photography at the Photographic Institution in New Bond Street, London. The author of a popular book introducing students and amateurs to photographic techniques, Delamotte also produced a number of photographically illustrated albums such as *The Sunbeam*, *Photographs from Nature*, and *Holland House*. These typically featured photographs of British landscape and scenes of country life.

ROBERT DEMACHY *French, 1859–1937/Page 72*

As the leader of the French pictorial movement in photography, Demachy was an effective advocate of the use of manipulated printing, the use of hand-coloured watercolour papers, and extensive handwork on prints and negatives. In 1894 he was among the first to work in the gum bichromate process, then an obscure method capable of very painterly effects. He decried 'hideous glossy paper' and declared that 'there can be no art without the intervention of the artist in the making of the picture'. In 1906 he abandoned gum bichromate for the oil painting process, and in 1914 gave up photography altogether for sketching.

J. DIXON-SCOTT *British/Pages 134–5*

A successful commercial photographer in the 1920s and 1930s. Many of his pictures appear in 'countryside' books, and in the regional studies of The Homeland Association.

IVAN DMITRI (pseudonym of Levon West) *American, born 1900/Page 132*

By the early 1930s, West's etchings of American Western scenes had been widely exhibited and acclaimed. During the Depression, however, West was forced to turn to photography for a livelihood. Adopting the psuedonym Ivan Dmitri, he saw his work published in magazines such as *Fortune*, *Vogue*, and especially the *Saturday Evening Post*. In 1959 he set aside his work as a professional photographer and founded Photography in the Fine Arts, an organization aimed at winning artistic recognition for photography.

KEN DOMON *Japanese, born 1909/Page 125*

Domon's documentary and landscape work heralded the advent of modern Japanese photography. He studied at the University of Tokyo until his expulsion in 1932 because of his radical activities. He subsequently became a studio photographer in Tokyo, turning to freelance work in 1945. In 1950 he helped establish the Shudan photo group, which brought a new emphasis on realism to postwar Japanese photography. In the mid-1950s Domon's documentary studies of the children of Tokyo and the children of coal-mining communities won wide attention, as did two books on the legacy of Hiroshima. At the same time, he photographed traditional Japanese sculpture, architecture, and landscapes, notably in the four-volume *Pilgrimages to Ancient Temples* (1963–71).

THOMAS EAKINS *American, 1844–1916/Page 64*

America's foremost realist painter of the late 19th century, Eakins aspired in his art to both scientific realism and psychological depth. His photographs share these same characteristics. Eakins' concern for the scrupulous description of the human figure lent an air of precision and sobriety to his photographs of the nude, which were often intended as studies for later paintings. His disarmingly candid photographs of his family and friends testify to his lucid and penetrating eye and they represent a notable departure from his era's prevailing taste for highly embroidered pictorial sentiment.

ALFRED EISENSTAEDT *American, born Germany 1898/Pages 115, 160–1*

Alfred Eisenstaedt was one of the first photographers to change to the small camera to record current events and people in the news. He covered the Ethiopian war and in 1935 he went to the United States, where he soon joined the staff of *Life*. Eisenstaedt sought unposed moments and declined to use special lighting or make-up for his portraits. His best-known work includes celebrity portraits, travel views, and candid street scenes.

PETER H. EMERSON *American, born Cuba, 1856–1936/Page 63*

Emerson strongly rejected the prevailing use of professional models and stilted studio portraiture and championed the idea of a 'naturalist' aesthetic. Dispensing with artificial studio settings and combination printing, Emerson demonstrated his approach to photography in his folio *Life and Landscape on the Norfolk Broads* (1886), consisting of 40 platinum prints mounted into a book that depicted the land and people of this marshy region. In 1889 he published a treatise entitled *Naturalistic Photography* in which he argued for a photographic aesthetic based both on optical vision (sharp focus on the central object, softer focus on the surrounding area) and on the specific characteristics of the camera image. A year later, however, he published another manifesto, *The Death of Naturalistic Photography*, in which he abandoned his earlier position and argued that photography could not aspire to art.

FREDERICK H. EVANS *British, born Cuba, 1853–1943/Page 1*

In the 1880s Evans learned photomicrography, for which he was awarded a medal by the Royal Photographic Society in 1887. He began in 1894 what became an extended series of photographic studies of English cathedrals and French châteaux. His profound love and knowledge of Gothic architecture was expressed in his delicate, contemplative studies of the great British cathedrals; often he focused on various architectural details and constructive elements. A meticulous craftsman, Evans was renowned for the gently lustrous tones he produced in his platinum prints. When platinum paper became unavailable during the First World War, Evans ceased photographing.

WALKER EVANS *American, 1903–1975/Page 16*

Born in St Louis and raised near Chicago, Evans began to photograph in 1927 after his return from a year in France. Dissatisfied with what he considered the excessive aestheticism of Stieglitz and the commercialism of Steichen – the two most prominent photographers of the day – Evans fashioned an influential documentary style marked by a luminous clarity and an unblinking directness. In 1835 he was hired by Roy Stryker of the Farm Security Administration to join the group of photographers documenting the social and economic effects of the Depression. Throughout his career Evans was drawn to various manifestations of vernacular culture and architecture: billboards, signs, shops, houses, churches, and streets.

ANDREAS FEININGER *American, born France, 1906/Page 139*

Son of the artist Lyonel Feininger, Andreas Feininger studied at the Bauhaus in the 1920s and began his career as an architect. Owing to the political turmoil in Nazi Germany in the early 1930s, he was unable to continue his practice, and turned to photography to provide his livelihood. After emigrating to America, he became a staff photographer for *Life* magazine from 1943 to 1962; during that time he completed nearly 350 assignments and worked in nearly every genre, including portraiture, landscape, abstraction, and the nude. In structure and feeling Feininger's photographs convey a cool intellectual charge. An unrelenting perfectionist, he has systematically explored virtually every area of photographic technique, from optical experiments employing telephoto or wide-angle lenses, to darkroom manipulations involving extreme contrast, solarization, and negative printing.

ROGER FENTON *British, 1819–1869/Pages 36–7, 38, 39*

In 1847 Fenton was among a group of British amateurs who formed The Photographic Club, which later became The Royal Photographic Society. In 1854 he went to the Crimea, becoming one of the first photographers of the battlefield. There he produced approximately 360 photographs of the encampments and fortifications, as well as images of camp life and portraits of officers and enlisted men. Back in England he occupied himself with a variety of photographic activities, producing stereoscopic pictures, landscape and architectural photographs for travel books, and folios of photographic reproductions of works of art.

GEORGE FISKE *American, 1835–1918/Page 87*

Born in Amherst, New Hampshire, as a young man Fiske migrated to California, where he initially worked as a bank clerk. By 1864, however, he had become a photographer, and after moving to San Francisco in 1868 served as a photographic assistant to the celebrated Carleton E. Watkins. In the late 1880s Fiske moved his operations to the Yosemite Valley, where he produced numerous commercial view photographs that were sold around the world. Most of his prints and negatives were destroyed in a fire in 1904. Ansel Adams, who became familiar with Fiske's surviving prints in the 1930s, hailed him as one of America's most outstanding Western photographers.

ROBERT FLICK *American, born Holland, 1939/Page 184*
After receiving a graduate degree in fine arts from UCLA, Flick joined the faculty of the University of Illinois. Currently he is Associate Professor of Art at the University of Southern California. He has served as a visiting artist at the University of Colorado, the Center for Creative Photography, and the California Institute of the Arts. His photographs have been published and exhibited internationally.

LEE FRIEDLANDER *American, born 1934/Page 194*
Friedlander first came to prominence in the early 1960s as one of a number of young photographers concerned with the American 'social landscape'. Whether photographing store-window reflections in which his own reflected image often plays a humorous role, or the visual incongruities with which the American urban landscape abounds, Friedlander brings an ironic and highly formal intelligence to bear. His most ambitious project, *The American Monument* (1976), explored the layers of cultural detritus that surround the nation's monuments. His most recent work, *Factory Valleys* (1982), surveys the industrial environment of north eastern Ohio and eastern Pennsylvania.

FRANCIS FRITH *British, 1822–1898/Pages 33, 56–7*
Frith is one of the earliest and most important topographical and archaeological photographers, and his large-plate photographs of Egyptian monuments are landmarks in 19th-century photography. He also established the first commercially successful photographic publishing house. In 1850 Frith opened a printing firm and began to experiment with photography. Six years later he sold the business and embarked on a photographic expedition to the Middle East, where he exposed hundreds of plates using the wet-collodion method. They were exhibited, published, and widely acclaimed. In 1857 he returned to the Middle East, and the photographs taken during that second trip were published in England as *Egypt and Palestine Photographed and Described by Francis Frith*, in which actual photographs were mounted on to a page. The edition ran to 2,000 copies. Further trips to Egypt and Palestine resulted in additional publications with mounted photographs. Frith's establishment remained in business until 1958, specializing in photographic views and postcards of landscape, architecture, and foreign places.

JOSEPH GALE *British, died 1906/Page 62*
Trained as a draughtsman, Gale was best known as a professional architect. An accomplished amateur photographer and a member of the Royal Photographic Society, he frequently pictured rustic characters and rural landscapes. An enthusiastic practitioner of the wet-collodion negative process and albumen-coated printing paper, Gale continued to employ these materials long after other photographers had abandoned them for the newer, less cumbersome dry processes and presensitized silver papers.

ALEXANDER GARDNER *American, born Scotland, 1821–1882/Page 53*
In 1856 Gardner emigrated from Glasgow to New York, where he found employment in Mathew Brady's portrait studio. Soon Gardner became manager of Brady's Studio in Washington, DC. When in 1861 Brady launched his ambitious plan to create a photographic record of the Civil War, Gardner went into the field as a photographer. In 1863, however, he left Brady's employ, possibly in a dispute over Brady's copyrighting Gardner's photographs in his own name. Gardner then became an official photographer for the Union Army of the Potomac, and at the war's end published his *Photographic Sketchbook of the War*, containing 100 photographs by himself and others. The book was not a commercial success, and Gardner in 1867 became an official photographer for the Union Pacific Railroad, for which he documented the route along the Chisolm Trail from Kansas to California.

WILLIAM A. GARNETT *American, born 1916/Pages 151, 165, 174*
During a cross-country flight in 1945 Garnett was suddenly struck with the idea of photographing the American landscape from the air. Piloting his own polished-aluminium single-engine plane, he prospects for suitable subjects on the earth below just as a street photographer scans the streets for his subjects. As John Szarkowski has written: 'Garnett is not a flyer who photographs, but a photographer who flies. His plane's function is to hold his camera in precisely the right spot at precisely the right moment, in order to achieve not a map but a picture.' The resulting photographs, many resembling expressionist painting, use as their material the pattern, texture and colour of the land below.

MARIO GIACOMELLI *Italian, born 1925/Page 191*
Giacomelli has spent most of his life in his native Senigallia, Italy, where he is active as a professional typographer and an independent poet, painter, and photographer. His photographs of everyday life rely on his intuitive grasp of the practice of daily experience, and his high-contrast landscape work is remarkable for its evocative graphic power.

LAURA GILPIN *American, 1891–1979/Page 91*
Supporting herself primarily through portraiture and commercial assignments, in 1919 Gilpin began to photograph throughout the Southwest. In 1930 she undertook a photographic study of the Navajo Indians that continued over many decades and culminated in *The Enduring Navajo* (1968). During the Second World War Gilpin became involved with aerial photography and later, at the age of 81, she produced a series of photographs of the Canyon de Chelly, Arizona, made both from the air and the ground.

HERBERT W. GLEASON *American, 1855–1937/Pages 82, 83*
Born in Malden, Massachusetts, Gleason was a Congregational minister until in 1899 poor health forced him to leave the ministry. He devoted the remainder of his life to photography and lecturing. His photographs of Walden Pond and other locales associated with the writer Henry David Thoreau were used to illustrate the 20-volume 1906 edition of Thoreau's writings. Long active as a naturalist and a conservationist, Gleason photographed wilderness areas in Alaska, the Rocky Mountains, the Southwest, and along the Pacific coast. These images were used by the US Department of the Interior to promote the establishment of a national park system. At his death Gleason left a collection of 6,000 glass-plate negatives.

BURT GLINN *American, born 1925/Page 179*
Burt Glinn rose to prominence when his colour photographs of the South Seas, Japan, Russia, Mexico, and California were published as complete issues of *Holiday* magazine. As a photojournalist he reported on the Sinai War, the US Marine landing in Lebanon in 1958, Castro's takeover in Cuba, and many other events. In addition, he has produced personality profiles on Sammy Davis, Jr., and Robert F. Kennedy.

FAY GODWIN *British, born 1931/Page 18*
Fay Godwin has had no formal training in photography, but since the late 1970s has been one of the most active and successful of British landscape phototographers. She was co-author, with Shirley Toulson, of *The Drovers' Roads of Wales* (London, 1977) and with Richard Ingrams of *Romney Marsh and the Royal Military Canal* (London, 1980). With Alan Sillitoe she worked on *the Saxon Shoreway from Gravesend to Rye* (London, 1983). Her prints are in major public collections, and were exhibited at the Victoria and Albert Museum in 'The Land' (1975). A large collection of her pictures has been toured by the British Council.

JOHN C. H. GRABILL *American, active 1870s/Page 85*

ERNST HAAS *American, born Austria, 1921/Pages 154, 155, 156–7, 186, 187*
As a student in Vienna, Haas presented a photographic portfolio in the pictorialist style to Arthur Kubler, the editor of the picture magazine *Du*. Kubler responded by showing him the work of the photojournalist Werner Bischof, thereby deeply influencing Haas' direction. Haas returned to Austria where he photographed the return of Austrian prisoners-of-war, thus launching a career as a photojournalist. In 1950 he emigrated to the United States where he became a *Life* magazine staff photographer and a member of the Magnum picture agency. An indefatigable experimenter, Haas has photographed in many cities using multiple exposures, colour filters, and blurred motion effects.

HIROSHI HAMAYA *Japanese, born 1915/Page 159*
Born in Tokyo, since 1937 Hamaya has established himself as one of Japan's leading documentary photographers. He has been associated with the Magnum photo-cooperative since 1960, and has carried out photographic assignments around the world. He began his career with photographs of Japan's urban scene, then moved on to an extended reportage on the remote villages of Japan's 'snow country.' In recent years he has concentrated more exclusively on landscape and the relation of people to their physical environment in many cultures. Explaining his approach, Hamaya has stated: 'I want to look intently at nature, as objectively as possible.'

DIMITRIOS HARISSIADIS *Greek, born 1911/Page 150*
Born in Kavalla, Greece, Harissiadis grew up in Athens. He exhibited his photographs from the age of 17 but studied chemistry in Switzerland and worked as a chemist until 1940. During the Second World War he served in the Greek army, and the photographs that he took were used by the army in the press and in exhibitions. At the war's end, Harissiadis established himself as a photographic correspondent for the European press. In 1955 he photographed Greece for a year with the aid of a government grant. Since 1960 he has directed a photographic agency in Athens, and his images have appeared in a number of publications. He has written: 'When all is said and done, it is the human being that remains the most interesting subject in the world.'

JOHN HILLERS *American, 1843–1925/Page 48*
In 1871 Hillers was hired to accompany Major John Wesley Powell on a geographical survey of the Colorado River. Signed on as a boatman, Hillers soon became interested in the work of the photographers accompanying the expedition and during the course of the survey became a photographic assistant. In 1873, as Powell's principal photographer, he photographed in what is now Zion National Park in Utah. The following year, on yet another government survey, he worked in the Grand Canyon. These photographs were published in numerous official publications as well as magazines. In 1879, when Powell became the director of the newly created Bureau of Ethnology, Hillers was hired as the Bureau photographer, a position he held for the remainder of his photographic career.

THEODOR HOFMEISTER *German, 1865–1943*
and
OSKAR HOFMEISTER *German, 1869–1937/Pages 74–5*
The Hofmeister brothers were amateur artistic photographers in Hamburg, Germany, and were active in the Hamburg Amateur Photographic Society. They typically exhibited their works jointly. Around 1897 they began to concentrate on producing large multiple gum prints, usually landscapes, male nudes and peasant studies. These prints attracted considerable attention at the international photographic salons at which they were shown, and in 1904 six of the Hofmeisters' works were reproduced in Stieglitz's Photo-Secession journal *Camera Work*.

FRANK HORVAT *Italian (active France), born 1928/Page 197*
Frank Horvat attended art school in Milan, Italy, to study painting, but eventually turned to photography. In France he is particularly known for his photojournalism and fashion photography. He is regarded as one of the innovative photographers, who, in the 1950s, used the 35mm camera for a spontaneous look in his fashion work. Two of Horvat's books are *Goethe's Travels in Sicily*, (Novecento, Sicily, 1982) and *The Tree*, a book on the landscape (Little, Brown & Co., Boston, 1979).

L. A. HUFFMAN *American, 1854–1931/Page 10*
Born and raised on a frontier farm in Iowa, Huffman learned the wet-plate process as a boy and opened his own studio when he was 21. In 1878 he left Iowa to become photographer for the US Army post at Fort Keogh in the remote Montana Territory, subsequently settling in nearby Miles City. Huffman avidly photographed the lives of the homesteaders, cowboys, ranchers, and Indians of that still undeveloped region, compiling a remarkable record of the settlement of one of the last American frontiers. In 1905 he closed his studio to concentrate on printing his negatives of Montana's frontier days. These prints were sold to mail-order customers accompanied by short written sketches related to frontier life.

PHILIP HYDE *American, born 1921/Page 199*
For three decades a professional photographer in California, Hyde has concentrated in recent years on outdoor photography. Working primarily with a view camera, he has photographed extensively throughout the Rocky Mountains and the Southwest. His work has been featured in many publications of the Sierra Club.

WILLIAM HENRY JACKSON *American, 1843–1942/Pages 12, 52*
An official photographer for the US Geological Survey until 1879, Jackson is celebrated for his photographs of the natural wonders of the American West. In 1874 he opened his own photographic establishment in Denver and spent much of his time depicting the cities and landscapes along newly opened railroad routes in the US, Canada, and Mexico. In 1893 he photographed the spectacular Beaux Arts architecture of the Chicago World Columbian Exposition. In 1898, nearing the end of his career as an active photographer, he moved to Detroit and established the Detroit Publishing Company, which produced and distributed photographs of urban and landscape views from around the world.

ANDRÉ KERTÉSZ *American, born Hungary, 1894/Pages 80, 101*
Kertész began to photograph in his native Hungary before the First World War. In 1925 he left Budapest for Paris where he worked as a freelance photographer for the European illustrated press. He acquired a Leica in 1927, and became a pioneer in the use of the hand-held camera to capture fleeting events of daily life. While he is best known for his keen-eyed observations of the commonplace, Kertész has produced a rich variety of work, including a series of surreal images made with a fairground distorting mirror in the 1930s. Still active in his eighties, Kertész is considered by many to be the most important living photographer. Weston Naef has written: 'When the history of modern photography in Europe is finally written, we shall find that André Kertész is a little like Christopher Columbus, who discovered a new world that, in the end, was named for someone else.'

HEINRICH KÜHN *Austrian, born Germany, 1866–1944/Page 90*
At the turn of the century Kühn was a leader of the Austrian pictorial photography movement and a recognized figure in international art-photography circles. In the 1890s Kühn was one of the first to master the gum bichromate process, and his subsequent portrait and landscape photographs, famed for their large size and delicate beauty, helped this technique to win wide acclaim. In 1907 he began to employ autochrome plates to produce striking colour transparencies.

DOROTHEA LANGE *American, 1895–1965/Pages 98, 108*
Lange studied photography in New York with Arnold Genthe and Clarence H. White. In 1919 she opened a portrait studio in San Francisco, but in the early 1930s, responding to the social hardships of the Depression, she turned to documentary reportage and resolved henceforth to 'photograph the *now*, rather than the timeless'. From 1935 to 1940 Lange photographed throughout the West and South as part of the Farm Security Administration team. Her most celebrated pictures captured what she called the 'human erosion,' in particular the desperate plight of migrant families and the struggles of sharecroppers and tenant farmers in the South. By the late 1930s Lange, like the other Farm Security Administration photographers, had broadened her viewpoint to include visual journalism on all segments of American society. In the 1950s she contributed photographic essays to *Life* and other magazines.

GUSTAVE LE GRAY *French, 1820–1882/Page 26*
Originally a painter of portraits and landscapes, Le Gray learned the daguerreotype process in the late 1840s and opened a portrait studio in Paris in 1848. He quickly won a reputation as a superb craftsman and a coveted place on the staff of the Commission des Monuments Historiques in 1851. Le Gray is known for four bodies of work: a set of remarkable views of the military exercises staged for Napoleon III at Camp Châlons, seascapes whose subjects are light and atmosphere, forest scenes that embody the intimacy of Barbizon painting, and portraiture. His championing of the purely aesthetic merits of the photographic print elicited admiration, but commercial success eluded him.

HENRI LE SECQ *French, 1818–1882/Page 6*
Le Secq was one of a number of talented young men who first studied painting in the Paris studio of Paul Delaroche before taking up the new medium of photography. He was recognized as one of the finest architectural and landscape photographers in France in the early 1850s. In 1851 he was one of a select group of photographers chosen to document France's medieval architectural heritage for the Commission des Monuments Historiques. Working exclusively with the paper negative process, Le Secq produced atmospheric renderings of the medieval architecture of old Paris, for which he received regular attention in the pages of *La Lumière*, the most prestigious of early French photography periodicals. After completing a series of mysterious still-lifes which he called 'fantaisies,' in 1856 Le Secq abruptly abandoned photography and devoted himself entirely to painting and to building a large collection of antiquarian ironwork.

ROBERT MACPHERSON *Scottish, 1811–1872/Pages 40–1, 43*
Born in Scotland, MacPherson began his career by studying medicine in Edinburgh, but it appears that he never completed his degree. Instead, by 1840 he was established in Rome as a landscape painter. In 1851, possibly with the idea of supplementing his income, he took up photography, specializing in views of Roman architecture and artifacts for the tourist trade. His reputation as one of the most accomplished of the photographers working in Rome was enhanced by a well-received 1852 exhibition in London, which featured over 400 of his photographs. MacPherson's Roman views, most of them albumen prints, are remarkable for their clarity of detail and clear, expository presentation.

COSTA MANOS *American, born 1934/Page 169*
Born in South Carolina of Greek parents, Manos was working as a professional photographer at 15. After two years as a staff photographer in the army, he became the official photographer for the Boston Symphony Orchestra, which became the subject of his 1961 book *Portrait of a Symphony*. During the 1960s Manos worked on assignment for publications such as *Life, Look, Esquire*, and *Sports Illustrated*, winning special attention for his coverage of the civil rights and anti-war movements of that decade. In 1964 he became a full member of the Magnum Photo-cooperative. A three-year stay in Greece resulted in the book *A Greek Portfolio* (1972), a sensitive study of that country's landscape and inhabitants.

FRIEDRICH MARTENS *German, ca. 1809–1875/Page 31*
Born in Germany, Martens made an early reputation as a steel engraver in Paris. He specialized in engraved panoramas of European cities, which he exhibited in the Salons in the 1830s and 1840s. After taking up the daguerreotype process, Martens in 1845 introduced one of the first panoramic cameras. During the 1840s, he worked with both the calotype and wet-collodion techniques, and became well known for his Alpine views, usually taken in Switzerland, which were shown in Paris at the Universal Exposition of 1855.

CHARLES MARVILLE *French, 1816–ca. 1879/Page 27*
Beginning as a painter and illustrator in Paris in the 1830s and 1840s, Marville took up photography by the early 1850s and furnished many architectural studies and landscapes to the albums published by Blanquart-Évrard. As a photographer he enjoyed many official commissions ranging from the reproduction of works of art for the Louvre to the documentation of new buildings for the Administration des Bâtiments Civiles. Marville's most celebrated work, however, dates from the 1860s, when he conducted an official photographic survey of the sections of old Paris destined for destruction as part of Baron Haussmann's renovation of the city. These photographs stand as the most notable precedent for the subsequent work of Eugène Atget.

RICHARD MISRACH *American, born 1949/Page 198*
Born in Los Angeles, Misrach received a degree in psychology from the University of California at Berkeley in 1971. Since that time he has been a freelance photographer and a photography instructor at Berkeley. His first book of photographs, *Telegraph 3 a m*, dealt with the social aspects of street life in Berkeley in the early 1970s. His night-time photographs of desert vegetation, begun shortly afterward, marked a notable change of direction. Combining long exposures and the use of selective flash illumination, Misrach created meditative, mysterious images of the desert landscape. He has said: 'The photographs evoke a mystical or other-worldly response from viewers. But, of course, it's strictly an illusion, the manipulation of the medium. What engages me is the authenticity of the illusion.'

RAY MOORE *British, born 1920/Page 175*
Ray Moore originally studied at the Royal College of Art, and after a period as an abstract painter he began to take photographs in 1956. During the 1950s he taught lithography and then photography at Watford School of Art. In 1959 the publisher Gordon Fraser commissioned him to photograph buildings of historic interest in Britain. In 1970 he travelled to the United States and met Minor White, Harry Callahan and Aaron Siskind. His first retrospective was staged by The Art Institute of Chicago in 1971, and ten years later The Arts Council of Great Britain put together a major survey of his work at the Hayward Gallery, London. His art, which is designed to 'convey an awareness or revelation of the marvellous', is well printed in *Murmurs at Every Turn*, London, 1981. Many of his photographs are of the Cumbrian coast and of Dumfries-shire, where he lives.

WRIGHT MORRIS *American, born 1910/Pages 127, 140*
Morris is best known as a writer, with more than eighteen novels and numerous short stories to his credit. Self-taught as a photographer, he first began to work seriously with

the camera in 1935. Morris' importance to photography arises from three books he calls 'photo-texts,' which typically pair full-page photographs with blocks of highly evocative prose. The first of these, *The Inhabitants*, was published in 1946, followed by *The Home Place* (1948) and *God's Country and My People* (1968). Morris' photographs usually depict everyday locations, objects, or interiors, often devoid of human presence but animated by an unmistakeable human resonance. Overt drama is absent from these images, which are informed by a quiet lyricism.

COLIN MURRAY *Nationality unknown, active 1870s/Page 54*

PAUL NADAR *French, 1856–1939/Pages 78–9*
The son of the celebrated portraitist, caricaturist, and balloonist Félix Nadar, Paul Nadar took over the management of his father's studio in 1880. While he retained the flowing Nadar signature as his trademark, the products of the Nadar studio graudally became indistinguishable from those of the other commercial portraitists of Paris. An astute businessman, Paul Nadar enjoyed a profitable association with George Eastman, and became the Paris agent for Eastman Kodak. As a photographer, Nadar *fils* is known primarily for the 'Photo Interview' he staged between his father and the French scientist Michel-Eugène Chevreul in 1886, on the occasion of Chevreul's 100th birthday.

NASA (US National Aeronautics and Space Administration) *Established 1958/Page 210*
During the last few decades, the US National Aeronautics and Space Administration has provided some of the most exciting photographic imagery of our time. NASA's manned and unmanned missions have furnished a steady stream of dazzling photographs of the moon, the planets, and of the earth itself. The photograph reproduced was made by a NASA Applications Technology weather satellite in fixed orbit over South America.

BOYD NORTON *American, born 1936/Page 171*
A Colorado-based photographer who specializes in outdoor and travel photography, Norton has worked throughout the US. His work has been featured in *Time, National Geographic, Audubon, Smithsonian, American Heritage*, and many other magazines. His seven books include *Wilderness Photography* (1977), *Alaska: Wilderness Frontier* (1978), *Backroads of Colorado* (1979).

TIMOTHY H. O'SULLIVAN *American, ca. 1840–1882/Pages 50–1*
O'Sullivan received his early photographic training in Mathew Brady's New York portrait studio. But the training that left the strongest imprint on him was received on Civil War battlefields, where he photographed ruins, encampments and casualties, employing the wet-collodion process he was to utilize throughout his career. Many of his powerful photographs were subsequently to become part of *Gardner's Photographic Sketchbook of the War*, a set of 50 original prints mounted in a limited-edition set. In 1867 O'Sullivan became the official photographer for the Darien Survey in Panama, and in 1871, he returned to the West, this time photographing for Lt George Wheeler's 100th Meridian geological survey.

GORDON PARKS *American, born 1912/Page 163*
A photographer, film-maker, novelist, poet, and composer, Parks told the story of his early life in *A Choice of Weapons* (1966). He took up photography in 1937 after seeing the work of the Farm Security Administration documentary team; five years later he became the first Black photographer to join that group. He became a staff photographer for *Life* in 1949 and went on to cover a wide range of subjects for that magazine. His best-known work focused national attention on the plight of black Americans. Parks' recent colour photographs have been in a more imaginative, poetic vein; the images are frequently accompanied by his own poems.

IRVING PENN *American, born 1917/Page 137*
A prolific and inventive artist, Penn rarely photographs landscape, favouring the controlled environment of his studio. He uses only the simplest equipment and accessories. His early still-lifes for *Vogue* relied on the unstudied arrangement of commonplace objects animated by his unerring sense of design. His monumental nudes, dating from 1949 to 1950, portray the female figure in primordially sculptural terms.

JOHN PFAHL *American, born 1939/Page 205*
In 1974 Pfahl embarked upon a witty series of unmanipulated colour photographs that depict picturesque natural sites in which he has painstakingly laid out his own designs, deploying coloured string, foil, tape, or other materials that are like drawings on the land. The 'drawings' call to mind a magician's sleight of hand and focus our attention on the issues of truth and illusion in camera art. More recently he has produced a series of photographs that dryly present picturesque vistas framed by the window through which he observes the view.

DAVID PLOWDEN *American, 1932/Pages 188–9, 190*
In 1962 Plowden began to create photographic essays dealing with America's rural and urban landscape, and with the changes wrought by an increasingly industrialized society. The author of 13 books, Plowden is currently Associate Professor at the Institute of Design, of the Illinois Institute of Technology.

ELIOT PORTER *American, born 1901/Pages 2, 145, 180, 181, 202*
Porter took his degree in medicine and taught biochemistry at Harvard for a decade. In 1938 he was invited to exhibit his photographs at Stieglitz' 'An American Place' gallery in New York. At the urging of Stieglitz and Ansel Adams, Porter decided henceforth to devote his energies exclusively to photography. In 1940 – at a time when few serious photographers considered colour a worthy artistic medium – Porter began to work largely in colour, eventually making his own meticulous colour prints by means of the difficult and expensive dye-transfer process. Natural landscapes and animal life form the subjects of preference for Porter, who says, '. . . my emotions, instincts, and interests are all with nature.'

ALBERT RENGER-PATZCH *German, 1897–1966/Pages 107, 109*
In 1928 Renger-Patzch published *Die Welt Ist Schön* ('The World is Beautiful'), which originally was to be called *Die Dinge* ('Things'). This series of photographs of organic and inorganic forms, animals, people and architecture sought to depict the underlying order – both symbolic and formal – in all manner of natural and man-made objects, and in living creatures. Enormously popular and influential in its time, Renger-Patzch's photography was of signal importance for the New Objectivity developed in Weimar Germany. He continued to publish and exhibit up until the 1960s.

MARC RIBOUD *French, born 1923/Pages 176–7*
While working as an industrial engineer, Marc Riboud took a week's leave of absence to photograph. He never returned to the job and has never regretted it. In 1950 he met Henri Cartier-Bresson and promptly joined Magnum. He has travelled widely throughout his career, photographing the Congo in 1961, Vietnam in 1968, and the India-Pakistan War in 1971, as well as Churchill at a Conservative Party Conference in London in 1954, Pope Pius XII's funeral, and the Nigerian Independence Celebration in 1960. The fame of these essays notwithstanding, his reputation rests on photographs of agriculture and industry in mainland China taken in 1957, 1965, and 1971 – years when few photographers were admitted.

JAMES ROBERTSON *British, active 1850s/Page 32*
Robertson, who was the chief engraver and superintendent of the Imperial Mint at Constantinople, joined in an informal photographic partnership with Felice Beato in 1850. Together they photographed in Malta, Egypt, and Greece, and published a series of these views during the early 1850s. In the fall of 1855 Robertson arrived in Sebastopol just as the Crimean War came to a close; his documentation of the English, French, and Russian positions served as an admirable supplement to Roger Fenton's earlier photographs of the war. In 1858 Robertson and Beato moved on to India, where Robertson was to remain, becoming a partner of the photographer Charles Shepherd.

HENRY PEACH ROBINSON *British, 1830–1901/Page 59*
Robinson, who worked in a bookshop and was an amateur painter, learned photography in 1852 and several years later opened a portrait studio. After seeing Rejlander's 'The Two Ways of Life' in 1857, Robinson, too, began to produce elaborate combination prints of a sentimental nature. Robinson felt that for photography to qualify as art, it must go beyond documentation.

Robinson became the best-known pictorial photographer of the time in Britain, and his 1869 book, *Pictorial Effect in Photography*, which applied academic rules of painting to photography, was one of the most widely read photographic treatises of the 19th century. Even after technical advances rendered combination printing unnecessary, Robinson's work was marked by his proclivity for genre scenes and Victorian sentimentality.

AUGUST SANDER *German, 1876–1964/Page 111*
August Sander set himself the impossible task of making a photographic portrait of the people of Weimar Germany. He worked systematically, gathering specimens type-by-type from circus performer to baker to bureaucrat to industrialist. All face the camera squarely – rich, poor, old and young alike. Among the Cologne Progressives and other Marxist political groups, Sander's rejection of 'arty' pictorialist conventions spawned the belief that his photographs were nothing less than models of 'objective realism'. Today Sander's subtle interpretive genius is apparent.

In 1929 Sander published *The Face of Our Time* as the first installment of his project. In 1934 the Nazis destroyed the plates, but the negatives survived. After the war, Sander concentrated on sorting and printing his existing negatives.

FRANZ SCHENSKY *Germany, 1871–1957/Pages 96–7*
Schensky's first photographs were made in the 1890s and depict the old sections of the Baltic city of Helgoland. Noted at one time for his pigment prints, he enjoyed a considerable reputation for his photographs of the Baltic coast. He was fasincated with the idea of photographing the sea during surging storms, and for over a year he would set out to sea in a small boat during storms, risking his life for the satisfaction afforded by the images he made with a hand camera. In 1944, when his house in Helgoland was set alight by British bombs, Schensky photographed his burning house before fleeing with his family by boat.

ALFRED SEILAND *Austrian, born 1952/Page 196*
A freelance photographer, Seiland was originally a small-camera enthusiast. He has gradually come to favour a large-format view camera as his picture-making interests have become more clearly defined. Today he seeks to combine much visual information into a unified whole, working along lines similar to American colour photographers such as Stephen Shore and Joel Meyerowitz.

CHARLES SHEELER *American, 1883–1965/Page 126*
Among the first photographs Sheeler exhibited were a number made in 1924 of a house in Doylestown, Pennsylvania, that he shared with the painter-photographer Morton Schamberg. Attracted by industrial and architectural subjects, Sheeler photographed frequently in New York City in the early 1920s; his photographs from this period are remarkable for their geometrical organization and rigorously formal ordering of surface, shadow, and plane. During the 1920s Sheeler divided his time between painting

in a highly photographic 'precisionist' style) and commercial photography for *Vogue* magazine and advertising clients. In the late 1920s he carried out extended photographic studies of the Ford Motor Company's River Rouge plant, and of Chartres Cathedral.

STEPHEN SHORE *American, born 1946/Page 195*
While still in his 'teens, Stephen Shore made the photographs of Andy Warhol and his studio that were published in the book *Andy Warhol* (1968). His first major solo exhibition of black-and-white photographs was held at The Metropolitan Museum of Art, New York, in 1971. In 1973 Shore began to photograph exclusively in colour with an 8 x 10-inch view camera, and in so doing was the leader of a movement away from black-and-white materials favoured by artist-photographers. Shore professes to have been deeply influenced by Walker Evans, with whom he shares a sensitivity to the often ironic interplay of America's indigenous architecture and natural landscape, and for his ability to crowd the picture frame with subtly interacting shapes, patterns, and colours. Working in an unobtrusive documentary style, Shore presents what Walt Whitman called 'facts showered over with light', which slowly disclose a cumulative meaning.

CAMILLE SILVY *French, active 1857–1869/Page 30*
A wealthy aristocrat who for a time served as a diplomat, Silvy in 1858 became a member of the Société Française de Photographie. A year later he moved to London, where he opened a luxurious portrait studio at Hyde Park. While best known at the time for his carte-de-visite portraits of the British and Continental social élite, Silvy created a sensation at the London Salon of 1859 with his photographic landscapes that featured striking cloud effects. In addition, he was one of the first to photograph horses and goats to study animal locomotion, and he contributed occasional articles on photography to various publications. Silvy sold his business in 1869 and retired to his château in France for the remainder of his life.

ART SINSABAUGH *American, 1924–1983/Pages 172–3*
Sinsabaugh's career parallels that of a number of the young photographers who, following the Second World War, helped photography win an increasingly important place in the university curriculum. He studied at Chicago's famous Institute of Design from 1945–1949; his teachers were Lázló Moholy-Nagy, Harry Callahan and Aaron Siskind. Sinsabaugh taught there from 1951 to 1959, then moved to the University of Illinois, Urbana, where he helped organize the photography programme. While at Urbana, he discovered the 'banquet camera' with which he began to produce long, horizontal images: views of the Midwestern landscape and remarkable cityscapes of Chicago.

AARON SISKIND *American, born 1903/Page 142*
Aaron Siskind began his career in photography with a deep social consciousness that led him to be an active member of the New York Film and Photo League. By the time he completed his series on Tabernacle City – a religious community in Bucks County, Pennsylvania – Siskind had begun to gravitate towards a style concerned with form and order. Documentary projects, such as the Harlem Document, were superseded by studies of inorganic objects, rocks, peeling walls, torn posters, etc., in which space was flattened and the image reduced to a play of shapes, tones, and patterns. Siskind's close relationships with several of the abstract expressionist painters of the New York School reinforced and supported this direction.

W. EUGENE SMITH *American, 1918–1978/Page 178*
Born in Kansas, where he took up photography in high school, Smith later graduated from Notre Dame University, and in 1937 joined the staff of *Newsweek*. In 1939 he began to photograph for *Life;* from 1942 to 1945 he covered the Second World War in the Atlantic and Pacific. In 1945 he was seriously wounded on Okinawa; only after two years convalescence did he return to work for *Life*. Driven by feelings of personal responsibility to *Life*'s vast audience and insisting that 'superficiality is untruth', Smith sought intense emotional involvement with the subjects of his photographs. After resigning from *Life* in 1954 in protest over the editor's handling of his photographs of Albert Schweitzer, Smith in 1955 began an ambitious, primarily self-financed study of the city of Pittsburgh: its mills, its factories, its workers, and the city itself.

JOHN LEWIS STAGE *American, born 1925/Pages 166–7*
Raised in Warwick, N.Y., Stage became an avid photographer while still in his teens. He has worked for more than three decades as a professional photographer, specializing in editorial photography for magazines such as *Holiday* and *Travel and Leisure*. His photographic assignments have carried him to more than 150 countries, where he photographed leading personalities for *Town and Country*. Although he has worked in virtually every camera format, Stage currently relies almost exclusively upon 35mm equipment.

EDWARD STEICHEN *American, born Luxembourg, 1879–1973/Pages 92, 93*
Encouraged by Alfred Stieglitz, Steichen emerged as one of the leading figures of the Photo-Secession and made his debut in 1898. A master of a wide array of processes, such as gum bichromate and platinum printing, he produced landscapes, cityscapes and portraits that show the pictorial style at its most evocative and compelling. During the First World War Steichen commanded a photographic division of the Army Air Services in France. In 1922 he destroyed his remaining paintings and, returning to New York, became chief photographer for *Vogue* and *Vanity Fair* magazines. Until he closed his studio in 1938, Steichen was recognized as one of the leading portrait, fashion, and advertising photographers in America; his brilliant studio technique and pared-down compositions helped shape contemporary practice. During World War II he led a small photographic unit in the United States Navy. From 1947 until his retirement in 1962 he

served as Director of the Department of Photography at The Museum of Modern Art, New York, where he organized the immensely successful *Family of Man* exhibition in 1955.

RALPH STEINER *American, born 1899/Page 148*
After attending Dartmouth College, Steiner studied photography at the Clarence White School of Photography in New York from 1921 to 1922. In 1923 he began to work as a freelance photographer, taking on advertising assignments as well as illustration assignments for popular magazines. His discovery of the photographs of Paul Strand in 1927 helped to determine the direction of his own subsequent photographic work, and Strand's example, too, led Steiner to undertake independent motion picture work. After working as a freelance photographer in New York from 1923 to 1969, and serving as picture editor and photography critic of the weekly *P.M.* during the 1940s, in 1970 Steiner retired to Vermont, where he continues to write, lecture and photograph.

ALFRED STIEGLITZ *American, 1864–1946/Pages 21, 95*
Stieglitz is unquestionably the central figure in the rise of modern art photography in America. As the editor of *Camera Notes* in New York from 1897 to 1902, he waged a successful campaign on behalf of pictorial photography; he was likewise the animating spirit behind the Photo-Secession (1902), and edited its superb publication *Camera Work*. Like the French and American modernist painters, Stieglitz was drawn to urban subjects. As early as the late 1880s, he was photographing city streets in a style influenced both by Impressionism and by Whistler. In 1917 he began what was to become an extended, intimate portrait of the painter Georgia O'Keeffe, whom he married in 1924. Stieglitz's photographs of clouds, originally called 'Songs of the Sky,' were begun in the 1920s; they inaugurated the idea that the photograph provides an equivalent for the photographer's moods, feelings, and emotions – for Stieglitz, indeed, an evocation of 'my philosophy of life.'

PAUL STRAND *American, 1890–1976/Pages 17, 100, 106, 130, 131, 136, 152–3*
Paul Strand was a towering figure in American photography for more than fifty years, and a major force in establishing sharp-focus, non-pictorial photography after the First World War. A student of Lewis Hine at the Ethical Culture School in New York, Strand was introduced to Alfred Stieglitz in 1907. After the war, he worked as a motion picture cameraman, collaborating with Charles Sheeler on the experimental film *Mannahatta* in 1920–21. Like many artists of his period, Strand was fascinated by the new urban landscape of high-rise buildings, the variety and energy of the city's crowds, and the dramatic light-effects in a wholly man-made environment. After concentrating on film making for a number of years Strand returned to still photography, and in 1946–47 collaborated with Nancy Newhall on the classic *Time in New England*.

KARL STRUSS *American, born 1886/Page 77*
Although most of his professional life was spent as a Hollywood cinematographer, in the years before the First World War Struss enjoyed a period of prominence as a pictorialist photographer. A student of the Photo-Secessionist Clarence H. White, Struss in 1909 became a member of the Photo-Secession and exhibited his work in the famous Albright Art Gallery show organized by Stieglitz. Struss subsequently published portraits and advertising photographs in publications such as *Vogue*, *Vanity Fair*, and *Harper's Bazaar* before moving permanently to Hollywood in 1919. A skilled photographic technician and inventor, he concentrated increasingly on motion picture photography for the remainder of his career.

A.H.P. STUART-WORTLEY *British, active 1860s/Page 58*

JOSEF SUDEK *Czechoslovakian, 1896–1976/Page 110*
During the First World War, as a conscript in the Hungarian army, Sudek lost his right arm, and was thus forced to abandon his trade as a bookbinder. He became a professional photographer, training himself even to change film with one hand. His highly romantic sensibility was expressed in lyrical, atmospheric photographs such as those taken from his Prague studio window. Using a panoramic camera, Sudek photographed Prague and the surrounding countryside in all seasons. It is the ancient city of Prague itself, with its churches, castles, and towers, that became a dominant subject in Sudek's photographs.

WILLIAM HENRY FOX TALBOT *British, 1800–1877/Page 23*
Frustrated by his inability to sketch accurately scenery in the Italian lake region, Talbot determined to fix the image he sought in the camera obscura. In 1835, exposing writing paper coated with salt and silver nitrate, he obtained the first photographic negatives and prints. He neglected, however, to announce his discovery until 1839, after Daguerre's process had been proclaimed in Paris. In 1844, in order to popularize his improved process, the calotype, Talbot published *The Pencil of Nature*, containing 24 of his own photographs as well as an accompanying text that prophesied many of photography's eventual applications.

JOHN THOMSON *Scottish, 1837–1921/Page 55*
Born in Edinburgh, Thomson was a restless traveller who photographed China, Cambodia, and Indochina. He spent several years in the Far East (mid-1860s–1872), and on his return to England published his photographs in a number of books, of which the four-volume *Illustrations of China and Its People* (1873–74) is perhaps the most impressive. In it Thomson revealed the Chinese landscape, cities, and people, presenting a rare and valuable record of the country and its customs in that period. Thomson settled in London as a professional portrait photographer but won enduring fame with his photographs of working-class Londoners, published in 1877 as *Street Life in London*.

GEORGE TICE *American, born 1938/Pages 182, 183*
Born in Newark, N.J., Tice began to photograph at the age of 14 and subsequently served as a photographer's mate in the US Navy from 1956 to 1959. He worked as a commercial portrait photographer from 1960 to 1969, but his non-commercial work excited the attention of Edward Steichen, then director of the photography department of The Museum of Modern Art, New York. Since 1969 Tice has worked as a freelance photographer, and since 1970 he has taught at the New School for Social Research in New York. He has proved himself a master of a variety of photographic techniques and processes; in recent years he has revived the lost art of platinum printing and produced exquisite prints on hand-coated papers. Tice's choice of subjects has been equally varied: landscapes, cityscapes, a photographic essay on Pennsylvania German farm communities, and an extended portrait of a factory worker.

KENNETH W. TYLER *Nationality unknown, active 1950s/Page 147*

JERRY N. UELSMANN *American, born 1934/Pages 206, 207*
Uelsmann coined the phrase 'post-visualization' to describe his work, which takes its principal form in the darkroom after the negatives have been made. He regards the darkroom as his 'visual research lab' for experimentation in multiple-printing techniques, and he employs a number of different negatives and enlargers to achieve his immaculate illusions. Through his unlikely juxtapositioning of images, he introduces photographic realism to the realm of the fantastic, seeking 'an innermost world of mystery, enigma, and insight'.

LORING UNDERWOOD *American, 1874–1930/Page 76*
The younger brother of the photographer William Lyman Underwood, Loring Underwood was born in Belmont, Massachusetts, and educated at Harvard College. In 1896 he began to lecture on landscape architecture and gardens, and took up photography at that time in order to provide himself with lantern slides to illustrate his lectures. After studying landscape architecture in Paris, he opened his own landscaping practice in Boston in 1900. During the next three decades he was active not only as a professional landscape architect, but also as Belmont's long-time park commissioner.

WILLIAM LYMAN UNDERWOOD *American, 1864–1929/Page 66*
Underwood at the age of 20 began to make annual trips to a cabin in Maine and to photograph and write about his experiences there. From 1899 to 1924, while serving as a special lecturer for the department of Biology and Public Health at The Massachusetts Institute of Technology, he regularly published photographic and adventure articles in *Photo Era* and *Open Road* magazines. He was an ardent naturalist and outdoorsman, director of the Massachusetts Zoological Society, and a member of the Audubon Society and the Boston Natural History Society.

HERMANN VOGEL *German, 1834–1898/Page 45*
One of the most important photo-chemists of the late 19th century, Vogel is best remembered for pioneering research that led to the introduction of orthochromatic emulsions. He was also a very active figure in both German and international photographic societies. In 1864, a year after completing his dissertation on photographic chemistry, he founded a Photographic Society in Berlin; in 1865 he directed the first Berlin Photographic Exhibition. Vogel remained a supporter of artistic photography throughout his career and frequently served as a judge at international exhibitions. In the history of artistic photography, Vogel is remembered especially as the teacher of Alfred Stieglitz, later founder of the Photo-Secession movement.

ADAM CLARK VROMAN *American, 1856–1916/Page 65*
A former railroad employee in Illinois, and subsequently a successful bookseller, Vroman photographed actively for perhaps only 15 years. In 1895 he attended a Hopi Indian snake dance, which proved to be a pivotal experience in his development as a photographer. Overwhelmed by the religious intensity and symbolism of the dance, he returned year after year to observe it. Thus began his commitment to the Indian cause, manifested through photographs, articles, and public lectures. For almost ten years he employed a direct, brilliantly sharp photographic technique unlike that of his pictorialist contemporaries.

WALMSLEY BROTHERS *American, active 1890s/Pages 68–9*

[GEORGE K.?] WARREN *American, active 1850s–1870s/Page 44*
Little is known of this itenerant photographer who worked in the American Northeast.

CARLETON E. WATKINS *American, 1829–1916/Pages 11, 49*
After learning the photographic process as a studio portrait photographer in San Jose, California, Watkins in 1861 embarked on his first expedition to Yosemite Valley, an area whose natural wonders had aroused public curiosity. Watkins transported slowly and laboriously on muleback a load of glass 'mammoth plates', with which he made the first of the Western landscape photographs that established his reputation. Returning to Yosemite repeatedly throughout the 1860s and 1870s, he developed a photographic approach that rested on a surprising but convincing perception of classical order and proportion in the wilderness. His studio failed in the early 1870s, and having lost his

negatives to creditors, he was forced to retrace his earlier footsteps. Although the bulk of his own collection of prints and negatives was destroyed in the 1906 San Francisco earthquake and fire, sufficient examples of Watkins' work have survived to establish him as one of the prominent 19th-century photographers of the West.

JACK WELPOTT *American, born 1923/Page 143*
Welpott has been a major influence on photographers in the San Francisco area since the late 1950s. He studied under Henry Holmes Smith at Indiana University and has benefitted from his acquaintance with Aaron Siskind, Minor White, Harry Callahan, and other prominent photographers. He is recognized for his metaphorical landscapes and interiors, and especially for his portraits of women.

He rose to national prominence in the early 1970s when he and Judy Dater began photographing women whom they found 'fascinating and who, in some manner, expressed something about the 'feminine mystique''. Each made portraits that are psychologically charged, although Welpott worked at greater remove. The photographs were published in *Women and Other Visions* in 1975.

BRETT WESTON *American, born 1911/Page 192*
Son of the photographer Edward Weston, Brett Weston learned photography from his father when he was 14. Within a few years he had become an active partner in the Weston portrait studio in Glendale, California, and had begun to exhibit his own photographs. In 1929 a large group of his pictures were included in the Film and Foto Exhibition in Stuttgart, bringing his work to international attention. After operating his own studio in Santa Barbara for a decade, Weston was drafted in 1941 and, while stationed in New York, photographed the city with a large 11 x 14-inch camera. During the 1940s he fashioned an unmistakeable personal style, one more insistently graphic and pattern-oriented than his father's.

COLE WESTON *American, born 1919/Page 185*
Cole Weston, son of the photographer Edward Weston, originally wanted a career in acting rather than photography. It was during the Second World War that he became a photographer for the United States Navy. After the war he went to work for *Life* magazine, until in 1946 his father who had become ill with Parkinson's disease asked him to return to Carmel, California, to assist him. Cole's own photography continues in the tradition established by his father of sharply focused, well-composed and carefully previsualized view camera imagery. Cole, however, has translated this aesthetic into colour work, primarily with the landscape, and, occasionally, the nude.

EDWARD WESTON *American, 1886–1958/Pages 19, 94, 102, 103, 104, 114, 121, 124*
Weston opened a portrait studio in Glendale, California, in 1911 and became one of the leading pictorialist photographers in the West. By 1922 he had moved toward a style that combined sharp-focus realism with an underlying sense of abstract form, and he emphasized the 'aesthetic beauty of the thing itself'. After a long interlude in Mexico, Weston returned to California in 1927 and began a series of close-up studies of sculpturesque natural forms; at the same time he began to photograph along the coast at Point Lobos. In 1932 he was a founding member, with Ansel Adams and Imogen Cunningham, of the F/64 group; in 1937 he received the first Guggenheim Fellowship awarded to a photographer. Weston's credo of previsualization – that the finished print should be seen in the mind's eye before the film is exposed – proved enormously influential among young photographers, as did his insistence on using photography's 'heightened sense of reality' to reveal 'the vital essence of things'.

CLARENCE H. WHITE *American, 1871–1925/Page 73*
In 1893 White became an active amateur photographer. By 1898, when he exhibited ten prints in the first Philadelphia Photographic Salon, he had begun to acquire a reputation for his intimate, softly diffused images, often depicting poignant family scenes or allegorical figures. In 1898 White visited Alfred Stieglitz in New York, and four years later figured as one of the founding members of the Photo-Secession. After moving to New York in 1906, he became a lecturer on photography at the Teachers College of Columbia University. In 1914 he founded the Clarence White School of Photography in New York, which for a decade served as a training ground for a number of outstanding young photographers such as Paul Outerbridge, Jr., and Margaret Bourke-White.

MINOR WHITE *American, 1908–1976/Pages 128, 141*
One of the foremost photographic educators of this century, White worked as a photographer for the Works Progress Administration in Oregon in 1938–39, and after military service in the Second World War joined the photographic faculty of the California School of Fine Arts in San Francisco. In 1952 he became the founding editor of the influential publication *Aperture*. White served as assistant curator at the George Eastman House from 1953 to 1956; he taught at the Rochester Institute of Technology in 1965. White extended Stieglitz's notion of the photographic 'equivalent' to encompass the search for spontaneous symbols that served to mirror the psyche. His study of esoteric literature – the teachings of Gurdjieff, Zen, and the I Ching – led him especially to favour the use of constantly metamorphisizing materials, such as water, ice, and clouds; in such constantly changing forms the 'sensitized mind' of the photographer might seize glimpses of a transcendental calm.

Glossary

ALBUMEN PRINT Albumen printing paper was invented by a Frenchman, Louis Blanquart-Evrard, around 1850. By 1855 it had become the major photographic printing technique, and it remained dominant until the 1890s. The great majority of nineteenth-century photographs were printed on albumen papers. The paper was prepared commercially by coating large sheets with a solution of egg albumen and ammonium or sodium chloride. It was dried, cut into smaller sheets, and sold in this form. Photographers sensitized it themselves by floating the paper, albumen-side-down, in a tray containing a silver nitrate solution. The silver nitrate combined with the chloride in the albumen coating to produce silver chloride, which darkens on exposure to light. After drying the paper, the photographer printed it by contact beneath a negative, exposing it to sunlight. The image appeared during exposure – no development was necessary. It was then toned in a solution of gold chloride and fixed in sodium thiosulfate (hypo). Albumen papers largely replaced plain salted papers, although the latter process remained in limited use because it was inexpensive and could be simply prepared at home or in a studio. Albumen had the advantage of a glossy surface, which could preserve image detail better than the matt surface of salted papers and also made the blacks appear deeper.

AUTOCHROME Introduced by the Lumière brothers in 1907, this was the first commercially successful colour process. It produced a positive transparency and was based on the additive colour system. Although the theoretical basis of colour reproduction had been understood as early as the mid-nineteenth century, colour photography had to wait until the invention of panchromatically sensitized silver emulsions – meaning emulsions sensitive to all visible wavelengths, not just to blue light as the earlier 'colour-blind' emulsions had been. In the Autochrome process a glass plate was first covered with a mixture of starch grains. The mixture was made up of separate grains dyed green, red, and blue. They were transparent enough to act as tiny colour filters. A panchromatic, black-and-white emulsion was then coated on top. The plate was exposed through the glass side, so that the light had to pass through the grains. The separate grains allowed only light of their own colour to reach the emulsion. The plate was bleached and redeveloped, which resulted in a positive image that could be viewed by placing a light behind. In the white parts of the image, light passed through all three types of starch grains, combining to give the illusion of white. No light passed through in the shadows. The other colours were produced by a combination of red, green, and blue, passing through in various proportions. Because the grains were so tiny, the colours blended together. Autochrome images were somewhat grainy, and the colours soft and pastel-like in quality. Autochrome plates were used until the 1930s, when the much superior Kodachrome process became available.

CALOTYPE Invented by William Henry Fox Talbot in 1840, the calotype was the first practical method for making photographic negatives based on the principle that certain salts of silver are sensitive to light and darken when exposed. Talbot first brushed a solution of silver nitrate over a sheet of paper, then dipped the paper in potassium iodide. It could be stored in this form until needed. Talbot sensitized the paper by brushing over a solution of silver nitrate and gallic acid. He placed it in the camera for exposure, then developed it by again brushing on the silver nitrate/gallic acid solution. He fixed it in sodium thiosulfate (hypo). To make this fairly dense paper negative more transparent, Talbot applied a coating of wax. He made prints from the negative using the salted paper process he invented in 1834. Because of the texture of the paper, prints from calotype negatives did not have the minute detail possible with the daguerreotype, the rival process at the time. But the calotype had a great advantage over the daguerreotype in that any number of prints could be made. The calotype was supplanted in the early 1850s by the wet-plate negative. Since it used a glass support instead of paper, the wet plate could better retain image details.

CARBON PRINTING One problem the early photographic experimenters faced was the tendency of photographs to fade or change colour because of the unstable chemical nature of the silver forming the image. During the 1850s, photographers began to look for ways to replace silver with more stable materials. The carbon transfer process, introduced commercially in 1866 by Joseph W. Swan, was one result. The technique is still used today. The process involves a special 'carbon tissue' – a sheet of paper coated on one side with a film of gelatin mixed with a pigment (the pigment is often carbon black because of its known chemical stability). The tissue is sensitized as needed in a solution of potassium dichromate, then hung in the dark to dry. During printing by contact under a negative, the gelatin becomes hardened (its melting point is raised) in those areas exposed to light. The tissue is then placed in a tray of cold water in face-to-face contact with a second sheet of paper coated with unpigmented gelatin already hardened by chemical means. The two sheets are taken from the water, pressed together, and left to dry. Next, the combination is placed in hot water. This softens the gelatin just enough to allow the original backing paper to be stripped away, leaving the gelatin film in contact with the second sheet. In the hot water the unexposed, unhardened gelatin melts and washes away, carrying pigment with it. The exposed gelatin, and its pigment, is left behind to form the image.

COLLOTYPE One of the earliest photomechanical printing techniques, the collotype process was patented by Alphonse Poitevin in 1855 and made commercially practical by Joseph Albert in the late 1860s. It is still used today, but only by a few printing companies. Collotype is based on Poitevin's discovery that a coating of gelatin (or other colloid) sensitized with dichromate and exposed to light beneath a negative can be made to accept printing ink and reproduce a tonal scale with great exactness. In its standard form the collotype process involves first covering a glass plate with dichromated gelatin. Usually the glass had been ground down on

one side so that the gelatin has a textured surface to which to adhere. The plate is dried in a warm oven, allowed to cool, and then exposed beneath a negative. Exposure hardens the gelatin in proportion to the amount of light passed through. After exposure the plate is soaked in water. The unexposed, unhardened gelatin in the highlights absorbs water; the exposed, hardened gelatin in the shadows absorbs no water; the middle tones absorb an intermediate amount. After soaking, the plate is taken from the water, blotted off, and a greasy ink is applied with a roller. Water repels grease. The ink sticks to the plate in the dry parts, is repelled by the water in the highlights, and forms intermediate tones in between. Finally a sheet of paper is placed over the plate and the two are sent through a press. The pressure causes the ink to transfer to the paper. The plate can be reinked and the process repeated on a fresh sheet.

DAGUERREOTYPE The announcement of Louis Jacques Mandé Daguerre's revolutionary process came in January 1839. It was the first time the public learned of photography. Daguerre had begun his experiments around 1826, and four years later formed a partnership with Joseph Nicéphore Niepce, another early experimenter. Following up on one of Niepce's discoveries, Daguerre found that an iodized silver plate, exposed to light, would produce an image if developed with mercury fumes. The daguerreotype process involved first sensitizing a silver-coated copper plate by placing it in a box filled with iodine vapour. This created light-sensitive silver iodide. After exposure in a camera, the plate was developed in another box containing mercury, which was heated until it vaporized. The resulting positive image was then toned in a solution of gold chloride and fixed in sodium thiosulfate (hypo). Because there was no negative, each daguerreotype was a one-of-a-kind image and, like the image in a mirror, was reversed from left to right.

DYE TRANSFER Eastman Kodak introduced this colour printing process in 1946 as a method for making colour prints from colour transparencies. Three colour separation negatives are first made from the transparency and each negative is printed on a sheet of gelatin-coated matrix film. The matrices are developed in hot water, which removes the gelatin from the unexposed areas. The result is a gelatin relief, higher in the shadows than in the highlights. The reliefs are soaked one each in solutions of cyan, magenta, and yellow dyes. They absorb their respective dyes in proportion to the thickness of the gelatin. Then the matrix images are transferred successively, in registration, onto a sheet of dye-transfer paper to make the final positive print. The gelatin itself does not transfer, only the dyes, and because of this the matrices can be used repeatedly to make additional prints.

GELATIN SILVER A general term for photographic printing papers containing light-sensitive silver chloride or silver bromide in a gelatin emulsion. Papers of this type first became available in the 1870s and are still in use. Before their introduction, most photographic printing was done on albumen papers. The various gelatin silver papers were superior to albumen in that they came ready to use (photographers first had to sensitize albumen paper themselves before printing), were far more sensitive to light, and were available in different contrast grades to suit different negatives. They made printing and enlarging with artificial light practical.

GUM PLATINUM This is a combination process in which the image is first printed on platinum paper and processed in the normal manner. Then a gum printing solution is applied over the platinum image. The original negative is placed in registration with the image and the gum coating exposed and developed as described below under Gum Print. The result is a gum print over a platinum print. By itself, the platinum process is not capable of a truly deep black. By superimposing a gum print a much deeper black is possible. A gum print, on the other hand, often fails to show the fine details in an image; but a platinum print can. Thus, if the photographer wishes, gum-platinum can combine the virtues of both processes in a single print. The gum printing can also add colour to the platinum image. Gum printing was also done over silver bromide prints. The only restriction was that the bromide print had to have a matt surface: otherwise the gum solution would not stick.

GUM PRINT *also* **GUM BICHROMATE** Alphonse Louis Poitevin patented the first gum printing process in 1855. It was based on a discovery made in 1839 that paper coated with potassium dichromate (then called *bi*chromate) darkens on exposure to light. About 1852, William Henry Fox Talbot, the inventor of the calotype process, had found that when a water-soluble colloid such as gum arabic or gelatin was mixed with potassium dichromate and exposed to light, the colloid became hardened and insoluble in all except very hot water. Building on this, Poitevin coated paper with a solution of gum arabic, finely ground pigment, and dichromate, and exposed it to sunlight beneath a negative. In the shadow areas the colloid became completely insoluble, but it remained soluble in the highlights and partly soluble in the middle tones. He then developed it in a tray of water. The soluble gum dissolved in the water, carrying the pigment with it. In the exposed parts the pigment remained on the paper, forming the image. One disadvantage of the process was that the image was less sharp and the tonal scale less accurate than was possible on the then-popular albumen paper. One important advantage was that pigments could be chosen that were far more permanent than the silver in an albumen print. The gum process was largely forgotten until the 1890s when it was revived by pictorial photographers, who found it especially useful for creating effects resembling those in Impressionist paintings. One of their methods was to develop the image locally with a brush or a stream of water to modify the tones or eliminate unwanted details. It was also possible to recoat the dry image with a gum solution of the same or a different colour and print it again in registration under the negative. This deepened the tonal scale, adding rich shadows, and also allowed colour effects to be introduced into the image.

KODACHROME, EKTACHROME, ANSCOCHROME Kodachrome film, introduced by Kodak in 1935, produces positive colour transparencies. It contains three separate silver-halide emulsion layers, each layer sensitized to one of the primary colours. A blue-sensitive layer is on top, then a green-sensitive layer, and finally a red-sensitive layer next to the film base. Processing is complicated and must be done by the manufacturer or by specially equipped labs. First, the film is developed to produce a

black-and-white negative image in each of the layers. From this point on, the unexposed silver creates the positive image, forming in each layer a colour complementary to the layer's sensitivity. After the first development, the film is exposed through its base to red light. This affects only the previously unexposed silver halide in the red-sensitive layer. It then goes into a developer containing a cyan colour-coupler, which forms a cyan dye in the red-sensitive layer as a by-product of development of the newly exposed silver. Following the same principle, the film is exposed from the top to blue light and developed again, but this time using a yellow dye-forming coupler to produce a yellow image in the blue-sensitive layer. Next, it is developed in a strong 'fogging' developer containing a magenta dye-forming coupler. This forms the magenta image in the green-sensitive layer. Finally, all the silver is removed in a bleaching bath, leaving only the dyes behind.

In the Ektachrome process the dye couplers are already in the film, each coupler in the appropriate emulsion layer. Ektachrome transparencies are first developed to give a negative image. The developer used does not affect the couplers present. Then the film is exposed to white light on both sides, and developed again – this time in a developer that does affect the couplers in each layer. Finally, the film is treated in a bleaching bath to remove the silver, leaving the dyes behind. Unlike Kodachromes, Ektachromes can be processed in an ordinary darkroom. In 1944 Ansco introduced a colour-reversal film called Anscochrome. It was similar to Ektachrome in that the dye couplers were contained within the emulsion layers. The processing sequence was the same.

PHOTOGRAVURE Karl Klie, a Viennese printer, introduced photogravure in 1879. It wasn't entirely Klie's invention – he based it on principles laid down in the early 1850s by William Henry Fox Talbot (the inventor of salted paper and the calotype, in addition to an early form of photogravure called *photoglyphy*). The process involves first dusting a copper plate with resin and melting the resin with heat to produce a grain pattern. Next, a sheet of gelatin-coated paper, sensitized with potassium dichromate, is exposed to light under a transparent positive. The paper is then soaked in water and laid gelatin-side-down over the grained surface of the plate. The paper backing is stripped off and the gelatin, now attached to the plate, is developed in warm water. The unexposed gelatin dissolves, leaving behind a layer of exposed gelatin that is thicker in the highlights than in the shadows. After the gelatin dries, the plate goes into an etching bath consisting of ferric chloride. This penetrates the gelatin and begins to dissolve the copper in the open spaces between the resin grains. In the shadow areas, where the gelatin layer is thin, the ferric chloride quickly penetrates to the copper and begins to etch. It takes longer to penetrate in the highlights, where the gelatin is thick. As a result, tiny pits are etched into the plate – the shadow pits starting sooner and thus being etched more deeply than those in the highlights. After the gelatin and resin grain are removed, the plate is ready for printing. The printer warms the plate, spreads etching ink over its surface, then wipes it with a rag. The rag forces the ink into the pits but removes it from the unetched surface of the plate. A sheet of paper goes on top and the plate and paper pass through an etching press to transfer the ink. The shadow pits, being the deepest, hold the most ink and print darkest.

PLATINUM PRINT The platinum process was a favourite of pictorial photographers around the turn of the century because of its beautifully soft, delicate tonal scale and matt surface. Platinum prints were regarded as more artistic in appearance than prints on glossy albumen or silver papers. Although commercial production of platinum paper ended in the 1930s, it can easily be made by hand and is still used by photographers who prepare it themselves. The platinum process was first patented by William Willis in 1873. It is based on the light-sensitivity of ferric (iron) salts. The paper is coated with ferric oxalate and potassium chloroplatinite and contact-printed in sunlight or under an ultraviolet lamp. Exposure reduces the ferric salts to the ferrous state. Development in a solution of potassium oxalate in turn causes the ferrous salts to reduce the platinum to the metallic state. The unreduced platinum and unexposed ferric salts are removed from the print in a bath of dilute hydrochloric acid. The result is an image in metallic platinum, an extremely stable material. Platinum prints have the important advantage of being considerably more permanent than photographic prints containing silver.

SALT PRINT Invented by William Henry Fox Talbot in 1834, this was the first truly successful photographic printing method. Talbot coated a sheet of paper with common salt (sodium chloride), then brushed it over with a solution of silver nitrate. The two chemicals combined to form silver chloride, a substance that darkens spontaneously on exposure to light. The photosensitivity of silver chloride had been known before Talbot's time, and others had experimented along the same lines, but Talbot discovered that its sensitivity could be greatly increased if prepared using an excess amount of silver nitrate, so that some silver nitrate was left over after the reaction forming silver chloride. He also discovered that he could fix the exposed image, so that it could be viewed in the light without continuing to darken, by washing it in a solution of common salt, thus reversing the nitrate/chloride balance. This crucial fixing method had eluded the earlier experimenters. Even so, Talbot did not reveal his discoveries until January 1839, prompted only by the announcement of the daguerreotype. Salted paper was popular from the 1840s through the 1860s as a printing paper for both calotype and wet-plate negatives. It was sensitized by the photographer, printed by contact in sunlight until the image had fully appeared, then fixed in sodium thiosulfate (hypo) – which had been found to do a better fixing job than salt. Sometimes the image was toned using gold chloride, before the fixing bath. Albumen paper began to replace salted paper beginning in the 1850s, but the process was revived for a time by pictorialist photographers in the 1890s.

TONED PRINTS The colour of a black-and-white photograph can be changed through various methods of chemical toning. Toning of daguerreotypes in solutions of gold chloride was introduced in 1840, a year after the process itself was perfected. Throughout the nineteenth century, albumen prints were routinely toned in gold chloride or platinic chloride to improve their colour. With albumen prints, the colours possible range from warm browns to cool purples, depending on the composition of the

toning bath, the length of time the print was in the toner, and the chemistry of the printing paper. In addition to modifying the colour and slightly deepening the image, gold or platinum toning protects the image by surrounding the highly reactive silver molecules with molecules of these more stable metals. This 'plating' slows down the rate at which the silver can react with contaminants in the atmosphere or in the photographic paper. After their introduction in the last quarter of the nineteenth century, gelatin silver bromide and silver chloride developing-out papers (so called because the image appeared only after development, unlike printing-out papers, such as albumen, in which the image appeared and grew darker during exposure) were also toned using gold, platinum, and other metals. Because of the expense of precious metals, most toning today is done with selenium. A dilute selenium toner acts to protect the image silver without changing its colour; a more concentrated solution usually gives a slightly purple cast.

TYPE C, DYE-COUPLER (TYPE-C) PRINT Type C is the general name for the various colour printing papers used with colour negatives. Type-C paper contains three separate emulsions, one sensitive to blue, one to green, and one to red light. Each emulsion also contains colour-couplers that form dyes when the exposed silver is developed. After development, the silver is bleached in an acid bath, leaving only the dye image behind.

WET PLATE Invented by Frederick Scott Archer in 1851, the wet-plate, or collodion process, was the most popular method of negative making until the introduction of the gelatin dry plate in the 1880s. The photographer first coated a sheet of glass with collodion mixed with potassium iodide. The collodion formed a clear film. Next, he sensitized the plate by dipping it in a bath of silver nitrate, placed it in the camera for exposure, and afterwards developed the image in ferrous sulfate and fixed it in sodium thiosulfate (hypo). The process got its name from the fact that all of this had to be done while the collodion remained moist; otherwise the plate lost its sensitivity. Collodion negatives were usually printed on albumen paper.

Acknowledgments

The publishers gratefully acknowledge the cooperation of
THE GALLERY OF WORLD PHOTOGRAPHY'S photographic research department.

Photographic researchers: Joan Ades, Gail Buckland, Sally Eauclaire, Mary Fanette, Abigail Solomon Godeau, Valerie Lloyd, Joanne Lukitsh, Gina Medcalf, Christopher Phillips, Toby Quitslund, Belinda Rathbone, Katherine Schlesinger, Ruth Silverman, Sally Stein.

Editorial Associates:

Assistant to Project Director: Ellen Bearn

Assistant to Editor-in-Chief: Tasha Hall

Chief Coordinator of Photographic Research: Katherine Schlesinger

Editorial (text): Mark Greenberg.

The publishers would also like to thank the many collections, public and private, whose staffs spent their valuable time in assisting the research department:

Amon Carter Museum, Fort Worth, Texas
Art Institute of Chicago, Chicago, Illinois
Boston Museum of Fine Arts, Boston, Massachusetts
Boston Public Library, Boston, Massachusetts
Center for Creative Photography, University of Arizona, Tucson
Humanities Research Center, University of Texas at Austin
International Museum of Photography at George Eastman House, Rochester, New York
Kodak Museum, Harrow, England
Library of Congress, Washington, D.C.
Metropolitan Museum of Art, New York
Museum für Kunst und Gewerbe, Hamburg, West Germany
Museum of Modern Art, New York
National Aeronautics and Space Administration (NASA), Washington, D.C.
National Archives, Washington, D.C.
National Park Service, Department of the Interior, Washington, D.C.
New York Public Library, Astor, Lenox, and Tilden Foundations, New York
Oakland Museum, Oakland, California
Philadelphia Museum of Art, Philadelphia, Pennsylvania
Princeton University (Minor White Archive), Princeton, New Jersey
Royal Photographic Society, Bath, England
San Francisco Museum of Modern Art, San Francisco, California
Science Museum, London

Service des Archives Photographiques (C.N.M.H.S.), Paris
Smithsonian Institution, Washington, D.C.
Société Française de Photographie, Paris
Victoria and Albert Museum, London
Worcester Art Museum, Worcester, Massachusetts.

Ansel Adams Publishing Rights Trust, Carmel, California
Agfa-Gevaert Foto-Historama, Leverkusen, West Germany
Bristol Workshops in Photography, Bristol, Rhode Island
Castelli Graphics, New York
Christie's East, New York
Imogen Cunningham Trust, Berkeley, California
Freidus Ordover Gallery, New York
Grapestake Gallery, San Francisco, California
Harcus Gallery, Boston, Massachusetts
Susan Harder Gallery, New York
Huffman Photos Ltd., Tucson, Arizona
Janet Lehr Inc., New York
Peter MacGill Company, New York
Magnum Photos Inc., New York
QED Editions, New York
Andrew Smith Inc., Albuquerque, New Mexico
Paul Strand Foundation, Millerton, New York
Time Inc., New York
Underwood Photographic Archives, Boston, Massachusetts
Weston Gallery Inc., Carmel, California
Daniel Wolf Inc., New York
Charles B. Wood III Inc., South Woodstock, Connecticut
Zabriskie Gallery, New York

Van Derren Coke, San Francisco, California
Arnold H. Crane, Chicago, Illinois
Harriet and Noel Levine, New York
H. F. Manes, New York
Sam Wagstaff, New York
Paul F. Walter, New York
Stephen White, Los Angeles, California

The publishers would like to thank the artists who loaned us their photographs and contributed their expertise.